TOWARDS SCULPTURE

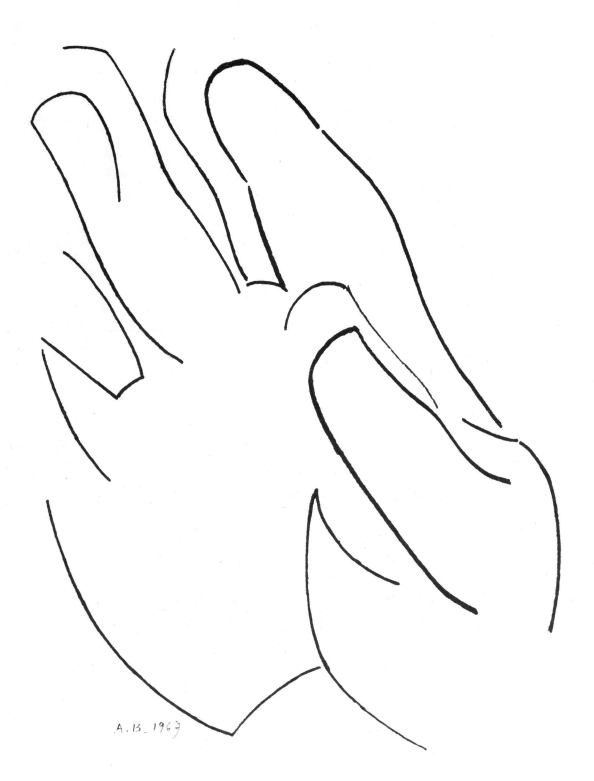

A. B. _ 1967

TOWARDS SCULPTURE

*Drawings and maquettes from Rodin
to Oldenburg*

W. J. STRACHAN

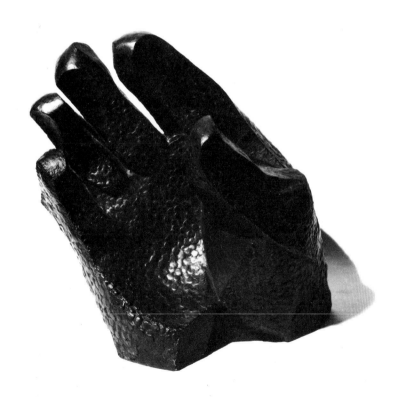

WESTVIEW PRESS · BOULDER · COLORADO

To Alexander E. Racolin

Frontispiece: ANDRÉ BEAUDIN Sketch for *The Hand*
Title page illustration: BEAUDIN *The Hand*

Published in 1976 in the United Kingdom
by Thames & Hudson Ltd.

Published in 1976 in the United States of America
by Westview Press, Inc.
1898 Flatiron Court
Boulder, Colorado 80301
Frederick A. Praeger, Publishers and Editorial Director

Library of Congress Cataloging in Publication Data

Strachan, Walter John, 1903–
 Towards sculpture.

 Bibliography: p.
 Includes index.
 1. Sculpture, Modern—19th century. 2. Sculpture,
Modern—20th century. 3. Artist's preparatory studies.
4. Models (Clay, plaster, etc.) 5. Drawings.
I. Title.
NB197.S88 735′.22 76-14955
ISBN 0-89158-618-0

Printed and bound in Great Britain

Contents

Acknowledgments

For both the Introduction and the main part of this book I have drawn on many oral and written sources. The latter are recorded in the Bibliography. For the former I am indebted to the sculptors themselves, who have allowed me to discuss their work with them in their studios and have so generously provided me with the material I needed for illustrating drawings. They have, without exception, been prodigal with their time, and, in many cases, visits have been followed up with correspondence on specific points. These personal contacts with all the British sculptors included in this book and many abroad have been stimulating as well as indispensable experiences. As, however, it is impossible to list all the sculptors and occasions, I would like to take this opportunity of recording my gratitude for their hospitality and cooperation. Two people I must mention in particular, for without their active help this book might never have been written, or at any rate would not have taken its present comprehensive form. The first is Henry Moore, who encouraged me in my project from the start, and whose advice in all stages of its progress has been invaluable. He gave me complete freedom to quote from his writings and *obiter dicta* as well as, with the help of his secretary Mrs Tinsley and David Michinson – editor of the admirable book of the sculptor's un-published drawings – access to his vast corpus of photographs for use in this book. As my deep interest in contemporary sculptors goes back to my first visits to Henry Moore's studio at the time when he was working on the *Northampton Madonna*, and has continued to be stimulated by countless visits for some three decades, witnessing, as I have, progress on all the works dealt with in this book and many more, I cannot be grateful enough for the great privilege implied by his friendship.

Although my link with Alexander Racolin, of New York, barrister, publisher and promoter of modern plays, has been more recent, it has been cordial and invaluable since his wide cultural connections have enabled him to put me in contact with many of the American and European sculptors who figure in this work, thereby enriching my field of representation, and putting me greatly in his debt.

Where deceased twentieth-century sculptors are concerned, I have discussed their work with relatives, friends or other representatives. These opportunities have been most valuable. I am grateful therefore to Lady Epstein, Madame Bourdelle-Dufet, Monsieur and Madame Claude Laurens, Madame Dina Vierny (for Maillol), Madame Jacquard (for Despiau), Madame Prévot-Douatte of the Galerie de France, Paris (for Gonzalez). Also to Madame Arp and Madame Zadkine for their cooperation in connection with their late husbands, to Monsieur Creuzevault of the Galerie Creuze-vault (for Germaine Richier). For contacts with some living sculptors I would like to thank Mademoiselle Madeleine Pont (for Leo Kornbrust), Madame Galanis (for Lobo),

7

Dr Wolfgang Fischer (for Wotruba). Owners, directors and officials of various museums and galleries – particularly the Perls, the Egan and Marlborough Galleries in New York – have been helpful, and, in France, Madame Goldscheider of the Museé Rodin, Mademoiselle Michelin of the Galerie Maeght, Madame Claude Bernard of the Galerie Claude Bernard, Monsieur Maurice Jardot of the Galerie Louise Leiris; in London Mr David Talbot Rice (for Dodeigne), Mrs Janet Mighel of the Waddington Gallery, Mr Neffe of the J. P. L. Fine Arts (for Leon Underwood), the Marlborough Fine Arts and the Leicester Galleries; nor should I omit to acknowledge help in the initial stages of the book from the British Council and, for the Introduction, of Mr Ward-Jackson of the Victoria and Albert Museum. My friend Mr Ian Lowe of the Department of Western Art at the Ashmolean has been most cooperative likewise in that connection, and Mr H. S. Ede of Kettle's Yard, Cambridge, for the work of Gaudier-Brzeska. In Paris Madame Viatte of the Cabinet des Dessins, the Louvre, was similarly cooperative for Carpeaux and other sculptors in the Introduction. Particularly rewarding also in Paris were my interviews with William Chattaway, Gilioli, Beaudin and Hajdu, with Monsieur Robin Lipchitz who put me in touch with Jacques Lipchitz and lent me relevant photographs, with Couturier in the studio inherited from his master Maillol. Memorable too was the visit to Dieudonné with the poet Pierre Lecuire to the studio and home of Ubac, and that with the artist Krol in search of what one of the guardians of the park of Versailles referred to as 'le Bernin loupé', unacknowledged in the guidebook. Correspondence with various sculptors has helped to clarify many points (as quotations in the text will show).

It becomes almost impossible to record all one's obligations for a work of this scope; often they resulted from the chance encounter, such as that with the enlightened American, Mrs Sobernheimer of San Marino, California, before the Porta del Paradiso in Florence, with the enthusiastic Italian boy, Camillo Binda, in the Galeria d'arte moderna in Milan to whom I owe my visit to the Centro studi Piero della Francesca to see the Marini bust portraits, to Mr Simon Knight, a former pupil, for an indefinite loan of valuable Italian books on sculpture and help in securing photographs.

Although they are listed in the official acknowledgments for reproduction permissions or photographic credits, I would like to add a personal note of gratitude to the Mansell Collection in London for their quick attention to my requirements.

W.J.S.

Foreword

> For the sculptor, drawing is the most complete way of exploring and the most reliable means of carrying out his experiments before realizing their conclusions in three-dimensional terms.
>
> AURICOSTE

The aim of this book is to explore the relationship between sculptors' first-idea sketches, studies, in some cases working drawings and maquettes, and the definitive sculpture. The approaches to the sculptural problem, the different idioms and the techniques of graphic media employed by some sixty sculptors of international reputation will be examined against the background of a few relevant examples taken from the classical tradition of sculpture.

I have adopted this procedure to emphasize the factor of continuity, persisting even in a century that, more perhaps than any other, has been characterized by its break with the past, but particularly in order to illustrate similarities and differences between sculptural and graphic treatment of a subject, or related themes, before Rodin and in our own time. For non-figurative and abstract or semi-abstract art, a parallel procedure, involving comparisons between contemporary sculptors at work on a wider range of kindred themes, provided a fruitful and interesting way of looking at preliminary drawings side by side with the end-product.

A glance through the illustrations will show that some of the studies have been taken to a higher degree of finish than others. This has depended partly on the attitude of the individual sculptor towards such drawings, partly on the phase of this preparatory work, partly on the nature and material of the artifact envisaged. Some – often the most fascinating – are first-idea scribbles; some are life-studies, others formalized schemata, executed in a great variety of graphic media.

Apart from any aesthetic merit they may have, sketch drawings bring us into an intimate relationship with the sculptor whom we meet, so to speak, *en robe de chambre*. The literary parallel is the first draft of a poem, though perhaps an analogy from ballet – the dance being one of the themes treated in both the Introduction and the main part of the book – would be more appropriate. Sculptors' drawings often represent a limbering-up process, comparable to the dancer's exercises *à la barre*. Sculptors from Michelangelo to Henry Moore have found the practice of drawing indispensable: 'drawing keeps one fit, like physical exercises', to quote the latter. Sometimes – to pursue the comparison with the dance – the drawing consists of a closer exploration of pose and movement, leading, as it were, to the ultimate choreographic statement. 'Drawing', to quote Moore again, 'lessens the danger of repeating oneself in sculpture and getting into a formula. It enlarges one's form repertoire and one's form experience.'

Before dealing in a general way with the nature of drawings for sculpture as opposed to other kinds of drawing, I should anticipate an obvious criticism – the absence from the illustrations of certain famous names, notably Picasso, Matisse, Renoir and Miró – painter-sculptors whose drawings are mostly linked with their painting activities.

9

Although their importance to sculpture cannot be overestimated, their inclusion would have involved a severe cutting-down in the representation of artists who are primarily sculptors. I have, however, included Arp, whose sculpture can be considered more important than his painting; Beaudin, whose major concern for some time now has been with sculpture; and Modigliani because of the thematic relevance of a specific work.

If some talented contemporary sculptors are also omitted, this is not necessarily through any lack of appreciation on my part. In many cases it is because the kind of sculpture they have produced has not involved drawing at all, or has involved it only to an insignificant extent. This explains why Robert Adams is represented only by a maquette for a major work. One of the younger sculptors whose omission I particularly regret is Robert Morris, whose schematic drawings, reminiscent of Le Corbusier's, have the strength and simplicity of their subjects such as *Hillside Observatory* and *Solar Reflector*. Here the vast disproportion of length to width has precluded reproduction in the present page-format.

Preface: the sculptor's drawing

The three-dimensional objects we call sculptures can assume mysterious, numinous powers. If they are removed or destroyed, the space they leave behind is not so much empty as emptied of 'presences'. They are in an aesthetic sense our vertical and horizontal gods. Moreover, in the case of the valid work of art, anything that has contributed to its ultimate realization has gained some of this magic in the process. This applies particularly to first-idea sketches and other studies for sculpture. They are the direct reflection of the quality of mind and imagination that produced the initial idea. Even a slight notation such as a trivial-seeming sketch by Carpeaux has a merit *sui generis*. From a page of a notebook we can follow a sculptor's explorations, see why he has followed one particular development, observe how a sculpture can result from a synthesis of several individual drawings, or how a sculptor – for example Maillol – extracts from the accidentals of a figure-study elements that give a universal quality to the final sculpture.

Before further consideration of the interest of such 'drawings towards sculpture', something should be said about the nature of drawing and its sculptural application. Although drawing, of all the arts, bar modelling – which requires only a lump of clay and a pair of hands – is the one demanding the simplest apparatus, it is by nature the most abstract, the most sophisticated, the least accessible to the uninitiated. Even with the addition of light and shade, it is already distanced from reality by the absence of colour, the furthest removed from illusionist art. Sculptors' drawings, moreover, differ from drawings done for their own sake. The latter are necessarily affected by the coordinates of the sheet of paper or other support, which play a part in the shaping of the 'picture' for which a mount or frame is ultimately envisaged. Sculptors do sometimes produce autonomous drawings of this kind – Ralph Brown and Elisabeth Frink, for example – and take them to a higher degree of finish than their purely sculptural studies. McWilliam and Moore record that a too-complete drawing can weaken their desire to realize the idea in three dimensions. The drawings or studies made with a painting in mind are similarly conditioned by two-dimensional coordinates and a notional sense of space. Their nearest equivalent among sculptural drawings are drawings made for reliefs.

This is not to say a painter's drawing cannot have predominantly sculptural qualities – drawings by Poussin and Daumier are cases in point – nor a sculptor's drawing be painterly. Readers will reach their own conclusions about certain sculptors' drawings reproduced in this book. Delacroix, haunted all his life by Michelangelo's sculpture, wrote that 'Sculptors are superior to us; in establishing the form, they fulfil all the

conditions of their art. Partisans of the contour, likewise, they are concerned with the disposition of the masses.' Many of the principles he laid down and the examples with which he illustrated them might have been formulated by a sculptor. He referred repeatedly to the 'ovoid construction of masses', which he called his 'eggs', and illustrated structures built up on this basis from his sketch studies, especially the sketches of horses. Indeed, his way of conceiving masses from the centre outwards is a *sine qua non* of good sculpture, and is implicit, as we shall see, in many sculptors' drawings where the ornamental element is of little or no consequence.

The sculptor Gaudier-Brzeska, for instance, translated drawings of the simplified, schematic kind into terms of solid geometry. On the subject of some sketches of human forms constructed on a framework of parallelepipeds, prisms and cubes, he writes: 'Here is a collection of cubes which delights me – on these I can inscribe the body of a woman.' These sketches show that, like the Italian Renaissance draughtsmen, he understood the relation between organic and geometrical form. In Brancusi's drawings for sculpture we shall see the same principle taken to its logical extreme, in a synthesis of spheres and ovoids which are not so much representational as analogues of organic, often human, forms.

Before dealing with contrasting approaches to drawings for sculpture, I should point out that the thematic arrangement of sculptural works has involved departures from the chronological order. I have judged it less important to show progressive differences in individual style or idiom of draughtsmanship than to offer examples of the different kinds of drawing evoked by a particular theme, and in some cases, to compare such drawings with those executed by sculptors of the pre-Rodin period working on the same or similar subjects.

The drawings reproduced range from apparently slight but immensely evocative sketches (such as Giacometti's *Walking Man*) to solid gouache drawings (such as Marino Marini's *Horse and Rider*); from sketch-book explorations (by Beaudin, McWilliam and Wotruba) to life-studies (by Despiau) and figurative nudes (by Reg Butler); from the transmutations of human and organic form in the drawings of Henri Laurens and Zadkine to the more animistic examples of Meadows, Ralph Brown, Germaine Richier and Gonzalez. There are preliminary working drawings by Rodin, Henry Moore and others which form a link with the Renaissance past, as well as those which unambiguously break with tradition, such as the detailed drawings by Kenneth Armitage for *Big Doll*, Gio Pomodoro's for *Sun of Cerveteri*, Claes Oldenburg's for *Three-way Plug*, Tony Smith's for *Smoke*; and, finally, schematic drawings for mobiles or mechanized constructions, by Alexander Calder and Pol Bury.

The drawing techniques employed embrace the use of wax-chalks combined with colour wash (Moore), oil and pencil (Barbara Hepworth), felt-pen (McWilliam), monotype (Geoffrey Clarke), collage (Arp), frottage (Ubac), and silk-screen and pen (Kenneth Armitage). At a time when new materials are constantly finding their way into sculptural use, the sculptor still appears to favour pencil and pen. Whether in the nervous pencil and wash drawings by Rodin for a *Ballet Dancer*, the bold ink-drawing for its counterpart in a primitive style, *Red Stone Dancer* by Gaudier-Brzeska, the spontaneous pencil sketch by Seymour Lipton for *Sentinel* or the exquisite pen and pencil studies by Manzù and Emilio Greco, we are reminded of the continuity preserved by that most conservative of the arts, from the Renaissance to the present century, in the service of another and more experimental one. Nevertheless, in both style and idiom, innovations in sculpture are reflected in the drawings, and my concern throughout has been as much with the drawings-sculpture relationships, as with the comparative treatment of themes.

Part One

INTRODUCTION:
THE CLASSICAL TRADITION
BEFORE RODIN

THE HISTORICAL PERSPECTIVE

> An art that has life does not restore works of the past, it continues them.
>
> RODIN

The purpose of this Introduction needs a word of explanation. The intention is to provide historical points of reference for modern sculptural themes and drawing techniques, and in addition, to underline the continuity, throughout all its variations, of the classical tradition in sculpture, linking as it does Rodin's individual genius with Antiquity and the Renaissance, and persisting into the post-Rodin period in the work of Bourdelle, Despiau, Maillol, Manzù, Emilio Greco and, in certain of its aspects, of Henry Moore, Marini, Lobo, Ubac and others. Even for those who repudiated the classical past, and whose relation with Rodin can be described as one of love-hate, the great sculptor's work acted as a catalyst, releasing potential energy derived from other sources. I refer to those who found their inspiration in primitive and exotic sources, or who were influenced by Brancusi and the Constructivists. Not all these sculptors rejected a figurative or anthropocentric approach, and a comparison of their work with that of the pre-Rodin period on kindred themes is revealing, particularly from the point of view of drawing. For instance the return of some contemporary sculptors to treatment of the female nude – Reg Butler, Ralph Brown and McWilliam, to mention three – allows us to compare their work with that of Goujon, Canova and Carpeaux; and the classical equestrian statue finds the modern counterpart in Marino Marini's and Elisabeth Frink's horses and riders.

The advent of new sculptural materials and techniques by no means vitiates comparisons stretching over half a millennium. Drawing is by its nature the most basic form of expression, so that sketches made in connection with artifacts of iron, fibreglass, or polystyrene, for mobiles or for soft sculpture, are expressed in terms that allow comparisons across the years and emphasize the essential qualities of imagination, perceptible in the first-idea sketch and realized in the final creation, be it a work by Michelangelo or Henry Moore, Canova or Manzù, Carpeaux or Rodin. To quote the French sculptor Raymond Martin: '*Le dessin, c'est l'écriture de l'âme, et c'est vraiment en lui que réside toute la personnalité du sculpteur.*' ('Drawing is the writing of the spirit, it is truly in drawing that the sculptor's whole personality dwells.')

Up to the time of the Early Renaissance, drawings for sculpture were rarely made, and where they existed, were generally executed by a draughtsman-amanuensis rather than by the sculptor himself. The question of preservation did not arise, and few have survived. Those we do have belong mostly to the later Renaissance; by then drawings by the great masters were starting to be collected, and Michelangelo did many such to offer as presents to patrons.

The genesis of the Renaissance can be found in thirteenth-century Italy, when the major contribution to sculpture was made by the Pisano family, Nicola and his son

Giovanni, known above all for their pulpit reliefs. Nicola's treatment of the reliefs at Pisa was influenced by one of the Antique sarcophagi, which were so to speak, on his own doorstep in the Campo Santo in that city. In Florence, the bronze doors by Andrea Pisano (no relation) for the Baptistery still show a predominantly Gothic spirit. It was the commission to make a corresponding pair of doors, resulting from the success of his trial panel on the subject of the *Sacrifice of Isaac*, that brought fame to Ghiberti, whose bronze reliefs provide the point of departure for the next chapter.

Although he adopted the typical Gothic quadrilobe frame to harmonize with earlier doors, Ghiberti's naked figure of Isaac was obviously based on a Classical model; and, indeed, on the second pair of bronze doors which he contributed, and which the enraptured Michelangelo later honoured with the name of 'the Gates of Paradise', we find further classical affinities, particularly in the portrayals of Agar and Ishmael. The panel of the *Scourging of Christ* (discussed in the next chapter) shows a break away from the medieval hieratic treatment of a scriptural theme. The critic Adolfo Venturi sums up Ghiberti's escape from medieval ascetism in these words: '[he] felt the antique statue in his hand . . . he felt its nude beauty, happy that Venuses were no longer buried away as works of the devil.'

Impressed and fascinated though we are by Gothic art in all its manifestations, it is for us part of an alien world whose symbolism has to be learnt before we can fully appreciate its expression. The spirit of other-worldliness is summed up in the rhetorical question, 'What is man that Thou art mindful of him?' The language of the Renaissance, on the other hand, is – though perhaps deceptively – a familiar one. Even if a modern generation, no longer versed in the classics, is unfamiliar with its myths, the sculptural canons of idealization, based on the traditions of Antiquity, have been accepted as the norm for centuries – and unquestioningly up to the time of Rodin, who still admired them while seeing the human form in terms of a new expressivity.

A brief reminder of the causes behind the Humanist revival is relevant. First, there was the renewed interest in the achievements of Greece and Rome, their art and literature. Then, from the point of view of the practitioner, art was becoming a more individual pursuit. Church guilds were replaced by workshops which provided apprenticeship under an acknowledged 'master'. The great artists were patronized and treated almost as equals by the princes and dukes who were heads of great families such as the Strozzi or Medici. Even the ordinary citizens of a town like Florence were encouraged to participate in the new learning and enjoy the creations of their artists. Burckhardt quotes the contemporary boast that, in the streets of Florence, 'even the donkey-man sang the verses of Dante'.

Leonardo da Vinci typifies the ideal of the *uomo universale* who engaged in every activity from inventing engines of war to painting masterpieces. Michelangelo was supreme not only as a sculptor and artist but also as a poet. Sublimely confident in their powers, these men of the Renaissance revered and imitated the best works of Antiquity. Michelangelo's bust of Brutus symbolizes the reverence felt for the heroes of ancient Rome – a Rome admired as much for its military and civic achievements as for its sculpture. All in all, it was a strange society, in which artists were as much at home in the world of pagan mythology as in that of Christian iconography. Cellini's *Perseus and Andromeda*, for instance, stood only a stone's throw from Donatello's *Judith and Holofernes*, and Filarete's bronze gates for St Peter's, Rome, whose main subject is the Martyrdom of St Paul, carry a small-scale *Fox and Stork* inspired by Aesop's fable.

The Church was no less involved than the artists in this duality. Pope Leo X called the study of Antiquity 'the finest and most helpful task that God could assign to

mortals next to that of knowing Him and preserving true faith'. 'Such a study', he claimed, 'refines and beautifies our existence.' This attitude from so high an authority set a seal on a new, self-conscious appreciation of art in the service of religion.

While continual archaeological discoveries of Roman statues or Roman copies of Greek originals provided sculptors with a shared repertory which led to a free exchange of ideas, and the revival of interest in the classical past provided the impetus, it is obvious that without the remarkable wealth of genius and high general level of craftsmanship during the fourteenth to the sixteenth centuries, the movement could not have made so strong and permanent an impact on Western civilization as a whole. The rhetorical question, 'What is man that Thou art mindful of him?' which characterized the attitude of Christian humility was replaced by the confident apostrophe: 'O what a piece of work is man, how noble in reason, how infinite in faculty! In form and moving how like an angel! In apprehension how like a god, the beauty of the world, the paragon of animals!'

Implicit in the artistic achievement of the time is the analytical spirit of the great initiators, the Florentines. This spirit explains their preoccupation with anatomy and perspective, exemplified in sculpture, particularly in the development of *rilievo stiacciato* (flattened relief), used originally by Donatello to create the illusion of depth by perspective. And despite the enormous problems presented by bronze-casting on the grand scale – occasionally unresolved – technique kept pace with artistic achievement.

It was an intellectual period and the aesthetic principles of the past were carefully studied, in particular those derived from the 'canon' of the Greek sculptor-architect Polyclitus, successor of Phidias and next to him the greatest of the early Greek sculptors (active 450–420 BC). His theory of human proportions – seven and a half heads to the body – was embodied in his figure of *Doryphorus* (*c.* 450 BC) which provided a standard model, and in addition the so-called *contrapposto* stance (one leg taking the weight, the other relaxed), which is to be seen again in the *Cnidian Venus* after Praxiteles (*c.* 350 BC), the *Medici Venus* of the fifth century BC, in a Roman dancer, in certain Canova figures, and in Rodin's *Eve*.

New discoveries of buried or neglected fragments of ancient sculpture excited artists and ecclesiastics alike. Michelangelo joined the throng to see the *Laocoön* statue, found in 1506 in a vineyard. ('All Rome', it is reported, 'day and night rushed out to the Terme.') Other important finds included the *Belvedere Apollo* in 1495, the *Belvedere Torso* (bought by Clement VII in 1523), so much admired by Michelangelo and Bernini, and the *Farnese Bull* in 1546. This practical exploitation of Antiquity was complemented by the Neoplatonist philosophy, set out in Picino's *De Amore*, in which he emphasized that external beauty is only an extension of the invisible beauty of God. This thesis influenced the more idealized sculpture of the High Renaissance, the period from the turn of the Quattrocento to around 1527, shading into the so-called Mannerist period up to about the year 1600.

The Mannerist sculptors (and painters) sacrificed anatomical realism and the Greek canons of proportion to various degrees of stylistic distortion, disagreeably muscular in Bandinelli's *Hercules and Cacus*, for example, but attractively elegant in Giovanni Bologna's *Rape of the Sabines* and his *Venus* of the Boboli Fountain, based on the *forma serpentinata* – the spiral form which has persisted to the present day in bronzes by Emilio Greco and others. Elongation of torso and limb occurs exaggeratedly in Cellini's *Nymph of Fontainebleau* of 1543, attractively in the reliefs of the *Fountain of Innocents* of 1547–9 by Jean Goujon. It is evident, too, in the nymph that reclines languorously on the rim of Ammanati's *Fountain of Neptune* in Florence.

Bernini (1598–1680) began by carving his figures, Michelangelo-like, out of a single block of marble, and with rare virtuosity and imaginative genius in the *Neptune* of 1620 (now in the Victoria and Albert Museum), but his later carving varied between a multi-faceted presentation and sculpture with a basically fixed viewpoint, such as the *Apollo and Daphne* of the Museo Borghese in Rome, and the moving but theatrical *Ecstasy of St Teresa*. In his religious subjects he obeyed the strict anti-erotic rules laid down by the Church of the Counter-Reformation, reserving his pagan exuberance for the fountains. Their Baroque spirit was to invade cultural centres outside Italy, notably the Versailles of Louis XIV with the disporting and recumbent nymphs of Coysevox, Tuby and Girardon. The Baroque impulse spread to Austria and central Europe, reaching a climax in the decorative idiom of Rococo, superbly exemplified in the sculpture of Günther and Neumann.

By the mid-eighteenth century, thanks to the excavations of the great German archaeologist and scholar Winckelmann at Pompeii and Herculaneum, a reappraisal of the architecture and sculpture of Antiquity became possible. The wave of enthusiasm generated was largely responsible for the movement known as Neoclassicism, the repercussions of which throughout Europe were considerable and sustained over a long period. It had many facets, but here we are concerned only with sculpture. In his *History of Art among the Ancients* of 1764 Winckelmann had laid down five rules that should govern art. They were based on his conviction that 'the Greeks and the Greeks alone discovered ideal beauty'. In sculpture, he declared, the main emphasis should be on 'volume'; overt emotion should be renounced in favour of restraint and simplicity. The noblest subject was the idealized nude. It is to a pursuit of these principles that we owe the masterpieces of the greatest exponent of Neoclassicism – Canova (1757–1822).

Napoleon had astutely identified both himself and his period, by analogy, with the Roman Empire, and Canova – until disillusioned, like Goethe and Beethoven – greatly admired him, and carved a larger-than-life portrait bust of the Emperor. The heroic male figure in the classic mould became a feature of Neoclassical sculpture, in contrast to the ubiquitous female nudes. The latter were modestly erotic, usually symbolizing some abstract virtue such as Hope or Charity, and at the best – as in the work of Canova – had great charm.

Bertel Thorwaldsen (1768–1844) left his native Denmark – as Flaxman had left England a decade before, in 1787 – for Rome, the acknowledged centre of the new international culture. Thorwaldsen, who specialized in stoical males (*Mercury about to kill Argus*, etc.), was indeed more of an Antique Roman than a Dane; he was outdone in this vein only by the less sensitive Swedish sculptor, Sergel, with his portentous figure of *Diomedes*.

In this movement so full of ambiguities and contradictions – often contained in one and the same artist – we note a predilection for the epicene youth, typified by Canova's *Endymion*, or the *Narcissus* of the English sculptor John Gibson. Thorwaldsen sometimes deserted his more pedantic vein and produced such charming figures as a *Shepherd Boy*, and a *Dancer* modelled in clay that anticipates Rodin. A similar modality can be seen in a plaster model by David d'Angers of *A Young Greek Girl* that invites comparison with an Emilio Greco. And we find Houdon, the brilliant French sculptor-portraitist of Voltaire, who in his time had produced a bronze *écorché* in the Cigoli manner, carving a bust of a *Young Girl* that looks as modern as a Manzù head-and-shoulders bronze portrait.

Neoclassicism shades into Romanticism in sculpture as in painting. François Rude (1784–1855), for example, alternates between the two modes: his bronze *Aristaeus*

mourning the Loss of his Bees has the contours and linear rhythm of the early Donatello whereas his famous statue of Marshal Ney has the 'noble simplicity and calm greatness' advocated by Winckelmann.

Rude's great pupil Jean-Baptiste Carpeaux (1827–75) is unambiguously classical. His *Ugolino* is linked with the Renaissance in its subject, Dante, in the treatment and in the idiom of draughtsmanship. Carpeaux was most at home with the female figure, nude and draped. Provided the nude had a Classical source, like his *Triumph of Flora*, it was readily accepted; not so, however, even if semi-draped, when flaunted as symbolizing *The Dance* on the outside parapet of the Paris Opéra (55–8). The public had apparently become so dulled by anodyne marble carvings of nymphs and cupids that this new vigour was too much for them.[1] It was a revitalizing shot in the arm for a moribund classicism.

It is difficult now to imagine that it was into a Paris dotted about with a hundred diminutive cast-iron statuettes (Fontaines Wallace) of the classical *Three Graces* that Auguste Rodin was to stride like his own *Walking Man*, soon to arouse protests with his unfamiliar idiom, then to be lionized, but finally fated not to outlive the outcry against his great masterpiece, the *Balzac* statue (393–4). He too, as we shall see, classicized, but with a difference.

The same can be said of his successors, Bourdelle, Maillol and Despiau; likewise of the Italian sculptors Manzù, Marino Marini, and Emilio Greco in some aspects of their work and – in certain instances – of Henry Moore. The influence of the classical tradition is sufficiently recognizable, and its various manifestations can usefully be placed against the historical background outlined in this Introduction for examination in the main part of the book.

Influences from other civilizations, or more exotic sources, have been widespread and significant for the majority of sculptors since Rodin, but unlike classicism, they do not lend themselves to a unified examination. I shall refer to them later in the text, where they have relevance to a specific sculptural project.

THE RELIEF

The relief stands half-way between sculpture proper and drawing. It may be shallow – low relief – or carved or modelled almost in the round. Reliefs may be executed on any flat or curved surface – pediment, wall, tympanum, door, pulpit, statue base – inside or out-of-doors. Although they are made by lowering the surface surrounding the design, examples going back to the cave reliefs of Les Eyzies show a judicious combination of relief with incision, on a similar decorative principle to the contemporary bronze reliefs by Manzù for St Peter's, Rome.

Ghiberti, as every visitor to Florence is aware, proved himself one of the early masters of the bronze relief, and the story of the competition he won against artists who included Brunelleschi has often been told. Following the decision of the judges, Ghiberti was assigned the North and East doors of the Baptistery at Florence for bronze reliefs. The reliefs for the former, which occupied him from 1403 to 1424, consist of twenty-four compartments dealing with the life of Christ and the Evangelists and the doctors. The East doors, later known as the *Gates of Paradise*, include the scene of *The Sacrifice of Isaac* – the subject of the prize-winning panel with its nude figure – and the *Esau and Jacob* episode with a classical edifice in the background.

The Scourging of Christ is the subject of the third panel from the left, second row down on the North door, and the studies for this panel show beyond doubt that

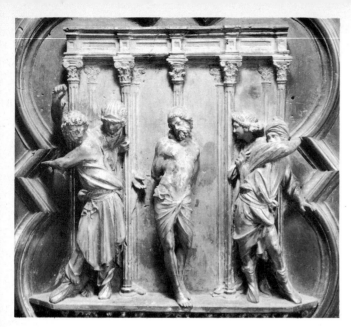

1 LORENZO GHIBERTI *The Scourging of Christ* 1403–24

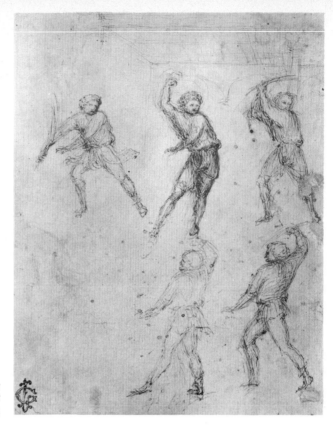

2 GHIBERTI Studies for
The Scourging of Christ
1403–24

Ghiberti was drawing from the life in order to explore attitudes and movements. This is the earliest of the sculptors' drawings illustrated, and early by any criterion, since few sculptors' studies survive from before the fifteenth century.

It will be noted that the centre top figure of the drawing becomes the left-hand scourger of the relief, but that the right-hand scourger of the sketch has changed considerably in the final sculpture. This modification has the effect of avoiding an over-symmetrical composition. The bringing of the right arm across the body, apart from increasing expressiveness, stresses a horizontal opposition to the dominant verticals of the classical columns. The latter in their turn emphasize the central figure of Christ. Ghiberti does not wholly separate the figures, but skilfully allows us to 'read' the Madonna standing behind the left-hand scourger and endeavouring to restrain him. The woman on the right wrings her hands in pity.

Ghiberti's version of this popular subject, which compares favourably with Vincenzo Danti's treatment of the theme with its muscular scourgers, and with Vecchietta's more Gothic interpretation, is outstanding in its moving simplicity. He expresses pathos without sentimentality. The composition is based on an equilateral triangle which runs from the outer feet of the figures on the edge to the head of the Christ (and the capital of the pillar behind it), bisecting a rectangle formed by the line of heads parallel to the base and the architrave resting on the columns.

Before leaving this Italian Renaissance relief, it is worth noting that the Ugolino theme from Dante, treated by the Florentine sculptor Pierino da Vinci (*Death of Ugolino*, in the Bargello, Florence), is to recur in the repertory of both Carpeaux and Rodin.

Jean Goujon's reliefs for the *Fountain of Innocents* could hardly be in greater contrast with the Ghiberti. The subject is pagan, the idiom, influenced by the contemporary work of Benvenuto Cellini, Mannerist in its stylistic elongation of the figure. Jean

20

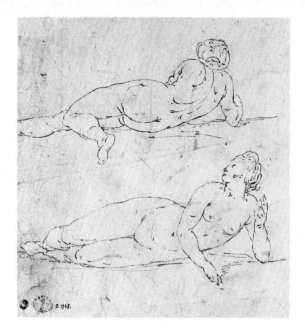

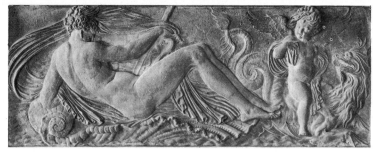

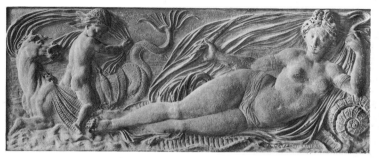

Goujon (died between 1564 and 1569) is the most distinguished of the sixteenth-century French sculptors, his interpretation of the classical tradition in terms of relief the most exquisite in the whole of French sculpture. Though little is known of his life, it is assumed that he visited Italy some time before 1540, and that he had seen works by Primaticcio and Rosso as well as by Cellini, all of whom had been induced to come to the court at Fontainebleau by Francis I. The *Fountain of Innocents* was completed by 1549. The sketches reproduced cannot be linked directly with this project but are sufficiently related to indicate Goujon's method of procedure. The study of the *Venus and Cupid* of the squared-up drawing demonstrates the attention to the geometric principles of composition by a sculptor who is credited with having collaborated with Jean Martin on the French version of Vitruvius' *Treatise on Proportion*. The two drawings – the one above being a sketch-notation of a pose – can be linked with elements in both the reliefs shown. The recumbent figure leans in a pose similar to that of the sketch-notation; the sensuous line of the thigh is smoothed and enhanced in the carving. The raised thighs are a feature of the first-mentioned study and the upper relief panel. More important than these details are the general spirit and graphic idiom of these two differently-purposed studies. The squared-up drawing is an exquisite work of art in its own right. The tentative contours and minimal touches of deft shading emphasize the modelling; the experiments in the placing of the cupid add dark areas which – albeit fortuitously – enhance the whole effect. The pure contour drawing – with the odd foreshortening of the legs – indicates the sculptor's preoccupation with the line of the thigh and the axial turn of the upper torso.

3 (above) JEAN GOUJON *Study of two female nudes*

4, 5 (above right) GOUJON *Nymphs of the Seine*, panels from the *Fountain of Innocents* 1547–9

6 (right) GOUJON Study of *Venus and Cupid*

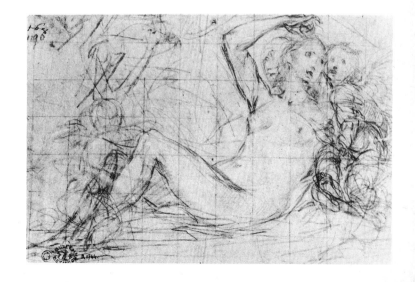

The subsequent history of carved reliefs is chiefly one of adherence to the classical pattern, sometimes exploited in a spirited and enlightened way, as in the nymphs by Girardon at Versailles. It was not until well into the nineteenth century, with Jules Dalou (1838–1902), that we see a radical change in subject matter, reflecting the advent of social realism. Pagan deities and carved allegorical figures, like those of Joseph Nolleken's monument to Sir Thomas and Lady Salisbury of 1777, gave place to field-workers, miners and road-menders with Dalou. Fortunately Dalou was a considerable artist, to whom Rodin paid tribute in his portrait. In modelling technique his work makes an interesting comparison with that of Raymond Mason, as in the *Odéon Crossroad*.

THE EQUESTRIAN STATUE

Equestrian statues from the Renaissance on were inspired by examples from Antiquity. Donatello's *Gattamelata* of the mid-fifteenth century in Padua and Verrocchio's *Colleoni* in Venice, cast posthumously at the end of the century, were influenced by the Roman bronze horses of St Mark's, Venice, and the *Marcus Aurelius* monument in Rome; and all three have a common ancestor in the horses of the Parthenon frieze. The first equestrian monument to be erected in Florence, in 1597, was the statue of *Cosimo I* by Giambologna, based on a drawing by Pollaiuolo. The horse rears up in a posture we will see again in Bernini's *Louis XIV*.

Whereas Pollaiuolo emphasizes the weight and solidity of the Renaissance war-horse, Leonardo da Vinci's series of drawings are the sketch-ideas of one obsessed with the horse theme. When he was forty and living in Milan, Leonardo wrote to Prince Lodovico Sforza (il Moro), offering to execute in bronze a horse 'which would re-bound to the immortal glory of signor vostro padre and your House'. The French invasion of Italy prevented the casting of the clay model, completed by 1493. The Sforza sketches in the Royal Library, Windsor, as well as being masterpieces of draw-ing, show how carefully Leonardo was considering the problem posed by the question of equilibrium for the bronze. It was essential to suggest movement by a raised foot, and in one sketch the hoof was shown resting on a tortoise, in another on an over-turned jug. It is a long story, but in the event the project was abandoned, allowing Michelangelo – possibly jealous of Leonardo's pre-eminence in the equine theme – to write to him: 'You who made a drawing of a horse to cast it in bronze and could not do so and out of shame abandoned it. . . .' Lodovico il Moro was expelled from the country, and the sketches illustrated, which bear the mark of first-idea rapidity, are studies for the commission which succeeded it, Leonardo's projected statue to Trivulzio, a Milanese commander of French troops.

We can observe three stages in these studies: the top sketch shows the figure direct-ing an attack, the hesitant lines of the hind legs indicating an attempt to capture the prancing motion. The sketch at bottom left shows the crouching foe attempting to ward off the horse's hoofs. The right-hand study, a combination of these two, shows the victim holding a shield. The introduction of this feature provides a mechanical device for supporting the horse, and also heightens the drama. The hint of a cloak (the Classical *trabea*) flying in the breeze became the conventional way of suggesting move-ment (see Bernini, 10, 11). Although Leonardo's plans for equestrian bronzes were too ambitious in scale to be successfully realized (the Sforza monument was intended to be some twenty-two feet high), his drawings have influenced other sculptors. Cer-tainly his sea-horses now in the Windsor Library suggested to the sculptor Ammanati

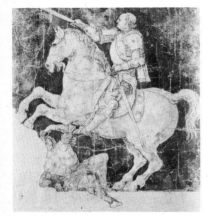

7 ANTONIO POLLAIUOLO Study for Sforza monument, second half of 15th century

8 GIAMBOLOGNA *Cosimo I, c.* 1593

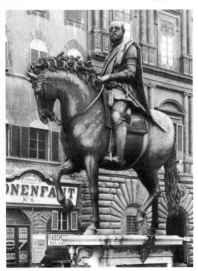

22

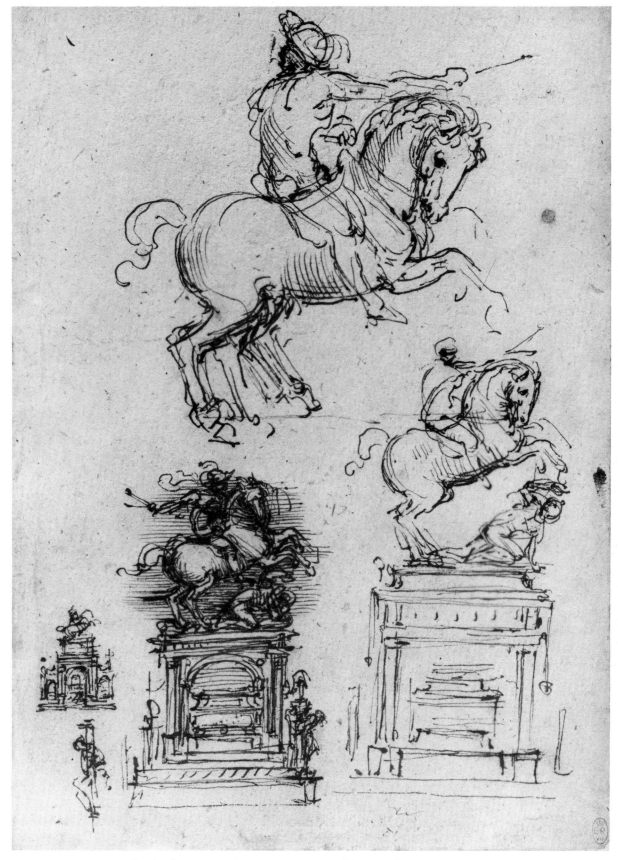

9 LEONARDO DA VINCI Sketches for an equestrian monument to Trivulzio, *c.* 1506–13

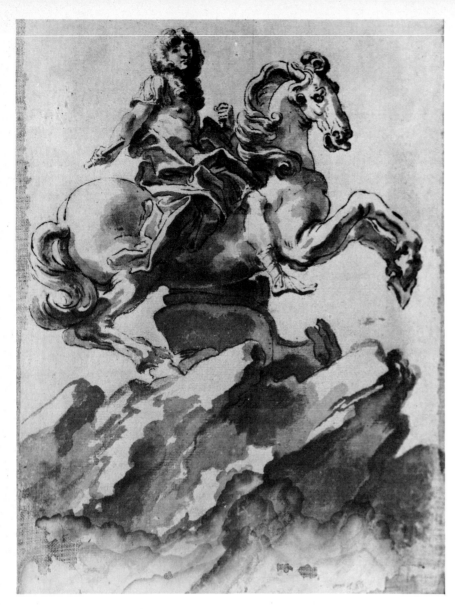

10 GIANLORENZO BERNINI Drawing
for equestrian monument to Louis XIV
1671–7

11 BERNINI Maquette for equestrian
monument to Louis XIV 1671–7

12 BERNINI *Marcus Curtius* (as altered
by Girardon; originally *Louis XIV*)
1671–7

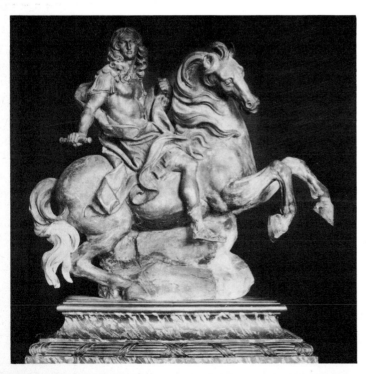

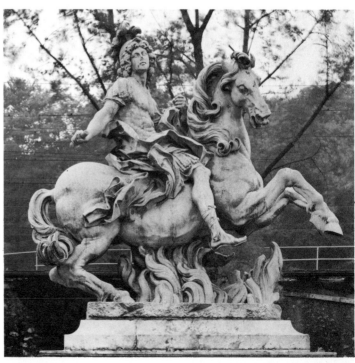

the general design of the vigorous steeds harnessed to Neptune's chariot in the Signoria Fountain, Florence.

Thanks to a drawing by a contemporary sculptor, Lodovico Cigoli, we have an accurate record of the original equestrian monument to Henry IV of France, destroyed during the French Revolution. It was begun by Giambologna in 1604, completed by Tacca, and unveiled on the Pont Neuf, Paris, in 1614. The bronze reliefs on the plinth by Pietro Francavilla, showing the traditional chained prisoners, were preserved, and can be seen in the Louvre. The present bronze statue, made by the French sculptor F. F. Lemot and erected in 1816, is a copy, but the themes of the plinth have been changed. Cigoli's drawing in the Ashmolean Museum could well have provided a blue-print. It was executed in pen and brown ink with areas of blue wash, heightened by touches of oxidized white, and is a faithful record by a minor sculptor. Ironically the slaves represented at the base, chained abjectly back to back, lack the inspired expressiveness of Tacca's corresponding but defiant captives (*i quattro mori* – the four Moors) for the statue of Ferdinand I at Livorno.

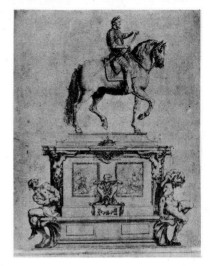

13 LODOVICO CIGOLI Drawing of Giambologna's equestrian monument to Henry IV of France, early 17th century

The project for the equestrian statue of Louis XIV by Bernini originated in 1665, when Charles Le Brun was planning the gardens and fountains of Versailles. It was intended to symbolize Louis' ascent to the height of his power up the rocky slope which the horse is mounting (and which incidentally was to provide a device for supporting the horse's belly). Bernini's wash drawing in black and sepia ink is a masterpiece. Everything is there in miniature – the intricate folds, the graceful curve of the mane (a counter-weight to the rider), the horse's rippling muscles. As for the statue itself, Girardon's unintelligent modifications have weakened but fortunately not destroyed the original conception.

Begun in 1671, it was not completed until 1677, the year of Louis' military glory and an appropriate moment to erect it at Versailles. But there were further delays, and the statue was not transported to Paris from Italy until 1685. Perhaps because of a rift between himself and Bernini concerning a proposed building commission, Louis affected a dislike for the final carving, though he had approved the magnificent terracotta sketch model, now in the Museo Borghese in Rome. The statue was sited in the furthest corner of the park of Versailles. Today, without any indication of subject or sculptor, it stands among the weeds on the far side of the sheet of water allotted to Louis' Swiss guards: 'la pièce des Suisses'. With a change in the head-dress and features Louis has become Marcus Curtius, while the rocky slope of the drawing has been transformed into a wall of stylized flames. Compared with the drawing the horse's rear legs appear exaggeratedly bent, with a certain loss of tension; but the vigorous treatment of the flying cloak, the realism of the muscles and veins, the decorative mane and sweeping tail remain impressive features.

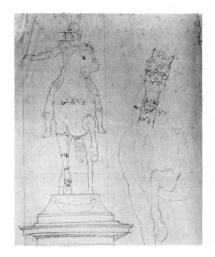

14, 15 EDMÉ BOUCHARDON Working drawing and maquette (*below*) for equestrian monument to Louis XV, 1750s–60s (the maquette is one of many preparatory studies for the final bronze of 1763)

French royal equestrian statues seem unlucky ventures. The one erected to Louis XV as an act of thanksgiving for his recovery from an illness, like that of his ancestor, Henry IV, was destroyed during the Revolution. It was designed by Edmé Bouchardon (1698–1762) and executed by Jean-Baptiste Pigalle (1714–85), both eminent French sculptors of the period. The admiring maidens at the base of the statue symbolized the Virtues. (Later, when Louis was no longer 'the well-beloved', a popular rhyme ran: '*O la belle statue, O le beau piédestal, les vertus sont à pied et les vices à cheval.*') Bouchardon's large bronze maquette can be seen in the Louvre, and in the Cabinet des Dessins of the same museum are his studies, which include a working drawing with measurements indicating the proportions. They allow us to see the modifications made in the final statue. The arm positions produce a more compact design; the angle of the

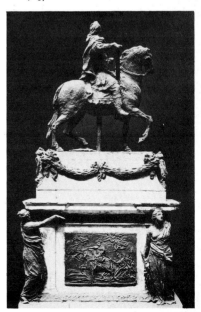

horse's head is less accentuated, the front hoof is nearer the ground. The support problem has been solved by the bronze block under a rear hoof.

The equestrian statue flourished during the eighteenth and nineteenth centuries, but distinguished examples became fewer. In our own century the celebrity is rarely put in the saddle. One of the last military leaders to be so treated was General Alvear, in the distinguished bronze by Bourdelle, sited in Buenos Aires. The aristocrat of animals, hitherto subjugated for man's greater glory, we shall see treated in his own right in the second part of this book, either riderless (Nadelman), or mounted by an anonymous rider (Marini and Frink).

FOUNTAINS, RIVER GODS, THE RECUMBENT FORM

Rivers, springs and fountains are surrounded with myth and legend in every civilization. For the Greeks Poseidon was almost as important as Zeus his brother, the great creator. The Romans paid more attention to river gods than to Neptune himself, though the latter became a dominating feature of Late Renaissance and Baroque sculpture. If river gods are associated with the life-bringing gift of water and usually bear a cornucopia, the trident-bearing Neptune embodies water's power, and – in angry mood – its threat.

The Early Renaissance *Fonte Gaia* in Siena, which embodies religious themes as well as the more recognized classsical Virtues, took ten years to build and involved a link with an aqueduct. The fountain was regarded with pride and enthusiasm by the inhabitants of Siena, earning its designer Jacopo della Quercia (*c.* 1374–1438) the nickname 'della Fonte'. Now in the loggia of the Palazzo Pubblico, it is in a state of severe dilapidation. I have nevertheless preferred to show a detail of the original fountain rather than illustrate the copy made by Tito Sarrochi in 1868, since the former ties up more satisfactorily with della Quercia's drawing.

The drawings are refined and semi-architectural, typical of the period. The mastiff of the drawing has been transferred in the sculpture to the lower right-hand rim of the

16 JACOPO DELLA QUERCIA *Fonte Gaia*
(detail) 1414–9

17 DELLA QUERCIA Drawing for
Fonte Gaia 1414–9

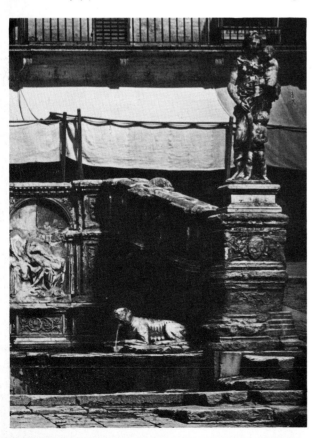

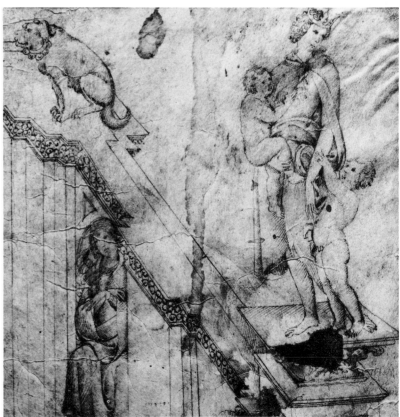

trough, and has taken on the features of Meleager's hound. The crowned Madonna has a Gothic grace and pose, while the angels are more robustly classical. In the carving the child (St Thomas) is closer to the Madonna's knees, resulting in a more tightly knit design. In both corner-statues the Christ-Child has been transferred to his Mother's left arm. Della Quercia's drawing uses double perspective to show the rectangular basin with its three-sided parapet. It is an attractive and subtle work of art in its own right, with the simple oblique hatching from right to left relieved by occasional cross-hatching in the smooth folds of the Madonna's robes, and pointed by solid areas. The hands – reminding one of the medieval emphasis on that feature – are drawn with great delicacy.

With Bernini and the advent of the Baroque, Rome displaced Florence as the centre of sculpture, and this is in no way more evident than in an exuberant explosion of fountains. Certainly the pagan world of nereids, tritons and dolphins was never expressed with more abandon and virtuosity than in the seventeenth-century Roman fountains of Bernini. Neptune and his attendant creatures provided a pretext admirably suited to the gesturing genius of the Baroque. The most impressive examples are the *Fountain of the Four Rivers* in the Piazza Navona and the *Fonte del Moro* (after Bernini's design). The grandiose *Trevi Fountain* by Nicola Salvi was inspired by a Bernini drawing at a century's remove – not the first instance of a drawing by one sculptor influencing a sculpture by another.

I have chosen to deal with a more modest fountain, the *Fonte del Tritone*, because the final sculpture follows the drawing so closely, and because the latter depicts the fountain in full spate – 'where urgent tritons lob their heavy jets'. Bernini left nothing to chance, calculating the effect of the gushing water in close relation to the design of the sculpture. This wash drawing[2] is compact and vigorous; the Triton torso has a Michelangelesque robustness. The contours and ovoid shapes of the muscular arms counterbalance the dolphins below. There are modifications in the final realization: the upper bowl becomes an open conch, the Triton bestrides both halves and the grotesque head is an additional enrichment.

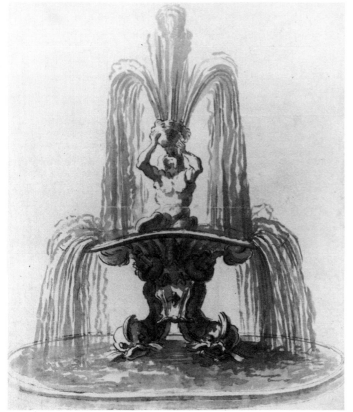

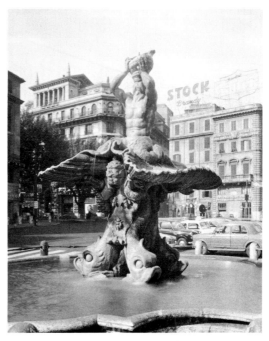

18 BERNINI Drawing for *Fonte del Tritone*

19 BERNINI *Fonte del Tritone c. 1632–40*

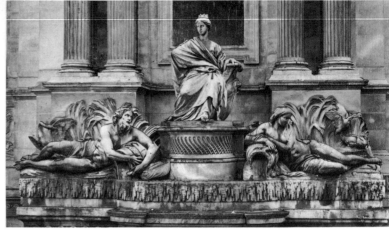

20 EDMÉ BOUCHARDON Study for
The Marne 1739–43

21 BOUCHARDON *Fountain of the Four
Seasons* 1739–43 (upper portion, with
The Marne right)

The fountains of Paris, though fewer, are mostly of distinguished design. Not all are favourably sited: Bouchardon's attractive fountain, erected between 1739 and 1743 in the narrow Rue de Grenelle, and known as the *Fountain of the Four Seasons* because of the carved reliefs on that theme on the lower surrounds, is less known than it deserves. It is surmounted well above eye-level by a central draped female figure wearing a crown. A triangular design is implied by recumbent figures on each side of her. The male on the left represents the river Seine; the female, reclining at ease on the right, the river Marne. Like the male river gods of ancient Rome her symbolic attribute is the vessel representing the source of the water, which supports her shoulder. The exquisite, harmonious forms of this partly draped figure are anticipated in Bouchardon's drawing, specifically named 'étude pour la Marne'. This shows only a slight element of Louis Quinze Baroque, and leads us naturally to more liberated classicism of Carpeaux's ambitious *Fountain of the Four Quarters of the World*, which stands at the north extremity of the Avenue de l'Observatoire. Carpeaux's four nimbly stepping figures are an agreeable alternative to the heavily burdened Atlas of Antiquity, illustrating the sculptor's ability to realize a complex and perfectly integrated group without sacrificing liveliness.

The small sketch is recognizable as a notation of one of the figures in the clay model. We see here three stages towards the creation of an imaginative masterpiece. It is, however, a far cry from this work in the classical tradition to Barbara Hepworth's sculpture made for the United Nations complex in New York (109).

22–4 JEAN-BAPTISTE CARPEAUX
Sketch, clay maquette and bronze
model for *Fountain of the Four Quarters
of the World*

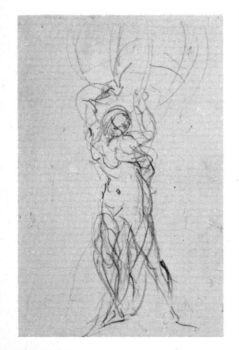

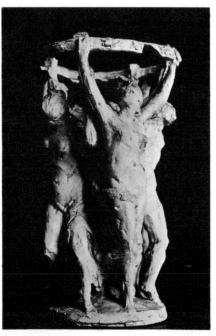

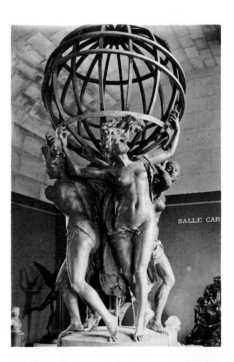

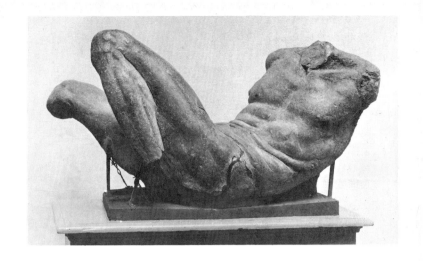

25 MICHELANGELO *Torso of a river god, c.* 1520s

26 (below) MICHELANGELO Working drawings for a
recumbent statue (*Day*), c. 1520–5

Reclining male figures like *The Nile* from the second century BC, in the Museo
Chiaramonti in Rome, and the more conventionalized *Tiber* in the Louvre, set the
pattern for generations of classicizing sculptors, from Regnaudin's *Loire* at Versailles
to Maillol's *River* in the Tuileries Gardens.

The persistence of the river god theme is remarkable, nor did Michelangelo escape
its fascination. Indeed it was his intention to carve river gods for the base of the sloping
sarcophagus of the Medici tomb in Florence, and to carve them unaided by assistants.
Because of the Sack of Rome in 1527 this project was delayed and eventually aban-
doned.

A reflection of the river god pose can be seen in the figures of *Day* and *Dusk* in the
Medici chapel. The working drawing for *Day* has a two-fold interest: first, it is
connected in style and pose with the river god which was to be sited on the right-hand
side of the step of Giuliano de' Medici's tomb in the Medici chapel; and second, it

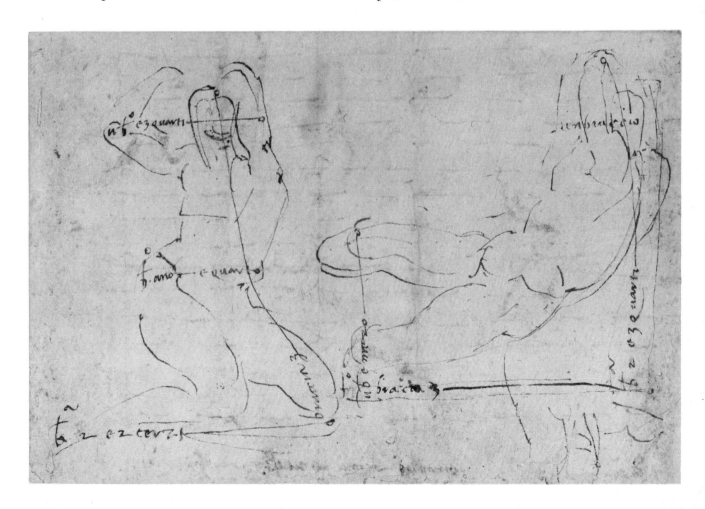

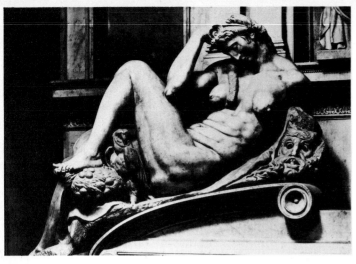

27 (left) MICHELANGELO *Night*, c. 1520–4

28 (below) MICHELANGELO *Male left arm*, study for *Night*, c. 1520–4

29 (right) ANTONIO CANOVA Sketch for *Paolina Borghese as Conquering Venus* 1805–7

30 (far right) CANOVA *Paolina Borghese as Conquering Venus* 1805–7

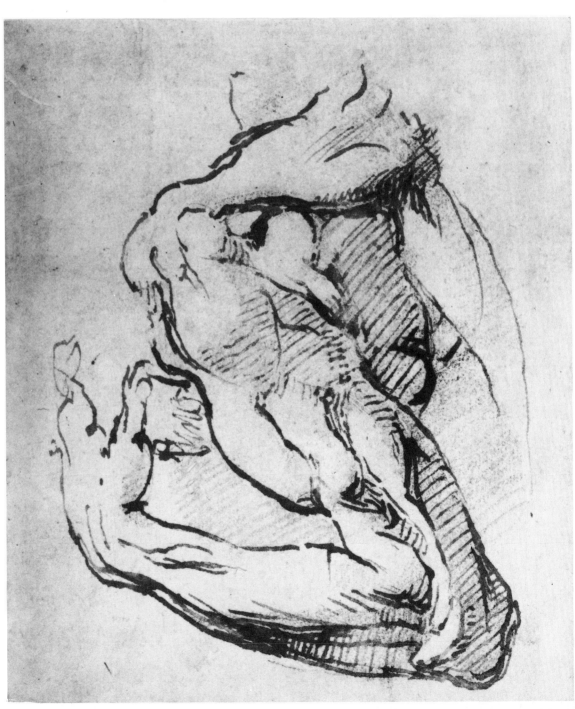

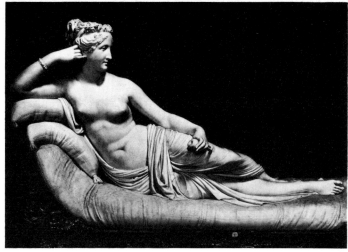

throws light on the sculptor's working methods, since, as Berenson has pointed out, these studies were made for the stone-cutter. The latter would draw the outline on the marble block according to the measurements[3] indicated on the drawing in Michelangelo's own handwriting, then the sculptor would attack the marble with the fine-pointed chisel, and with the outline cleared, continue with the two- and three-toothed claw. This left the marble in the unfinished, unpolished state we see in the head of the figure of *Day*.

The working method revealed by this drawing is, interestingly, the same as that adopted by Henry Moore in his squared-up drawing of *Mother and Child* (188).

Michelangelo's male nude *Day* is shown from the front and lying against a prop which is not visible. It will be noted that the figures are placed on the paper without any concern for their pictorial function: these are typical sculptor's studies, but of masterly ease and fluidity.

From these studies it is a natural transition to Michelangelo's female reclining figure of *Night*, about which so much has been written in praise and criticism. She lies drowsily in a pose reminiscent of the sculptor's *Leda*, but now though the head is youthful and the limbs taut, the flesh of the torso is wrinkled and sagging. The drawing reproduced is for the raised right arm of the sculpture. It is, however, a study of a left arm, and obviously the model was male. Michelangelo was emotionally and aesthetically obsessed by the male nude, whose musculature provided the challenge he welcomed. In the present case we see how he was fascinated by the surface modelling that thinly veils what is virtually an *écorché* study, with no concessions to pictorial qualities. Such studies are complementary to other types of sculptors' drawings, a necessary preliminary to avoid repetitive, cliché anatomy.

The transition from male river god to recumbent female is an important one in the history of sculpture – the undraped recumbent female form had been almost unknown in Classical Antiquity. It was also frowned on in the period of and succeeding the Counter-Reformation. Neoclassicism revived its popularity, while somewhat changing the rules; Bouchardon's and Canova's partly draped or virtually nude female figures, though individual, are respectfully obedient to the prevailing canons of the 'idealized nude'. Canova was an indefatigable draughtsman, continually drawing from the Antique and from life. That he idealized his subjects we can see by comparing his recumbent portrait of Paolina Borghese as the 'conquering Venus' with the dumpy figure depicted by David in his painting *The Coronation of Napoleon*. The sketch shown here may well have been from a model, but the head is a very recognizable likeness, and the pose has been closely adhered to in the sculpture. Such a spontaneous

31

pencil sketch is refreshingly different from the rather stereotyped pen and ink drawings he executed in a style that seemed to become international during the Neoclassic period.

Though our main concern is not with the sculpture, two features are worth noting. First – like Bernini who in his carving of *Apollo and Daphne* shows the pressure of the hand on the marble flesh – Canova unambiguously indicates the weight of the reclining Paolina on the creased cushion. This foreshadows a modern interest in simulated 'squeezed' forms, evident in recent bronze sculpture for a Norwich building by Bernard Meadows (p. 60–1), and, though differently purposed, in the soft sculpture of Claes Oldenburg. Secondly the realism – the imitation of gilded wood, the tassels of the sofa – also finds an echo in some modern sculpture by Oldenburg and others. However, as far as the recumbent figure itself goes, the comparison will be with Maillol and Moore.

THE MADONNA AND CHILD, VENUS AND THE NUDE,
DRAPERY AND THE TORSO

Mother and child is a basic and universal theme, but the religious or philosophic background naturally affects the expression. A sense of awe is inherent in the Madonna and Child of, say, Henry Moore's Northampton version no less than in the two versions by Michelangelo, although in the Moore the child is not idealized in the same or even a comparable way. Moore's earlier, less restricted *Mother and Child* of 1924–5 (189) and his *Family Group* of 1955 (192) offer, with their related drawings, a more fruitful comparison with the Michelangelo sculptures and drawings, and also with those of Epstein (84–5) and the Spanish sculptor Lobo (193–7).

Michelangelo's first-idea sketches and some of his working drawings are usually characterized by an absence of shading. The purely outline sketch of the *Bruges Madonna* brings us close to the genesis of the project – it has the intimacy of an as yet uncommitted thought. There is general agreement about its authenticity, and evidence that it preceded in date the statue itself, which having been carved in 1504–5 was ready for transport to Bruges from Florence in 1506. This had been a period of intensive drawing, and included the two *Taddei Tondo Madonna* drawings now in the British Museum. Michelangelo captures the essence of the theme in this pen and ink notation. It decides the final position of the Child, half standing, half wedged between the Madonna's knees, and gives more than a hint of the richly carved head of the sculpture, and the arm positions of mother and child. The Child is the focal point of the drawing: the essential anatomy is ready to be translated into terms of three dimensions, and a certain thickening of the lines concentrates attention downwards. The sculpture shows a slight change of axis in the Madonna's shoulders and turn of the head. The facial expression, now universalized as the anxious mother, bears a strong resemblance to the *Madonna lattante* sculpture in the Medici chapel, Florence, which in fact was not completed until two decades later, although the drawing for it, illustrated here, was done only slightly later than the Bruges drawing. This pen drawing was evidently made chiefly as a study for the drapery and possibly from a lay-figure. The idiom in which the Child is delineated differs little from the Bruges version. Here, too, Christ's pose is little changed in the sculpture, apart from the position of the left leg. Most remarkable is the way the drawing characterizes the Madonna's face in so small a compass and with no more than five or six strokes. The free-style hatching prefigures almost precisely the carving of the marble folds.

32

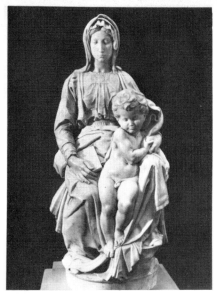

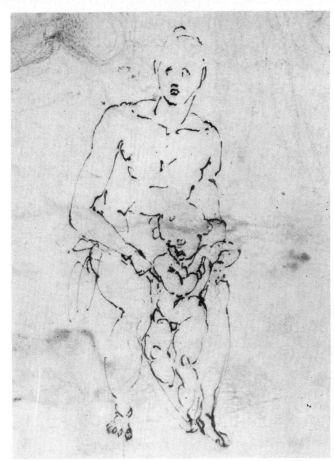

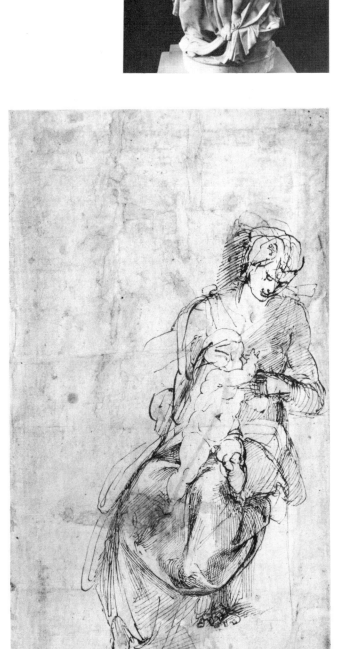

31 MICHELANGELO *Bruges Madonna, c.* 1504–6

32 MICHELANGELO Sketch for the *Bruges Madonna, c.* 1504

33 MICHELANGELO *Madonna and Child (Madonna lattante)* 1524–34

34 MICHELANGELO Study for *Madonna and Child, c.* 1520–4

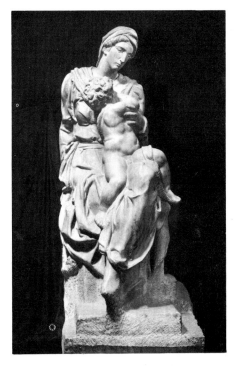

35 ANTONIO CANOVA Drawing for
Italian Venus, c. 1810–2

39 CANOVA Drawing for *Italian
Venus, c.* 1810–2

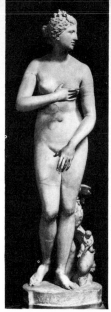

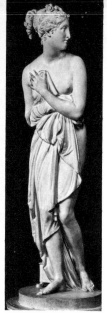

36 *Three Graces* (central
figure). Graeco-Roman

37 *Medici Venus* Roman
copy of early 3rd century
BC original (derived from
Praxiteles' *Cnidian Venus,
c.* 350–330 BC)

38 ANTONIO CANOVA
Italian Venus, c. 1810–2

In Renaissance times Venus appeared as a pagan substitute for Eve, her birth surrounded
by a comparable mystery. Moreover, there were inspiring examples of the subject in
Antique sculpture, from the first full-scale model in the *Cnidian Venus* by Praxiteles,
to the *Medici Venus* which is the prototype of the 'Venus pudica' – posed in the attitude
of modest concealment shared by the Eve of tradition.

Canova's *Italian Venus* was carved as a replacement for the *Medici Venus*, which had
been taken from Italy by Napoleon for the Louvre. The Canova profile pencil sketch
shows the model in almost the exact pose of the *Medici Venus* – arms in the position
that modesty dictates, but with the head lowered. It is a sensitive drawing with
emphasis on the convexities of buttock, belly and thigh; light shading indicates the
modelling and shadow. The legs are more stylistically elongated than in the sculpture
and the feet are barely sketched in. The facial expression is one of a somewhat 'period'
sweetness, avoided in the carving of the marble. The sculpture in fact relates closely
to the back view shown in the spirited and brilliant pen drawing on Ingres paper. The
final attitude is rather that of Diana surprised bathing: it is evident that Canova had
been preoccupied with the role of the drapery, here loosely held and anchoring the
lower portion of the sculpture. There is a striking similarity between the *déhanchement*
caused by the stance with one leg bent, and the pose of the central figure of an Antique
Three Graces.

Drapery and the torso play so important a role in Classical, Renaissance and Neo-
classical sculpture, and even in much sculpture of the twentieth century (and necessarily
in the drawings connected with all these periods), that the work of Canova, who was
a virtuoso in the treatment of flowing and 'wet' drapery, seems the juncture at which
to look at the subject in more detail.

The Greeks had chiefly reserved the female nude in sculpture for depiction of the
goddess Aphrodite and the Maenads; consequently the treatment of drapery gained in
importance as a vehicle of plastic expression, whether in the Kore figures, where it had
the attractive severity of the flutings on columns (echoed today in the slate torsos of
the French sculptor, Ubac), or in the more elaborate and sophisticated folds seen on
the East pediment of the Parthenon, in which the foreshortened curves create an
oblique rippling movement and a notional sense of depth.

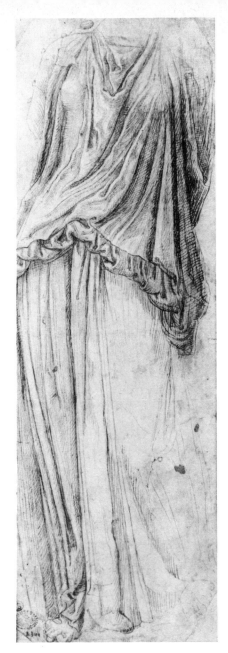

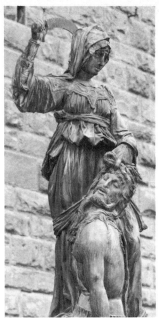

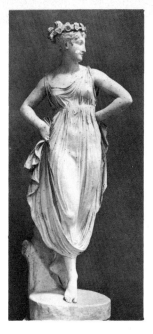

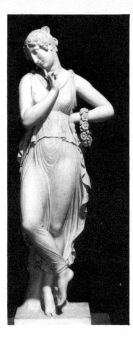

40 Attributed to DONATELLO, *Drapery Study*, probably mid-15th century

41 DONATELLO *Judith and Holofernes*, c. 1456–60

42 ANTONIO CANOVA Model for *Dancer with Hands on Hips* 1806–10

43 CANOVA *Dancer* 1806–10

44 HENRY MOORE *Fragment* 1957

45 MOORE *Draped Reclining Woman* 1957–8

46 MOORE *Draped Torso* 1953

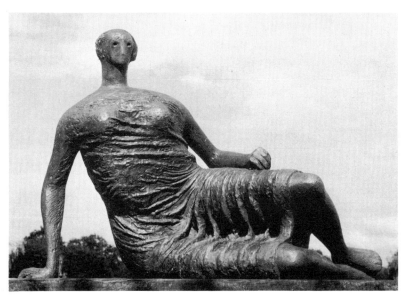

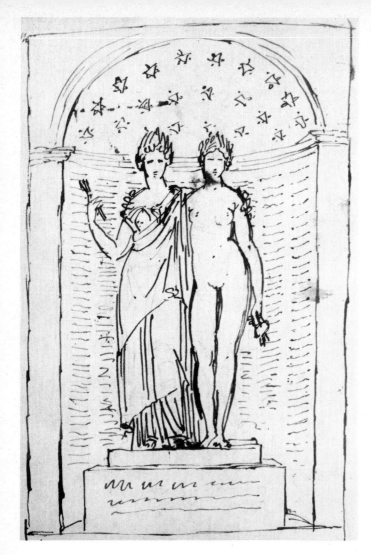

The chiton as a garment offers such opportunities for emphasis of the contrasts between the soft flesh of the breast and the bone structure of knee and arm that it is not surprising Donatello clothed his Judith of the *Judith and Holofernes* in one, although she is a biblical figure. The drawing attributed (probably erroneously) to Donatello at least gives us an idea of the kind of preparation that was made for such a sculptural detail. It makes an interesting comparison with the treatment of loose folds in Canova's *Paolina Borghese* and *Italian Venus* (both sculpture and drawing). It is also interesting to see juxtaposed three examples of drapery by Henry Moore on sculptures of Greek inspiration – two recumbent figures and a torso. In this connection Moore observed that 'drapery can emphasize the tension in a figure . . . it can also by its direction over the form make more obvious the section, that is, show the shape. . . . Also to connect the contrast of the sizes of folds, here small, fine and delicate, in other places big and heavy, with the form of mountains which are the crinkled skin of the earth.' These functions of drapery – and we shall see others in the main part of the book – can all be observed in the works illustrated.

Wet drapery serves to emphasize the sensuous curves of the female body and limbs poised for movement. It also appealed to Canova's virtuosity. His *Dancer* shows that

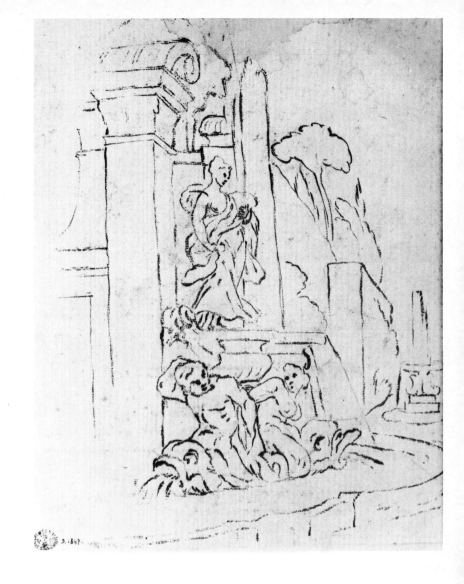

47 (far left) DENIS-ANTOINE CHAUDET
Drawing for niche sculpture

48 (left) JOSEPH NOLLEKENS Page from
sketchbook, c. 1802

49 (right) PIERRE PUGET Sketch for a
fountain, mid-17th century

he was more than equal to the challenge of creating the illusion of flimsy, transparent drapery in marble.

The linear rhythms are exquisitely balanced. Canova's treatment of drapery stands half-way between the 'frozen' theatricality of Bernini and the free-flowing style of Carpeaux's *Triumph of Flora* and *The Dance*.

It is interesting that in his *Penelope with Spindle* (small version) Bourdelle returns to an idiom of Hellenistic inspiration (423), while his female torso (133) is much more of our time and can be compared with examples by Gonzalez or Dodeigne.

Before leaving the Neoclassical period it is worth glancing at the kind of sketch-book idiom that became ubiquitous in European notations for sculpture. Chaudet (1763–1840) and Nollekens (1737–1823), a Frenchman and an Englishman,[4] use a characteristic broken outline technique, attractive in the results but unmistakably 'period' if one compares it with the universal qualities of Michelangelo's unpretentious *Bruges Madonna* sketch. The fountain sketch by Pierre Puget (1625–94), a century earlier than the Chaudet and Nollekens examples, is closer in execution and spirit than they are to the inspired little sketch for the *Fountain of the Four Quarters of the World* by Carpeaux (22).

37

I have often felt that only Carpeaux, Rodin and Medardo Rosso in the whole of the second half of the nineteenth century really understood the purposes and principles of sculpture.

HENRY MOORE

The importance of Pierre Puget, who was mentioned above in connection with seventeenth- and eighteenth-century drawing, is more evident in his drawing for a major work, *Milo of Crotona* (1683) – a typical 'subject' sculpture of the mythological and literary kind, linked with the Renaissance tradition. This work provides a comparison with a subject sculpture by Carpeaux, *Ugolino*, of two centuries later, and with subject themes – a diminishing number – of our own century by Epstein and Lipchitz, illustrated in the main part of this book.

The legendary athlete Milo is supposed to have won the wrestling contest at the original Olympic Games on six occasions, only to be beaten on the seventh. The legend relates that while he attempted to wrench open a cleft in a tree-stump it closed up and trapped his arm. Held thus captive, he was devoured by wolves. It was the kind of dramatic subject to appeal to a sculptor familiar with Bandinelli's *Hercules and Cacus*, the *Hercules and Antaeus* by Pollaiuolo and the Baroque idiom latent in the late Hellenistic *Laocoön* statue. Puget's vigorous wash drawing with its strong oppositions of light and shade emphasizes Milo's tragic situation; the frozen anguish of the victim is expressed with a realism that would be too stark for the restrained stoicism of Neoclassic taste. The emphasis on swelling veins and muscles, the agony of the features, is more in the Florentine spirit. The sculpture departs little from the drawing; the pose is essentially the same, and even the taut drapery – so important to the highly organized composition – is little changed. The work so greatly impressed Cézanne that he made eleven known pencil drawings of the bronze in his sketchbooks.

50 PIERRE PUGET Study for *Milo of Crotona* 1683

51 PUGET *Milo of Crotona* 1683

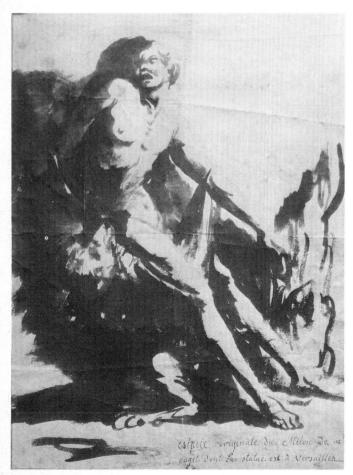

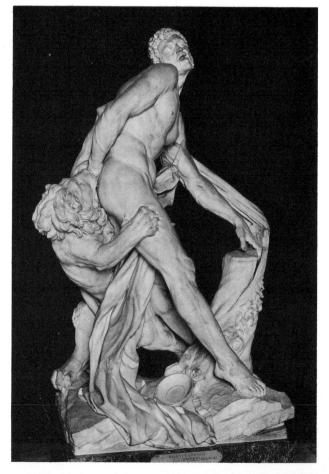

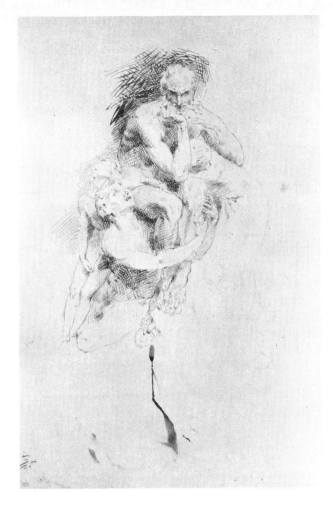

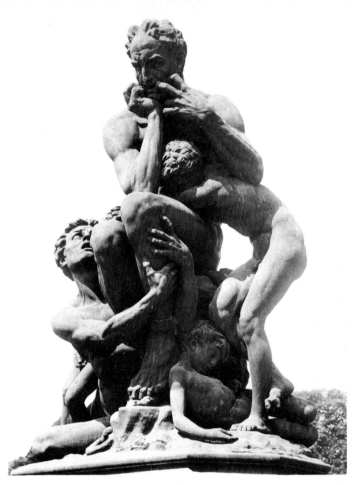

The *Ugolino* theme from Dante was treated by both Carpeaux and Rodin. The two drawings by Carpeaux illustrated are made at different stages. The pen and ink drawing provides a clear statement of the disposition of the figures making up the group, and the hatching – very much in a Renaissance tradition perfected by Michelangelo – is related to the anticipated effect of the masses in a frontal view, as we now see it in the finished sculpture. Both drawings and sculpture reveal the attention Carpeaux gave to agony expressed in hands that 'have no tears to flow'.

Like his great successor Rodin, Carpeaux was fascinated by movement. In his figures for the *Fountain of the Four Quarters of the World* and even more in those of *The Dance* (carved for the outside of the Paris Opéra building, see p. 40–1) he takes movement a stage further than either Canova in the *Dancer* or Bernini in his Baroque subjects, where flying drapery seems as if held in a *tableau vivant* suspension of animation. In these preliminary studies free, graceful movement is of the very essence. The staid, classical dance of the *Three Graces* has been replaced, if not quite by a Rubensesque *kermesse* spirit, at least with a feeling of movement in the open air. The sketches are obviously made from life, and suggest a dedication to the dance worthy of Degas. The sheet of thumb-nail pen sketches contains at least one – the right-hand figure leaning back – that indicates the pose of one of the dancers in the final sculpture. The other sketch evokes the whole feeling of a group of dancers in motion. It is as modern in its technique as many of Rodin's similarly-purposed attempts to capture movement.

52 JEAN-BAPTISTE CARPEAUX Study for *Ugolino*, c. 1857–61

53 CARPEAUX *Ugolino* 1857–61

54 CARPEAUX Study for *Ugolino*, c. 1857–61

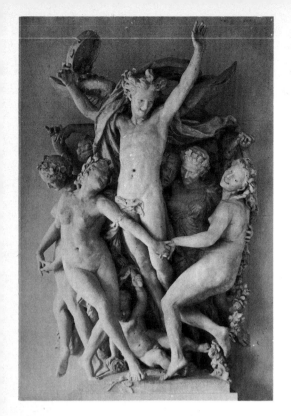

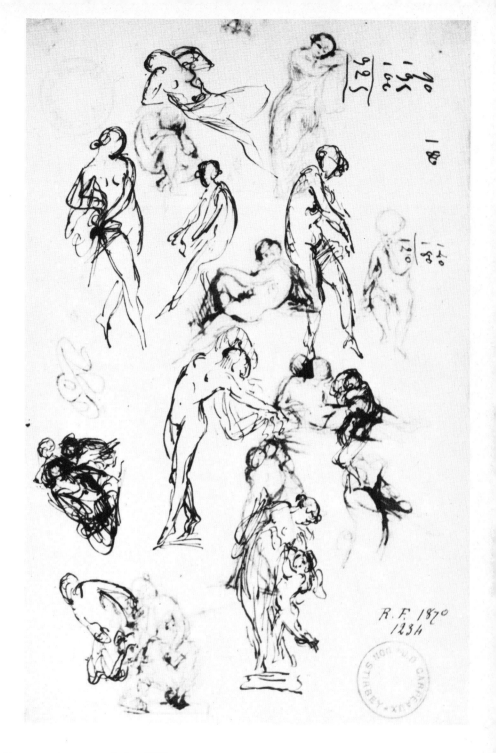

55 Jean-Baptiste Carpeaux Model
for *The Dance* 1869

56–8 Carpeaux Studies for *The
Dance*, c. 1865–9

The dance, a subject common to all ages and most periods of Western art, seems
an appropriate one with which to close the introductory part of this book. Rodin's
work in this context will be examined in a later chapter.

Some twenty-five items of sculpture and almost half again of maquettes and draw-
ings have been illustrated so far, chosen to provide points of reference for the treatment
of ten parallel themes to follow. In the second part of the book, drawings will be
given pride of place.

41

Part Two

RODIN TO OLDENBURG

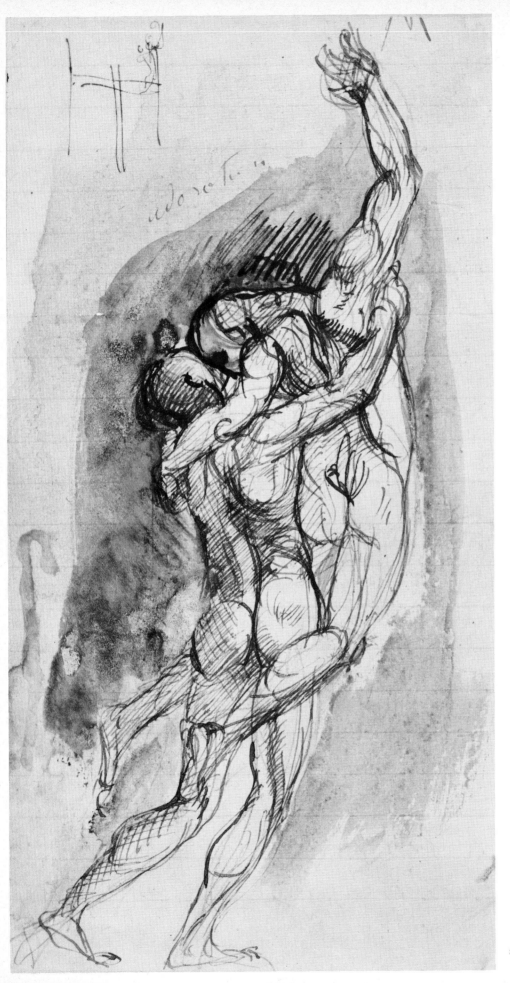

59 AUGUSTE RODIN *Adoration*,
study for the *Gates of Hell*,
1870–90

1 *Rodin: the watershed*

Keep ever prominent World Tradition.

HENRY MOORE IN SKETCH-BOOK NOTE

Rodin can be regarded as a watershed, comparable in this to Michelangelo ('I freed myself from academic conventions by studying Michelangelo,' he wrote); and even within the limits of this book, in which I am concerned only with his treatment of three themes, his influence is so great that it must be acknowledged. It has been both direct through his pupils and disciples, and indirect, as a catalyst. All contemporary sculptors react to him in some definite way. Henry Moore has said: 'I think we were all aware of Rodin – even Brancusi'; and: 'I think it would be possible to show that Rodin's work foreshadows all the subsequent phases of modern sculpture.' Bourdelle's discipleship is well known; Zadkine and Epstein both acknowledge their debt. ('Rodin opened windows and restored our freedom,' wrote Zadkine.) In due course we shall be seeing Rodin's influence on the sculpture and sculpture-drawings of more recent generations of artists whose work at least began under his sign. Obviously Rodin's preoccupation with symbolic themes is out of key for our period, and even sculptors like Lipchitz who do not eschew 'subject' sculpture can find his work overwhelming. Some, like Reg Butler, react against the attempt to convey philosophic messages, implicit in Rodin's *Gates of Hell*. Butler writes: 'I do objects of sensation not philosophical statements.' Maillol, who shared Rodin's admiration for Greek Antiquity, rejected the vibrant surface for the monumental form of smooth surfaces.

Although Rodin is a great original he is also an important link with Classical Antiquity and the Renaissance. He goes back to first principles, as exemplified in the *Belvedere Torso* (see p. 17), with a refreshingly new understanding: 'I find the cubic factor everywhere so that plane and volume seemed to me to be the laws of all life and beauty.' He re-animated the marble fragment, and explored the power of the worn or mutilated statue of Antiquity by intentional abridgement, eliminating the subject or representational element to concentrate on the expressive shape of his creation. 'Make your fragments live,' he advised, 'the shock of vibration coming from interior sources will enable the mind to create all the missing parts through the interplay of the active fragments.' The principle can be summed up in his reply to the young lady who enquired why a female torso had no head: '*La tête? Mais elle est partout!*' ('The head? But it is everywhere!')

It is too often forgotten that Rodin was to some extent responsible for the movement *away* from 'subject' sculpture. His primary concern was to use the human body as an expressive form.

While at one time he exploits the sensuous qualities of the female body, in such subjects as *The Toilet of Venus* or *The Faun*, or in his dancers, at another – like Rembrandt – he conveys in plastic terms the pathos of old age and degeneration, notably

in the flaccid and shrunken flesh of *La Belle Heaulmière*, an inspired example of transposition from one art to another.[5] These general observations touch only on a few aspects of the art of the great sculptor on whom much, but still not enough, has been written. Less than twenty years ago the French painter Ozenfant justifiably protested: 'It is somewhat surprising that Rodin, the *revolutionary*, should be systematically ignored in works dealing with modern art,' and he went on to claim, 'Yet his liberating influence was tremendous. . . . The freedom with which Rodin treated Nature and the human form was added to that of Cézanne, liberating himself from the subject.' The break-through represented by Rodin cannot be over-emphasized.

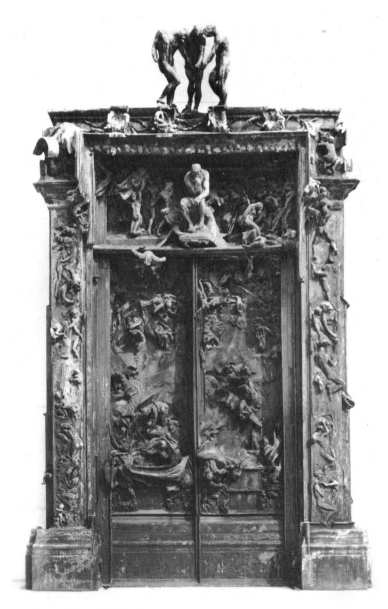

60 RODIN *Gates of Hell* 1880–1938

2 *The relief and façade sculpture*

> Establishment of the surface is a primary move, since the parting from
> and clinging to a surface is the essence of the relief. Then that space be-
> tween the surface and the highest point becomes a sphere of play and
> conflict between opposites, representing the desire to break away and the
> inability to leave the norm.
>
> <div align="right">KENNETH MARTIN</div>

The quotation above underlines the problems that beset the carver or modeller of
reliefs, low or high – problems which are reflected in the preparatory drawings.

Rodin's bronze *Gates of Hell* and the detail drawing illustrated (59) offer a parallel
to Ghiberti's bronze doors for the Baptistery at Florence and sketches for the *Scourging
of Christ* of a half millennium earlier. Much has been written on the subject of Rodin's
gates, which were inspired by Dante's *Inferno*; into them he continued to integrate
important subjects throughout his life. They are indeed a summing-up of his whole
spiritual and artistic experience, in this respect comparable to Donatello's achievement
in the vast San Lorenzo pulpit reliefs.

The drawing, *Adoration*, was made on exercise-book paper in sepia ink against a
background of blue gouache. The outline contour and system of cross-hatching
summarize the turning form. It is undated but belongs to the period 1870–90. Not of
striking quality compared with many of the drawings less closely related to specific
projects, it is nevertheless important as a rare example of a Rodin working drawing.
The struggling youth symbolizing moral aspiration is reaching upward, aided by a
figure below. In the sculpture the swell of the buttock and calf muscle and the serpen-
tine form have been abandoned – this treatment would have been impracticable in
the context – but both sculpture and drawing illustrate Rodin's statement that 'every-
thing is movement in my *Gates of Hell*'. An indication on the drawing shows the
position intended for the Gates – one not easily viewed because of the shadow cast by
the lintel.

The Gates had been commissioned in 1880 by the Minister for the Fine Arts, for the
entrance to the new Museum of Decorative Arts in Paris. The sombre subject was
Rodin's own idea. It reflects a conscious attempt to produce a worthy rival to Ghiberti's
doors, and, in contrast to the Italian sculptor's optimism, at the same time to express
his own tragic view of life. Following the completion of the full-scale plaster frame
(now at the Villa des Brillants, Meudon) in 1882, Rodin proceeded to incorporate into
the work all his sculptural ideas as they occurred, so that, ultimately, the Gates became
the repository of a lifetime's work, and the original commission an impossibility.

Manzù's *Gates of Death* are equally ambitious, and striking in their homogeneity and
originality. They were commissioned for St Peter's, Rome, though not under this title.
The work in its present form bears only a distant relation to the original subject
stipulated: *The Triumph of Saints and Martyrs*. Controversy, aesthetic and religious,

47

61-2 GIACOMO MANZÙ (left) *Angel of the Assumption* 1962, and (right) *The Death of Abel* 1961, studies for the *Gates of Death*

63 MANZÙ *Gates of Death* 1964

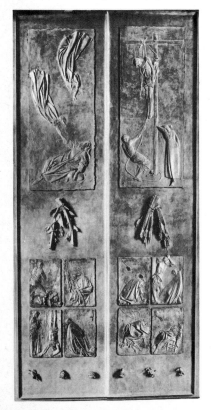

surrounded the changes introduced by the sculptor and – to judge from conversations with Catholic priests on the spot in 1972 – has not yet ceased. In *Death on Earth*, illustrated, Cardinal Testa objected to the child's position in the window, wanting it removed to a conventional place by the mother's skirt. But in this, as throughout, Pope John staunchly supported the sculptor's own judgments with regard to both themes and treatment. It was therefore fitting that on Pope John's death in June 1963, a year before the *Gates of Death* were completed, Manzù should have replaced *Death by Drowning* with the subject of *Pope John in Prayer*; an aesthetic improvement also, since the panel balanced the seated figure of Pope Gregory on the other wing.

Departure from the Ghiberti convention of a series of high relief panels with condensed perspective, all of equal dimensions, allowed Manzù to achieve a broader effect, more easily read at a distance; furthermore the two larger panels with their contrasted subjects – the *Angel of the Assumption* on the left and the *Descent from the Cross* on the right – and the subsidiary flora and fauna, provide an intentional link with the *Crucifixion* on the nearby bronze doors by Filarete (1400–65), which carry comparable marginal themes (see p. 16). Manzù went to immense pains over each of the ten individual subjects, executing a host of pen and pencil sketches before proceeding to model in wet clay and also to draw lines on the surface in sweeping, fluid curves. The drawing for the *Angel of the Assumption* panel is essentially a study for the soft folds which Manzù contrived to reproduce in bronze by modelling over paper soaked in plaster. The flowing rhythms and (in the final panel) feeling of space contrast with the violence of the *Crucifixion* at the right. Death in various forms is echoed in every detail, for example in the vine stock and wheat-sheaf significantly inverted. *The Death of Abel* is a first-idea sketch – in contrast with other studies which more nearly approach the final relief. The relief *Death on Earth* is the result of a combination of the two studies illustrated. The one in ink and pencil decides the position of the chair (an obsessive theme in Manzù's work) and suggests the stylized form the skirt will take, whereas the study in soft pencil is a detail for the dangling arm and the upper drapery.

64 GIACOMO MANZÙ *Death on Earth*, study for
the *Gates of Death*, 1963

65 MANZÙ *Death on Earth*, study for the
Gates of Death, 1963

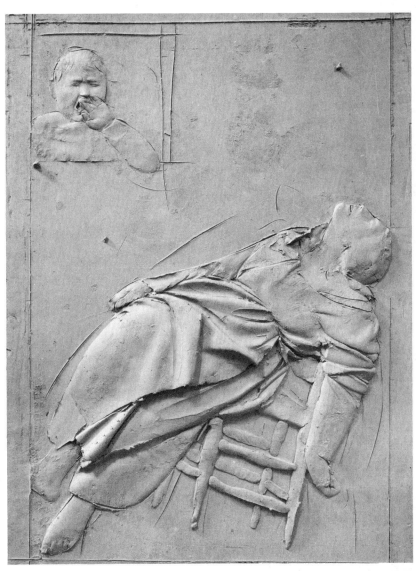

66 GIACOMO MANZÙ *Death on Earth*,
model for panel for the *Gates of
Death*, 1963

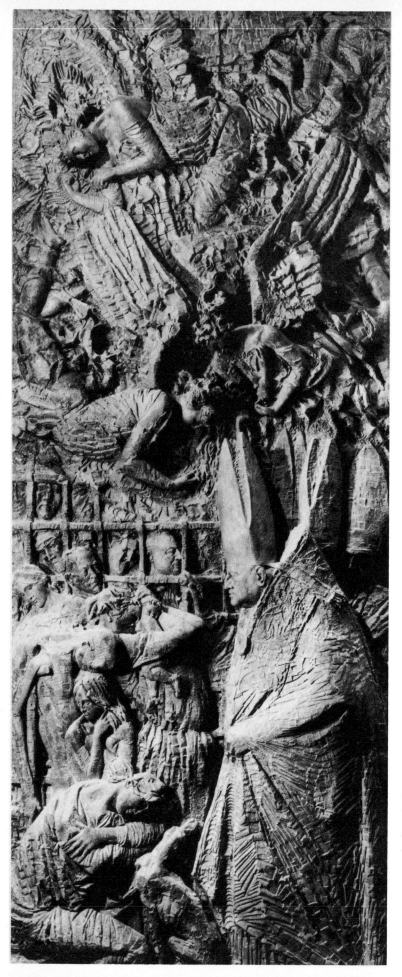

67 EMILIO GRECO *Pope John visiting the Prisoners and the Sick* 1965–7

68 GRECO Study for *Pope John visiting the Prisoners and the Sick* 1962

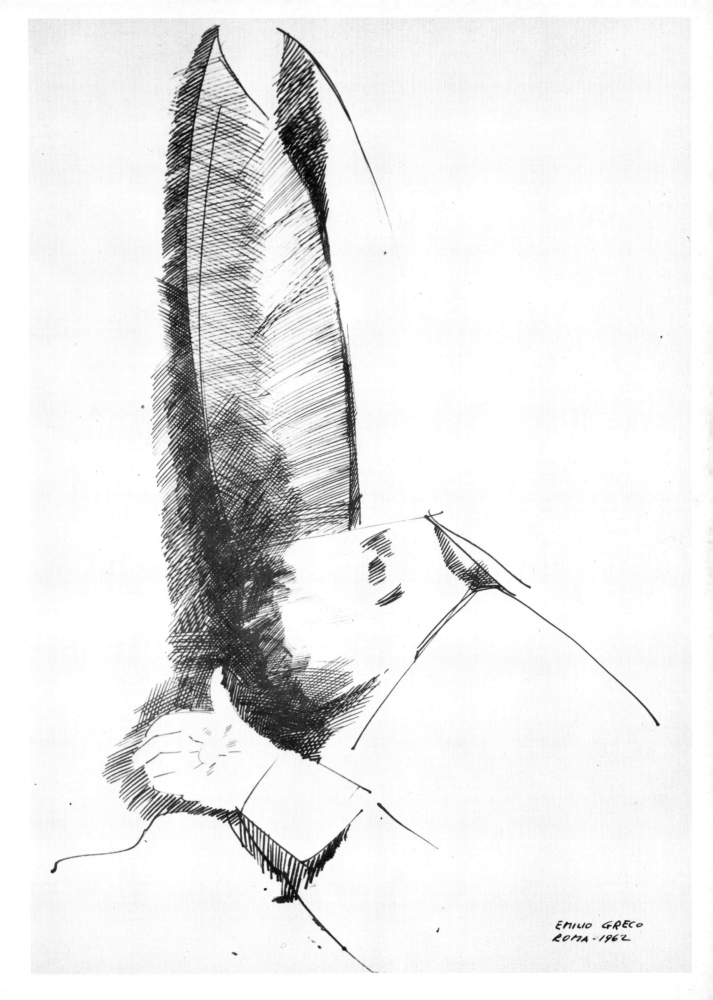

EMILIO GRECO
ROMA - 1962

The official memorial to Pope John was a bronze relief in St Peter's by Emilio Greco. For this subject, *Pope John visiting the Prisoners and the Sick*, Greco had evolved an effective 'chunky' idiom of deep relief alternating with areas of smooth surface. The mitred figure of Pope John is considerably raised from the background. The smooth areas are reserved for the emaciated cripple on the left, the stooping woman and the shoulders of the angel at the top, and also for the neck of the dog whose presence, apart from its symbolism, is important to the whole design. The eye follows the line of its raised head along the Pope's arm and shoulder, over the mitre to the arms and wings of the lower angel, and finally descends again on the wing of the angel on the right.

The study for the head of Pope John both is a telling likeness and seizes the essential importance to the final composition of the mitre, which provides the climax of the hieratic figure without sacrificing its essential humanity. Greco's individual cross-hatching technique is superbly managed, as much in the shadows as in the characteristically unenclosed space for which the eye supplies the contour.

The variation in the shading indicates very precisely the relative depths of the modelling in the bronze. This particular drawing was chosen in consultation with the sculptor, whose fascination with figures invested in ecclesiastical robes is well known. Mitre, stole and cope are symbolic and imposing as objects, and especially (in the sculpture) in the setting of attendant bishops.

Reliefs in bronze or other metals are sometimes used for the decoration of the interior walls of modern buildings. Examples in recent years are the aluminium reliefs by Geoffrey Clarke for the Castrol (now Leyland) Building in Marylebone, London (1959) and the Nottingham Playhouse (1963) – in both cases abstract themes. Smaller scale works, independent of buildings, are, however, more relevant here because of the kind of drawings they require, especially when they are figurative subjects. The studies by Ralph Brown for aluminium (and gun-metal) reliefs have some affinity with those done by Manzù, whose work he much admires, and whose studies for the same subject, *Lovers* (182), provide an interesting comparison.

Ralph Brown is an exceptionally gifted draughtsman. His admiration for Rodin and the Michelangelo tradition is implicit in his early drawings, where he was more preoccupied with the musculature of the male nude than the female roundnesses which at present obsess him. In the early sixties he evolved a sculptural animism, evident in his bronzes such as *Eclogue* and *Pastoral*, which link up with more figurative public commissions such as the two at Harlow New Town in Essex, *Sheep-shearer* and *Meat Porters*.

The drawing for the *Pastoral* relief, which he followed very precisely in the aluminium panel – a closeness naturally more possible for a relief which has similar coordinates to a picture – shows the beginning of a break-away from the aggressiveness and brutal eroticism of *The Queen* of the same period. The rounded forms of the *Pastoral* drawing are more sensuous, and set off by the pivotal arch; the mysterious, filament-like vertical lines produce one of the sculptor's most successful and most sculpturesque drawings.

In the aluminium *Lovers V* of some nine years later, erotic obsession is unambiguous; likewise the change of expressive idiom. Smooth curves and rhythm convey an intentional voluptuousness, dissolving, as it were, in notional space. Again, the drawing is remarkably close to the final relief in which the accents of form are effectively emphasized in the ribs and lower part of the body. Manzù's drawings for the same subject have already been mentioned, but readers will find the closest parallel in recent work by Reg Butler, particularly in his *Stooping Nude*, a free-standing bronze (185).

69　Ralph Brown *Pastoral* 1963

70　Brown Drawing for *Pastoral* 1963

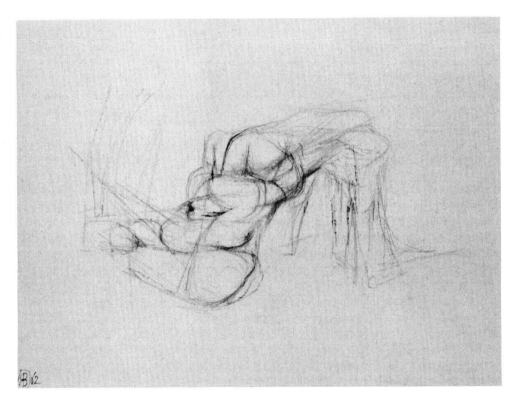

71 (below left) Brown Drawing for
Lovers 1971

72 (below right) Brown *Lovers V* 1972

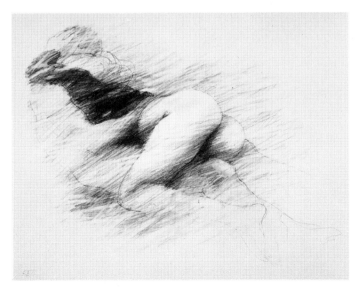

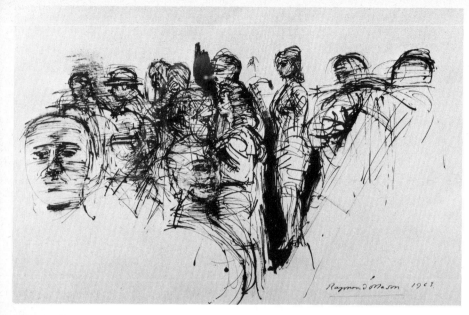

73 RAYMOND MASON *Crowd study* 1963

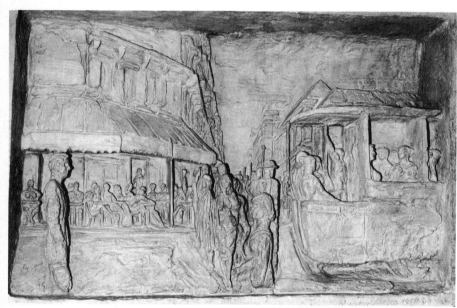

74 MASON *Odéon Crossroad* 1958–9

Raymond Mason, an English expatriate living in Paris, shares with some Early Renaissance relief-sculptors a predilection for group and crowd scenes realized in high relief – indeed the French critic Claude Roger-Marx has compared his work to Ghiberti's. But in his case they centre on some everyday subject – a kind of poetic 'throw-away'. In their deliberately rough finish they recall reliefs by Dalou, such as *Stone-breakers*, *Fishing*, etc., but whereas Dalou's are imbued with a spirit of nineteenth-century social realism, Mason's express the poetry of the street.

In an anonymous crowd Mason discreetly isolates one or two figures, such as the young woman in the centre of the drawing illustrated, which could be a study for the bisected foreground figure in his *Odéon Crossroad* (though for this he executed another, more painterly study, now in the Musée National d'Art Moderne in Paris). There is an apparent dichotomy in Mason's work between the pen and ink studies of exquisitely calligraphic lines and curves from which the recognizable human features

54

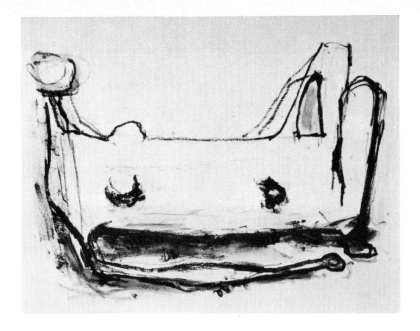

75 KENNETH ARMITAGE Sketch for *Reclining Figure* 1953

76 ARMITAGE *Reclining Figure* 1953-4

emerge, and the almost brutal modelling of the crowd forms (this becomes more noticeable in recent high reliefs and coloured sculpture). Then we realize that the drawings represent a more indirect relation to his sculpture than is the case with most sculptors. Each is complementary to the other.

The bronze reliefs by Kenneth Armitage and Couturier are not dissimilar in subject and treatment, but the distortions are individual. Both sculptors' drawings of the human form are as far removed as possible from classical or even academic idealization, and there is about them almost a kind of detached humour, stripping the female figure of its dignity, though never of its potential for expressiveness. Armitage seems fascinated by man's evolution from quadruped to biped; and, recumbent or upright, leaning or walking, his figures show his self-confessed obsession with the upper limbs for maintaining equilibrium and gesturing, and the weak shanks below for moving around – especially in groups – in playful activity. The transformation of a seemingly casual sketch in chalk and wash into the impressive bronze *Reclining Figure* is typical of this sculptor. There is a parallel transformation in the case of Couturier's brush drawing *Hommage à Maillol* – a dialogue between two lovers – which he calls *Desire* in the bronze version. By the year 1950 – he began his career in 1925 – the French sculptor increasingly deserted expression by solid volume for what he calls 'lamelli-forms' – linear and open form, sometimes combined with the sphere of the head or the cups of the breast as in the *Three Graces*. In the *Hommage* drawing he has envisaged a virtual relief in which the two figures are at once the sculpture and the niche. The dedication of the relief to Maillol is significant; Couturier was the Master's assistant in his last years and has inherited his studio.

The high relief *The Corpuscles* by Rumanian-born Etienne Hajdu, like the two reliefs by Ralph Brown previously described, is in aluminium. There, however, the similarity ends. Brown's reliefs are cast; Hajdu's are cut, worked, beaten, polished, sometimes brazed, and, as in the present example, figurative only inasmuch as the shapes suggest organic life. He has animated a background-support of slight curvature with fascinating forms, polished and three-dimensional.

No drawing could prefigure a complexity so dependent on reflecting surfaces, virtually in three dimensions against a background, and Hajdu feels that the wash-drawing (reminiscent of Leonardo's blot drawings) is in the nature of a preparatory exercise for this kind of sculpture.

77 ROBERT COUTURIER *Hommage à Maillol* 1969

78 COUTURIER Model for *Desire*

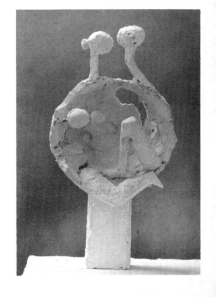

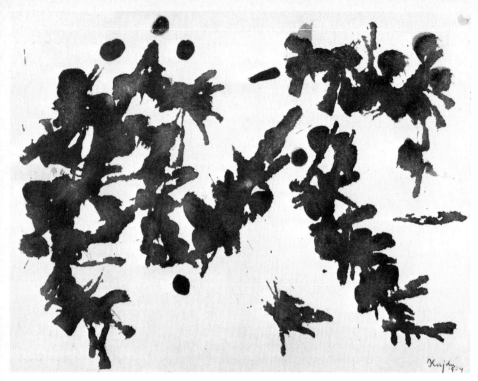

79 ETIENNE HAJDU Preparatory exercise
for *The Corpuscles* 1964

80 HAJDU *The Corpuscles* 1968

81 RAOUL UBAC *Torso*

82 UBAC Rubbing from incised plank
of wood

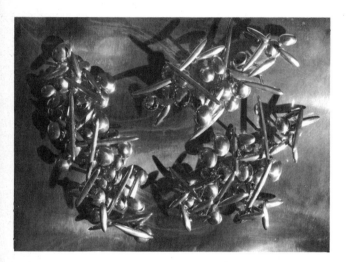

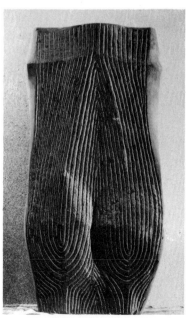

Although the element of reality seems remote in Hajdu's work, this should be considered in the light of his statement: 'For me there is not an interior reality and an exterior reality – they are two aspects of one and the same reality.' Their fusion is illustrated in *The Corpuscles* drawing and relief.

Slate reliefs are not peculiar to our time: there is a striking Renaissance example on the St George and the Dragon theme in the Victoria and Albert Museum in London (in the style of Giovanni Caggini), and slate memorials are to be found in many Cornish churches. Ubac's reliefs are unusual, however, in being cut out like silhouettes before being sculpted into his designs. His reliefs are an extension of his previous activity of engraving intaglio on copper, learned at the Atelier 17 under W.S. Hayter. He explained to me how this new idea came to him fortuitously one day in the countryside when he picked up a piece of slate and a nail and made incisions. With his nostalgic memories of the grey and blue slates of the quarries of his native Ardennes, this was enough to start him on his career as a sculptor. The relief illustrated is not a direct outcome of the drawing – which is in fact a rubbing from an incised plank of wood. (Ubac has described how he found inspiration in textured bark.) His slate reliefs have a classical austerity and sobriety suggesting the grooves on Doric columns – or perhaps the criss-cross furrows on the ploughed fields that surround his studio-home in Dieudonné. One is tempted to find too many parallels with his austere graphic and sculptural language. The rubbing with its exploitation of wood grain links up with the frottage experiments of Max Ernst (Ubac had a Surrealist period), while his slate carvings evoke memories of the torso of an Armenian princess in the department of Egyptian antiquities in the Louvre.

The Neoclassical revival has been responsible for a spate of imitations of Antique reliefs on public buildings. Churches, banks, and museums have had their pediments and façades decorated with sculpture of increasing dullness. It must therefore be a cause for permanent regret that the opportunity afforded Jacob Epstein to provide modern façade reliefs for the headquarters of the British Medical Association in London (a Renaissance-inspired building in the Strand) should have begun with a scandal and ended with the removal of carvings of real distinction.

Fortunately some of Epstein's sketch drawings and a few photographs of the finished carvings survive to enable us to appreciate the qualities of the originals.

Epstein was commissioned by the architect Charles Holden to carve the series of figures for his building in 1907. He undertook the carving on Portland stone blocks already built, untrimmed, into the structure, working on the face of the building on scaffolding forty feet above the ground. There were to be eighteen statues flanking the recesses of Palladian-type windows. The public outrage was his carving of *Maternity*, symbolized by a pregnant woman holding a child – not wholly inappropriate, one would have thought, for a building that housed (*inter alia*) obstetricians.

The drawing (85) reveals the beauty of the subject stated in simple rhythms from which all accidentals have been excluded. The firm left-hand ink contour emphasizes the statuesque element, the right-hand pencil line the softer feminine curves that express fecundity. The raised left arm echoes the line of the left vertical, hinting at the child that figures in the final sculpture. The folds of the drapery are already almost completely planned out. Only in the angle of the sculptured head is there a slight modification, relating it more intimately with the window arch.

Henry Moore wrote after Epstein's death that he 'took all the brick-bats', so preparing the way for the acceptance of his own work and that of other sculptors. At

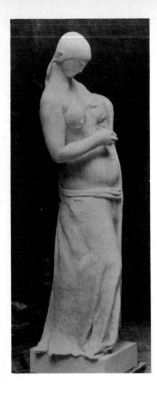 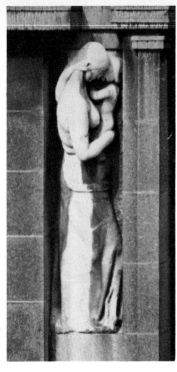

83 (far left) Jacob Epstein Full-scale model for *Maternity* 1967

84 (left) Epstein *Maternity* 1908 (mutilated 1937)

85 (below) Epstein *Pregnant Woman*, study for *Maternity*, 1907

Opposite:

86–7 Epstein Studies for *Night* 1928

88 Epstein *Night* 1929

89 Henry Moore *North Wind* 1928–9

90 Moore Idea-sketch for *North Wind* 1928

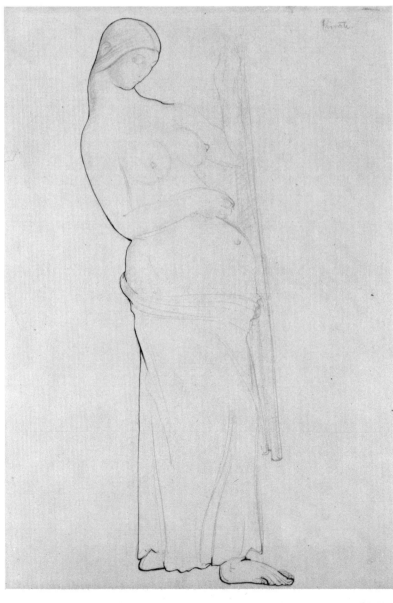

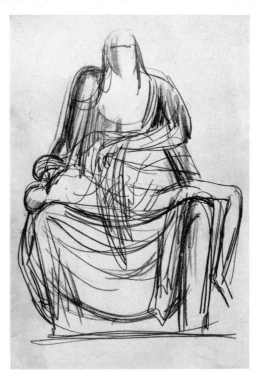
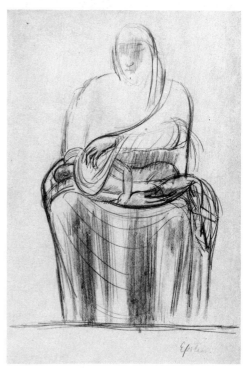
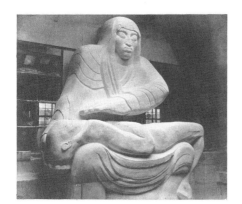
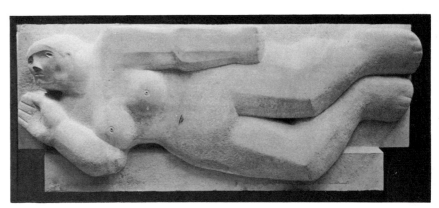
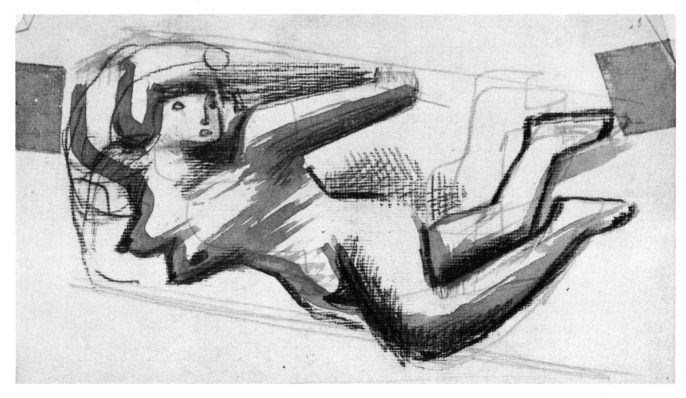

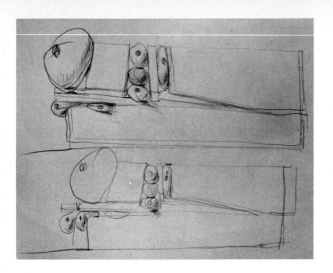

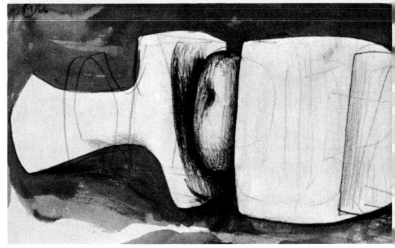

least Epstein received Charles Holden's next commission, a relief for St James's Park Underground Station in London in 1928. His treatment of the subjects *Night* and *Day* inevitably invites comparison with Michelangelo's, but the pose for the *Night* group, a seated figure with an almost limp figure across its knees, is nearer that of the St Peter's *Pietà*; and the seated figure suggests a Buddhist origin. One of these sketches is a first idea; the second stresses the sweeping curve of the left arm and the importance of the hand. The swell of the knees and hollow of the lap are summarily indicated.

Henry Moore received a commission for the same building. His evocation of the *North Wind* is the very opposite of Epstein's weighty theme. In view of his stated preference for the static qualities of sculpture, it is interesting that his first public commission was concerned with the suggestion of movement. This is implicit in the sketch-drawing – one of several explorations – which is the nearest to the carved Portland stone figure. The shading in sepia wash even hints at vectors of flight movement. The figure is rather like a swimmer; the upward tilt of the head and the raised forearm have the effect of lightening the horizontal form with its changes of plane. The emphasis on vitality rather than physical beauty makes it a fascinating landmark in Moore's early sculptural style.

Bernard Meadows, once one of Moore's assistants (and now Professor of Sculpture at the Royal College of Art in London), has evolved a strongly individual sculptural language, never more marked than in his recent contributions to sculpture and architecture. The new Eastern Counties Newspaper building (Prospect House) in Norwich provided a commission for sculpture that would integrate into the structure.

Unusually, the sculpture, composed of bush-hammered concrete (granite agglomerate) and polished bronze, enters the façade of the building at right-angles. It is meant to be viewed from the front and sides, right into the reception hall which it penetrates

91 (above left) BERNARD MEADOWS Idea-sketch for sculpture project for Eastern Counties Newspaper building, Norwich, 1969–71

92 (above right) MEADOWS Study on *Help* theme related to Norwich project

93 MEADOWS Sculpture on Eastern Counties Newspaper building, Norwich, 1969–71

to some considerable depth. Some of the effect is unfortunately lost because of the interruption of a rather fussy entrance porch. Meadows' whole concept is bold, and stems partly from his recent preoccupation with the opposition of hard and soft forms under tension or pressure, noticeable as early as 1967 in a bronze entitled *Soft Form Watchers*. The principle applied to sculpture is not new (it certainly dates back to Bernini's *Apollo and Daphne*, see pp. 31–2), but Meadows, in such sculpture and other smaller examples, adopts it in non-figurative themes, as in the piece called *Help*, sketches for which (I, p. 65) are equally relevant to the Norwich project. The behaviour of material under pressure carries obvious analogies with the human situation, even were the title less evocative. The squeezed spheroid with holes of the Norwich piece, contrasted with the chamfered concrete blocks, builds up to a climax in the ultimate sphere, tilted upward as if hopefully. Interpretations apart, the piece must be judged on its plastic qualities. It is interesting to note that the point of departure for an imaginative artist may be as simple as a pebble (for Henry Moore) or the roped woolsack inn-sign of a Norwich pub (for Meadows). The sketch shows the evolution of the idea, and was the basis for the scale model constructed for submission to the architect and others concerned. The colour drawings are characteristic explorations.

The ideal sculpture-architecture relationship was expressed by the veteran Austrian sculptor Fritz Wotruba as follows: 'I dream of a sculpture in which landscape, architecture and city become one.' Wotruba's work as a whole represented a fusion of the Gothic and classical traditions. He divided his admiration between the more recent heirs of these traditions, Lehmbruck and Maillol respectively, but also admitted to an attraction to the work of Marino Marini and Germaine Richier. This somewhat eclectic background should not obscure the essential individuality of a sculptor whose characteristic reduction to simplicity of form is well shown in the bronze standing reliefs illustrated. The drawings are sensitive and assured. Sometimes he sketches the general shape in a thin, broken line, as if he were deciding the relative proportions of different square or rectangular sections of his modern caryatids; sometimes he develops a sketch more fully with casual-seeming but effective hatching to bring out the separate nature of each relief figure. On occasion he explores an angular view. We can see the care with which he considers the problem of the articulation of the parallelepipeds, cylinders, the spheroid of the knees and head in relation to the total effect, and each complete figure in relation to its neighbours. Each of his drawings, from the most sketchy to the more complete, is a work of art in its own right. In the sketches straight lines are relieved by a sparing use of curve, in the reliefs by orchestration of spheroid and cylinder. The graphic idiom is well adapted for showing frontal and profile views. In the third figure from the left in the relief we recognize the leg position of the centre sketch studies, while the raised arms of the sketch appear in the extreme left-hand relief figure.

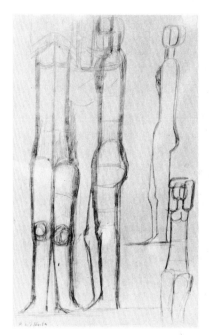

94 FRITZ WOTRUBA Sketches for *Figure Relief* 1956–7

95 WOTRUBA *Figure Relief* 1957–8

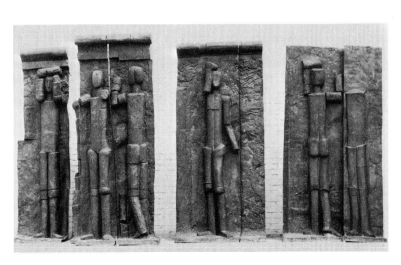

Before turning to drawings related to frontal or screen-type sculpture, I should mention the screen made for the theatre at Gelsenkirchen in Germany by Robert Adams, who, following his normal practice, dispensed with preliminary drawing and proceeded instead from maquettes. The illustrations show the link between the bronze maquette and what is, up to date, one of the sculptor's most important works, both in scale and in concept.

Halfway between sculpture in the round and the various types of relief are works intended only for frontal, or for frontal and back viewing, but which are also in most cases free-standing. Two sculptors who have produced this type of work are César and Gio Pomodoro.

The Italian sculptor Gio Pomodoro combines a mathematician's intellect with a strong plastic imagination; the results are highly sophisticated, as we see in his *Crowd* drawings and sculpture, with its cross-rhythms and effects of reflected light. It represents an elaboration of the idiom of curved surfaces used in the earlier piece, *One* (Tate Gallery, London). The proportions worked out in the drawings for *Crowd* are controlled by careful calculation. The light is assumed to come from a source at the left (this has been followed for the sculpture photograph). The form of the extremities of this long composition – the analogue for a crowd – has been closely studied. The photograph showing the piece viewed from a side angle will correct any assumption that such sculptures make sense only when seen as in the picture plane.

Such constructions as César's *Pied de Vestiaire* of 1958–60, built up in welded iron, do not normally proceed from preliminary detailed studies, but the *arrachage* (paper-tearing) illustrated bears the same sort of relationship to the sculpture as Ubac's rubbing to his slate relief (p. 56). They are – in the Baudelairean sense – striking '*correspondances*'.

Jean Arp's reliefs of painted wood come somewhere between painting and constructions. He himself called them reliefs, and as with César and Ubac, one feels justified in relating them to a process other than drawing, in this case collage, which Arp used specifically to simulate a three-dimensional effect. This collage method allows the artist to consider different arrangements of elements to achieve the desired effect. Concerning *Celestial Objects* Madame Arp wrote to me: 'This relief was made in wood painted white on white after the collage in colour.'

96 GIO POMODORO *Crowd IV* 1963

97 POMODORO Studies for *Crowd* 1963

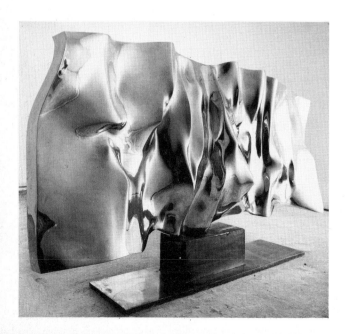

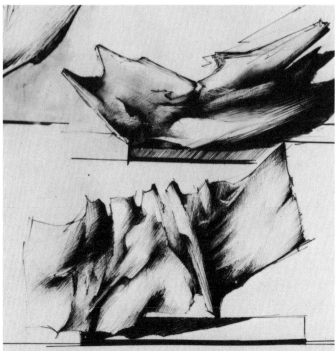

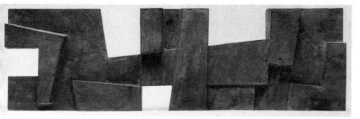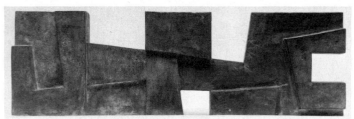

98–9 ROBERT ADAMS Maquettes for architectural screen at Gelsenkirchen 1956

100 ADAMS Architectural screen, Gelsenkirchen 1956

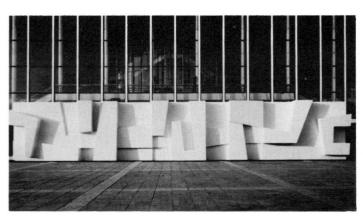

101 CÉSAR *Arrachage* (Paper tearing) 1961

102 CÉSAR *Pied de Vestiaire* 1958–60

103 JEAN ARP *Celestial Objects* 1958

104 ARP *Celestial Objects* 1961

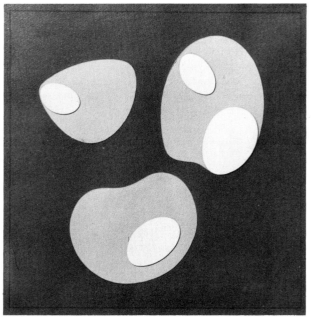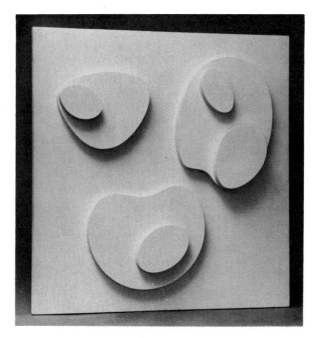

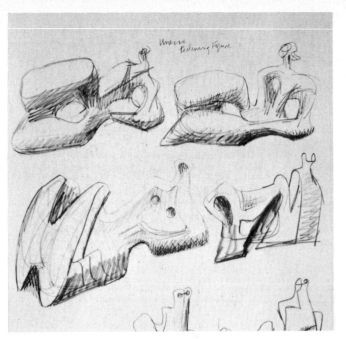

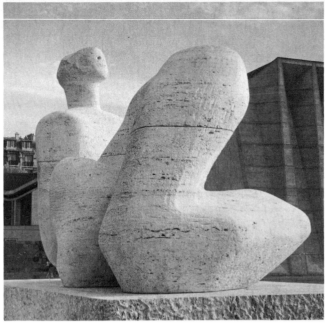

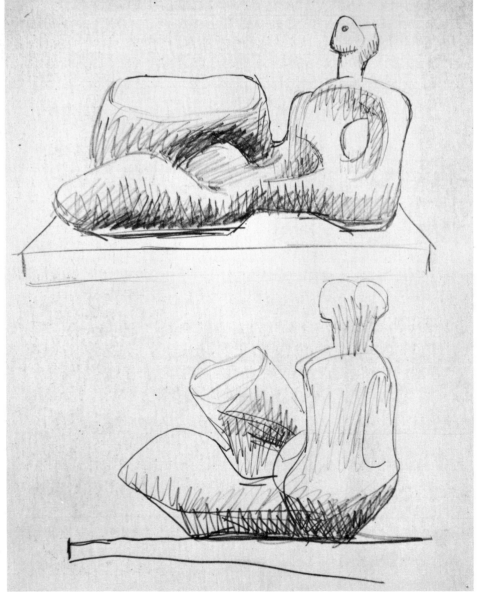

105 HENRY MOORE Sketches for Unesco *Reclining Figure* 1956

106 MOORE Unesco *Reclining Figure* 1957–8

107 MOORE Sketches for Unesco *Reclining Figure* 1956

I BERNARD MEADOWS Drawing related to *Help* and to the sculpture for Eastern Counties Newspaper building, Norwich 1970 (*see 91–3, pp. 60–1*)

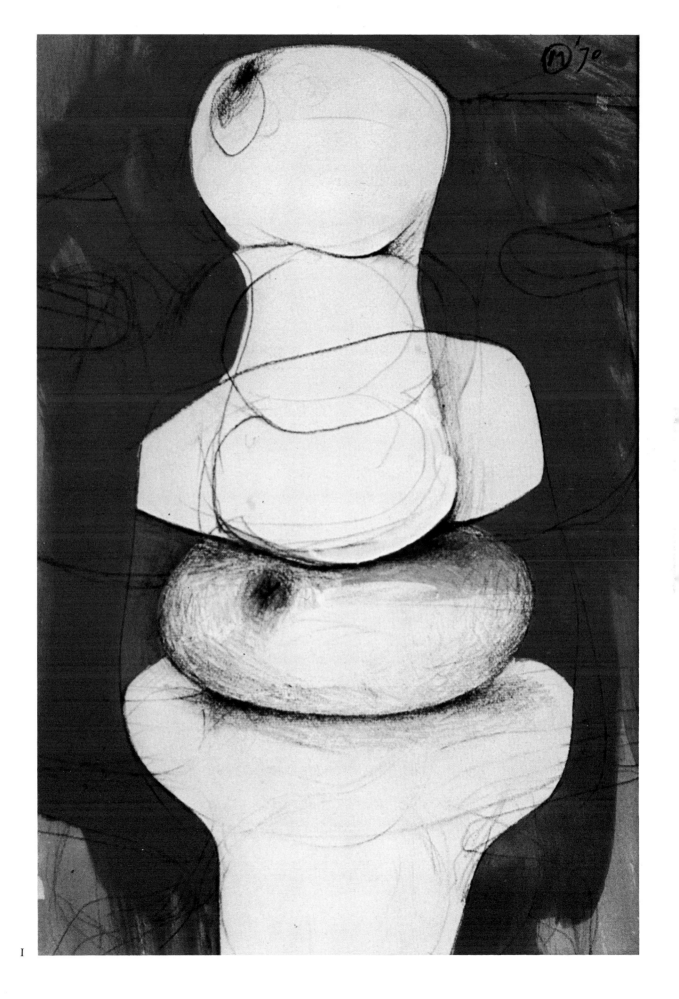

I

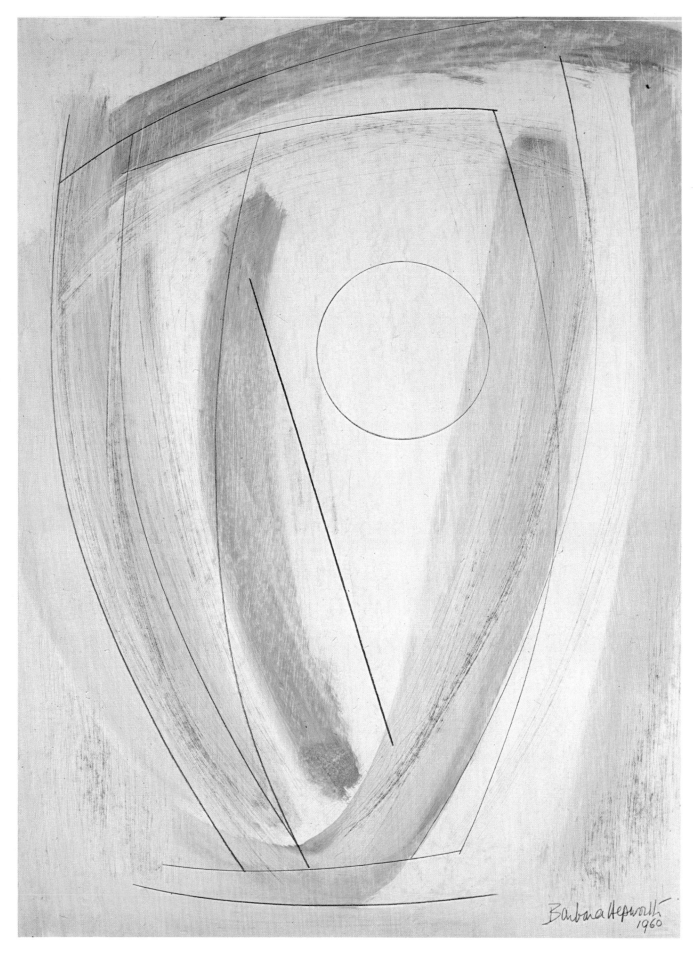

Barbara Hepworth
1960

3 *Sited sculpture and open-air monuments*

The post-war outcrop of new buildings incorporating modern constructional techniques, allied to a sculpture revival, resulted in many interesting commissions. Here I can only deal with some of the more important official or semi-official examples of sculpture designed for specific buildings or sites.

Henry Moore was invited in 1956 to contribute a large-scale sculpture for the Unesco complex in Paris (for which several other artists of international fame – including Picasso, Miró, Calder, Noguchi and Matta – were also to execute works in characteristic media).

Moore's main problem was presented by the proposed siting against a background of fenestration which could be confusing to the viewer's eye. The sculptor therefore began by making models that incorporated – since to begin with he was thinking in terms of bronze – a bronze background screen. Finally, however, Moore decided that, from every consideration, a carved recumbent figure in Roman Travertine marble provided the best solution (106). The honey-coloured stone, especially in the open air, would make a greater impact on the eye than a bronze – it would be monumental and unique; and, as he conceived of it, strong contrasts of light and shadow and cave-like mysteries would lend it interest even on the dullest days.

The scale – sixteen feet long and over eight feet high – was large enough for the sculpture to hold its own against the architectural background. In point of fact, several years after the unveiling it was moved to a more central site on the complex, where it provides an attractive and impressive focal point, away from the shadows cast by the building.

Looking at the sheet of small sketches we can appreciate why the top left-hand example was the idea chosen for the final exploration in the two larger drawings. The rising thigh, characteristic of many of Moore's recumbent figures and a feature of classical origin, takes away any sense of mere weight as opposed to telling volume; the deep perforations already give promise of spaces that will be as eloquent as the solid areas and make every viewpoint unpredictable and exciting. Moore's experienced eye had allowed him to prefigure the view at right-angles to the main axis, and already at this stage he had decided the pose. The small raised head increases the feeling of awe inherent in this matriarchal figure. It will have the effect of distancing us physically and psychologically from a figure that is both human and landscape.

Barbara Hepworth, whose career ran parallel to Moore's, was a personal friend of Dag Hammarskjöld, the Secretary-General of the United Nations so tragically killed in an air-crash. He had known and admired her work and possessed a carving in walnut, *Single Form*, which for this and other reasons naturally suggested itself as a

II Barbara Hepworth *Thea*. Drawing related to *Single Form* and to Hammarskjöld memorial 1960 (*see 108–9, p. 68*)

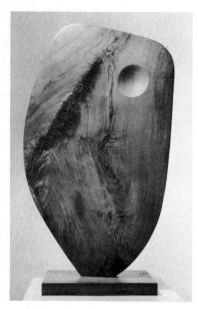

108 BARBARA HEPWORTH *Single Form* 1961

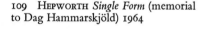

109 HEPWORTH *Single Form* (memorial to Dag Hammarskjöld) 1964

basis for the design for the memorial to him at the United Nations Headquarters in New York. This strong, harp-like shape – one which Dame Barbara made peculiarly her own – is admirably suited to the soaring building behind. Like the walnut carving it evolved in stages from the pencil and oil drawing (II, p. 66), made in 1960.

The first version of the Memorial was a half-size plaster model made when Dame Barbara heard of Hammarskjöld's death in September 1961. In this the left-hand edge corresponded to the curved right-hand edge of the drawing. In the greatly enlarged design the long straight opposite edge was an evident necessity to counterbalance the curvature and to echo the vertical of the towering building.

The pencil and oil drawing is typical of the sculptor's preoccupation with geometrical shapes softened by the use of colour. Patination plays a similar softening role in the bronze. The lines marking sectional joins (seven separate pieces had to be cast) add a further interest to the whole vast composition, at the foot of which the jets of the symbolic fountain play.

The work, like Henry Moore's two-piece in bronze for the Lincoln Center, unveiled in the same year (1963), for which a reflection in water was also a calculated effect, is a characteristic one. It is a measure of the sculptural distance that separates her creations from the Classical, Baroque and Neoclassical idioms considered in the Introduction.

In contrast to her characteristic, more autonomous oil and pencil drawings, the spontaneous exercise for an open form illustrated relates to themes that obsessed her around the years 1957–60. Among the fascinating open sculptures of that period is the aluminium wing-like construction on the face of the John Lewis department store in Oxford Street, London. The present drawings, however, are more closely linked with *Meridian* – the open bronze for the State House building, London, which stands against a concave screen of Cornish granite, ideal in colour as a foil for the basically linear treatment of the sculpture. On the subject of drawing Barbara Hepworth has said, 'I rarely draw what I see – I draw what I feel in my body,' and the present pen drawings, which seem to have the qualities of Chinese calligraphy or a Tudor paraph, illustrate her point.

The monuments by Zadkine and Reg Butler are significant departures from the usual associations of war memorials. Gone are the realism of the uniformed soldier, the mourning widow, the element of heroic stylization. Zadkine was commemorating the bombardment of an open city, Rotterdam; Butler the 'unheroic' subject of the 'unknown political prisoner'.

Zadkine, Russian by birth, had been a witness of the destruction wreaked by the aerial bombardment of 1940. He referred to 'the howls of the ruins'. 'What I saw', he wrote, 'made me sleepless . . . it was as if I had been personally stricken by the holocaust.' His idea of recording his emotions in sculpture came long before the official commission: he began work on a model in red clay almost immediately. The bronze memorial, *The Destroyed City*, imprinted on the retina of every visitor to present-day Rotterdam, was completed in 1951 and unveiled on its site on the Leuvehaven Quay in 1953.

Zadkine had been concerned to produce a figure that could be read as a silhouette against a background of harbour water and would fit into its setting of ships' derricks and marine furniture. The features of the bronze figure were expressionistically exaggerated – the huge gesturing arms, the central gash, symbolic of the heart torn out, the strange torso, the gaunt form of the charred tree-stump. The result – a successful grafting of expressionism on to an earlier cubist idiom – can be seen in embryo in

110 BARBARA HEPWORTH *Meridian*
1959

111 HEPWORTH Project for *Spring Morning*
1957

112 HEPWORTH *Figures*, project for iron
sculpture 1957

113 OSSIP ZADKINE Drawing for *The Destroyed City* 1950

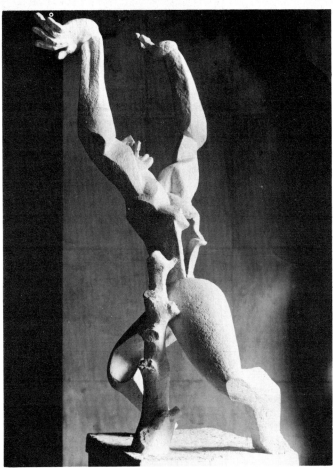

these pen-and-wash drawings of 1950. The first shows the figure kneeling, gesturing arms closer together than in the sculpture. The technique is a contour of fragmented pen-line reinforced with cross-hatching that sometimes follows the curve of the plane. The second drawing shows the final pose of the sculpture; the slight modifications – the increased tilt of the head and the back-thrust of the hands, the inclination of the right leg, the scaling down of the tree-stump – all enhance the dramatic effect. Zadkine was awarded the sculpture prize at the Venice Biennale on the strength of the model, even before the statue was erected – a confidence that proved fully justified.

Reg Butler's design (maquette) won the first prize in the open international competition on the theme of the 'Unknown Political Prisoner'. Among the competitors were F. E. McWilliam, Lynn Chadwick, Barbara Hepworth and Naum Gabo, the first three of whom won special awards. Gabo's comment in 1952, that 'No country in their present state of conscience would dare to erect a monument with this name', may explain why the full-scale project has never been realized.

The conception is imaginative – it aroused hostile if uninformed comment at the time of the Tate Gallery Exhibition of competition entries – and makes full use of contemporary techniques. All Butler's obsessions seem to have led up to this work – open figures set in space, the uplifted head, towers, and, technically, his preoccupation with metal constructions. 'All my life,' he said later, 'I have only been concerned with four sculptures: a girl – usually standing, a man – usually small headed . . . St Catherine (associated very often with her wheel) and boxes . . . which I think have become towers. Obviously they suggest a preoccupation with forms capable of being made very large.'

114 OssIP ZADKINE Drawing for *The Destroyed City* 1950

115 ZADKINE Model for *The Destroyed City* 1950–1

71

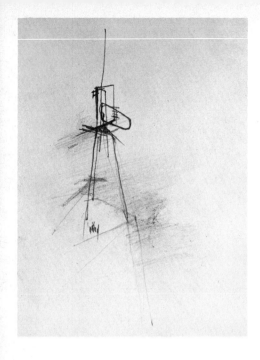

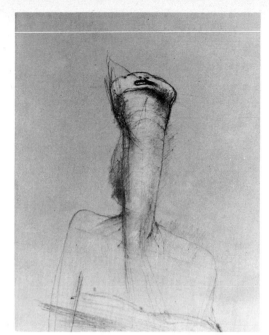

116–17 REG BUTLER Studies for *Three Watchers*

118 BUTLER Studies for *Unknown Political Prisoner* 1951–2

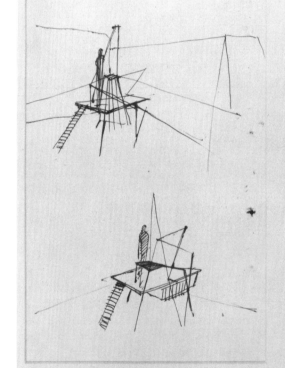

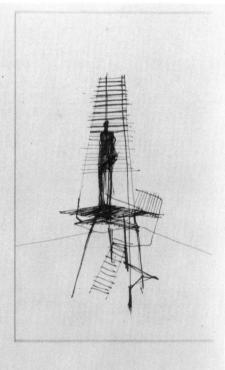

119 BUTLER Detail of maquette for *Unknown Political Prisoner*

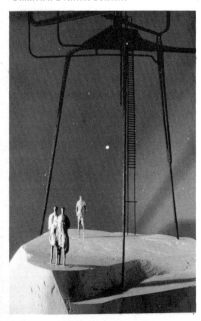

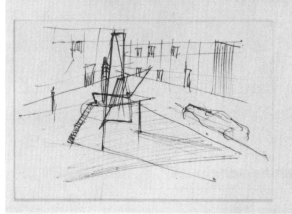

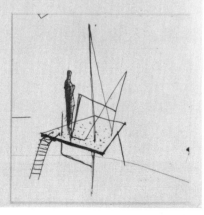

The sketches illustrated consist of explorations to do with the general composition, the siting and levels of the component parts, a study of the head looking up, a study for *Three Watchers* (wash and indelible pencil) and the definitive sketch (in the same medium) for the final version of the sculpture. The 'watcher' of the head-sketch can be identified with the background figure on the maquette. It is the kind of drawing that emphasizes the three dimensions of the composition, which combines bronze wire and cast bronze figures. The tower with its inevitable evocation of concentration camps expresses a Kafka-like despair: the prisoner stands in a kind of physical and spiritual limbo. Butler remarked to me apropos this and other maquettes (e.g. *Woman walking* and *Head and Shoulders*, both of 1951), 'my wire sculptures are three-dimensional drawings'. As a spatial exploration the *Unknown Political Prisoner* has had a considerable influence on contemporary, including non-figurative, constructions.

The works shown by Maillol, Emilio Greco and McWilliam are 'civic monuments' in the sense that they are sited in public parks. Although unrelated to architecture, they fulfil the function of animating a space with their presence.

The Maillol nude in the Tuileries Gardens celebrates the River Garonne and harks back to the Roman and Renaissance river gods. Unlike most of his nude figures, which are in more static poses (for example the serene *La Méditerranée* or *Three Nymphs*), *The River* suggests in its dynamism the unrestrained movement of a river in spate.

Maillol worked almost exclusively from models, his favourite being Dina Vierny, now owner of the Paris gallery of that name. She posed for the *Monument to Claude Debussy* and *Girl Stooping*, as well as for *The River* and a host of other life-studies. Maillol's extremely large-scale drawing in black pencil on a rough paper shows his superb control of contour, his masterly articulation of the roundness of form and the balance of volumes. The treatment of the contour edges is interesting. The dark recedes in tone as it moves inwards, the effect of which is to emphasize the modelling and give unity to the whole. Maillol uses the same technique in his life-study in red chalk reproduced in the next chapter (158), and for his *Monument to Claude Debussy*.

There are often time-intervals between such Maillol studies and the eventual sculpture. In no sense are they more than preparations – but essential preparations – undertaken before the modelling stage (as in *Young Woman Crouching*). 'One must make a synthesis,' he said, 'like Negro carvers who have reduced twenty forms into one.'

Designing a monument with a more specific allusion presented Emilio Greco, winner of the open competition for a sculpture on the theme of *Pinocchio*, with demands not easily reconcilable. The site was a park in Collodi, which the author of the book had adopted as his pen-name. Greco had to find a way of combining a recognizable pictorial element with a satisfactory sculptural solution. This he happily contrived in an open arabesque (reminiscent of the *forma serpentinata* of Giambologna) rising from a simulated olive tree-trunk. The tree-trunk symbolizes the wood from which Geppetto carved the puppet; the figure at the top is the Fairy who, touching his hand, evokes the moment in the story when the puppet becomes a boy for good. Greco has also simultaneously alluded to the dove in the story who bears Pinocchio over the sea after the death of 'la bella bambina', but in a more plastically satisfactory heron-like form. The sketch-drawings date from 1953, three years before the completion of the monument. The pen sketch shows alternative positions for the bird.

Greco builds up his forms in a series of cross-hatchings and curvilinear patterns that evoke the final composition and the feeling of surrounding space – 'the arabesque, in fact, is a way of taking possession of space.' In striking illustrations for an Ovid, Greco has shown how well he understands the requirements of two-dimensional coordinates,

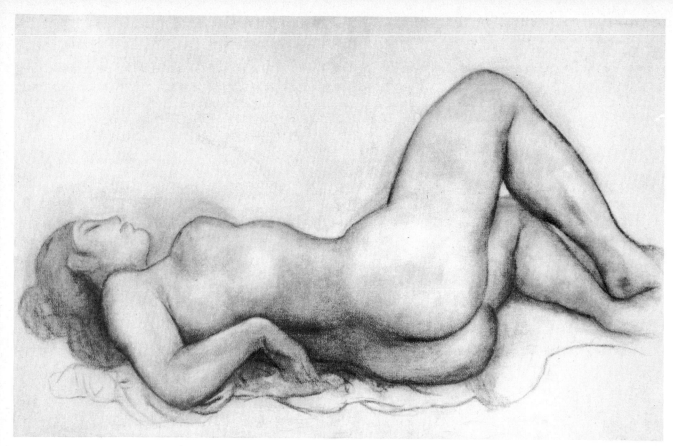

120 ARISTIDE MAILLOL Drawing of Dina Vierny

121 MAILLOL *The River (La Garonne)* 1938–43

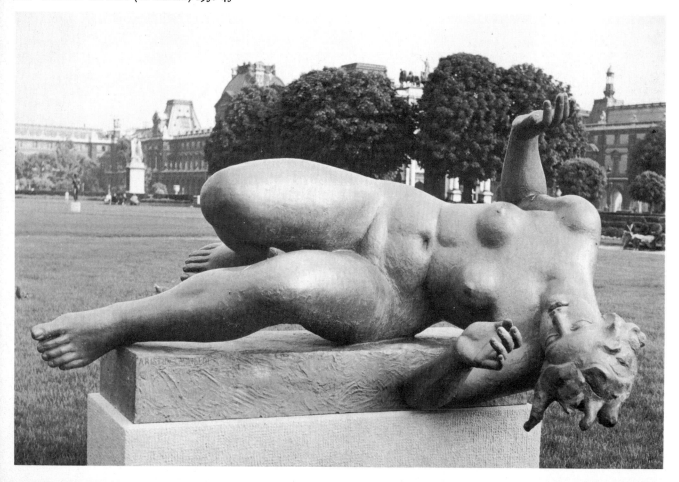

122 EMILIO GRECO Drawing for *Pinocchio* 1953

123 GRECO *Pinocchio* 1953–6

124 GRECO The sculptor working on the plaster model for *Pinocchio*, Rome, 1955

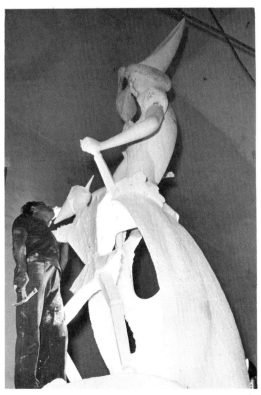

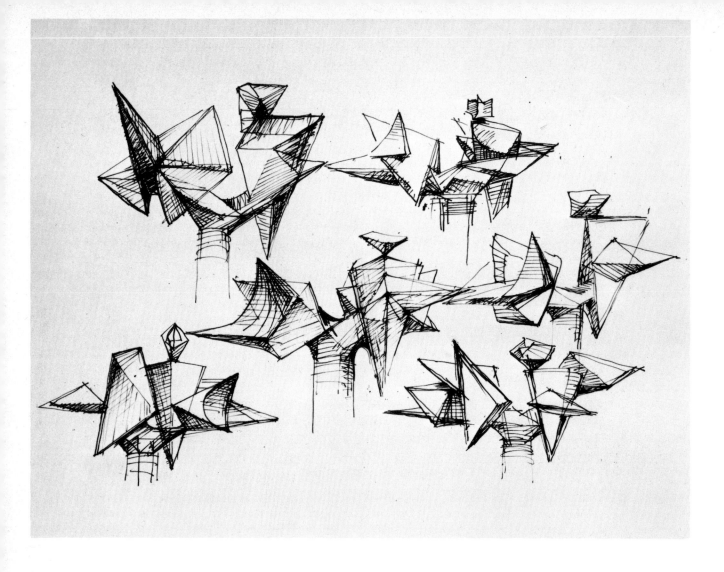

125 F. E. McWilliam Studies for
Hampstead Figure

126 McWilliam *Hampstead Figure*,
1964

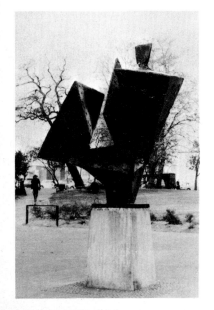

but here in these studies for sculpture every line, every hint of shadow evokes form in space. They are masterpieces of economic statement and vitality.

With McWilliam's sculpture for Hampstead (now Camden) Civic Centre, London, we exchange the graceful sinuosities of Greco's *Pinocchio* monument for a contrapuntal arrangement of bold geometrical shapes, reaching a climax in what we read contextually as a head. It is a sculpture whose angularities stand in contrast to the natural surroundings of trees. One of the most versatile of English sculptors, McWilliam is an obsessive draughtsman, filling whole notebooks with ideas as they occur until he is struck by the sculptural potential of a specific group, such as that on the page reproduced. He may then make a synthesis of several drawings in the form of a wax maquette. This in its turn is scaled up into a final form. Here we see the top left-hand sketch combined with the lower left-hand one. The column idea has been dropped in favour of a rectangular base with battered sides. The space-interval in the top drawing simulates that envisaged for the sculpture, and the crystalline shape of the left-hand side of the lower sketch and the inverted pyramid with the contextual head both figure in the final result. Compared with McWilliam's *Kneeling Torso* (1947), *Princess Macha* (229) and the more recent *Women of Belfast*, this large open-air composition is his least anthropomorphic to date, but it is far from being 'abstract'.

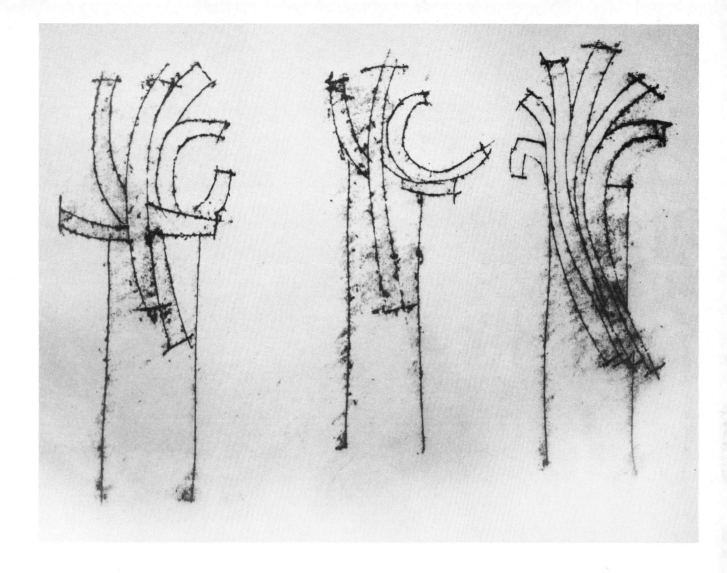

Geoffrey Clarke's name is associated with many examples of contemporary English architecture. A specialist in aluminium which he casts at his own studio in Suffolk, he has executed gates for Winchester College Chapel, many items for Coventry Cathedral including a ten-foot-high cross and candlesticks, and the striking pulpit, lectern and other items for Chichester Cathedral. The sculpture illustrated is one of the *Torii* series commissioned by the Physical Training College, Bedford. The sketches were made in 1965 and led to a series of maquettes in aluminium cast on the lost wax principle using polystyrene cut out from a block by the hot wire method.

Clarke has evolved an individual technique for his drawings, based on a monotype method. He draws lightly on a thin, translucent paper laid on a hard surface, usually metal, coated with printing ink. The impressions made by the pressure of the pencil are thus transferred to the clean sheet underneath, which accounts for the soft-ground etching appearance and rather spectral lines. The coating method allows him to add an element of tone here and there with a mere touch of a finger tip. This indirect method has the effect of situating the objects in three-dimensional space; one is not conscious of the sheet coordinates.

The *Torii* maquette was the outcome of the right-hand sketch of the trio, and this in turn was scaled – with the necessary adjustments for so tall an object – to the eight-

127 GEOFFREY CLARKE Drawing in *Torii* series 1965

128 CLARKE *Torii* sculpture 1965

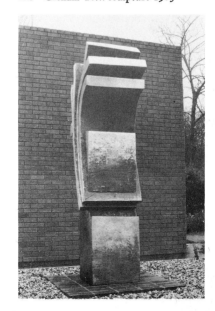

foot-high unique aluminium sculpture, which with contrasts of rough and smooth polished surfaces stands out against the stark brick background of the college.

In connection with sited sculpture I should mention the current fashion for plans for statues and monuments not seriously intended for execution.

The most original of these plans have emanated from the witty and fertile imagination of the Swedish-born sculptor Claes Oldenburg who works in America, and who is most widely known for his soft sculpture. In the Tate Gallery exhibition of 1970 he included drawings called 'Proposals for Monuments', among them the *Thames 'Ball'*, the *Pivoting Lion* and the sketch reproduced here, *Proposed Colossal Monument for the Thames Estuary: Knee* (1966). Oldenburg builds up whole series of notebook-drawings of this kind, mostly in crayon and watercolour, and accompanied by pointed comments. He calculates that he fills about six hundred sheets a year – some of thin typing paper – which he collects up into binders in due course. These informal sketches make an interesting contrast with the precision drawings he prepares for actual projects (*Three-way Plug*) or soft sculpture (*Soft Typewriter*), illustrated in Chapter 7.

Apropos the *Knee* he writes: 'This was one of several monuments proposed in 1966 on my first visit to London, using the knee subject. It grew naturally from the knee-consciousness of the time. The extent of knee exposure, depending on the rise and fall of the top-boot (choice of boot height) and skirt hem (at the top extreme) was equated with the rise and fall of Thames' tide. The knee is the most architectural part of the body, therefore suitable to monuments. The Colossus of Rhodes was in the back of my head . . .'

We continue to hear about similar and more ambitious schemes under the heading 'ecologic art'. These involve the transformation of a natural or urban feature or even an entire area by wrapping it up in nylon bound with rope – a coastline, a city sky-

129 CLAES OLDENBURG *Proposed Colossal Monument for the Thames Estuary: Knee 1966*

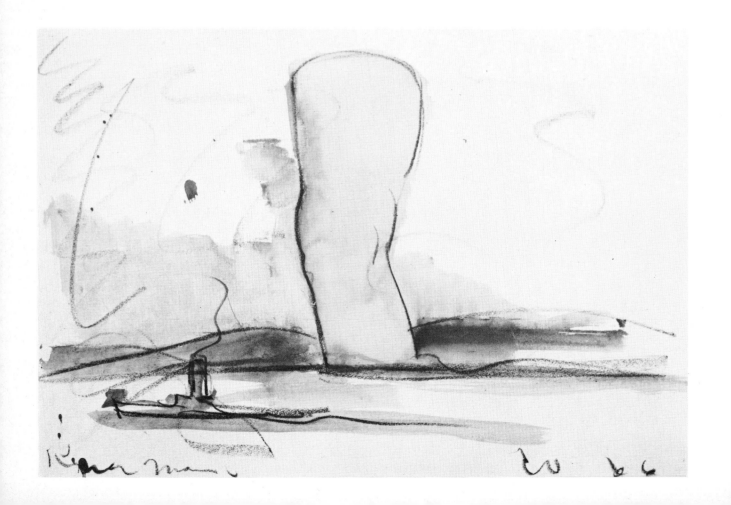

scraper. One of the experimenters in this field has been Christo, also American, with a series he calls 'Projects not realized', although in fact several of his projects have been carried out, literally embracing actual buildings – a fountain and a medieval tower, for example, at the Festival of Two Worlds in Spoleto, Italy, in 1968, the wrapping of the Museum of Contemporary Art, Chicago (involving 2,800 square feet of drop cloths), in 1969 – and transforming landscape, as with his valley curtain of 1970–2. His wrapping of an Australian coastline (*Little Bay*), illustrated, is the most ambitious of contemporary ecologic art. There is in his packaging projects – not all intended to be carried out nor all on the heroic scale – an intriguing ambiguity, since in viewing these 'Temporary monuments' our attention alternates between the existing item as we remember it or know it to be, and the sculptor's transformation. He exploits contemporary feelings, satisfaction mixed with frustration, about the package syndrome, but over and above these associational evocations, he achieves a successful blend of formal and calculated effects – his skilled divisions of areas and the linear patterns of the binding ropes – with the accidental. His semi-schematic drawing, seen in relation to the photographed reality, shows how far he was able to anticipate the effect of this ambitious experiment. One certainly cannot dismiss this result as an abortive attempt to improve on nature; it evokes, rather, a romantic Totenmeer or a frozen landscape by Caspar David Friedrich.

Whether such projects represent more than a striving after novelty, and whether, when realized, they have sculptural validity, it is hard to say. However, a drawing by Henry Moore – who seems to have anticipated most new developments in art – called *A crowd looking up at a tied-up object* (dated 1942), makes one inclined to believe they have limited possibilities as ephemera of sculpture, perhaps to veil polluted or derelict areas or dilapidated buildings, replacing ugliness by intriguing mystery.

130 CHRISTO *Packed Coast* project 1968

131 CHRISTO *Wrapped Coast*, Little Bay, Australia 1969

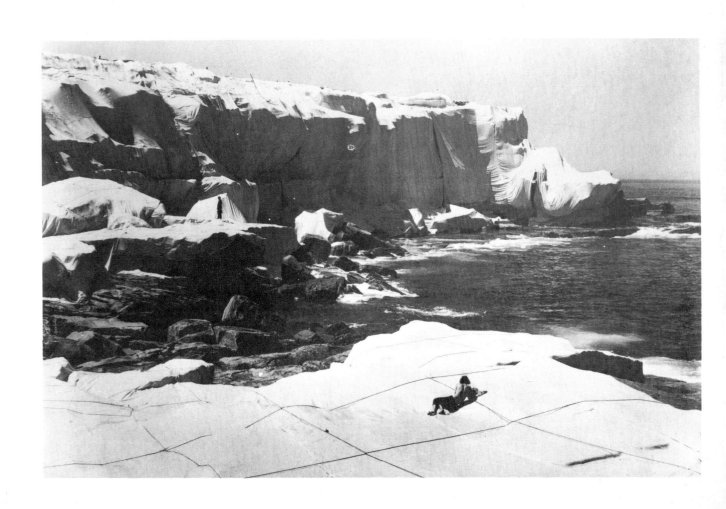

132–3 ANTOINE BOURDELLE Studies for *The Urn*

134 BOURDELLE *The Urn, c.* 1928

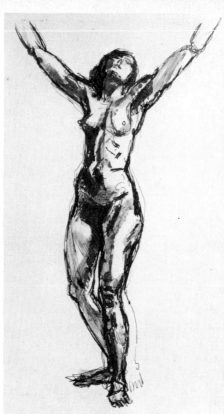

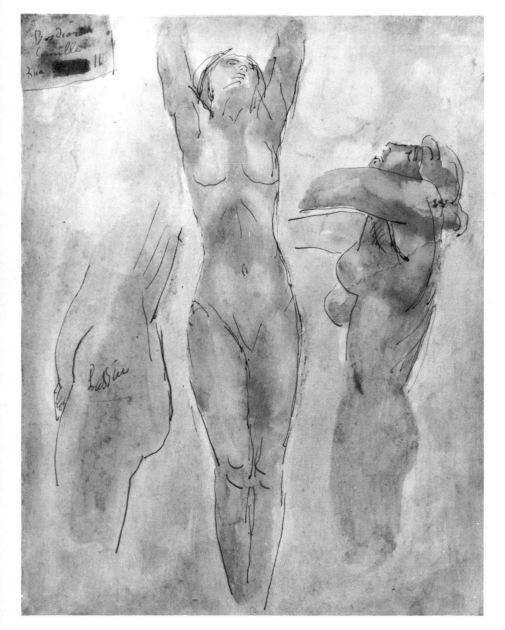

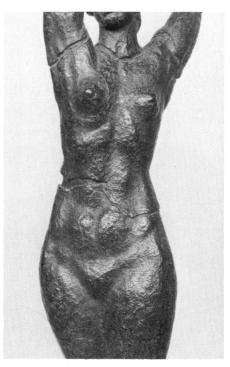

4 *The torso and the nude*

The human body is dramatic in itself. It is also the standard of harmony.
RODIN

The torso in modern sculpture immediately evokes the torsos of Antiquity – those remains of marble carvings which have been unable to survive Michelangelo's famous 'rolling down the side of a mountain' test or have suffered fatal stresses on the notoriously weakest parts, the neck and ankles. The exploitation of the fragment as a model for copying or adapting during the Late Renaissance and Neoclassical periods went side by side with attempts at restoration. Since Rodin's time, however, sculptors have realized the potential the fragment offers for the avoidance of 'literary' expression, through the omission of the head, the depersonalization of facial features, or by reduction of the figure to a torso – that is, by a concentration on form. In a notebook of 1922 Moore reminds himself of this in these words: 'meaning by shape not feature . . . effect to be gained not by features'. Moore in fact began by reacting against the fragment, modifying his view only after seeing the larger, more impressive examples on his travels in Greece in 1951. 'What pleased and surprised me,' he wrote concerning his *Draped Torso* of 1953 (46), 'is how Greek it looks.' By the same token he likes a small torso (44), aptly called *Fragment*, since it was cast from an accidentally broken plaster model, which does not look out of place close to a Hellenistic example, and led to the large Stuttgart bronze of 1957/8 (45).

It was Rodin who reinstated the fragment. ('What do breaks matter?' he wrote. 'Draw from mutilated figures; the planes will still be there.') It is not easily appreciated nowadays the extent to which his work in this genre was denigrated. It is interesting to read Zadkine's comment: 'In a period when one had little use for any but sculpture of smooth forms, it was tantamount to a revolution to proclaim the harsh beauty of the mutilated figure.' Although the post-Rodin torso has assumed forms far removed from the classical canon or Rodin's interpretations, the survival of the torso almost as a sculptural test-piece – carved, modelled or constructed with some allusion to a previous source – is evidence enough of the persistence of a classical tradition. Indeed this tradition, which we associate also with the nude and draped female form, has shown signs of revival in the latest phases of work by Reg Butler, McWilliam and Ralph Brown.

By its very nature the torso – as opposed to the complete figure – has fewer drawings connected with its sculpture. This, however, is the relevant moment for the reader to glance back at the page that includes Moore torsos in the Introduction (p. 35).

Antoine Bourdelle, when not indulging in academic stylization, reveals some of the best qualities we associate with Antiquity. The shape of the Grecian urn is said to have been inspired by the female torso; hence the title of his bronze, *The Urn*. The nude studies are among the best drawings by this sculptor; they have fluency and freedom

81

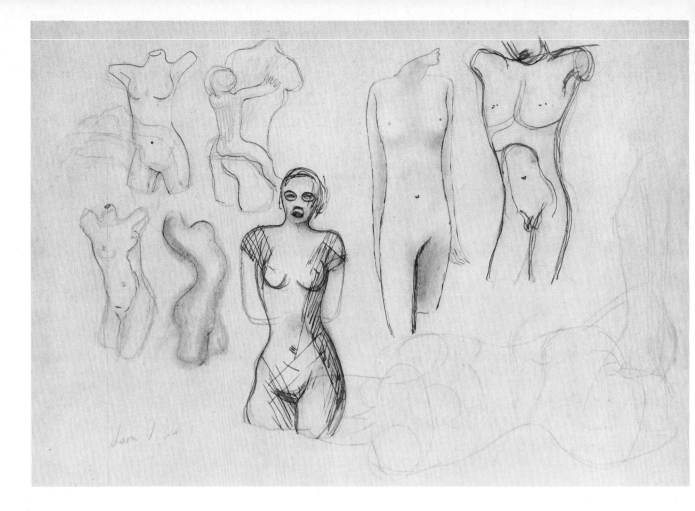

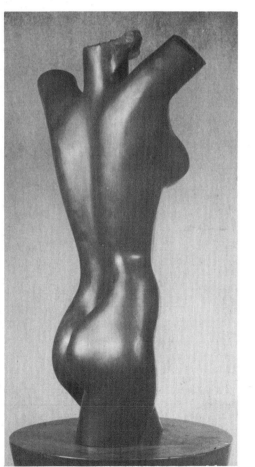

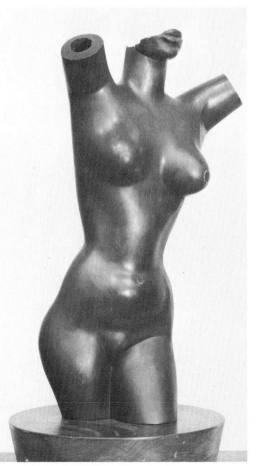

135 LEON UNDERWOOD Sketches
for *June of Youth* 1934

136–7 UNDERWOOD *June of Youth*
1937

III JACQUES LIPCHITZ Study for
Prometheus 1936 (*see 206–9,
pp. 113–15*)

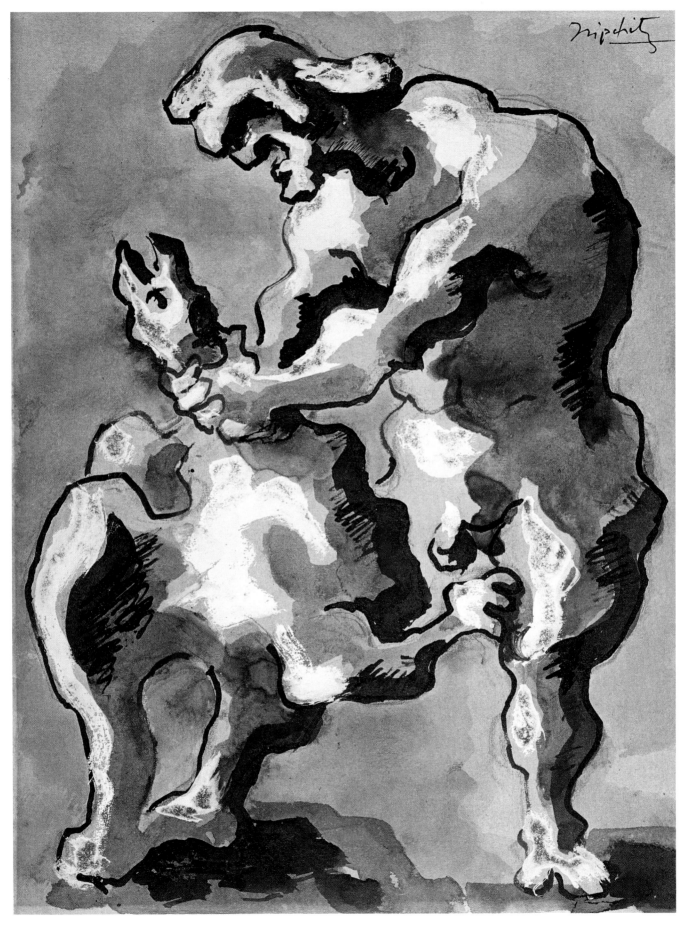

III

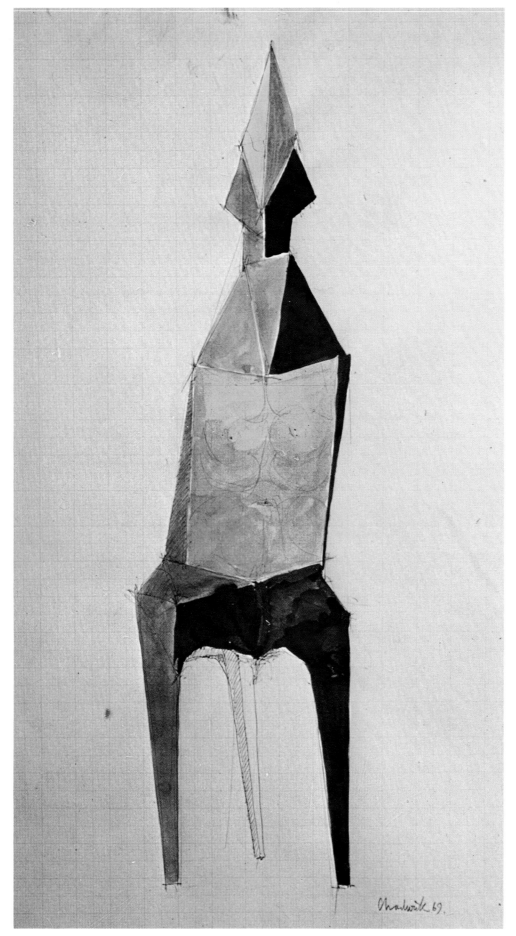

Chadwick 69.

IV

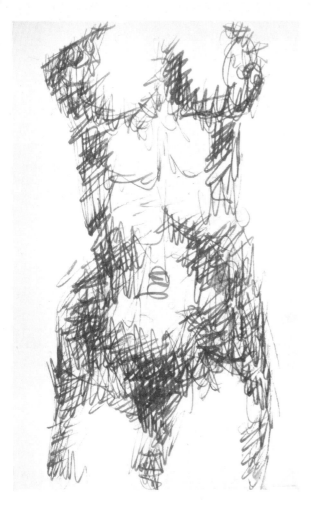

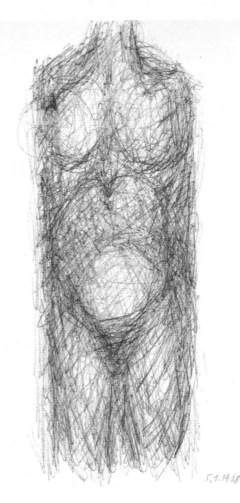

and at the same time a rare appreciation of the expressivity of the female form. In the pen-and-wash study he is concerned with the contours and modelling; in the darker ink drawing with a touch of sepia wash, more with the stance and structure of the form (one notices the 'pentimento' on the right). The striking features of both are the tautness of the stretched skin and the tension of the pose, coming to a climax in the facial expression.

The neglected English sculptor Leon Underwood created in *June of Youth* a more sophisticated nude, not without a degree of erotic distortion. It is a successful example of partial suppression: 'You see the rest,' he explains, 'without it being materially there.' The sketch drawings show interesting explorations. There is the top left-hand thick-waisted figure, strong and simple, the squeezed-in torso of the centre pen sketch, and the shaded study showing part of the neck and jaw, anticipating the final bronze. The figures are drawn with considerable dexterity and avoid the academic cliché. The top left-hand sketch is the clue to the posture, the sketch on its right suggests the exaggeration of the buttocks adopted in the bronze, while the sketch immediately below it shows Underwood's confessed fondness for Hogarth's 'serpentine contour'.

Since the early 1950s, Ubac has used a resin adhesive to bind together thick slabs of slate, to produce what he calls *taillées doubles* ('double cuttings') in a series of 'Large Torsos' which present viable back as well as front views (see also 81, 82).

The pen drawings shown are sketches for these works, which he considers a necessary prelude to the carving process. He dispenses with preliminary contours, and his

138–9 RAOUL UBAC Sketches of torsos 1968

140 UBAC *Large Torso* 1966

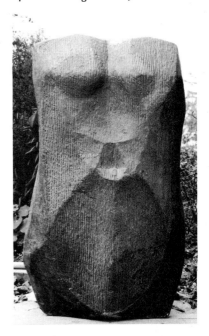

IV LYNN CHADWICK Study on squared paper for
Elektra 1969 (see 246, pp. 134–6)

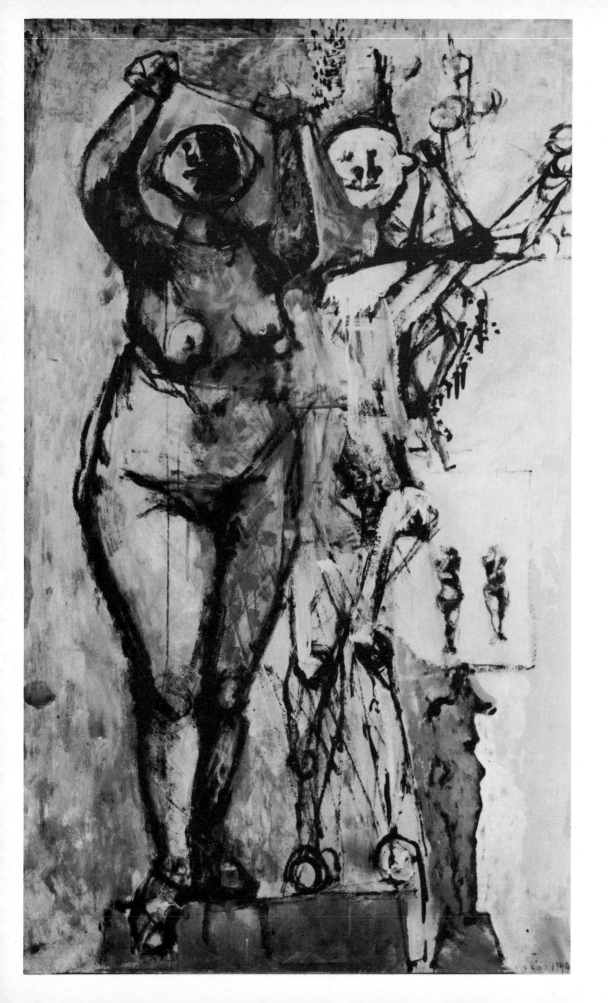

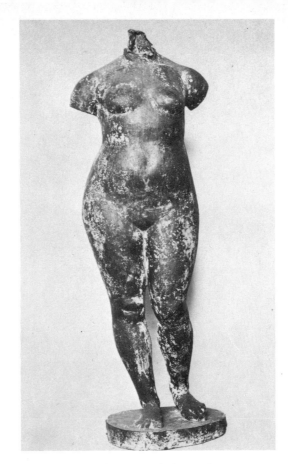

141 (left) MARINO MARINI *Pomona Composition* 1949

142 MARINI *Pomona* 1941

rhythmic calligraphic searches for the forms have similarities with those of Giacometti, inasmuch as the subject seems to emerge rather than be drawn. In an alternative idiom, the drawing is constructed with rough pen strokes that reveal the inner form. In the slate sculptures themselves one can deduce the influence of the Parthenon friezes. In some of his recent series of 'Stelae', Ubac has followed the example of the Doric column in dispensing with a base and allowing his seven-foot-high figures to rise directly out of the ground.

Marino Marini admits his debt to Antiquity. 'My nudes', he writes, 'seek to revive the tradition of Greek Classical sculpture, my portraits are founded on Etruscan and Roman art.' It should be noted, however, that in figures such as the 'Pomona' series he does not emulate the idealized Greek woman but – fittingly since Pomona was the Roman divinity of the fruit-tree – evokes a woman with obvious attributes of fertility. His *Venus genetrix* – modern version – with her creases and folds of flesh, shows a totally unclassical realism. Indeed the 'Pomona' series reminds one rather of Rubens-esque deities. Marini associates the sketch illustrated, entitled *Pomona Composition*, with the bronze *Pomona* in the Musée des Beaux-Arts, Brussels, which differs from it mainly in the leg stance. The oil sketch with the wide hips and short thighs suggests first and foremost the physical weight of the sculpture; the heavy left-hand contour detaches the figure statuesquely from the background. A feature of the drawing is the harlequin lozenge-pattern on the left leg, which would seem an arbitrary addition, were it not of such frequent occurrence in his many polychrome wood sculptures. Its effect is to distance the object from reality and to provide a decorative element which softens the rigidity of the carving.

There are parallels to be found in the treatment of the female torso by the Spanish-born sculptor Chillida and the naturalized French sculptor of Italian parentage Gilioli.

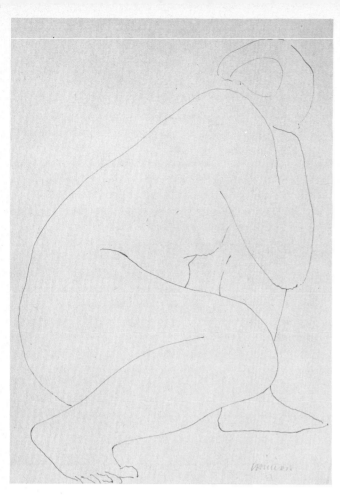

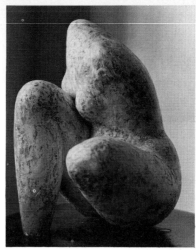

143 EDUARDO CHILLIDA Study for *Torso*

144 CHILLIDA Master cast of *Torso*

145 EMILE GILIOLI *The Sleeper* 1962

146 GILIOLI Drawing for *The Sleeper*

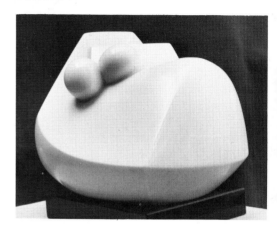

The pen-and-ink study of the former for *Torso* and the pencil study by the latter for *The Sleeper* both emphasize roundnesses and volume, which in turn characterize Chillida's master cast (plaster) and Gilioli's carving in Carrara marble. This early work by Chillida shows a classical derivation, and from it we could hardly have anticipated the wrought iron sculptures (such as *Modulation of Space*[6]) or his present highly individualized drawings, illustrated in Chapter 7 – though we know of the Spanish predilection for wrought and welded iron, exemplified in the work of Picasso, Gonzalez, Gargallo, etc. The sketch drawing for the *Torso* is executed in a sensitive line that indicates torsion (a Chillida characteristic) and volume.

Gilioli is fascinated by the interplay of curve and line, and his work becomes increasingly geometricized, though never totally divorced from a figurative origin. We see in a later example, *Babet*, that even his portraits are basically a synthesis of plane geometry in the Brancusi manner – but personal enough (412).

The torsos (plaster casts and definitive bronzes) by Raymond Mason, an English sculptor working in Paris, in contrast have the broken, light-catching surfaces we associate with Rodin, under whose sign we shall be placing a *Reclining Figure* by William Chattaway (180), likewise an English expatriate in Paris.

The carved stone *Double Torso* by Couturier, photographed in the Sigiku-Goyen garden, Tokyo, would seem to fall under the sign of Brancusi of *The Kiss* period rather than that of Maillol to whom Couturier was at one time assistant. Like *The Kiss* it is composed of two independent carvings standing side by side – in Couturier's case on a stone plinth. However, the notional distance from the declared subject reminds one more of a fetish seen in the Musée de l'Homme. The cheeks of the buttocks placed in a vertical plane, the breasts represented as a single unit, superbly placed in relationship to the straight spine and angled front, are a recognizable translation, or rather adaptation, of the lithographic chalk drawing which shows a completely closed contour, relieved only by the suggestion of dangling hair. In comparison the drawings relating to the *Three Graces* (described in Chapter 7) seem almost schematic, though the line itself is fluid and nervous.

Dodeigne, of Belgian origin, is a native of Bondues, not far from the quarries of stone called 'pierre de Soignies' or (erroneously) 'Belgian granite'. Dodeigne works alternately between carving and modelling for bronze. The intractable nature of the particular stone lends itself to broad treatment and to impressive, rugged shapes. 'Sculpture', he has said, 'is a combat, a battle with materials; with stone above all.'

Grouped as Dodeigne often arranges them, the shapes of his carvings can look like Titans on an ancient battlefield – primitive, menacing. Though they would not look out of place among the sarsens of Avebury, they are essentially anthropomorphic. Indeed, had the foreground torso the smooth surface of the same sculptor's bronze torso, one would be less surprised to know that he is a great admirer of Hellenic sculpture. His drawings – he is an obsessive draughtsman and works in intensive spurts between periods of modelling and sculpting – alternate between a classical modality and Nordic expressionism. The foreground study for the carved torso conveys a vision excited by the subject and translated in rapid, expressive strokes which, far from being notional, take us into the internal structure. The strong charcoal lines show the sculptor's preoccupation with the human form as a vehicle of vitality in repose. The fainter, smudgy lines evoke atmosphere, and also emphasize the modelling and help to set the figures in space. The drawing for the bronze has the tautness of the sculpture itself. One's eye is carried back through the foreshortened breasts and torso to the straddled thighs that are the salient feature of the smooth bronze.

147 ROBERT COUTURIER Drawing for *Double Torso* 1963

148 COUTURIER *Double Torso* 1963

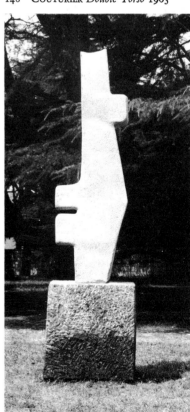

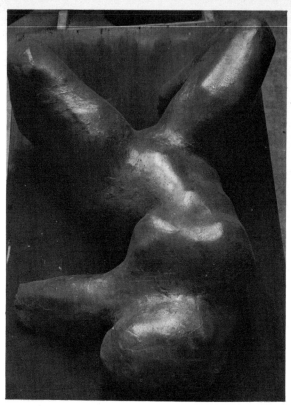

149 EUGÈNE DODEIGNE Drawing for bronze *Torso* 1965

150 DODEIGNE *Torso* 1967

151 DODEIGNE Drawing for carved stone *Torso* 1965

152 DODEIGNE *Torso*

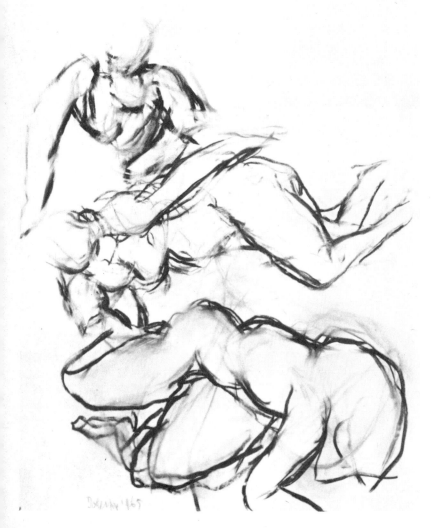

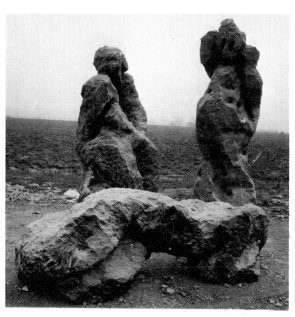

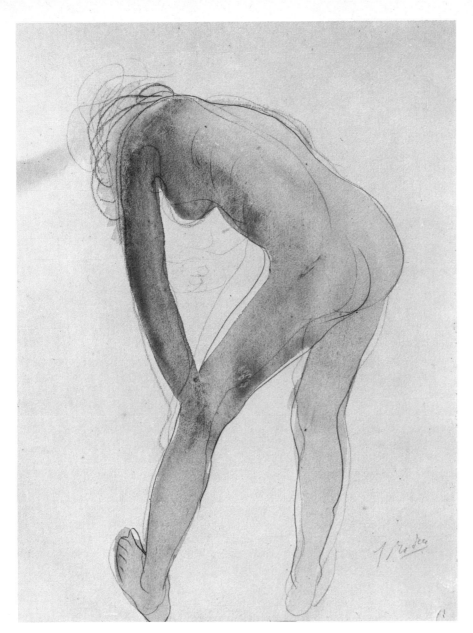

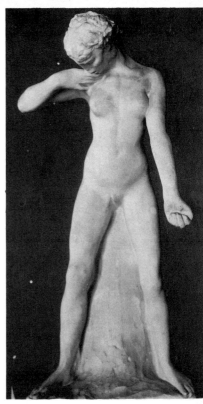

154 RODIN *The Faun*

153 AUGUSTE RODIN *Nude study*

Rodin's marble carving *The Faun* is one of the sculptor's most charming representations of a youthful nude. The proportions of body and limbs, the treatment of the breasts and above all the firm flesh evoke the *Esquiline Venus*. Rodin himself wrote that 'even the most beautiful Venus of Antiquity is less beautiful than our young girls'. Here the sculptor has found a happy and aesthetically satisfying solution to the problem of support for the legs (necessary both to offset the mechanical weakness of the ankles and to avoid a spindly appearance). The drawing reproduced, though done at a later period, represents a parallel to the sculpture. The pose is different, the mood the same. The medium of pencil and wash combined with pen and ink is characteristic of Rodin. The spontaneity and virtuosity is self-evident – the pencil 'pentimenti' even enhance the general effect. The angle of the left foot – noticeable in other Rodin drawings – seems to push the figure towards the viewer and avoid its identification with the picture plane. The wash shading emphasizes the volumes and planes of the

91

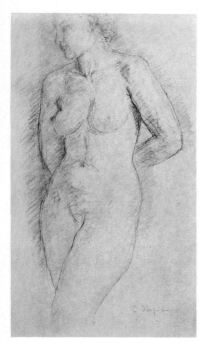

155 CHARLES DESPIAU Drawing for *Assia*

156 DESPIAU Model for *Assia, c.* 1938

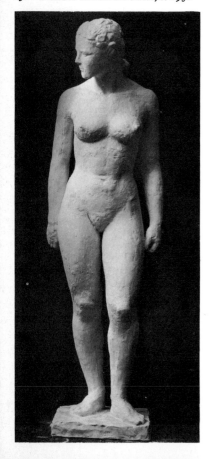

body and anchor it down. It should be compared with drawings by Rodin like the study opening Chapter 9 in which he is above all concerned with movement (349).

Charles Despiau, like Bourdelle, was a pupil of Rodin's and content to adhere to the classical mood in which we have just seen the master. Despiau's female nudes have affinities with the *Cnidian Venus*, said to be the first female nude in Greek sculpture. Although he is obviously attracted by the physical beauty of his mostly youthful nude girls, the figures are essentially portraits. In other words, the face and expression are of paramount importance, and give the modality to the whole sculpture or drawing. This may have been because for economic reasons he used models who were relations or friends, whose personalities were interesting and attractive to him. Nearly all these figures of Mediterranean proportions are characterized by their grave or serene composure. They are so natural and unselfconscious that the sculptor feels no need to have recourse to a 'Venus pudica' pose. Innocence is their only armour; sensuously attractive, they seem unaware of it. The pencil study illustrated is for the plaster model for *Assia*, from which the bronze in the Musée National d'Art Moderne, Paris, was made. The pose of the head and the facial features are identical with those of the sculpture. The lithographic quality of the pencil drawing reminds us that Despiau made a great many drawings in this medium for *livres d'artistes*, notably *Poèmes* by Baudelaire.

For Maillol the female form was a vehicle of infinite expressivity. There is the dynamism of *Action in Chains* (a monument at Puget-Thénier, near Grenoble, to the French socialist Blanqui), with the striding purposeful figure like Rodin's *Walking Man*, the provocative eroticism of the *Île de France*, the serenity of the *Young Woman Crouching* and *Venus with Necklace*. In the latter we see the reversal of the usual process – a feature (the necklace) added rather than eliminated in the final bronze, enabling us to see its importance to the sculpture as a whole. Maillol used two models. One, Lucile Passavant, herself a sculptor of considerable talent, appears as the nymph facing the two others in the Tate Gallery *Three Nymphs*, the other, Dina Vierny, already mentioned, posed for *Dina, or Harmony*, the *Monument to Claude Debussy* and many other works including the present example. The *sfumato* contours of Maillol's drawings emphasize the volumes and mould the forms. Unlike Despiau he is not interested in making a portrait. 'A head attracts me', he said, 'when I can build architecture out of it.' His drawings are architectural, static, in comparison with Rodin's which are vibrant with suggested movement. Here Maillol is concerned with the merging of smooth planes into each other and the play of light that results – as we see – on the polished surface of his kneeling figure.

The vitality of *Action in Chains*, completed 1908, is already inherent in the *Torso*, the bronze fragment of 1904–5 illustrated. The flesh is conveyed as soft but taut. The '*élan passionnel*' of Matisse's description is harnessed to a message of energy bursting its bonds. The model – said to be in this instance his wife – represents a more mature figure than Maillol's *Île de France* (in the Tuileries Gardens), whose pose is similar but informed with the exuberance of youth. For once the sculptor shows more than a care for the harmony of counterpoised smooth volumes, and there is a hint of Rodinesque musculature in the rib-cage.

Rodin's sensuous *Crouching Woman* has no real parallel among Classical examples, but the sculptor may well have had in mind Michelangelo's *Crouching Boy* in which the axis of the shoulders is likewise turned, though in the opposite plane, and where it is the opposite arm that stretches round the foot. Rodin's figure belongs to the period when he was in love with Camille, sister of the poet Paul Claudel. The drawing in sepia wash over pencil bears the same title as the bronze and conveys the same

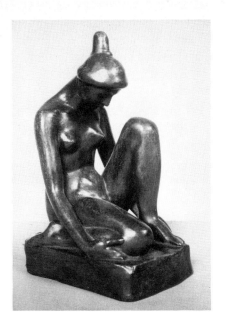

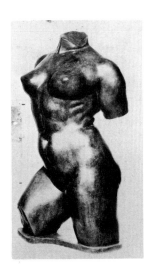

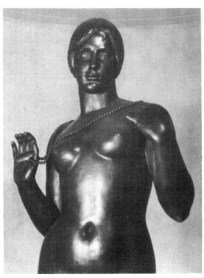

157 (top left) ARISTIDE MAILLOL *Young Woman Crouching* 1900

158 (above right) MAILLOL Study for *Young Woman Crouching*

159 (above) MAILLOL *Venus with Necklace* 1918

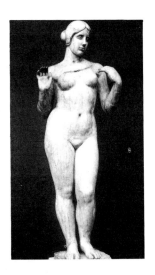

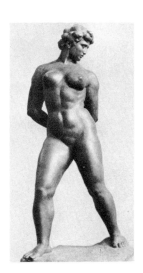

160 MAILLOL Model for *Venus with Necklace*

161 MAILLOL *Action in Chains* 1905–8

162 MAILLOL *Torso*, study for *Action in Chains* 1904–5

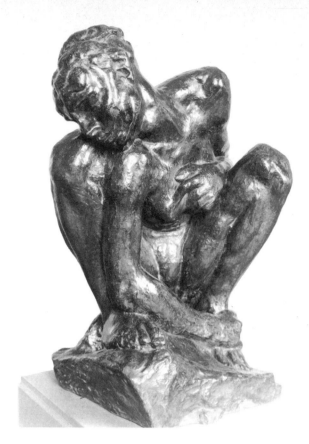

163 AUGUSTE RODIN Drawing for
Crouching Woman

164 RODIN *Crouching Woman,*
c. 1880–2

emotion, inner ecstasy. Aesthetically, it illustrates Rodin's observation about drawing: 'I try to see the figure as a mass, a volume. . . . That is why I sometimes wash a tint over the drawings. This completes the feeling of massiveness. . . .'

Giacometti moved a long way, technically and psychologically, from his master Bourdelle. Some of his early drawings of 1922–3 are within strictly classical canons and show an emphasis on plane ridges characteristic of certain Quattrocento drawings. Subsequent sculptural contributions, however, such as the well-known *Palace at 4 a.m.,* link him with both Surrealists and Constructivists. His most characteristic sculptures have more kinship with Cycladic dolls, or those elongated lead votive figurines dredged from the mud of the Seine. Pared down to spectral proportions, his bronze figures, solitary, withdrawn, are the very converse of Renaissance or Rodinesque assertion. Irrespective of scale, grotesquely tall or minuscule, these filiforms haunt us. The sculptor has forged an iconometric idiom of his own. By the skeletal diminution of the body, Giacometti focuses our attention on the head, to which our eyes are involuntarily drawn by the upper curve of the exaggerated feet. Hypnotized by the figure's own gaze, we follow the invisible vector of this *Standing Woman.* Sometimes – as in the figure opposite the large group in the open-air hall at the Fondation Maeght at St Paul de Vence – the gaze leads us to other figures that stand like ghostly witnesses.

The characteristic drawing reproduced, *Triptych,* has a figure at the left related to the *Figurine on a Pedestal.* The spatial cube is the graphic equivalent of the wire frame Giacometti sometimes used for delimiting an area of space around a bronze and incorporating it in the sculpture. The chalk or soft pencil has moved over the paper surface almost without being lifted, and the resulting drawing shares the hypnotic intensity of the sculpture. The head of the central figure is an obvious study for one

94

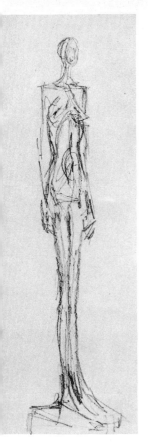
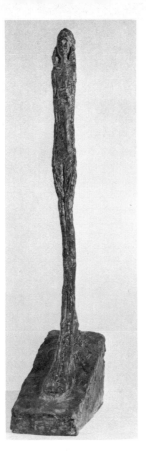
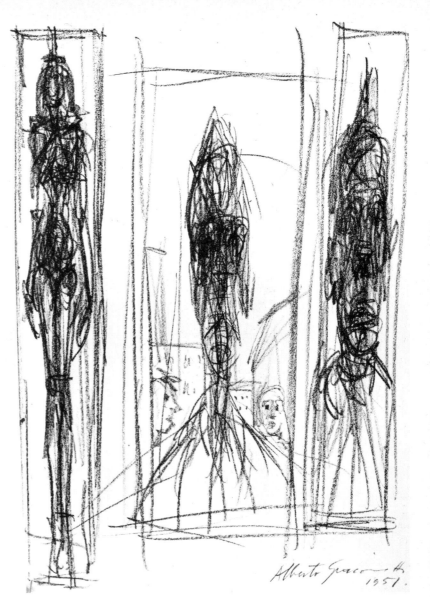

165 ALBERTO GIACOMETTI *Large Figurine* 1960

166 GIACOMETTI *Figurine on a Pedestal* 1959

167 GIACOMETTI *Triptych* 1951

of the many portraits of Giacometti's brother Diego, which we shall be considering in the chapter on heads and portraits.

Among classicizing figures, those of Emilio Greco claim attention for the high quality of the related drawings as well as the sculpture. He is an outstanding draughtsman. Like Cézanne and Renoir, Greco has been fascinated by the subject of the 'Bather' and has made seven major versions to date, including *La grande Bagnante*, illustrated, which was a centre-piece at the Venice Biennale of 1956 and won him the Prize for Sculpture. Greco has evolved an original form of drawing technique, immediately identifiable, and yet related to the hatching of pen strokes we have seen in Michelangelo. As in his sculpture, he bridges the period from classical tradition to sophisticated modernity as perhaps only an Italian artist could. The drawing for *La grande Bagnante* is typical; it shows his characteristic sparing use of contour, the creation of notional modelling by the strong contrasts of hatched lines against whole blank areas of white, and the short statements of the left hand and right cheek. One notes the attention to formal qualities in the linear connectives – the right hand and the arms

95

form a satisfying but not obtrusive triangle, softened by the curves of the right shoulder and hips.

This sportive, elegant girl belongs to the second half of the twentieth century, yet there are faint echoes of Bernini, of whose work Greco made an honourable exception to his general distaste for 'gesticulating figures' of the Baroque. There is, for example, a parallel to Bernini's *Rape of Proserpine*, where the pressure of Apollo's hand is visible on the thigh of the pursued, in the way the soft flesh of *La Bagnante* is squeezed by the token *cache-sexe*. The facial expression is enigmatic, reminiscent of Canova in its serenity. The Italian critic Daniele Grassi refers to 'the Leonardesque smile of Greco's women who are almost all surprised in their journey through a mysterious adolescence'. The faces of his young women are evocative in a Proustian way; they are neither impersonal nor, compared with Despiau's, personal, but rather a sophisticated type. The carefully styled and stylized hair adds to this impression of graceful eroticism, achieved in the drawing by the greatest sobriety of means.

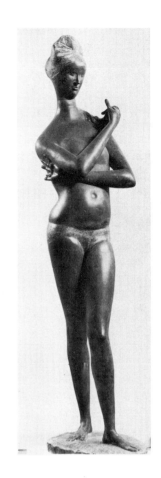

Renaissance and Baroque sculptors, though fascinated by rivers and fountains and the deities associated with them, feared the power of the sea. For Henri Laurens, who made the sea's acquaintance late in life, it was as a friendly domain inhabited by mermaids and 'oceanides', its shores haunted by the 'fisher-girls' who figure so frequently in his maquettes and larger sculptures. This *Fisher-girl*, a bronze of 1939, seems, like so many creations by this imaginative sculptor, to be in a state of metamorphosis.

Whereas Greco constructs with his economical hatching and penstrokes of ranging width and closeness, Laurens' drawing is characterized by the spontaneous fluidity of line, the summary treatment of the terminal points – hands, feet, hair – as if they were parts of an inspired child's notional conventions. The number of pencil strokes is minimal and we can guess their sequence. The sketch anticipates the open nature of the bronze inasmuch as the spaces enclosed by the arms and the space outside are as important as the lines. The main modification in the sculpture is that the convex curve of the thigh has become the sculpturally more effective concave vestigial leg. Like almost all Laurens' smaller figures, it is an example of wit in three dimensions, as the drawing is in two.

168 (left) EMILIO GRECO
Drawing for *La grande Bagnante*
1956

169 (above right) GRECO
La grande Bagnante 1956

170 HENRI LAURENS Sketch
for *Fisher-girl* 1939

171 LAURENS *Fisher-girl* 1939

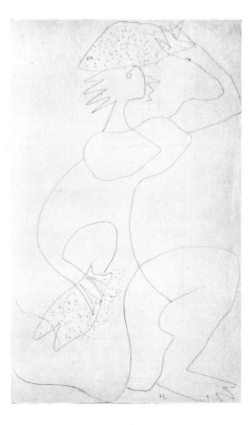

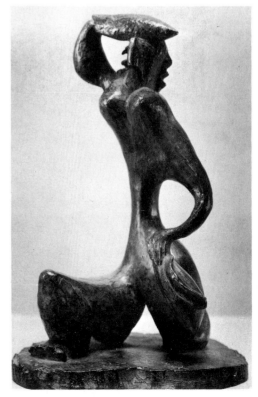

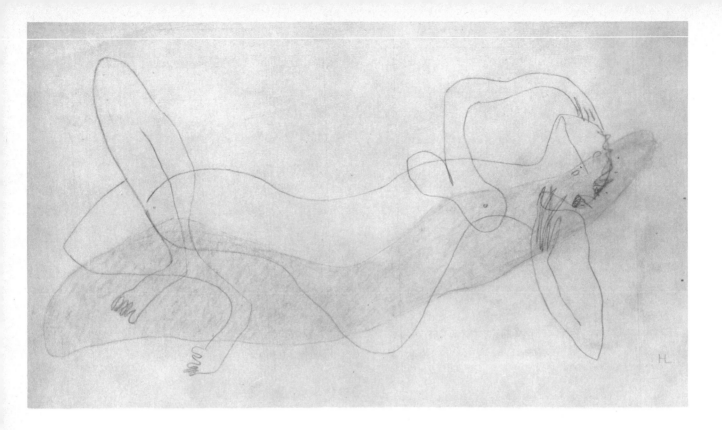

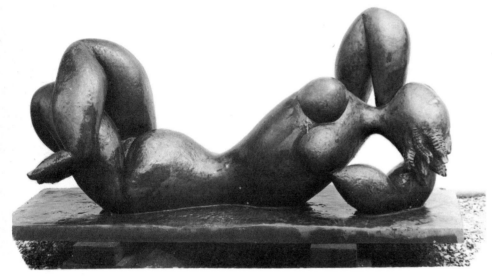

172 LAURENS Sketch for *Reclining Woman*

173 LAURENS *Autumn* 1948

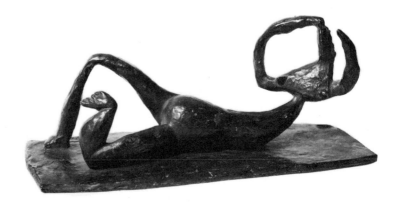

174 LAURENS *Reclining Woman with Raised Arms* 1950

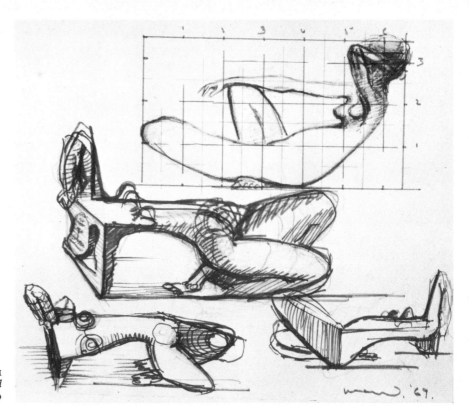

175 F. E. McWilliam
Studies for *Girl with Raised
Arm* 1969

Laurens' *Autumn* belongs to the same phase, and I have chosen it particularly for comparison with a sculpture by McWilliam on a similar theme. Whereas the Laurens bronze form is conceived as an interplay of rotundities like ripe fruit, McWilliam's *Girl with Raised Arm* is based on geometric shapes relieved by curves. The Laurens reminds us of his statement: 'I aspire to a ripening of forms, rendering them so full, so juicy that nothing can be added.' McWilliam is conducting an experiment between flat and three-dimensional forms – using a kind of half-way language between drawing and sculpture-in-the-round that he has invented. The Laurens sketch can be linked with both the *Autumn* and the *Reclining Woman with Raised Arms*. It combines the two poses – the thrown-back head and figure propped on left elbow of *Autumn* and the thin legs and curved right arm of the open form of *Reclining Woman*.

Laurens never thought of his drawings as blue-prints for his sculpture. He drew for sheer pleasure in the activity and only incidentally as exploration of ideas; yet the two thematically related drawings help us to an understanding of his sculpture.

He made a practice of doing small versions of subjects in bronze to be enlarged and modified subsequently. The *Little Musician* was to become the *Large Musician* – five times as high. The simplifications of form are a feature of these larger syntheses, as in

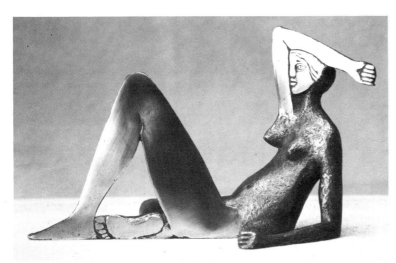

176 McWilliam *Girl with Raised Arm*

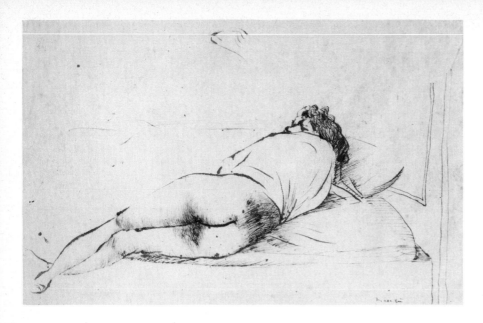

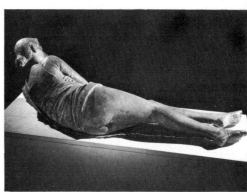

177 GIACOMO MANZÙ *Reclining Figure*, study for *Susanna*, 1937

178 MANZÙ *Susanna* 1942–52

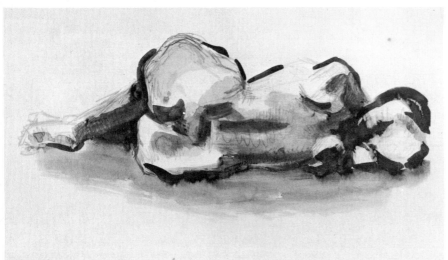

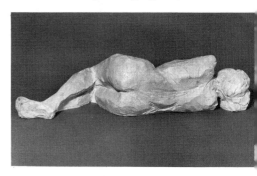

179 WILLIAM CHATTAWAY Study of *Reclining Figure*

180 CHATTAWAY *Reclining Figure* 1962

the large and small *Fisher-girl*, and similar versions of *Sirens* and *Oceanides*. Sometimes one feels closer to the creative impulse and certainly to the sculptor's playful mood in the smaller bronzes (in the way one feels closer, say, to Constable in the sketch for the *Leaping Horse* than in the final, Academy version).

The phase of McWilliam's work represented by *Girl with Raised Arm* called for many drawings, done as usual in his sketch-book with any instrument that came to hand – in this case a sepia felt-pen. The flat surface and contrasting three-dimensional parts are clearly shown; the pose of the bronze is a synthesis of several sketches. The squared-up drawing is nearest to the raised arm, breasts, torso and curve of the right thigh of the final sculpture. They are contained in a rectangle of near golden-section proportions. There could scarcely be a greater contrast between this drawing and Laurens' version of the identical subject.

Another contrast of treatment of the recumbent female figure is provided by the work of Manzù and William Chattaway, an English sculptor working in Paris. In the *Susanna* by Manzù the planes merge smoothly into one another, while Chattaway's *Reclining Figure* is viewed almost as stereometric volume with shed-ridges marking the

100

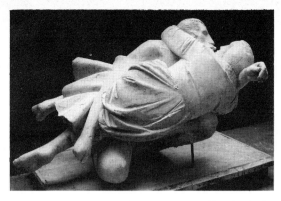

181 GIACOMO MANZÙ *The Lovers*
1968

changes of plane. This defining function Manzù leaves to the drapery, with only slight indications in the sketch. The pose of the limbs in the sketch is carefully repeated in the bronze. The drawing technique is typical of Manzù's earlier manner, combining a broken contour with shading at right angles to the form but following the curved planes.

Chattaway's drawings are of two kinds – the first represent a search for the general volumetric effect (that is, a concentration on the internal modelling), and the second, detailed objective study. The former type is usually in ink, often with the addition of wash, the latter in pencil. Chattaway works slowly on sculpture, continually renewing himself by drawing from life and the object. He is an admirer of Rodin and the fragment; he has produced bronze torsos in which the back and vertebrae become a most eloquent instrument of expression. As in the bronze reproduced he models with a spatula, and the drawing reflects this technique.

Though the sculptural languages of Manzù, Ipoustéguy and Reg Butler differ strongly, their drawings offer enough similarities to justify grouping them together under the present thematic heading. The sketch drawing by Manzù for *The Lovers* is in a different style from that for the *Susanna* of thirty years before. The hard pen line has been replaced by soft pastel-like pencil shading and the draughtsmanship is more refined, assured and experienced. It is a study for a detail of the drapery (reversed in

182 MANZÙ Study for *The Lovers*
1966

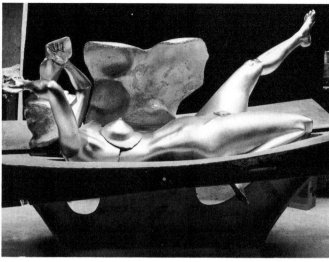

183 (left) JEAN-ROBERT IPOUSTÉGUY Study for *Woman in the Bath* 1969

184 (above) IPOUSTÉGUY *Woman in the Bath*

the plaster model), whose folds Manzù has resolved with masterly simplicity. The rest of the study situates the figure, in a few exquisite lines.

Sculptors tend to have 'key' pieces – several works illustrated in this book have been so described by the sculptors themselves. The term can indicate a technical breakthrough, or the exploitation of a new inspiration, which, as we shall see in the next chapter, can result in a thematic obsession. One such is Ipoustéguy's *Woman in the Bath*, a constructed form in bronze, cast from polystyrene segments, of great simplicity. The upper portion represents a kind of folding lid, suggestive of an astronaut's decompression chamber, and the whole figure is let into the metal bath. One leg is immersed and bent under, the other raised in the air. The arms, too, are raised, with one hand against the forehead. The study of the thorax and raised arm is a working drawing, as opposed to the many Ipoustéguy anatomical studies (comparable in subject and technique to Barbara Hepworth's series of drawings of hospital scenes, surgeons' gloved hands etc.). These enlighten us about this sculptor's scrupulous attention to vocabulary in the service of highly original sculptural ideas.

Reg Butler has long abandoned the conceptual language of his earlier period and developed the more figurative themes associated with *Girl in Space*. The distortions are there, but modified.

The female form with the raised head has always been one of his avowed obsessions, and in this bronze, *Stooping Nude*, it is interpreted in a novel way. First there is a

realism, new for him, in details such as the simulation of hair, the nipples, and in the careful treatment of the veins, for example in the feet. The naturalism in detail helps the spectator to accept the exaggerated but formally satisfying postures of the nude figures. He has coloured the surface, not to imitate flesh, but to obtain a paler shade than is possible in bronze, and to get rid of the otherwise inescapable sense of its weight. More important, of course, are the plastic qualities of this stooping figure. The studies for it show Butler's interest in the taut round buttocks, set off by the straight back. The first study is a detail of the buttocks – note the indications of proportion in the horizontal line. The drawing brings out the beauty of the soft form flowing from the back, which could be the neck of an amphora. Indeed this interest in the presentation of soft but firm form is an aspect of Butler's latest phase which offers a parallel to that of the *Help* series by Bernard Meadows. The second study of the whole stooping figure is only one of a number of explorations. Here, as so often, Butler is fascinated by the veiled form, observable for example in several versions of *Girl removing Vest*. Butler began as an architect, and this influence can be detected in his attention to the spatial planes in which his figures are placed; but these studies could not be mistaken for anything but a sculptor's work. The whole emphasis is on the internal form, to which he leads the eye with every graphic device. Butler seems incapable of executing even the most rapid study that is not *per se* an autonomous work of art.

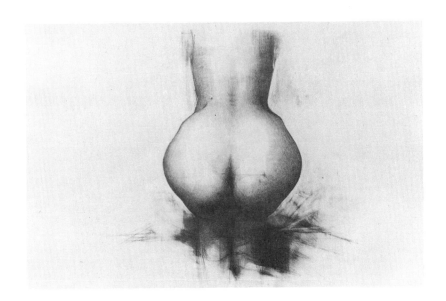

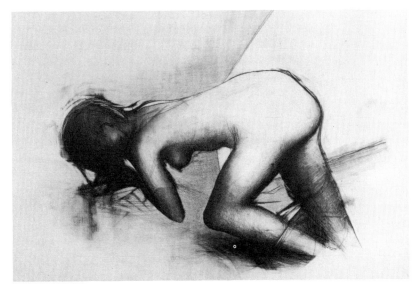

185 REG BUTLER *Stooping Nude* 1969–70

186–7 BUTLER Studies for *Stooping Nude*

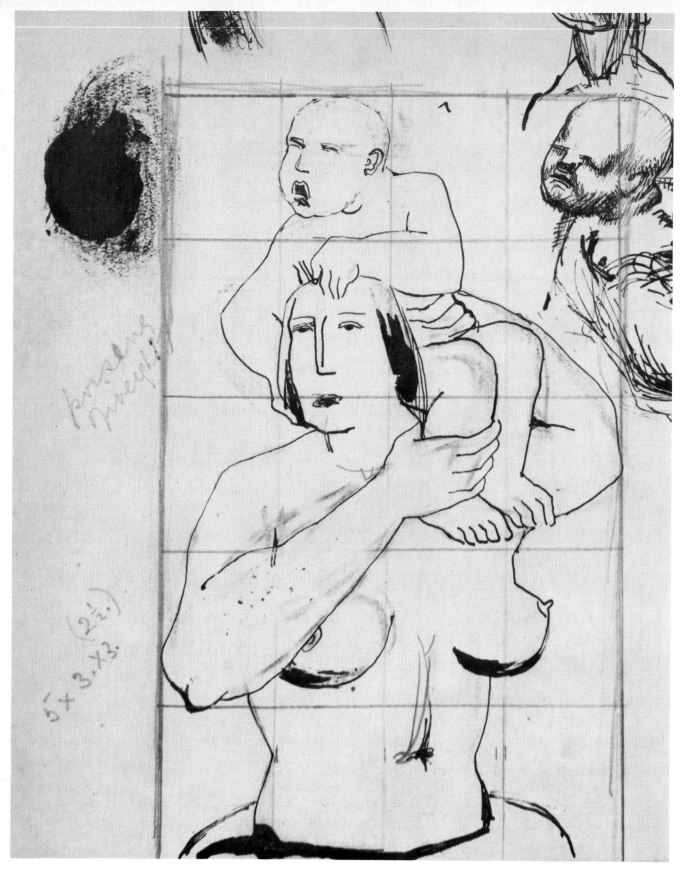

188 HENRY MOORE Page from sketchbook—studies for *Mother and Child* 1925

5 Thematic and formal obsessions

Sculpture must have its own life.
HENRY MOORE

More significant than technical links with the classical or Renaissance tradition – which, as we have seen, did not die with Rodin or Bourdelle – is the modern attitude towards 'subject' sculpture. With a few exceptions, classical or biblical subjects have rarely inspired impressive works in the twentieth century, though they still continue to provide allusive titles (for example Lynn Chadwick's *Elecktra*, Nakian's *Mars and Venus*, Ipoustéguy's *David and Goliath*, Berrocal's *David*), not invariably divorced from subject suggestion. Fundamentally, however, the interest is elsewhere – namely in the formal treatment. In fact Bourdelle, no less than Brancusi under whose sign some sculptors I am dealing with have predominantly worked, believed that sculpture had value uniquely as the result of the planes governing its effects.

In the first quarter of this century sculpture was influenced by Cubism and Surrealism, witness the early works of Giacometti, Lipchitz, Henri Laurens and Zadkine. Tied up with the former movement was the 'discovery' of primitive art (Mexican, Cycladic, African, etc.) mostly seen – as in the case of Moore, Modigliani, Arp, Couturier and Brancusi – in the ethnological departments of the British Museum or the Musée de l'Homme in Paris. The range of themes opened up was infinitely wider than that available to Rodin, whose inspiration was for the most part Classical or Gothic. Gulfs widened between masters and their pupils, and between the pupils themselves – like those that separated, say, Giacometti, Germaine Richier and Hajdu from one another, as well as from their teacher, Bourdelle; or, similarly, Brancusi from Henri Laurens – the latter having broken away from Rodin as Couturier was to break away from his master Maillol, whom he nevertheless continued to admire. The classical schema was supplanted by new conceptual frameworks, each sculptor evolving his own.

189 MOORE *Mother and Child* 1924–5

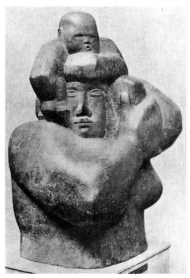

MOTHER AND CHILD

Before moving into a rather twilight world where the influences at work were not always satisfactorily resolved, we should pause on a subject, that of mother and child, whose universality links Henry Moore with Michelangelo, and, in turn, Baltasar Lobo with Moore.

It is doubtful whether Henry Moore's obsession with the mother and child idea[7] would have taken the form of a Madonna and Child had the subject not been a challenging commission. The enlightened patron, Canon Hussey, then rector of the Church of St Matthew, Northampton, knew that despite the limitations imposed by the nature of the building, he could be sure of an original interpretation that would

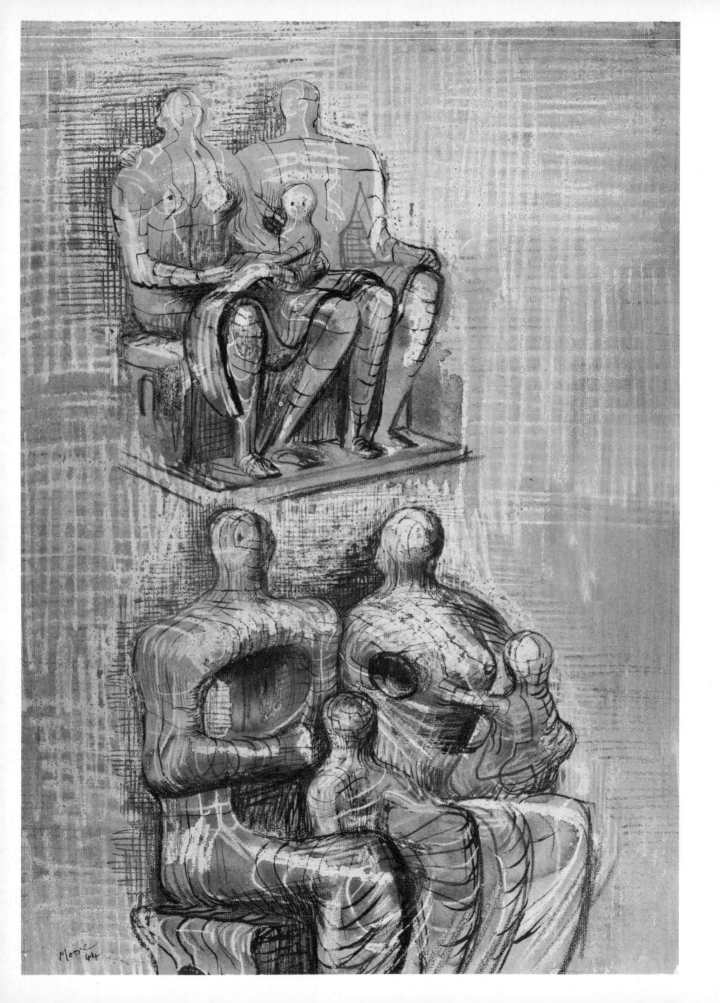

not offend worshippers. Two things immediately strike the viewer: first, the treatment of the Child's head, which owes almost its whole expressivity to formal qualities and makes no concessions to sentimentality; and second, the unusual degree of facial expression in the tender aspect of the Madonna – unusual, that is, for Moore. The sweeping folds of the drapery are characteristically simplified in an idiom that persisted in Moore's work up to and including the *Three Standing Figures* of 1947–8, and should be compared with that – more classical – of the Time-Life *Recumbent Form* of 1957 and *Draped Torso* of 1952–3.

There is a starker element in the earlier *Mother and Child* illustrated (189), which dates back to 1924–5. It is a landmark in Moore's work, being his first use of a block of stone (Green Hornton) ordered to specific dimensions (as indicated in the squared-up drawing). Until that time, for economic reasons, Moore had simply relied on odd blocks of stone obtained from masons' yards.

His method of working from the drawing is similar to Michelangelo's – that is, cutting into the stone from the frontal plane. (Michelangelo transferred a scaled-up sketch on to the face of the marble on which he was going to carve, see pp. 29, 31.) Moore's pen and pencil contour drawing with a hint of tonal shading has an additional interest in its margin note about 'poising of weight'.[8] The strong form is conceived as a series of flat planes, for the most part at right angles to each other, in a solid block that recalls the stone-carvings of Egypt and Mexico. It is a far cry from his virtuoso copy in marble of the *Head of the Virgin* by Domenico Rosselli, which had attracted him in 1922 – an early indication of the ease with which Moore moves between varied modalities. Even on this single theme of mother and child there is a world of difference between Moore's brooding stone *Mother and Child* of 1924–5 and an aggressive seated bronze of 1953, where a serpent-like child seems to be devouring the mother.

Moore's projects usually take their point of departure from a 'find', such as a pebble, bone, or rock – even the cliffs of Etretat, or from an event or situation in his private life. The family groups – the one carved in Hadene stone for Harlow New Town, Essex (1955) and the bronze for Barclay School, Stevenage, Herts (1948–9) – were

190 (opposite) MOORE Page from sketchbook—studies for *Family Groups* 1944

191 (below left) MOORE *Family Group*, maquette for Harlow piece

192 (below right) MOORE *Family Group* 1955

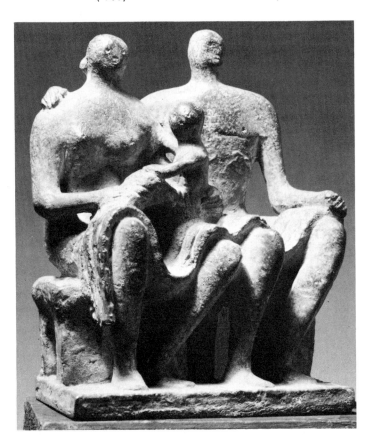

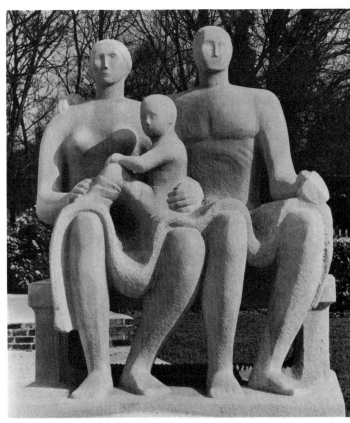

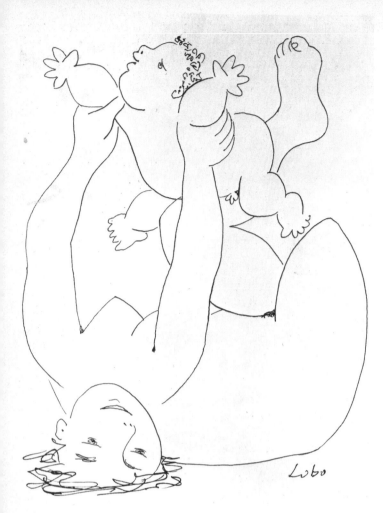

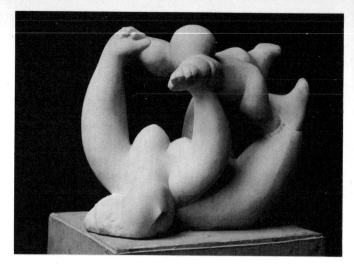

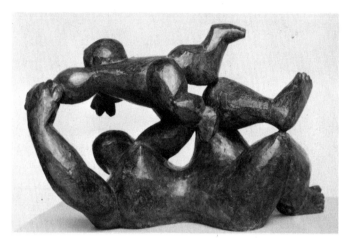

193 BALTASAR LOBO Sketch for marble *Mother and Child, c.* 1949

194 LOBO *Mother and Child* 1953 (marble)

195 LOBO *Mother and Child* 1949–50 (bronze)

carved in the period shortly before and following the birth of his daughter. During this time he made many studies, mostly in chinagraph chalk, pen and watercolour. The example illustrated is the nearest to the Harlow group, and is followed closely in both the terracotta maquette and final carving. The angle of the child's head – and therefore of the vectors of its gaze – has been modified in the sculpture, increasing the dignity of the group. The lower drawing on the same sketch-book page shows a version in which the male figure (rare in Moore sculpture) has the chest pierced by a rectangular hole. In both drawings Moore is using lines to show internal plane directions, here as in the *Shelter* drawings of a few years before adding a textural quality, while the stronger ink-lines emphasize the important rhythms of the drapery over the opposing columns of the legs.

The two sculptures share the same serenity. The unity of the family is expressed in the symbolic interlocking of the three figures. Facial features, hardly more than hinted at in the smooth bronze, are summarily indicated in the carving. The gaze of the parents is significantly turned outwards – towards the community – in the Harlow sculpture, whereas in the Barclay bronze – fittingly in a subject for a school – the focus of the group is the child.

Lobo's obsession with the mother and child theme goes back to his first *Maternity* of 1945. In 1970 a whole exhibition was devoted to his carvings and bronzes showing variations on the subject. Technically – as in the examples shown – he moves between

108

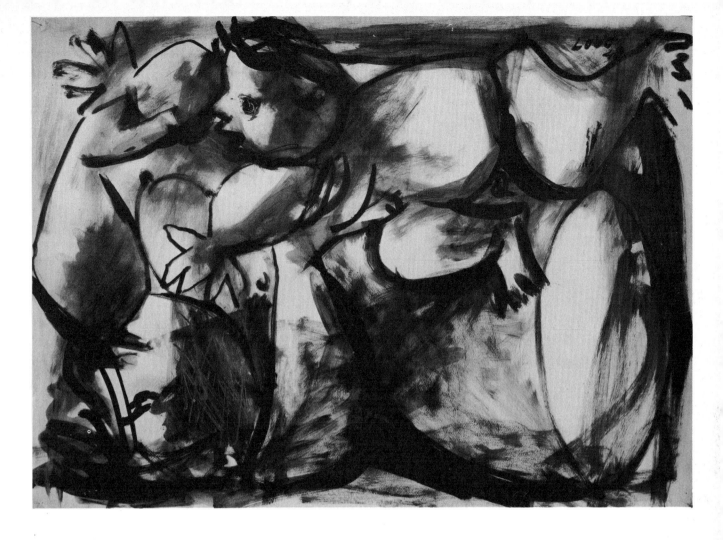

the poles of Brancusi and Henri Laurens, with the simplified syntheses of the former (*Mother and Child*, 1953), and the counterpoint of ovoid and sometimes vestigial shapes we associate with the bronzes of the latter (*Maternity*, 1950). The exuberance of these works Lobo associates with his feeling of relief after first the end of the Spanish Civil War, and later the end of the German occupation of France. 'The blood must return and pulsate in my marble,' he writes, 'and wrench them from their prison.' The subject is universal and sympathetic, but it is the compositional rhythms that give these interlocking figures their distinction. Their caressable roundnesses appeal to the fingertips and hands. '*J'aime beaucoup les ventres*' – 'I love the female belly', he wrote. Lobo has carved a remarkable number of female torsos – another of his obsessions – and his animal syntheses rival Brancusi's. He draws a great deal – sometimes diminutive sketch line-drawings reminiscent of Oldenburg's – sometimes wash drawings, when he wants to emphasize the volumetric potential of his subject. The examples shown relate to the marble carving and the bronze respectively. The flattening of the woman's head is a feature of the drawing for the carving; the pose of the child is similar in both wash drawing and bronze. They are good instances of the elimination of the accidental in sculpture and the successful anchoring of twin forms.

Lobo's preparatory *modelli* throw complementary light on stages towards his definitive bronzes, as exemplified in the plaster cast shown – partly sculpted – of 1950, for a bronze of the same year.

196 LOBO Drawing for bronze *Mother and Child* 1949

197 LOBO *Woman and Child*, model for *Maternity* 1950

198 LOBO *Maternity* 1950

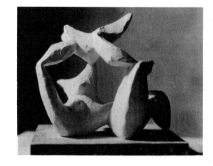

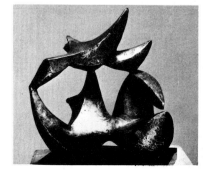

A reclining figure can recline on any surface. It is free and stable and fits in with my belief that sculpture should be permanent and last for eternity.

HENRY MOORE

For half a century Moore's recumbent female figures have been his most important and frequently recurring theme. His variations have rarely even approximated to the idealized forms associated with ancient Greece, or Renaissance or Neoclassic Italy. 'Beauty, in the later Greek or Renaissance sense, is not the aim of my expression.' But this is not to deny classical influence. One can say that if in his early years Moore was most impressed by the Aztec 'Chacmool'[9] river-god pose with its curving female-shaped thigh (as in his brown Hornton stone *Reclining Figure* of 1929, a key work now in the Leeds Art Gallery), the *Dartington Hall Memorial Figure* of 1945, on the other hand, has the more static serenity we associate with the draped reclining figures of the Parthenon frieze. Subsequently, of course, Moore broke further and further away from the representational, especially in his two- and three-piece recumbent figures which combine vaguely feminine form with elements of natural background – gentle hills or rising cliffs.

The Cranbrook elmwood *Reclining Figure*, another key work in the understanding of Moore's recumbent figures, belongs to the same year as the Dartington Hall figure, 1945. It was the outcome of a new idea – a figure within a semi-open form, the foetus within the womb, rendered in terms of simplified shapes and volumes in which internal spaces assume a positive role in the total work.

Every great artist has 'constants' which stamp his personality on each work he produces, and, despite the differences of purpose and technique that separate these two carvings, we are struck by the basic pose – the leaning on the forearm, the angle of the neck and head, and above all, the rising thigh, the female counterpart of the pose of the famous Ilissus in the pediment of the Parthenon, or of the model by Michelangelo for a river god in the Accademia, Florence. One can, indeed, link the two Moore sculptures with the draped female figures of the Parthenon, but at the same time we are aware of a new dynamism – not movement as Rodin thinks of it, but energy latent in the rising thigh, and, in the Cranbrook elmwood figure, enhanced by the cavern-like hollows that take away any feeling of dead weight.

The drawings date from 1942, and although the top sketch was obviously the one to develop sculpturally, Henry Moore himself prefers the lower drawing as being more vigorous and stronger in contrasted shapes. They are in the familiar mixed media of chalk, crayon, pen and wash. The general conception can be related to a sketch-book page of 1935–6 entitled *Ideas for sculpture – reclining figures*. 'Sometimes I may scribble doodles in a notebook,' Moore writes, 'and within my mind they may become a reclining figure ... then perhaps at a certain stage the idea crystallises ... drawing is a means of finding your way about things and of experiencing more quickly than sculpture allows.'

The point of crystallization of two other variations on the reclining figure are also to be seen on the sketch-book pages. The final realization of the bronze *Reclining Figure* commissioned by the Arts Council for the Festival of Britain in 1951 resulted from an idea maturing in the sculptor's mind since 1939, as the page of sketches demonstrates. The idea to be developed is most clearly shown in the centre of the

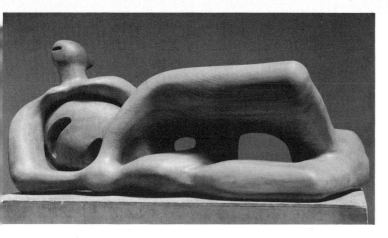

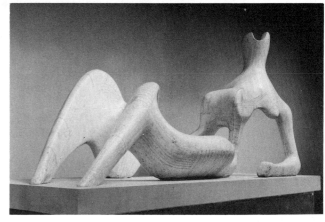

199 HENRY MOORE Cranbrook *Reclining Figure* 1945

200 MOORE *Reclining Figure* 1951

201 MOORE *Ideas for wood carving* 1942

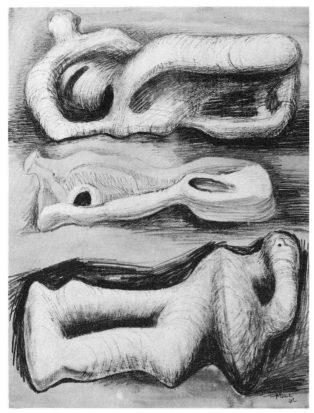

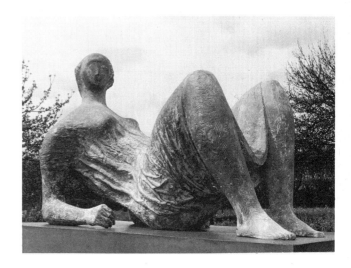

202 MOORE *Draped Reclining Figure* 1952–3

203 MOORE *Ideas for sculpture—reclining figures* 1939

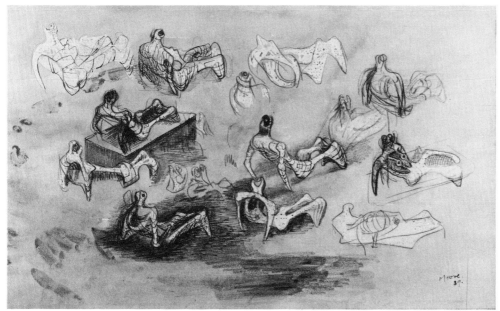

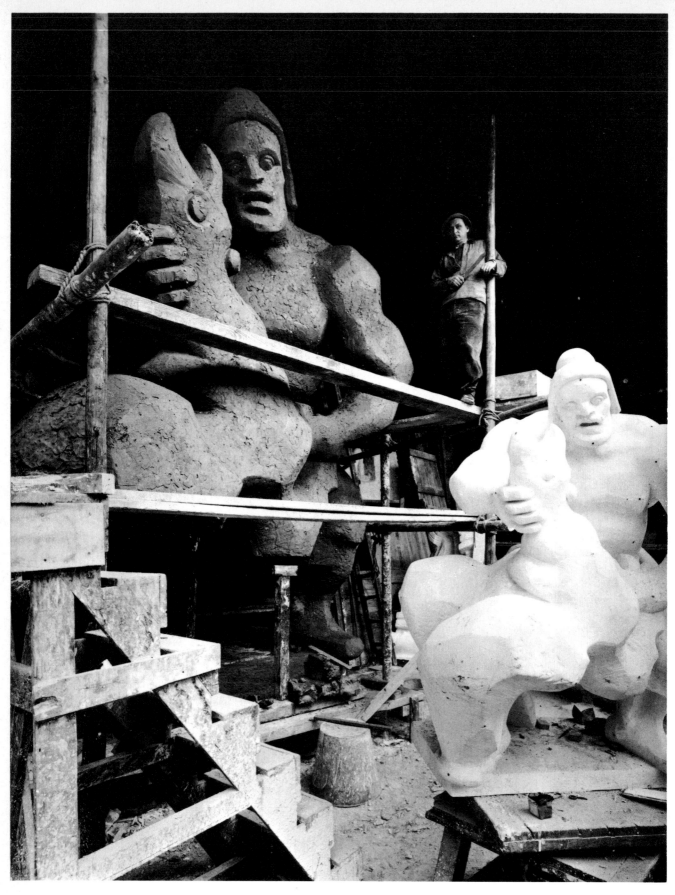

204 JACQUES LIPCHITZ Working model and plaster for *Prometheus*

sheet, and on the left it is significantly raised on a pedestal. It is an early example of Moore's use of the chinagraph (greasy) chalk method, which allows a colour wash to be passed over the chalk without being absorbed. The small specks of colour where the chalk has not wholly covered the paper lend an attractive texture to the drawings.

The chief modification of the initial idea is in the treatment of the forearm and the distortion, in the interest of spatial shape, of the breast. The directional lines that indicate changes of plane on the drawings become interesting surface decoration on the sculpture. These emerge more clearly on the plaster model and indicate their contribution to the rhythm of the figure. The reader will also notice a relationship between these drawings and the Time-Life *Draped Reclining Figure* of 1952-3 (202). The basic shape is the same.

SUBJECT SYMBOLISM

Among the sculptors inspired by Cubism – from whose limitations they were later to escape – were Henri Laurens, Jacques Lipchitz and Ossip Zadkine. Paradoxically enough, in exploiting the simultaneous viewpoint of cubist painting they tended to desert the essentials of three-dimensional sculpture, and their work is nearer to reliefs or frontal artifacts. Perhaps to compensate for this they indulged in surface decoration and semi-surrealist anatomical dislocation. They introduced guitars, mandolins, architectural scrolls and volutes, recognizably imitative of cubist painting. These experiments were a stage in their evolution towards personal idioms, and are mentioned now not because of their historic importance but because in some of the artists' subsequent work we can discern unmistakable traces of the cubist revolution.

Lipchitz moved from the austerity of such bronzes as the *Head* of 1955-6 and the frontal cubism of the *Guitar Player* to the more open sculpture of *Pastorals*. On the way he seemed to make a volte-face towards 'subject' sculpture, exemplified in the *Prometheus* and *Europa and the Bull* (1942); and indeed, to the last he was far from repudiating the notion that moral meanings should not be wholly divorced from aesthetic considerations. Without going into the Tolstoyan 'art and moral purpose' controversy, it is not without significance that Lipchitz, though Russian born, must during his long period in Paris have become steeped in the tradition that has always adapted Classical mythology to its own purposes. Its symbolism in plays by Cocteau, Giraudoux, Camus and others poses no problems to contemporary French audiences, and similar themes chosen by this sculptor carried a valid message over and above their sculptural – that is, formal – qualities. Lipchitz's *Prometheus*, for example, symbolizes man's endless struggle against bestiality, represented by the vulture. The defiant hero, it will be remarked, wears the Phrygian bonnet. The vast plaster model (nearly twenty feet high) stood in front of the Palais de la Découverte during the Paris World Exhibition of 1937, but it was destroyed by the Germans during the Occupation. Fortunately a photograph survives of the full-scale model and the vast wooden armature, and there are smaller versions, such as the first plaster study for *Prometheus*, illustrated. Like Picasso's *Guernica* and Goya's *Disasters of War*, it belongs to the works of art of protest that will survive by virtue of their artistic validity.

The pencil sketches and wash drawings show phases of the work's development. The back view of the Prometheus single figure reminds us of Daumier's vibrant lines suggesting frenzied movement. The profile study corresponds to the pose retained in the small bronze, but modified in the plaster model in order to produce a more interesting interior spatial shape.

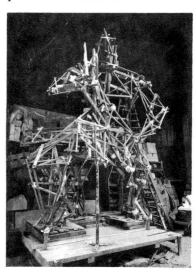

205 LIPCHITZ Armature for the plaster model of *Prometheus*

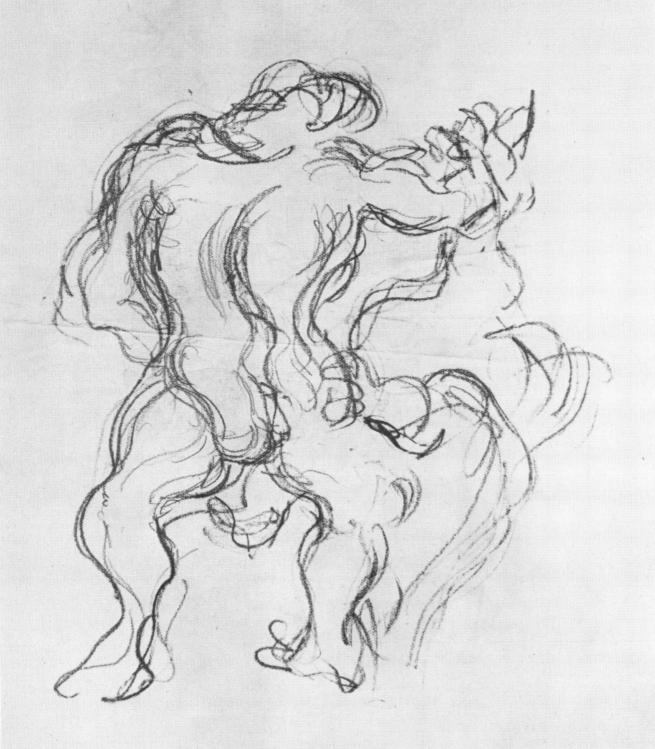

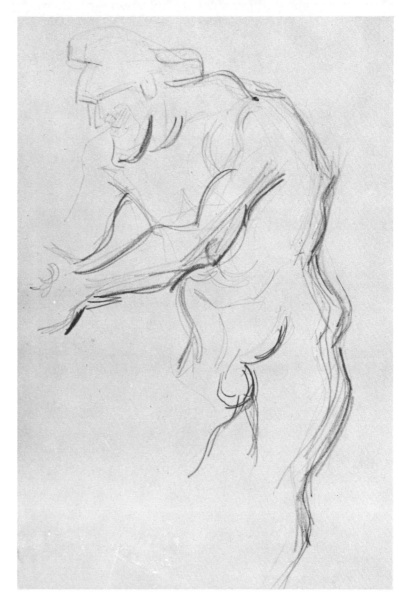

206–7 JACQUES LIPCHITZ Studies for *Prometheus*
(*see also III, p. 83*)

208 LIPCHITZ First model for *Prometheus* 1936

209 LIPCHITZ *Prometheus*

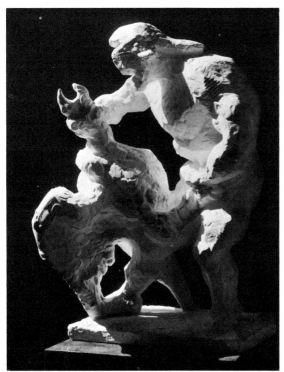

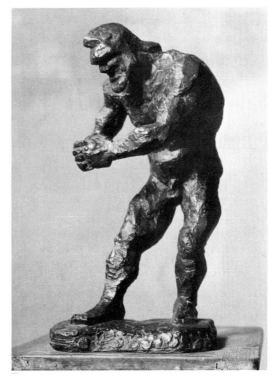

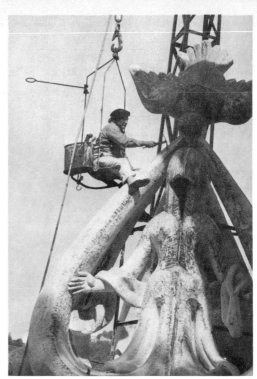

210 JACQUES LIPCHITZ Maquette for
Between Heaven and Earth 1958

211 LIPCHITZ The sculptor at work
on the plaster for *Peace on Earth*
(*Between Heaven and Earth*) 1957

212 JACQUES LIPCHITZ Study for
Between Heaven and Earth 1958

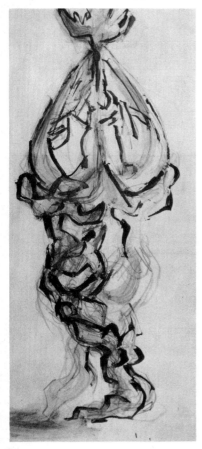

The colossal bronze by Lipchitz commissioned for the Performing Arts Center, Los Angeles, and erected in 1960, is an example of what the sculptor used to call his 'transparences' (inner rhythms and the integration of space being a major preoccupation of that period); however the work is rightly considered under the present heading of 'subject symbolism' rather than under 'open forms', since (as reported to me by his brother) Lipchitz undertook this symbolic celebration of *Peace on Earth* only because he believed peace truly to be assured after World War II. The work was one of his most ambitious undertakings. A photograph shows the seventy-year-old sculptor suspended in a builder's cradle high in the air at work on the plaster model (the sculpture's alternative title was *Between Heaven and Earth*). As hinted in the sketch-drawing and apparent in the four-foot-high bronze maquette, the composition is made up of a number of elements: the woman kneeling at the base (the symbolic foundation of life), supporting figures of men; a bull (aggression subdued); birds; the standing woman – arms extended in a gesture of peace; and at the summit the dove that has gathered the great billowing cradle in its beak. It is a masterpiece of integration, structurally coherent, with superlative formal qualities that underline a not over-insistent symbolism.

The later Laurens was more and more drawn towards the free interpretation of organic symbolism. His *La Femme Fleur* of 1942 could be a modern Daphne turning into a flower, as Bernini's Daphne, pursued by Apollo, is caught at the moment of her metamorphosis into a tree. The sketch-drawing, composed with not more than seven or eight strokes but which contrives to suggest volume rather than contour, is a good example of exploitation of analogies. One thinks of Moore's leaf-figures, Braque's leaf-birds, and the animistic figures of Germaine Richier and Gonzalez, which stray still further away from anthropomorphic form. It is a strong, assured drawing, belonging to a period when Laurens produced some of his most impressive bronzes, including the masterpiece *The Adieu*, and *Morning* (two versions). These share with *La Femme Fleur* the virtual absence of plinth or base, indicative of Laurens' concern not to put his figures, so to speak, in parenthesis, but to allow us to move among them freely.

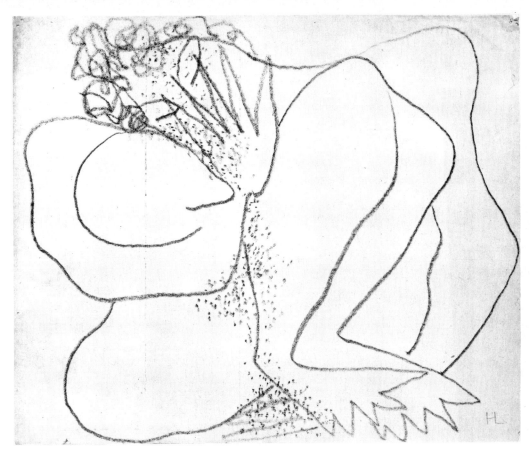

213 HENRI LAURENS Drawing for *La Femme Fleur* 1942

214 LAURENS *La Femme Fleur* 1942

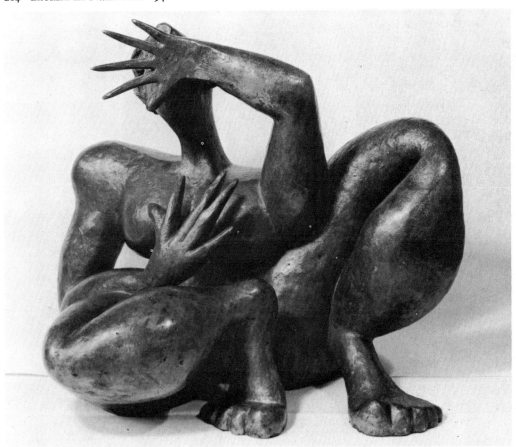

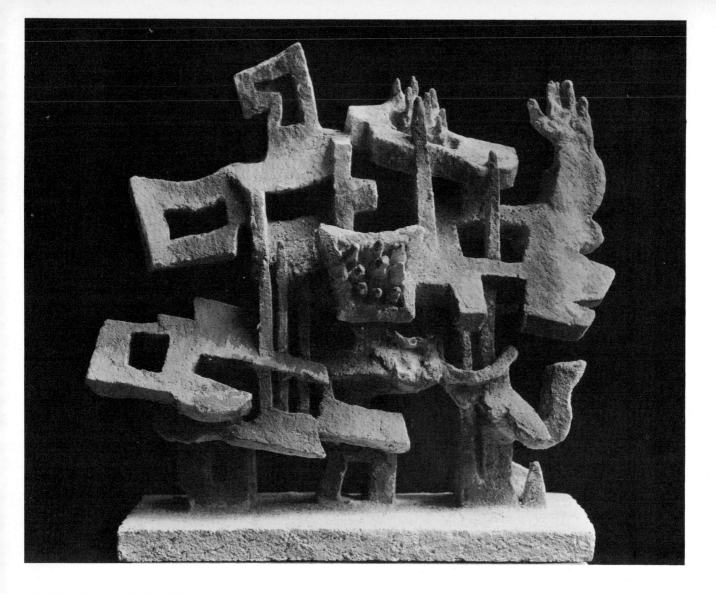

215 OSSIP ZADKINE *Floral and Human Forms* 1964

There is nothing menacing about Laurens' creations; in the figure he calls *Metamorphosis* the woman is being transformed into one of his delightful mermaids. The animistic element is often playful, witty, always plastically satisfying.

Zadkine's *Floral and Human Forms* is a more formal excursion into a similar world. His concern is partly symbolic, but also represents a shift, like Lipchitz's later work, towards more open sculpture, away from the expressionistic idiom of his *Destroyed City*.

The drawing for the *Floral and Human Forms* is a complex affair; the planes are indicated by directional shading, the spaces variously by inconsistent but effective areas of black and white. The central feature – like coral-stalks in the sculpture – is tilted towards us and attracts our eye through a circular, flower-like form. The contextual aid to the reading of the terracotta sculpture is the hand and arm on the right, which justify the title. In fact it could be argued that these are too realistic for the whole, in which the dominant feeling is one of organic growth in some marine garden, and that the original metaphorically suggestive hand of the drawing would have been preferable. Nevertheless the composition of vertical thrusts through the tilted horizontal shelves is lively and original.

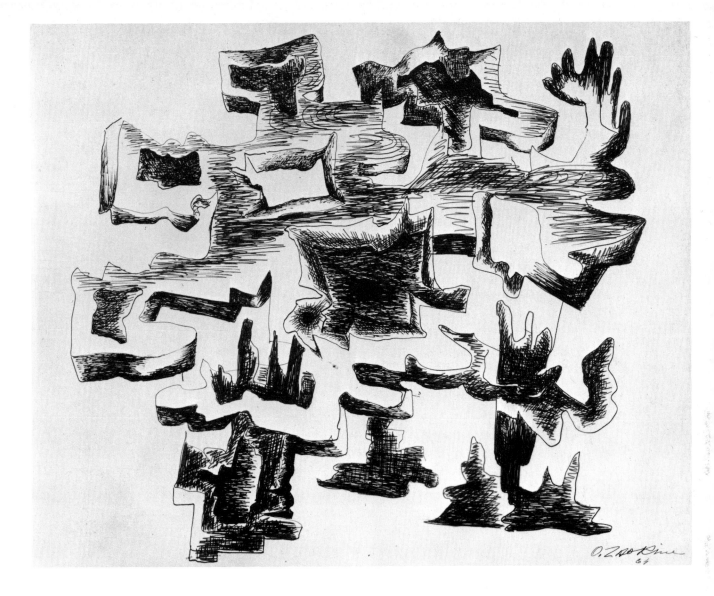

216 ZADKINE Drawing for *Floral and Human Forms* 1964

The hand theme leads us to a sculptor, Dodeigne, already mentioned in an earlier chapter, for whom the human hand is an obsessive vehicle of expression. His hands gesticulate (*Hand*, 1964), plead (*Prayer*, 1969), clutch, or droop relaxed on prehensile arms (as in two of his rugged stone figures). Perhaps, paradoxically, they are never more present, never more effective than when merely implied, as in *Seated Figure*. Our eyes are led irresistibly upwards by the body's concavity to the head where the hands are imprisoned in a convulsion of anguish. In this bronze we are reminded, not of the classicizing torsos of the previous chapter, but rather of Medardo Rosso's melting forms. We note the same fluidity, the same supple surface modelling. The face, cleft and lowered, is obliterated; the whole expressivity radiates from the hidden hands. The charcoal drawing in sombre chiaroscuro is similarly intentioned, and the high-lights in white chalk prefigure those of the bronze.

Dodeigne's technique in bronzes of this kind and the drawings for them suggest the wax of the lost-wax process in their smoothness and tactile qualities. The sculptor occasionally rubs down his stone figures to a smoothness comparable to that of the bronze, as visitors to the Fondation Maeght chapel at St Paul de Vence will have noticed in the figure of St Bernard.

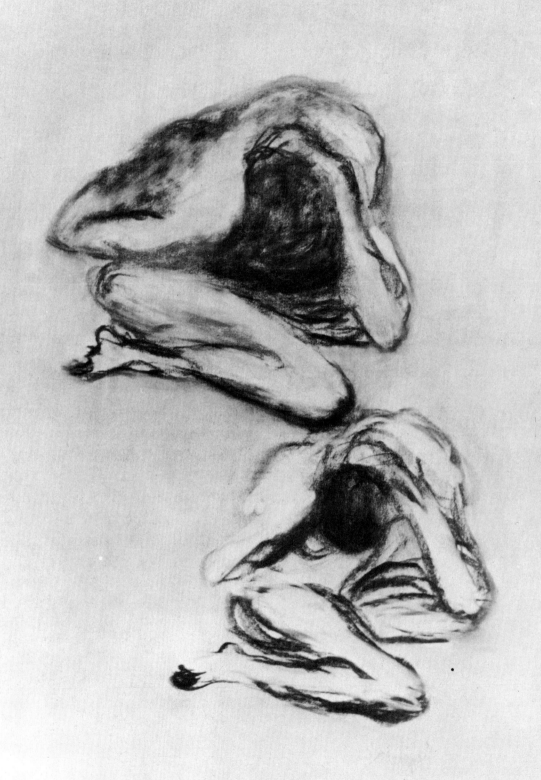

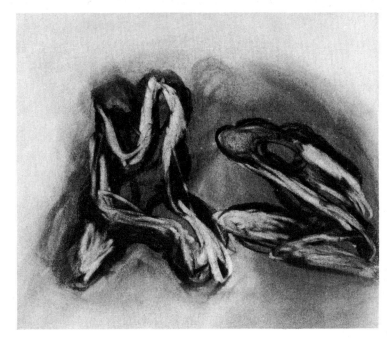

217 Eugène Dodeigne Studies for *Seated Figure*

218 Dodeigne Studies for *Hidden Hands*

219 Dodeigne *Seated Figure*

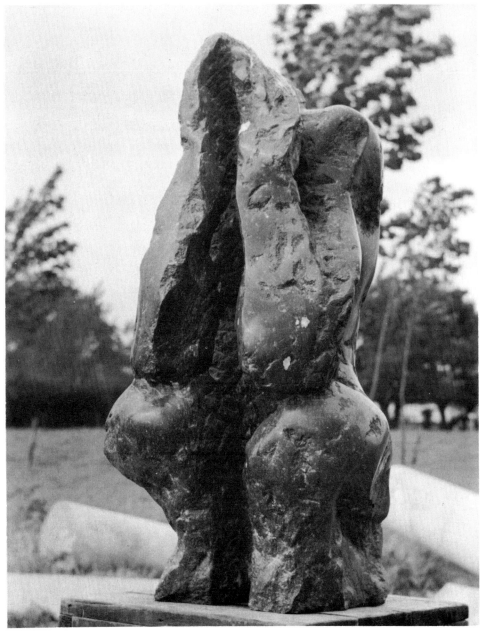

Alternating between classical, impressionistic and Nordic expressionist modalities, Dodeigne finds constant renewal in drawing. 'Drawing is very important in my work . . . in my drawings I choose the themes of the sculptures I will make – in stone or bronze – thanks to these drawings there is a renewal.'

UNDER THE SIGN OF BRANCUSI

La taille directe, c'est la victoire.
BRANCUSI

Brancusi's aim was to liberate sculpture from surface excrescences, the 'macaroni of the Baroque'; to replace the broken-surfaces of bronzes of the Rodin school with smooth, egg-like forms, a tacit recognition of Helion's statement: 'The egg structure constitutes an aspect of the double rhythm-unity, totality, continuity.' He extends his repertory by exploiting bird shapes, familiar to us in the polished bronze *Bird in Space* of 1940 – already a considerable development from his marble carvings, in which he was promulgating the gospel of direct cutting, to arrive at the ultimate simplicity of *The Seal*. He had successfully produced portrait syntheses, notably in *Portrait of Mlle Pogany* (drawing and bronze, 1912–13, 408–9) and the *Portrait of Princess X* (1916), which because of its apparently fortuitous phallic resemblance caused a considerable scandal. Certainly the drawing illustrated gives no hint of the sculptor's alleged ambiguity. It is still a long way from the kind of absolute form that was always Brancusi's aim, but the 'handwriting' is recognizable. The curves, like those of the left thigh, the hair, and the flipper-like hands, are readily identifiable signatures of Brancusi's work. One senses the pleasure with which he drew these sweeping sensuous curves, and exuberantly completed the linear connectives of the left shoulder and arm.

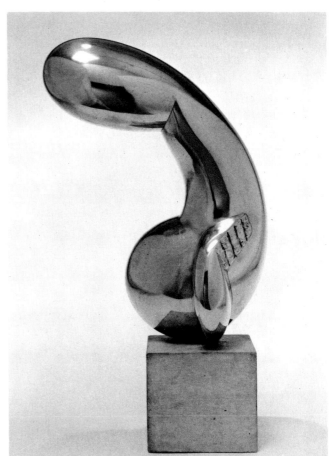

220 CONSTANTIN BRANCUSI *Portrait of Princess X* 1916

221 (opposite) BRANCUSI Drawing for *Portrait of Princess X*

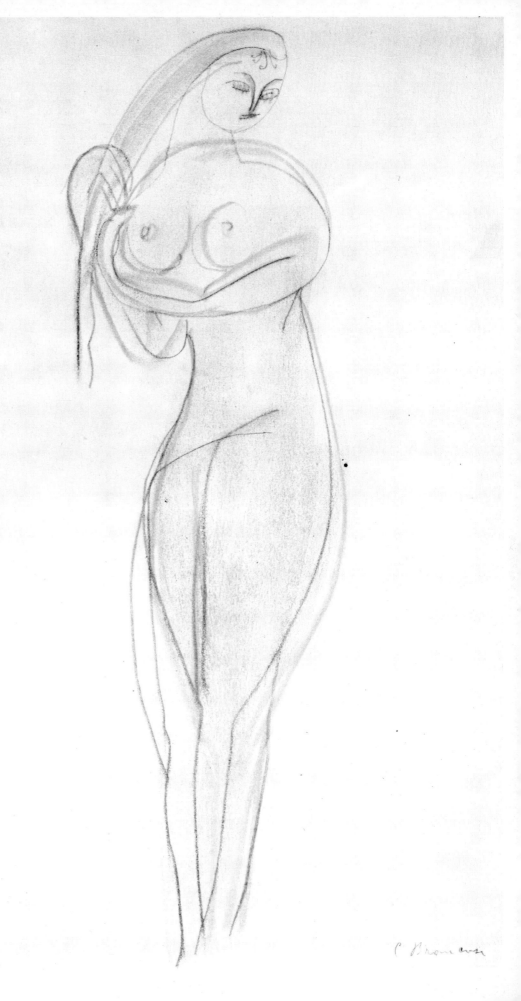

C. Brancusi

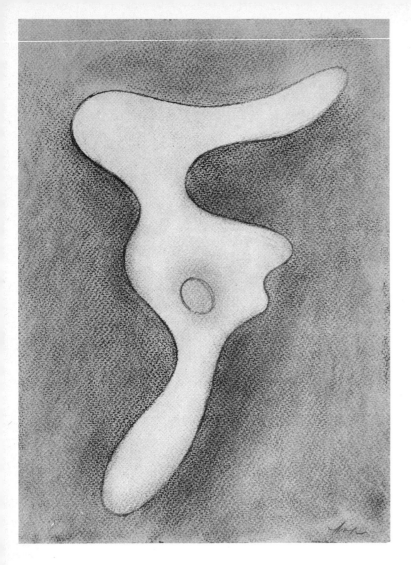

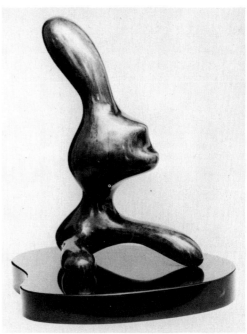

222 JEAN ARP *The Forest Apparition* 1961

223 ARP *The Hares' Idol* 1965

There is an observable kinship between Arp and Brancusi. Arp's work is also predominantly based on the ubiquitous curves of natural form as opposed to man-made straight lines. In his case the curves are of organic growth or of moving creatures like amoeba, characterized by the enclosed forms of his drawings. His sculptures often seem inspired by surrealist, even mystical sources, reflected in the titles he gives them, such as *The Hares' Idol* (in fact originally entitled *L'Idole des Lapins*), which evokes the ambiguous form of the bronze. 'Arp never made sketches before realizing his sculptures,' wrote his wife, pointing out, however, the affinities between some of his drawings and sculptures. *The Forest Apparition*, for instance, is recognizably an inverted form of *The Hares' Idol*. Whatever the actual link between the two works, they underline the point that an artist has his own private repertory of obsessive shapes which we get to know in their various disguises. It is interesting to note how the fluid and somewhat amorphous form of the pencil drawing has become the solid, balanced bronze anchored on its plinth; a skilful composition of echoing shapes.

Gilioli alludes to the Samian *Hera* (Louvre) as one of his key figures – 'one of my poles of reference'. This is far from being inconsistent with his equal admiration for the work of Brancusi, who could be called the opposite pole. 'I am attracted by geometry and its severity,' he writes, 'for I like architecture and I would like my

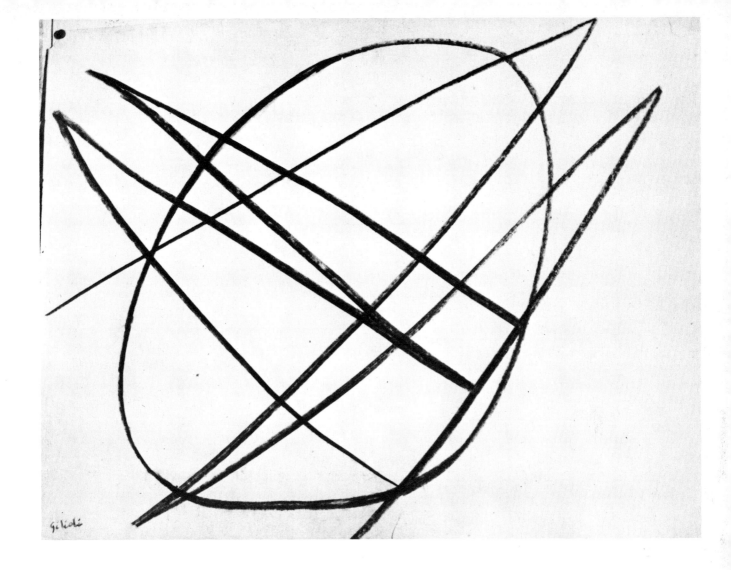

sculpture to be an element of architecture.' The sphere is as important to him as it is to Bernard Meadows (see pp. 60–1). The work *The Sphere* illustrates Gilioli's modelling procedure. 'I start from a ball, and the sculptures I make are layers of plaster. I stop applying these when I have no more to say. . . .' The drawing shows a compact design of a compressed sphere and triangles which together summarize the final sculpture, shown here in its plaster form. Viewed from the side, the boulder-like shape can be recognized as the blunt convexity of the sculpture, while the lower triangle suggests the three-dimensional equivalent.

224 (above) EMILE GILIOLI Sketch for *The Sphere*

225 GILIOLI *The Sphere* 1947

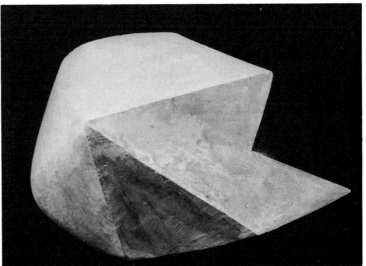

Reference has already been made to Bernard Meadows' obsession with the sphere, culminating in his ambitious work for Prospect House, Norwich. But the origin of the inspiration is different from Gilioli's. Whereas Gilioli is preoccupied with the sphere as a geometrical shape of Platonic association, Meadows is fascinated by organic form, such as that of the soft, fleshy plum. We recognize variations of its squeezed form in elements of the *Pointing Figure* of 1966. In the *Pointing Figure with Child*, illustrated, the squeezed spheres are an obvious analogue for the 'child' cradled in the concavity. The 'pointer' is an animistic reminder of a lobster's scythe-like claw. The whole is a contrast of hard and soft forms, of surfaces polished and chased to different colours. It conveys a feeling of contemporary *Angst*, if less explicitly than an earlier *Pointing Figure* which evoked memories of armoured cars like those that invaded Czechoslovakia about that time, familiar in press photographs.

Meadows never embarks on a sculpture without conducting a thorough investigation on paper of the ideas that occur to his fertile imagination. He uses colour wash to detach and emphasize his forms, in conjunction with a basis of pencil. The shading is limited to a few touches to emphasize the volume of the three tiers of the composition, already clearly integrated. Only the pointing arm is left in a flat plane which will be developed into the all-important feature of the bronze.

The works resulting from a variety of obsessions, formal and thematic, on the part of the sculptors discussed in this chapter have achieved expressive validity inasmuch as they represent a fine balance between an inner impulse (the germ of which can be seen in a first-idea sketch), external influences (which the sculptor may acknowledge explicitly or by implication) and technique. The personal idioms that emerge are recognizable already in the drawings, which allow us to observe the stages in the resolution of these three elements and in the solution of a sculptural problem.

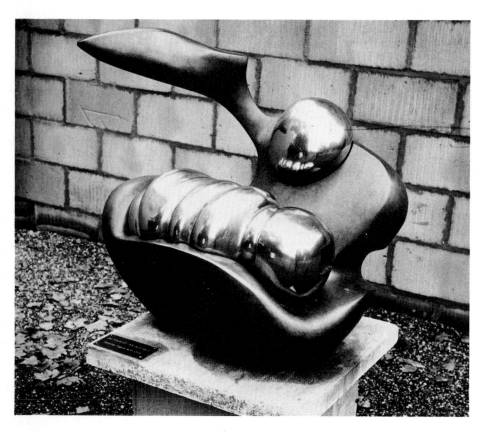

226 BERNARD MEADOWS *Pointing Figure with Child* 1966

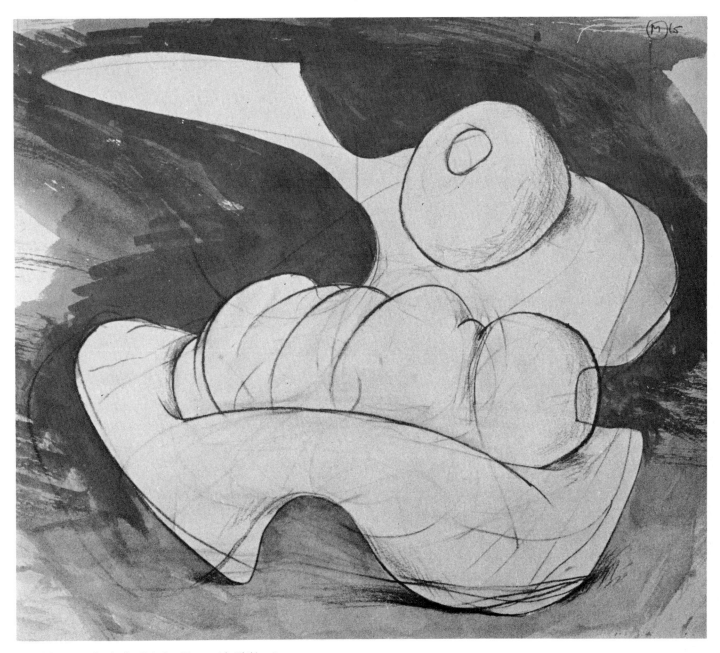

227 MEADOWS Study for *Pointing Figure with Child* 1965

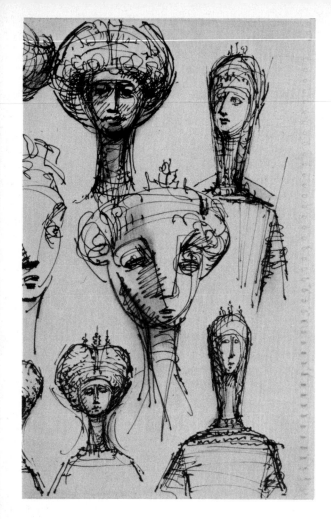

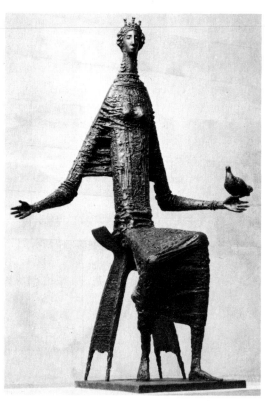

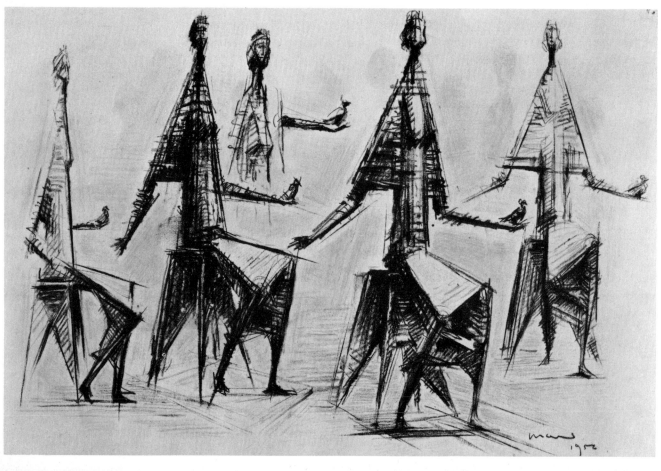

6 *The hieratic and totemistic element*

A good piece of sculpture must combine barbarism and culture.

WOTRUBA

The sculptures we are concerned with in this chapter differ in one fundamental respect from the classical, traditional examples from Antiquity to the Neoclassical period, which by and large observe certain aesthetic canons of proportion with regard to their model, the human form. The present sculptures, on the contrary, are obviously not based on life-studies, but are drawn from the well of the imagination, sometimes stimulated by the memory of artifacts of primitive societies seen in museums of art or ethnology (or, in the case of artists like Gauguin, *in situ*). and inspired not a little by their materials and the potentials of new techniques. Such 'visual experiences' – since the *religious* content of fetish and totem can be appreciated only by the society or tribe which creates them – are supplemented by our awareness of the subconscious, and of the potentiality of the principles of free association applied to art. In other words, although the modern sculptor judges these exotic objects by aesthetic criteria which take account above all of their expressive vitality, he is also intuitively appreciative of their numinous qualities, which we in our turn discover in his own creations.

The fallacious belief that Greek sculpture, since it was essentially representational, was 'realistic', has tended to make the public, long nurtured on the classical tradition and suspicious of three-dimensional objects that do not immediately declare their intent, ask who or what a given artifact is meant to represent. The modern sculptor requires more of the viewer, his aim having being to create something that had no existence before; something valid in its own right. As for reality, the sculptor David Smith has summed up the truth of the matter: 'Everything imagined is reality. The mind cannot conceive unreal things . . . the sculptor's world is one of vision with no conception barred.'

The demands made by the sculptor who starts out with more or less recognizable human schemata are for that very reason often *less* acceptable to the public than purely abstract constructions which raise no questions regarding their identity. The first-idea sketches for the former kind of sculpture – irrational, mysterious – are by the same token more fascinating than blue-print statements of abstract works.

McWilliam's *Princess Macha* has the hieratic quality one might expect to find in the treatment of a semi-legendary figure of Celtic origin, associated with sorrow and suffering and therefore symbolically suitable for the hospital in Londonderry for which it was commissioned. McWilliam, who is of Irish descent, incorporated in the surface treatment of the gilt-bronze opulent decorative elements of Celtic origin. Several of the drawings are in fact variations of Celtic arabesque designs.

The sculptor took great pains to explore the expressive potential of his theme, filling scores of sketch-book pages, first with groups of female seated figures holding birds,

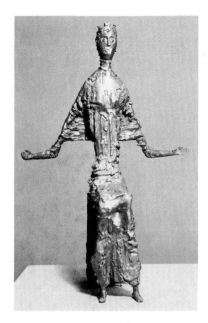

231 McWILLIAM Model for *Princess Macha*

Opposite:

228 F. E. McWILLIAM Studies for head of *Princess Macha* 1957

229 McWILLIAM *Princess Macha* 1957

230 McWILLIAM Studies for *Princess Macha* 1956

129

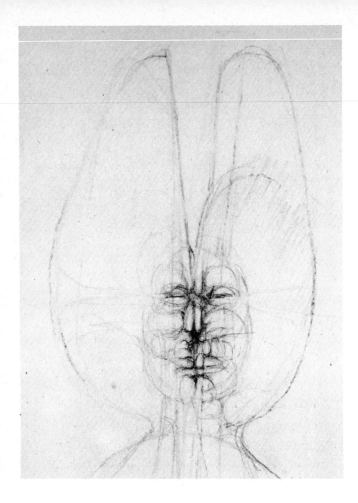

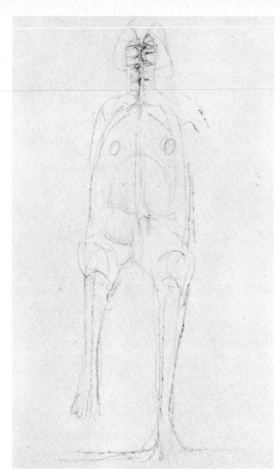

232–3 RALPH BROWN Studies for *The Queen* 1962

234 BROWN *The Queen* 1963

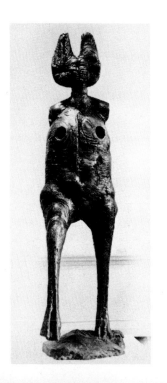

then with details, some in conté, some in pen and ink, the latter reserved for the clarification of individual parts. These sketches illustrate the stages towards elimination of realism, and the depersonalization of an hieratic form that, without sacrifice of individuality, should have a universal appeal. Even at the sketch stage the sculptor had a clear notion of the pose, the expressive elongation of the arms and slope of the narrow shoulders. The drapery, stretched taut across the arms and legs, anticipates the focus of thrust of breasts and knees, emphasized in the final bronze. The pen sketches for the head allow us to see that McWilliam chose to develop the narrow version at the right-hand top rather than the graphically more attractive head on its left. The drawings were succeeded by a wax maquette in accordance with the sculptor's usual practice, to enable him and (in the case of a commission) his clients to judge the project in the round. The final bronze of this stylized 'Princess', dignified, imposing, is one of the sculptor's most striking sculptures. After a showing at the Tate Gallery it was unveiled at the Altnagelvin Hospital, Londonderry, in 1957.

Ralph Brown, like most of the artists illustrated here, has evolved a highly personalized graphic idiom, side by side with his sculptural development. Drawings of an early period show the influence of Michelangelo and Rodin, as I have already mentioned in Chapter 2. His *Man and Child* and *Meat Porters*, bronzes of 1959–60, and their related drawings, also show an idiosyncratic departure from classical influence – stick-like extremities. These still persist in his drawings for reliefs and *The Queen* (1963) of the same period. Nevertheless, we note in the drawing for the latter figure a technical step towards the predominating curves and unambiguous eroticism of the later *Lovers* series, illustrated in the chapter on relief sculpture. Brown's delicacy of

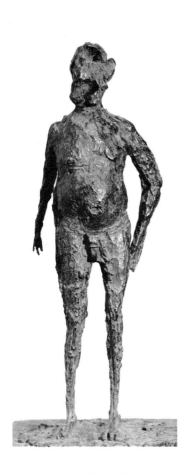

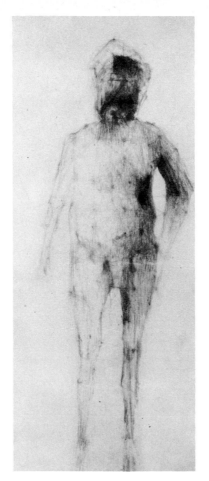

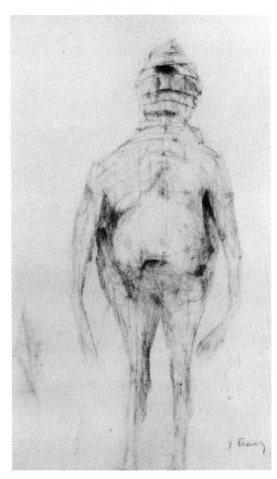

line is almost that of silver-point, and he relies on a minimum of tonal shading. At first the drawing for *The Queen*, with the cleft head, the holed breast and totemistic modality, impressive and awe-inspiring, seems at odds with the solid sculptural artifact. There is a similar though less pronounced difference between the drawings and sculptures of Germaine Richier – whose work the English sculptor greatly admired – as we can see in the *Pentacle* and *Ogre* bronzes and their studies. Brown's drawings are more skeletal than the bronze, revealing the frame that is to be covered by the flaccid flesh. The face is more fully realized – wizened, intimidating. Richier's lines are nervous, broken, staccato, reflecting the fascination exercised on her by mythical monsters or predatory insects. Both sculptors use shading to suggest volume, but Brown has conveyed it chiefly through contour and a few directional lines. The web of fine lines of triangulation on Richier's drawings is partly structural for defining the changes of plane, partly an incidental enrichment of texture. The mask-like faces, like Moore's helmet-heads and the triangular helmets on Lynn Chadwick's recent figures, reflect the dark side of life, as man resorting to courses of action of dubious morality or thuggery dons a mask or hood, as much to hide from himself as to conceal his identity. Germaine Richier's corpus of work evokes a Baudelairean beauty of corruption. Her drawings for sculpture, in a technique not unlike Giacometti's, express psychological malaise in terms of refined sensitivity, voicing, if with genius, a near-pathological distress.

Moore's genius is more robust. Although a minority of his sculptures – the 'Helmet' series and the *Fallen Warrior* – also reflect the grimmer aspects of life, the control with which they are managed lends them a transcendent universality. This control in-

235 GERMAINE RICHIER *The Ogre* 1949

236 RICHIER Study for *The Ogre*

237 RICHIER Study for *Pentacle*

238 RICHIER *Pentacle* 1954

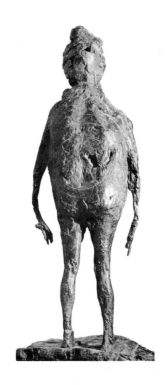

volves the subordination of expression to the over-riding demands of sculptural qualities. As is so often the case with Moore, a technical exploration (for the helmets, of the lost-wax process applied to lead-casting) combined with sketch-book ideas has led to results of striking originality.

In the helmet the animistic element proclaims its presence. 'I am very much aware', Moore has said, 'that associational, psychological factors play a large part in my sculpture.' The very shape of a helmet reminds us of the menacing helmets of Renaissance condottieri (like that worn by Gattamelata in Donatello's equestrian statue) or the helmetted Fascist soldier of a Manzù relief. Moore's version is the more intimidating for having the inner form with eyes on stalks peering from the shadowy interior.

The first of Moore's drawings connected with the subject appear in 1939 under the heading 'Drawings for metal sculpture: External and Internal forms, chalk and water colour'. These formed the basis for the lead helmet of 1939–40 cast directly from the wax in the sculptor's own furnace, and from this original, bronze casts were subsequently made.

From 1940 on, chalk, pen and wash drawings are more often replaced by wax-chalk, pen and wash. Moore also adopted, especially in conjunction with the wax-chalk medium, a method of sectional lines to indicate changes of plane, replacing the cross-hatch shading of the 1939 *Heads*. White wax-chalk is particularly effective for indicating high-lights, which frequently correspond either to focuses of thrust or an emphasis of polished patina in the bronze. The helmet-heads of 1950 show a return to the theme, with further elaborations on the kind of open-basket form inspired by certain African techniques. Sometimes they are helmets with a moveable interior section, analogues for eyes; sometimes they are hollow, like the *Openwork Head and Shoulders*, suggestive of a helmet with its visor down or the helmet-head. The top left-hand drawing of the 1939 sheet, and the one on the top row, second from the left, of that of 1950 have provided the basic form for the *Helmet Head No. 2*. The sketch-techniques show Moore's transition to a tighter, more precise drawing, nearer to the practical realization of a project. The systematic cross-hatching of the second group shows the helmets strongly lit by a frontal light. The first group are more surrealistically threatening, with a dark, impressive background. Moore has always been skilled in the emotive use of colour, which also provides a partial substitute for perspective. The 1950 group reveals the role colour can play, first in showing up the inner forms (yellow), second as a background-foil: grey-blue for the top row, indian red for the lower, blue-toned helmets.

Following his practice of developing an earlier theme, Moore returned in 1951 for *Standing Figure* to a series of chalk and watercolour drawings of 1948 entitled 'Ideas for metal sculpture'. His sculptural work, as already mentioned, alternates even during a single period between basically figurative forms and purely imaginative creations with – to use Herbert Read's description – the 'ambiguity of half-human, half-animal pieces'. As we look at the *Standing Figure* we recognize a similar duality – a successful wedding of geometrical and organic shapes. The bone-like forms that support the stalk-eyes belong to Moore's iconometric code as much as do the double-ring and hole-eyes of his earliest period. It is the upper part of the *Standing Figure* (which is set on a rock in a Scottish landscape[10]) that supplies the necessary identification, evoking warriors armed with shields and battles of long ago.

The triangles, like shields guarding front and rear, topped by watching eyes, rise with authoritative inevitability from the open, harp-like torso set on what reads like a tilted hip-bone supported on conceptual tibias. Of the page of sketches – showing

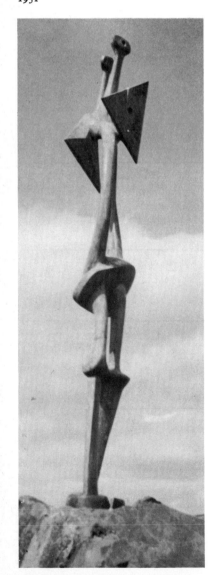

239 HENRY MOORE *Standing Figure* 1951

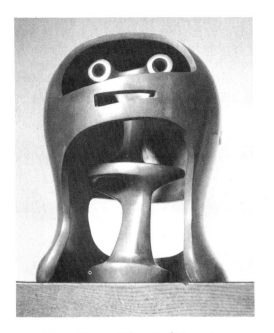

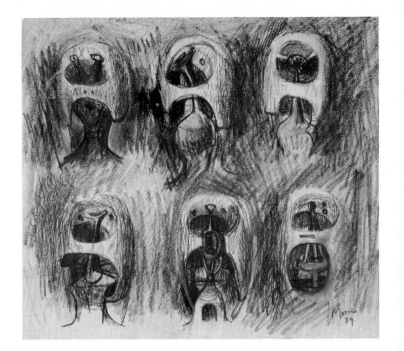

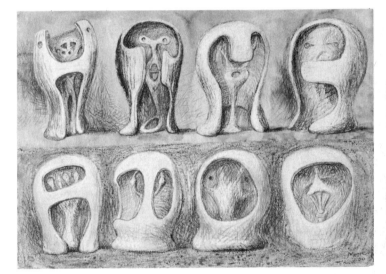

240 HENRY MOORE *Helmet Head No. 2* 1950

241 MOORE *Heads* 1939

242 MOORE *Heads No. 2* 1950

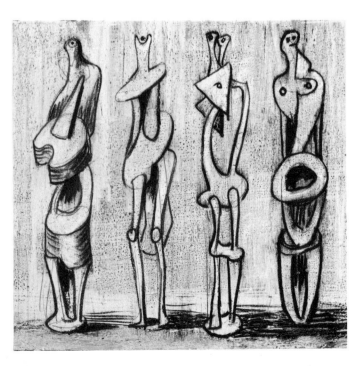

243 MOORE *Standing Figures* from *Ideas for metal sculptures* series 1948

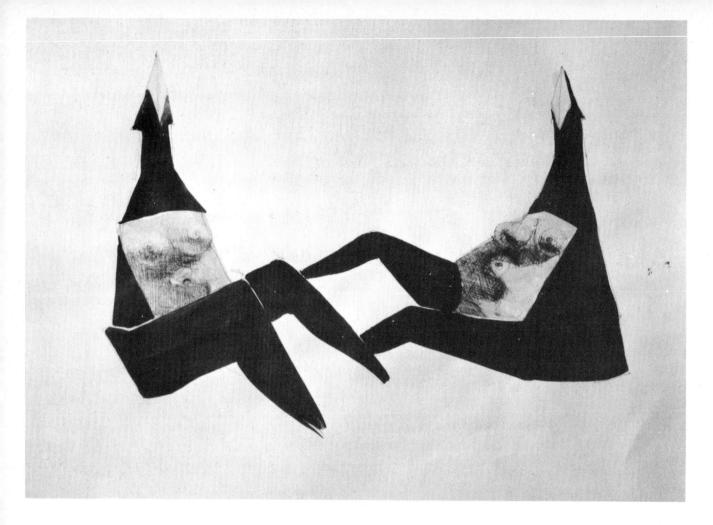

244 LYNN CHADWICK *Seated Pair* 1968–9

245 (below) CHADWICK *Seated Pair* 1973

246 (opposite) CHADWICK Group of *Elektras* 1969 (*see also IV, p. 84*)

eight ideas in all, of which only the lower row is reproduced – the second from the right was obviously the most satisfying open shape, and one can see that the modification of the tilt of the hip bears a relation to the figure on its right. The *Double Standing Figure* has paired but not identical forms constructed on the principle of complementaries in the hip and knee sections. The drawings are in wax-chalk and watercolour, a medium much favoured by Moore since the 'Shelter' drawings period, though the variety of media employed and combination of drawing techniques is infinite.

With one of his not unusual reversions, Moore, two years following the surrealistic *Standing Figure*, produced an anthropomorphic *King and Queen* which, like the former, is now sited in a Scottish landscape (Dumfries). The King's head evolved from one of those holed lumps of flint which have so often inspired the sculptor as a point of departure. It suggests a head-*cum*-crown, and becomes a strangely impressive symbol of the divinity that hedged a king in ancient times. The miracle is the successful blending of near-realism of the hands with an expressive distortion of the two heads. It was mapped out in embryo by a maquette with space-frame.

If Moore's *Standing Figure* conveys the association of a watcher, Lynn Chadwick's three *Elektras* barring the way in the corridor of his neo-Gothic castle, with their helmet-heads and polished bronze breasts to which they owe their name of 'shining ones', convey the suggestion of female guardians. Separate or together they make a dramatic impact – all angular except for their breasts, the roundnesses of which are emphasized by the thrusting nipple. Half goddesses, half Amazons, set on the tripod

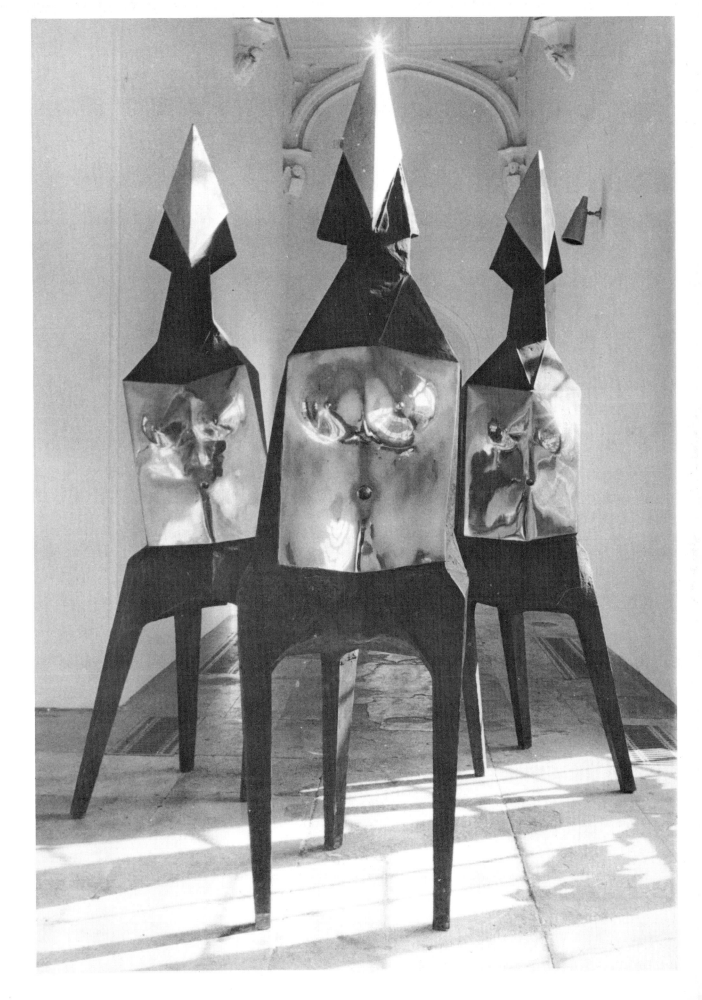

legs which are almost a Chadwick constant (features of *The Watchers* and *Trigon*), they threaten and command. Both technically and expressively, they represent a new breakthrough for this sculptor, in a form that is evocative rather than conceptual. The highly polished bronze of the breast-plates contrasts with the mat surface elsewhere, since the latter produces only negative shadows whereas the shiny surface reflects and distorts. Our eyes enjoy a twofold pleasure, in the recognition of a strong animistic shape of grouped tetrahedrons rising to a pyramidal climax, and in the teasing mystery of the centre part that shimmers like water. The tripod legs, asymmetrically disposed, buttress the central figure of the trio.

A new sculptural problem has required a different approach in the drawing. The effect of the new sculptural idiom depends on contrast of mat and polished patina in the bronze. Chadwick's previous objects, constructed on steel armature with iron-filing fillings (as described in Chapter 8) were the finished artifacts, whereas the *Elektras* (and the sculptures of the *Seated Pair* series of 1973) were later cast in bronze from such constructions. Pen and wash drawings that had reflected the sectional nature of the steel, here give way to refined pencil studies that show a precise concern with the proportions of the tripod base of the breastplate bodies to the head, and the angles of the legs. Essentially practical, they are also attractive in their own right, especially those with touches of colour – yellow in one (IV, p. 84), blue in another. Chadwick has used colour to emphasize the contrasts of surface he envisaged for the sculpture, and to simulate the reflection of the polished metal. Right down to such details as the bevelled edges of the tripod, these drawings are more complete than any others by this sculptor in relation to a particular project. They should be compared with those for *Inner Eye* (276–7), *Lion* (338), and *Strangers IV* (377), belonging to an earlier phase and, as we shall see, differently purposed.

The drawing of two similar figures is of particular interest since we are witnessing the sculptor moving towards the next theme he was to treat, the *Seated Pair*, already mentioned. We note the transitional nature of the drawing; the two figures seated, both female, are exchanged for male and female in the bronze *Seated Pair*, and their lozenge-shaped heads become tetrahedral variants (of polished bronze in some of the series) in the sculpture. In them we see Lynn Chadwick, like several other British sculptors – Ralph Brown, Reg Butler, Elisabeth Frink, for example – abandoning an earlier aggressive mood for a gentler, more euphoric idiom with a greater emphasis on the curved and rounded form. Yet these latest works of Chadwick's, despite more anthropomorphic reference, still belong to a world of fetish strangeness and anonymity.

Gonzalez's *Cactus Man II* is iconomorphic, no less aggressive than Chadwick's *Elektra* figures, and in its spikiness resembles Meadows' *Standing Armed Figure* of 1962. The sculptor seems to have grafted ideas garnered from primitive metal fetishes in the Musée de l'Homme in Paris on to his own imaginative concept, associated with the cruelty of thorns and the aridity of the 'Cactus Land'; but the result is not without a touch of black humour. With Gonzalez, drawing and sculpture were parallel and complementary activities, the correspondences between a sketch and a sculpture of the same name are sometimes far from precise. He is seized by an obsession, such as *Cactus Man*, and executes variations on the theme in both media. There are several drawings near to the final *Cactus Man II*, the closest being the one illustrated, in a mixed technique of Indian ink and coloured chalks. Parts of it, such as the centre covered with spikes, relate more closely to *Cactus Man I*, and one must conclude that, as so often with Gonzalez sculptures, each work is a synthesis of a number of drawings. After

247 JULIO GONZALEZ Study for *Cactus Man* 1939

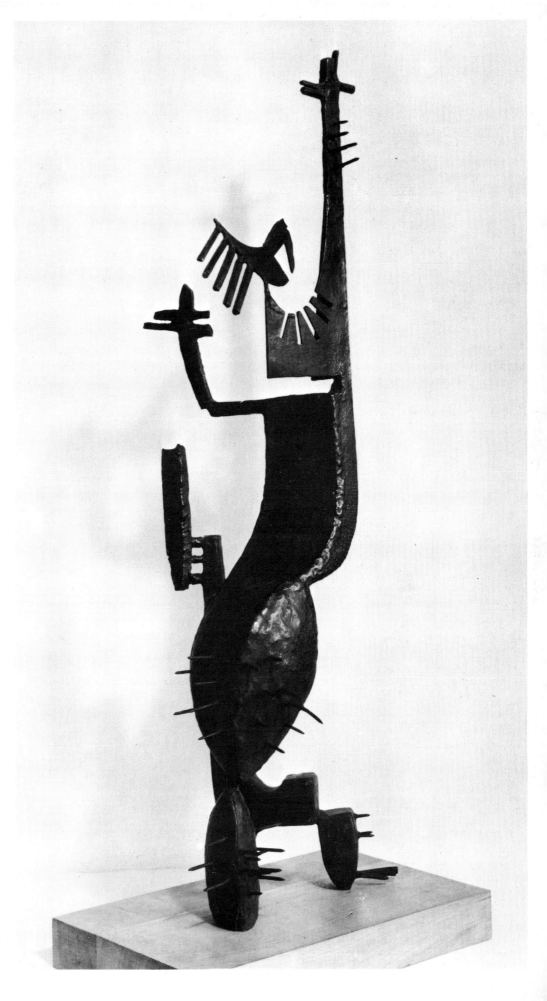

248 GONZALEZ
Cactus Man II
1939–40

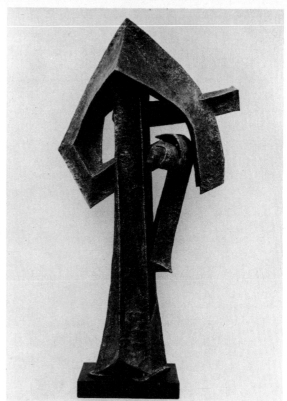

249 SEYMOUR LIPTON Drawing for
Sentinel 1959

250 LIPTON *Sentinel* 1959

251 LIPTON *The Defender* 1963

252 LIPTON Drawing for *The Defender*
1963

abandoning his career as a painter late in life, Gonzalez always draws as a sculptor. His most fantastic creations, whatever the drawing medium employed, demand to be realized three-dimensionally, albeit in simplified form. The reader will notice the variation in technique, from the strongly contrasted planes of studies for welded and cut iron (*Montserrat*, 413), to the delicate lines in space for the filiform studies (the *Petite Maternité*, 281), and the mixture of chalk and ink tones in the *Cactus* study.

Seymour Lipton and David Smith are two of the American sculptors – as opposed to expatriates working in the United States – whose pioneer creations in metal belong under the present heading of hieratic and totemistic sculpture. (Two other American sculptors in metal, Alexander Calder and Nakian, of an older generation, are considered elsewhere in the book.)

I emphasize the nationality of these sculptors in metal to point to the time-lag that occurred before the American public was ready to accept cutting and welding techniques from non-European hands. Such innovations were considered valid only if they emanated from sculptors of international reputation, whether or not they were living in their country of origin or had settled in the United States. Besides their American birth, Lipton and David Smith shared other initial disadvantages: neither was academic in the accepted sense, and both were self-taught. Lipton had trained as a dentist, Smith began as a riveter – not an insignificant equipment in each case. Both had learned a great deal from their observations of work by European sculptors working in metal – Gargallo, Picasso, and the early Gabo of the sheet-metal period. David Smith had travelled extensively in Europe. Both artists approached their comparatively novel materials with arresting originality. However their drawings, like their sculpture, could hardly be more different.

The work by Seymour Lipton shows how the sculptor's eye has been opened to new analogies and metaphors by the nature of his inspirational material, drawing on

a range of images that embraces funerary bronzes of ancient China, wood-carving from American Indians and from New Ireland in the Pacific. His idea-drawings he describes as 'results from the unconscious being, improvisations for sculpture' which he claims to be 'completely unselfconscious as an autonomous art form'. 'This', he adds, 'is an advantage both in fun and excitement of spontaneity – though it may lack in other qualities. Usually I make a series of drawings on some thematic approach, varying as I go forward what I consider sculptural fulfilment in terms of my temperament.' His works reflect his intuitive approach, and their evocative titles challenge the viewer's imagination and invite his participation. Such titles as *Empty Room* and *Mandrake* are characteristic of Lipton's animistic and organic images. We are not too troubled about resemblances; the metaphor is there – the idea is inseparable from the form, as it should be in any work of art.

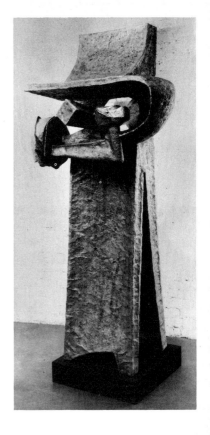

Sentinel of 1959, like *Crusader* of the same year, marks his preoccupation with paramilitary themes. The idea-sketch for the former is a powerful crayon drawing, made on thin typing paper. The vigour and spontaneity have been successfully translated into the final sculpture executed in nickel-silver welded on monel metal. *The Defender* maquette and drawing supply the conceptual essentials for the sculpture. The metal rod at right angles to the picture plane in the sketch represents, or rather suggests, the eye protected by the boxer-like arms, and clarifies the image without removing its totemic mystery. The hooded top (which also occurs in *Mouton Variations* of 1964 by Kenneth Armitage) is a recurring shape of our time.

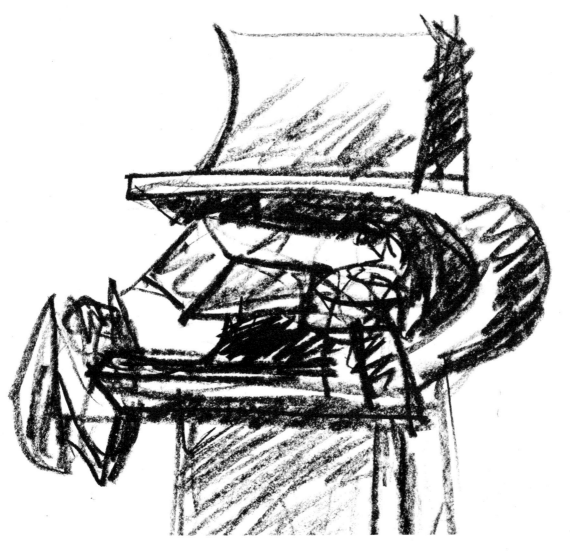

In the great modern sculpture-revival we continually detect evidence of cross-fertilization. David Smith, the first American sculptor to work in cut and welded iron, and the liberator of sculpture in America from the strait-jacket of monolithic carving of an academic type, admits his indebtedness to Gonzalez and Germaine Richier. His *Insect* of 1948, for example, has all the latter's ruthless overtones. But whatever phase of his work we look at (including the final *Cubi* series of 1963–4,[11] geometric constructions in non-reflecting steel), two of his observations are relevant. One is: 'I have no interest in surface embroidery'; the other, 'Sculpture is a poetic statement of form.'

David Smith's drawings serve as a clearing-house of ideas. 'Drawings', he has said, 'remain the life force of the artist. Especially is this true for the sculptor who works in media slow to take realization and where the original creative impulse must be maintained during labor.' We see the importance he gives to this activity, for example, during the years 1952–4, when he was obsessed with totemic themes which he named 'Personages' and 'Tank Totems'. For these metal figures he executed a whole series of drawings which he describes as 'the visionary projection of what the next sculptures are to be'. Most of the sculptures, like the present example, are an amalgam of two or three sketch-ideas. These animistic, surrealist creations can be looked on as the totems of a civilization dependent on military threats (recent examples of which flood the memory). Technically, the sculptures of this phase are experiments with constructions from separate cut-out sections of metal, in which the spaces between sections read positively as part of the whole. They are a stage on the way to the *Zig* and

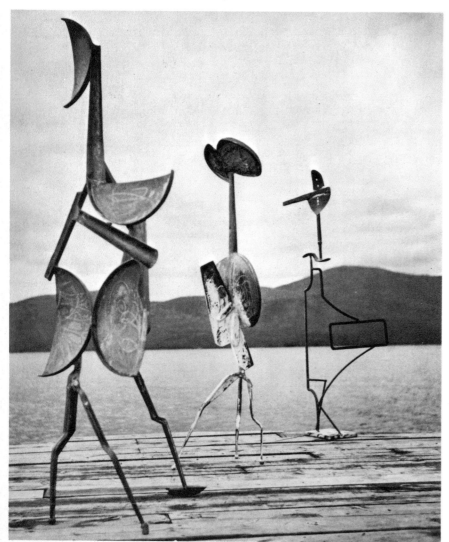

253 DAVID SMITH *Tank Totem IV, Untitled* and *Tank Totem III* 1953

254–5 (right) SMITH Studies for *Personages* and *Tank Totems* 1952

Tower, completely spatial constructions, almost wholly composed of rods, before the final solid shapes of the sixties. They may well have originated, in his words, as 'chalk drawings on the cement floor'. 'I follow no set procedure in starting a sculpture. Some works start out as chalk drawings on the cement floor with cut-steel forms working into the drawings. When it reaches the stage that the sculpture can be united, it is welded into position upright. . . . Sometimes sculptures start with no drawing at all.' Smith's work in its turn had a great influence on sculpture in metal throughout the world. He must be accounted one of the leading figures – like Seymour Lipton, Alexander Calder, Nakian and Isamu Noguchi, in the heroic American age.

Although he is half Japanese – his father was the poet Yone Noguchi, his mother the novelist Leonie Gilmour, graduate of Bryn Mawr – the bulk of Noguchi's work has been done in America, which was also the scene of his early struggles, before he received proper recognition there and ultimately far beyond its confines. We can link his name with Calder's from his time in Paris, when he helped the latter with his famous 'wire circus'. Calder has shown that wit and humour are not out of place in art – a fact confirmed by his drawing for *Double Helix* (268) – and the Noguchi fetish *Humpty Dumpty* is in a comparable light vein. Likewise his piece belonging in mood and technique to the same period (1944–5), *Fish Face*, with its accompanying graphpaper schemata: 'How to make a drawing'.

As the sculptor himself has reminded us, there is no native sculptural tradition in Japan apart from that concerned with dolls and idols; but Noguchi has successfully

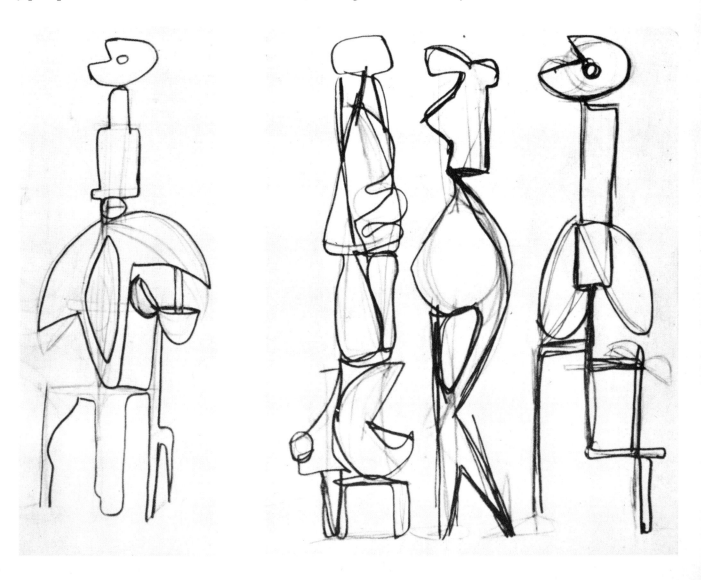

assimilated Western experience and technical knowledge, without his work ever totally losing its Oriental identity. We feel this as we look at some of his best-known carvings, such as the *Mu* (symbol of nothingness), with its circle formed by touching thumb and fore-finger, or the *Ring*, in black Swedish granite, or on a grander scale, the sixteen-foot-high fountain for John Hancock Insurance Company, New Orleans – and especially as we wander among the skilfully sited rough-hewn granite blocks of the Japanese Garden he contributed to the Unesco complex in Paris in 1956–8. Nevertheless, Noguchi is the first to acknowledge a debt to Brancusi, whom he assisted in his Paris studio for two years. 'I was transfixed by his vision,' he writes. Unlike most of the American sculptors of his time Noguchi has followed Brancusi's example in a preference for carving and cutting natural materials (Brancusi considered that welding interfered with sculpture). The corollary of this, when it comes to constructing which also fascinated him, is the integration of separate carved or cut-out sections on a system based on grooves and gravity. We can see this clearly exemplified in the *Humpty Dumpty*, built up from the five interlocking sections shown in the schemata cut-outs. In these sections, as in the six to be assembled for *Fish-face* (which he has called 'How to make a sculpture'), we note variations on certain of the obsessive shapes which occur in other, free-style, drawings. The schemata reflect his ability to envisage the effects of intersecting planes in a space continuum; their relative proportions and forms are as carefully worked out as parts of a Calder mobile. The sculptures chosen happen to be carved in black slate which emphasizes weight, but in the well-known *Kouros*, of the same date, in carved grained marble, also based on cut-out schemata, we can appreciate Noguchi's remark that 'a fragile beauty is more poignant'. Some of his work is not too far removed from an antecedent of doll-sculpture and many, in their exploitation of space enclosure, lead us away from the field of totem and fetish – which was also Brancusi's – to sculpture that is open yet free of animistic overtone.

256 (right) Isamu Noguchi *Humpty Dumpty*

257 (far right) Noguchi 'Cut-outs' for *Humpty Dumpty*

258 (below) Noguchi 'Cut-outs' for *Fish-face* ('How to Make a Sculpture')

259 (below right) Noguchi *Fish-face*

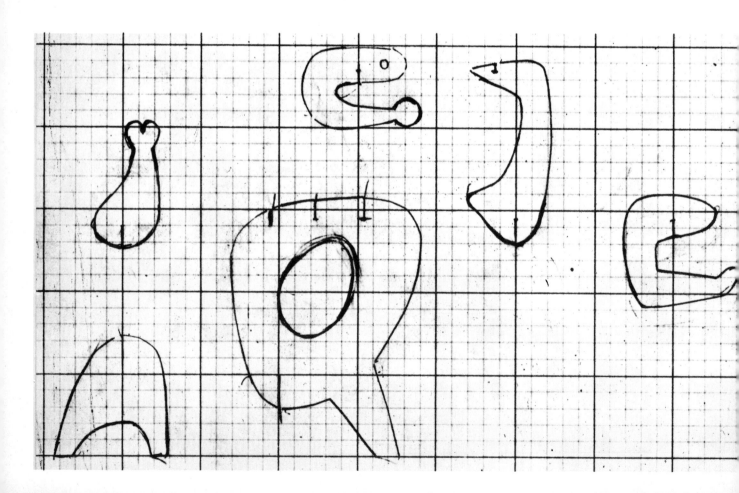

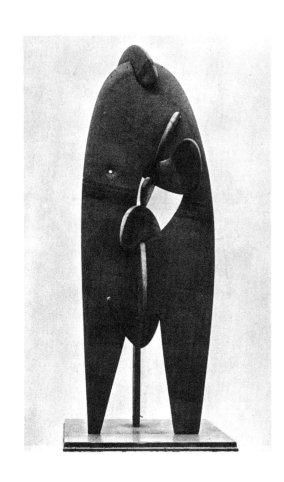

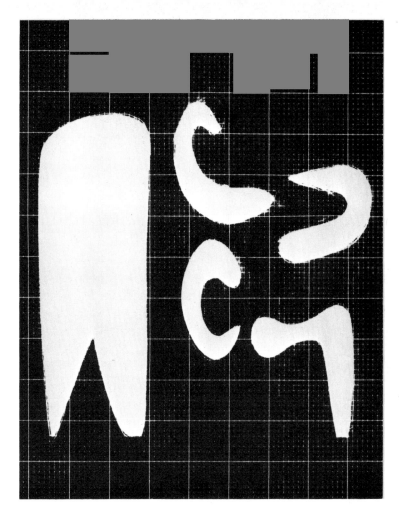

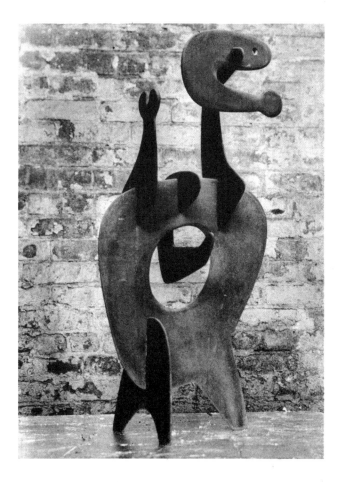

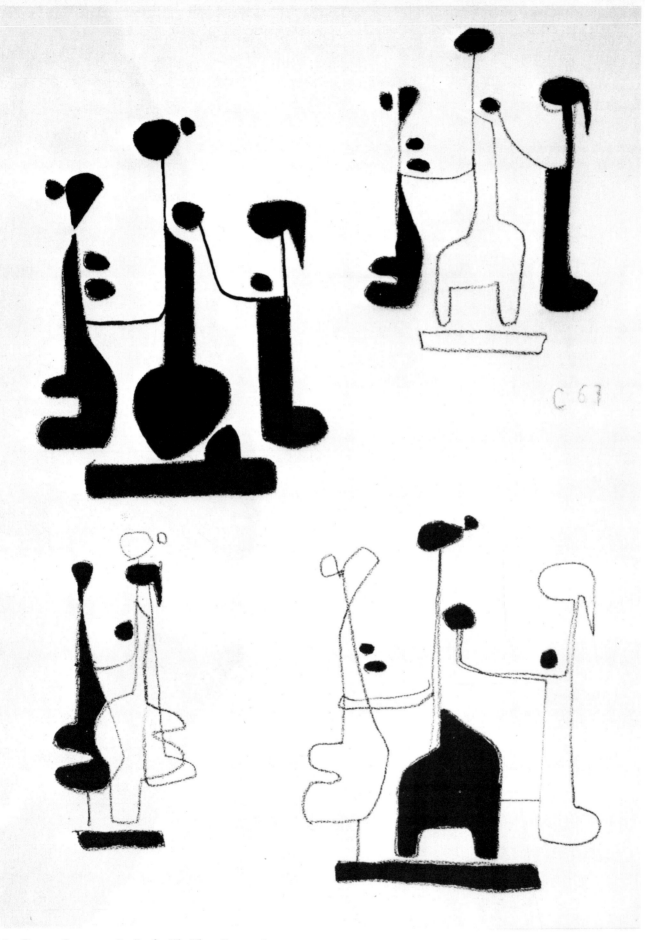

260 ROBERT COUTURIER Studies for *The Three Graces* 1967

7 Open forms and constructions

DRAWING FOR SPATIAL SCULPTURE

> Sculpture is above all a taking possession of space.
>
> HENRI LAURENS

The term 'open sculpture' is widely used in two different senses. It may be a synonym for 'spatial' sculpture, in which the whole is viewed primarily as a composition of voids which have a positive function, defined by the solid portion of the carving or construction. I would include Beaudin's *The Hoop* and *The Dance*, and much of Calder's work under such a heading. The term 'open' is also in frequent use as the opposite of 'closed', as applied to forms. In this sense 'open' describes such figurative sculpture as Zadkine's *The Destroyed City* – not because there is in fact a gaping hole in the body where the heart has been torn out, but because the viewer's eye is led outwards to the extremities, particularly by the gesticulating hands, and the silhouette is important. 'Closed' implies that the focal points are within a form, even though there are voids or holes in the composition, perhaps in the crook of an arm or between two interlocking forms. The deliberate opening-up of solid form we have already seen exemplified in two Moore recumbent figures. In these, space is a positive element integrated into the whole composition. In many constructions of metal or other materials the spatial element is an important, if not the primary, consideration.

Drawings for open and spatial sculpture, in this chapter irrespective of theme, are grouped to show analogies and contrasts of approach at the preliminary stages. Their variety of style and approach illustrates an individual sculptor's feeling about sculpture, and is revealing in terms of personality. Independently of the scale, the subject or sculptural medium of the projected artifact, the drawing represents the initial step towards a solution of the problem the sculptor has set himself. It supplies the touchstone of competence, talent, in some cases genius; and we can apply Moore's observation quoted earlier: 'good vision in drawing will come out in the sculpture.' Vision is a difficult quality to define; it is something we feel as much in an apparent scribble as in a more finished study. It can be present in a working drawing, such as those of Gio Pomodoro or Armitage, but is rarely to be associated with 'finish' or virtuosity – which can be suspect when vision is lacking. Despite idiomatic and other divergencies, all the preliminary studies in various graphic media for 'open' sculpture dealt with in this chapter are original and imaginative.

To begin with the more figurative examples: Couturier's *The Three Graces* is a structure depending on subtle relationships of solids and voids integrated around a circular space. The physical vectors (the arms) and the invisible one (the triangle of the three heads) lead our eyes in a gyratory movement. The spatial rhythms can be appreciated in two-dimensional terms as a succession of silhouettes, in these charcoal and wash sketches, constituting preliminary studies. They enable us to see the significant intervals between the ovoid heads, and the relation of these shapes if not their depth.

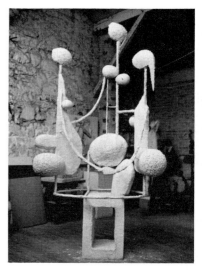

261 COUTURIER *The Three Graces* 1963–8

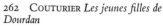

262 COUTURIER *Les jeunes filles de Dourdan*

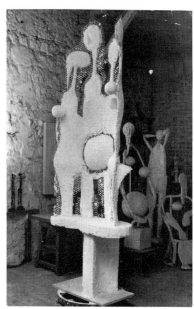

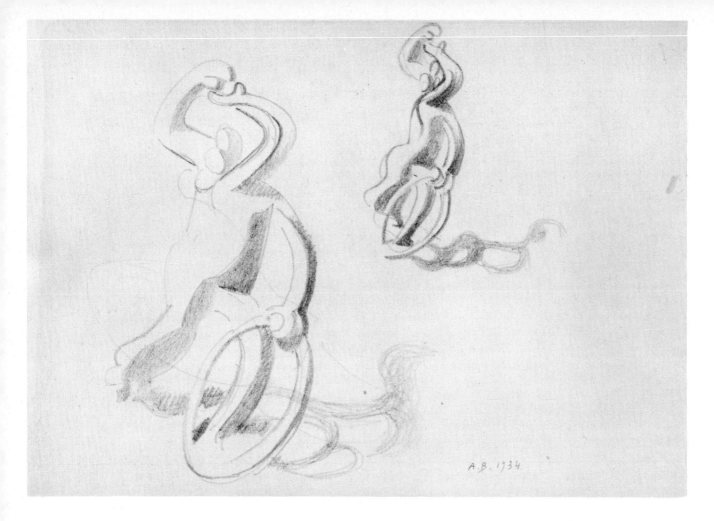

263 ANDRÉ BEAUDIN Studies for
The Hoop

264 ROBERT COUTURIER Maquette for
a *Girl with Hoop* 1952

265 BEAUDIN Maquette for
The Hoop 1934

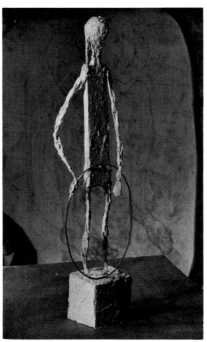

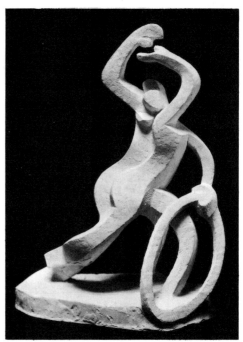

They agreeably evoke a musical image – a page of music with notes, representing sculptural solids, waiting to be sounded in the final composition. Side by side with such schematic sketches, Couturier explores the human figure in the search for expressive distortions, as in his study for *Double Torso* (147), the belly shape of which will be recognized in the centre of *The Three Graces*.

Beaudin's *The Hoop* has already been mentioned. Unusually for this sculptor – whose characteristic bronzes up to 1933 are reliefs, or shallow open compositions such as *The Dance – The Hoop* invites us to walk round its serpentine form. As Gérard Blanchard puts it, 'the arabesque is a certain way of taking possession of space.' The pencil sketch, a linear design around a space, gives a very clear idea of what the bronze was to be like. Unusually in a sculptor's drawing, the 'floor' is suggested by shadow. These small and spirited sketches are the normal preliminary for all Beaudin's bronzes of this type, though he varies them with outline drawings such as that for *The Bird of Marriage* (348). The former are reminiscent of the free rhythms of cave drawings, and like them seem unrestricted by page coordinates.

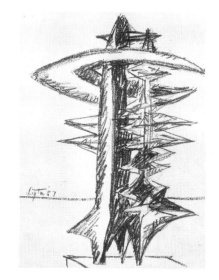

266 SEYMOUR LIPTON Drawing for *The Sorcerer* 1957

The next group of spatial sculptures includes more or less abstract examples by the three Americans mentioned earlier, Seymour Lipton, Alexander Calder and Nakian, and by two English sculptors, Barbara Hepworth and Lynn Chadwick. Four of the works are completely abstract; one, despite its title, *The Sorcerer*, is virtually abstract; while the remaining four examples have at least contextual allusions relating them to the human form or – in the case of Calder's *Black Fungus* – to organic growth.

Seymour Lipton's and Calder's drawings for *The Sorcerer* and *Double Helix* respectively have a superficial resemblance, but the titles indicate the wholly different sources of inspiration. The Lipton derives from psychological delvings, and his first-idea sketches have the immediacy of a 'happening'. The graphic style reflects this spontaneity – rapidly executed strong lines – whereas Calder's controlled, deliberate drawing reveals the constructional outlook of an engineer. Lipton's *Sorcerer*, helped perhaps by the suggestion of the title, evokes the idea of a magic spell, represented by the encircling form from which the figure inside cannot escape. The pointed shapes – vertical and horizontal – express the cruelty of this modern Antaeus embrace. Calder's drawing also shows an inner form encompassed by two opposing pivoted spirals.

267 LIPTON *The Sorcerer* 1957.

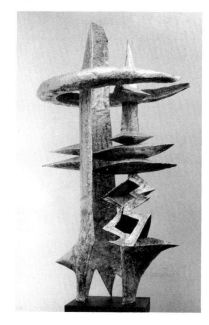

The Calder bronze, like *On One Knee*, discussed later, is built up from three pieces, manually mobile. The sculptor has not been able to resist extending the idea in the drawing to make an attractive page, and, as it were, to laugh at himself in the guise of naked onlookers, astonished by the claw-like forms that face them. Humour in drawings for sculpture need in no way detract from their dignity, as we shall see in drawings for screen sculpture by Kenneth Armitage in later chapters. Calder had started his sculptural career modestly with wire models of circus animals for his 'mobile' circus, appropriately exhibited at the Salon des Humoristes in Paris, 1927. The present drawing, entitled *Family with Sculptures*, shows Calder combining light-heartedness with the incidental adumbration of a sculptural idea.

Nakian's titles make evocative use of historical or aesthetic association – classical themes such as *Mars and Venus*, or references to specific works of art by great masters (such as his *Duchess of Alba* – not his only allusion to Goya). There is an element of mockery in his work which rebels against the clichés of mythological and 'subject' sculpture, but the result is positive and original. The figurative schema is virtually absent in both the sculptures illustrated, unless one thinks of the metal sheets as torsos and the rods as limbs. Rather must one accept both *The Duchess of Alba* and *Mars and Venus* as evocative images.

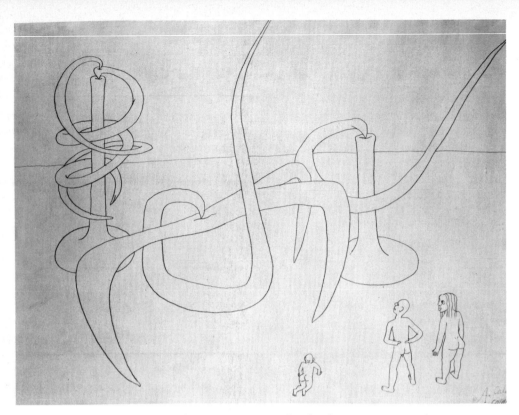

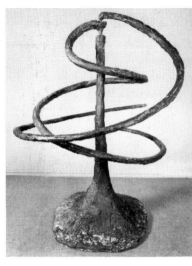

269 CALDER *Double Helix* 1944

268 ALEXANDER CALDER *Family with Sculptures* (incorporating drawing for *Double Helix*) 1944

270 CALDER *Sculpture Project II*, a study for *Black Fungus* 1944

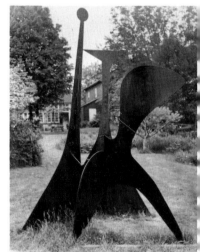

271 CALDER *Black Fungus* 1957

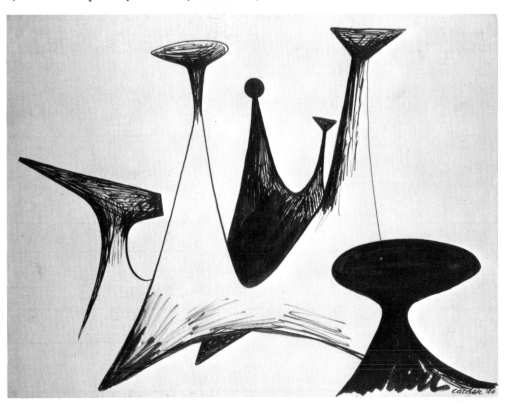

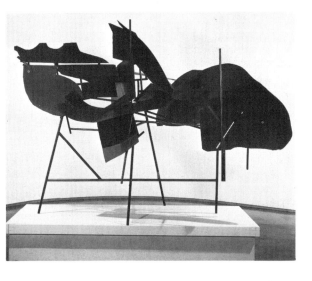

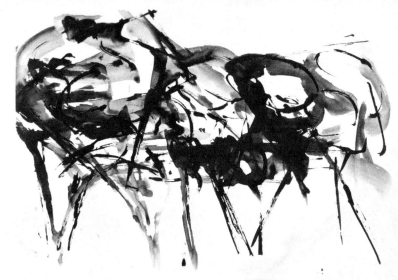

272 REUBEN NAKIAN *The Duchess of Alba* 1959

273 NAKIAN Drawing in *Duchess of Alba* series 1959–60

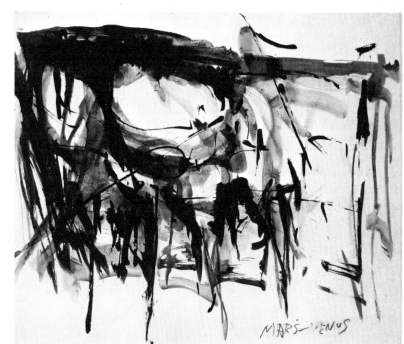

274 NAKIAN Drawing in *Mars and Venus* series 1959–60

275 NAKIAN *Mars and Venus* 1959–60

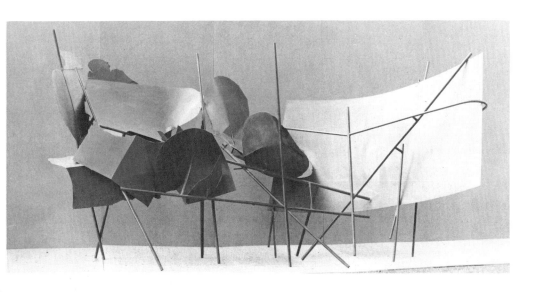

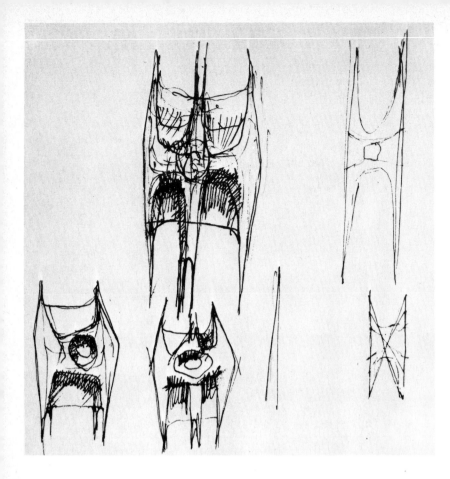

276–7 LYNN CHADWICK Studies for
Inner Eye 1951

278 CHADWICK *Inner Eye* 1952

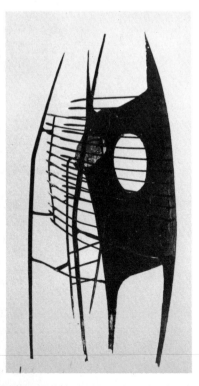

Certainly the wash drawings do not allow us to discover any further figurative allusion. Their interest lies elsewhere; they are expressions of a feverish imagination, corresponding to Nakian's characteristic method of working in metal (welded steel), which is cut out and bent in a frenzy until 'rightness' is achieved. It is in fact only in the light of the final construction that we can read the shadowy forms of the sketches as contrasted areas of tensile metal sheets and subtly spaced rods.

A glance at the *Mars and Venus* sculpture, a construction of steel sheets and rods on the heroic scale commensurate with the theme, will suffice to show that no single drawing could do more than synthesize the overall form and give an indication of the effect envisaged, seen from one angle. Superficially the drawing seems more Oriental than Western; not only because the artist has used a brush for lines (as well as for the bistre and black tonal areas), but because of their calligraphic nature. The resemblance of the whole to a Japanese brush drawing on silk or unsized paper is increased by the fact that Nakian has worked on a dampened paper. The brush strokes, however, reflect the American's temperamental zest to set down an idea, and the speed with which it was carried out. We are reminded of Emerson's splendid hyperbole: 'the work of art is then beautiful when it begins to be incomprehensible.'

Calder's graphic idiom varies widely according to his specific aim. In the drawing called *Sculpture Project II* he is concerned with the play of silhouettes, with an eye on future 'stabiles' made of cut and welded iron plates, such as *Black Fungus*, constructed in fact many years after the pen and wash sketch was made. The rising forms of the drawing terminate in round and fish-tail heads, closer in shape to 'fungus' than the sculpture bearing the title. The interest is in the shapes' articulation. They make a dialogue in the air, anticipating the spatial sculpture – comparable to that we saw in Couturier's

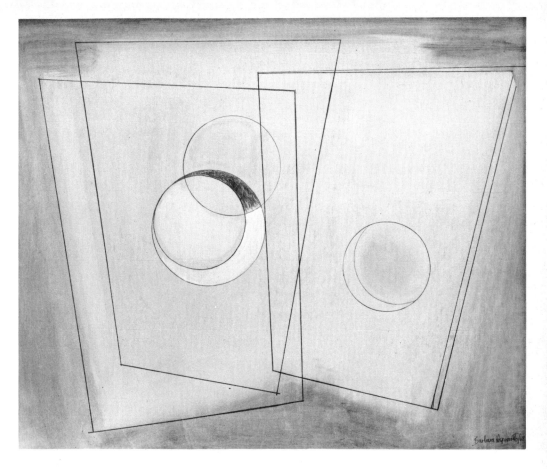

Three Graces (261). The main modification in the final construct is in the height of the various components, and the more parabolic arch of the foreground shape.

Lynn Chadwick's *Inner Eye* belongs in modality to some of the totemic sculptures considered in the previous chapter, but its importance is in the exploitation of spatial composition. The crystal eye held by mobile iron claws is located within an open iron frame that suggests a beetle carapace. It is a contextual allusion to 'Big Brother' – the contemporary Polyphemus that pries into our lives.

Chadwick's drawings are characterized by a strong spirit of geometrization, evident here in the skeletal pattern of lines. They show him concerned with a three-dimensional problem, not the production of a pretty drawing. His draughtsmanship retains something of his architect's training, and in the single sketch there are indications similar to those observable in Reg Butler (likewise architect-trained) of planes of reference, as if we were seeing the construction in plan view. In the sketch-group the sculptor is concerned with the frontal shape and focal point for the eye.

Barbara Hepworth's semi-open structure is purely abstract, an exercise in geometrized spaces. The absence of any self-evident representational element endows her

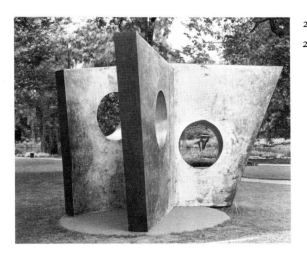

279 (above) BARBARA HEPWORTH *Oblique Forms* 1968

280 HEPWORTH *Three Obliques (Walk In)* 1968

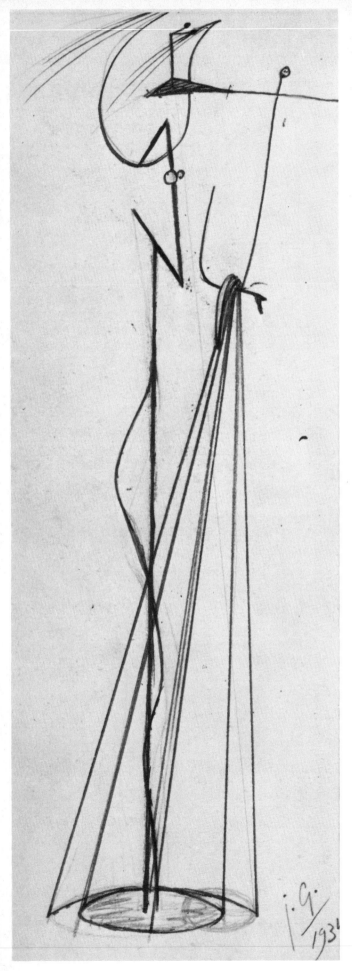

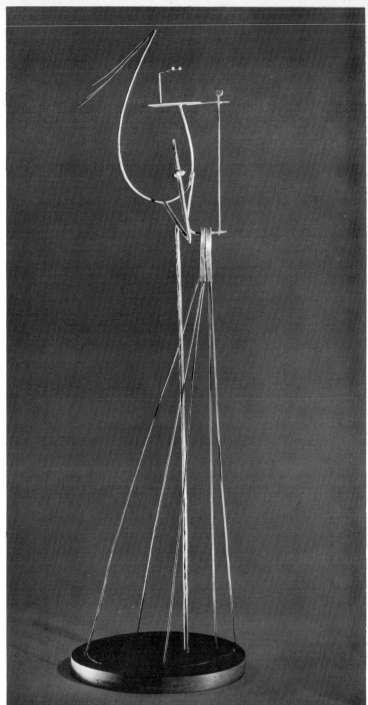

281 (left) JULIO GONZALEZ Drawing in *Petite Maternité* series 1934
282 (above) GONZALEZ *Petite Maternité*, c. 1933–4

work with a certain austerity. But to deny its emotional appeal would be like denying the same to a Bach fugue because of its underlying formal framework. In her case we recognize the polarization of two sources of inspiration – the crystalline forms of organic nature and the lyrical impulse derived from communion with the hills and, above all, the cliffs and the sea, and, by association, with the dolmens and standing stones of Cornwall. Titles like *Menhirs*, *Sea Form*, *Rock Form*, *Two Ancestral Figures* (a rare hint of anthropomorphism) are in a tiny minority among those with geometric points of departure, such as *Square Forms with Circles*, *Sphere with Inner Form*, *Rhomboid*, and the bronze which is our present concern, *Three Obliques*. Its sub-title, *Walk In*, an invitation to explore the composition from every angle and at leisure, should encourage the viewer of Barbara Hepworth's drawings and sculpture to evaluate the human, as well as the purely formal, appeal of her work as it deserves. The drawing she associated with *Three Obliques*, in her favourite medium of oil and pencil, is a two-dimensional synthesis of the sculpture. In her skilled superimposition of the component forms we are able to read the whole like some intriguing puzzle. Colour as a background to the pattern of straight lines and circles mitigates their severity. Its application in broken areas of related tones has a similar effect to the brown surface of the bronze, patinated in green and off-white, which helps it to appear less stark in an open-air site. The viewer's eye appreciates these textural qualities and their role in the total effect. In the case of no other sculptor is a study of the indirectly related drawings more rewarding.

There could hardly be a more obvious claimant to the title 'spatial sculpture' than the *Petite Maternité* by Gonzalez, and for this reason it is more appropriately discussed here than under the heading 'obsessive themes'. In the drawing illustrated we have the key to the original idea. This piece belongs to the period 1931–6 when Gonzalez made some of his most original contributions to sculpture in space – humanizing, poeticizing as it were, the more rigid aesthetic and mathematical principles of the Constructivists. 'The truly novel art', he said, 'is quite simply inspired by Nature and executed with love and sincerity.' It was the period of his *Woman dressing her Hair*, with which *Petite Maternité* offers striking resemblances in the treatment of the analogies for hair and 'stalk' eyes.

Several drawings after 1934, bearing the title *Petite Maternité*, closely resemble the open metal filiform sculpture. This is virtually a drawing in three dimensions, presenting itself simultaneously to every viewpoint. The human form is evoked by conceptual references, without too much insistence, but sufficiently to aid us in the reading of the sculpture, which in no way depends on its title for enjoyment. In this it is a far cry from the *Maternité*, subsequently known as *Montserrat*, shown in the Spanish pavilion of the Universal Exhibition in Paris, 1937 – an aggressive mother wielding a sickle in her right hand and holding a child in her left arm. This is realized in the mood and welded-iron technique of the *Montserrat* to be considered in the final chapter of this book. The two conceptions of 'maternity' underline a duality of attitude – the patriot and the poet – each with an appropriate idiom for its expression.

It is the material that dictates to us our creation.

BRANCUSI

The material is secondary to the idea.

HENRY MOORE

Drawings for metal constructions and for models made from materials such as expanded cut polystyrene, which are usually non-figurative, have an affinity if we compare them as a class with preparatory sketches for figurative models, fashioned in wax or plaster.

Geoffrey Clarke is a modern artist-artisan, carrying out his own casting in aluminium in his Suffolk studio.[12] This practical experience, following his art school training, has led to many commissions from leading English architects, notably Sir Hugh Casson and Sir Basil Spence, and, more recently, for environmental sculpture (Aldershot Civic Centre, 1973). His *Battersea I* is a free-standing piece, not associated like most of his artifacts with architecture or specific environment.

Clarke's original monotype method of drawing for sculpture has already been described in the section on open-air sculpture. It has been particularly successful for the *Battersea* series. The shapes are not merely abstract, they carry animistic overtones – a nostalgia for primitive agricultural implements is evoked by these earth-

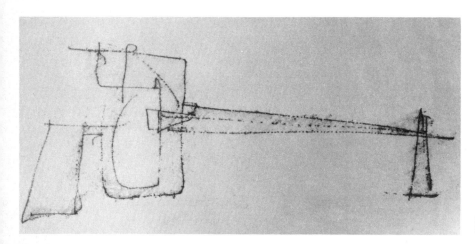

283 GEOFFREY CLARKE Monotype drawing for *Battersea I* 1962

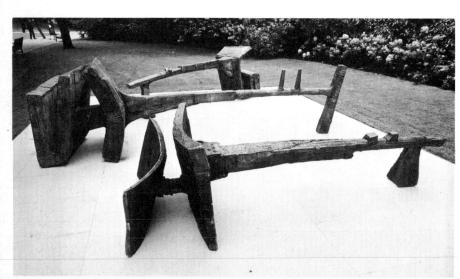

284 CLARKE *Battersea Group* 1962

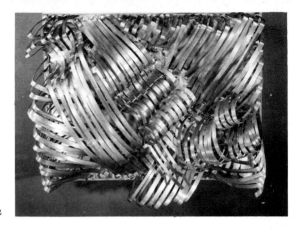

285 ZOLTAN KEMENY *Optimized Image* 1962

286 KEMENY Study related to *Optimized Image* 1962

embracing horizontals, raised on short bars or wedge-like supports. Clarke's language is fundamentally based on signs and symbols chosen for their pictorial qualities, and we should not try to discover further meanings. Each viewer, however, tends to find some subjective analogy – a measure of the artist's vitality. In the drawing shown, line and tone are happily wedded. The tone, produced by finger-pressure in the monotype, helps – to quote Henry Moore on sculptors' drawings – 'to break the tyranny of the flat plane of the paper and open up a suggestion and a possibility of space'. The particular sculpture to which the drawing relates, *Battersea I*, is in the background of the photograph; the whole group is shown to illustrate their variations on a theme. The three sculptures were originally exhibited together at Battersea Park in London in 1963.

Kemeny, a Rumanian who divided his time between Paris and Switzerland, worked mostly in brass and aluminium. His creations have mostly abstract titles, like *Synthetic Spirit* or *Seven*. The example illustrated, *Optimized Image*, evokes a Platonic abstraction, but an examination of the related drawing and the brass high-relief suggest a series of wave-like movements. Like Klee, Kemeny – who studied architecture – is fascinated by rhythmic structure. Viewers familiar with the painter-sculptor Pasmore's recent pencil drawings will find a kinship between the English and Rumanian artist. Kemeny's studies, usually done in pencil, present different aspects of the complex relief he envisaged.[13] The example shown here helps us to understand how he arrived at the interplay of straight and curvilinear strips. It represents the first step towards the composition of gleaming strips of brass, as vibrant with life as coiled springs, or the meeting of turbulent waters.

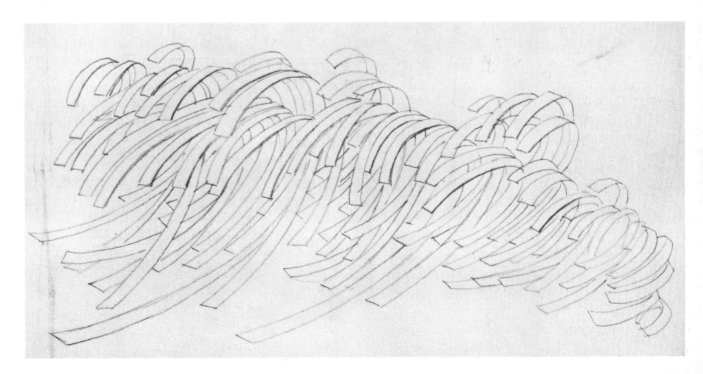

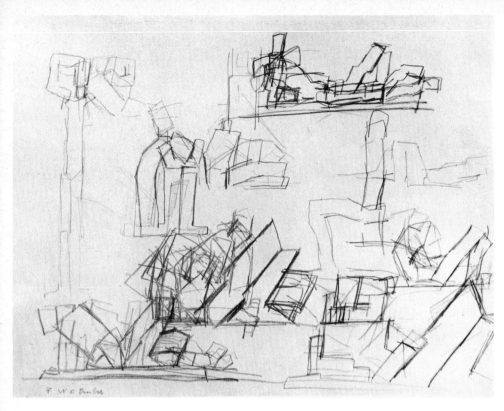

287 FRITZ WOTRUBA Sketches for *Recumbent Figure* 1962–3

288 (below left) WOTRUBA *Recumbent Figure* 1963

289 (bottom left) ISAMU NOGUCHI *Woman (Rishi Kesh)* 1956

290 (below) NOGUCHI Sketches for *Woman* 1955

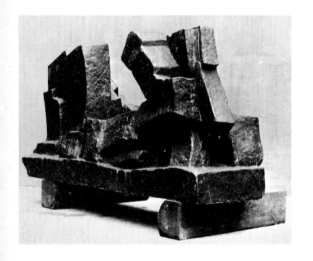

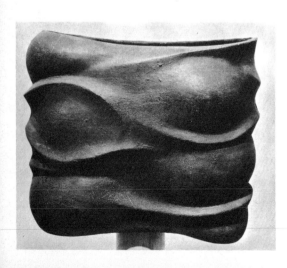

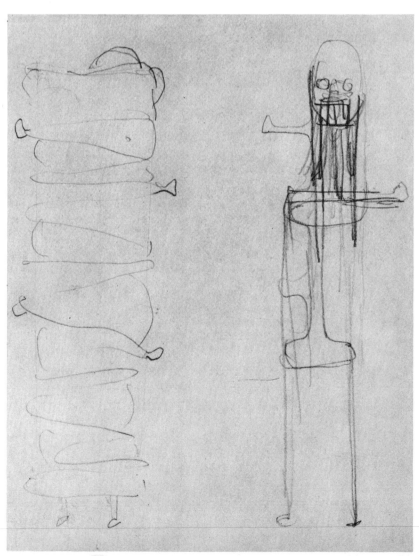

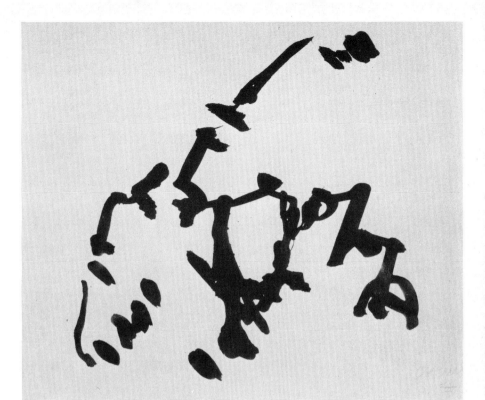

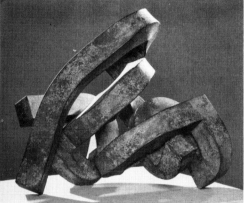

291 EDUARDO CHILLIDA *Modulation of Space* 1963

292 CHILLIDA Sketch for *Modulation of Space*

Wotruba's bronze alone among the works considered in this section is anthropo-centric, to the extent that it is based on sketches of recumbent and squatting figures which the sculptor has built up into a unified whole. These rough, vigorous pen sketches represent initial stages in the building-up of masses composed of inclined cubes and cylinders, relieved by the occasional segmental arc. A parallel in painting would be Cézanne's reduction of human form, in more figurative terms, yet on simi-lar analytical principles. These idea-sketches of elements for a composition, evidently executed with great rapidity, reflect the tremendous energy of Wotruba's creative impulse. They should be compared with the more precise idiom of the drawings for bronze reliefs and caryatids (94). His statement: 'the human body has never ceased to be the main source of my work,' is implicit in both subjects, but in the present examples more as a point of departure.

Noguchi describes his work as being basically concerned with morphologic quali-ties. Certainly his free-style, exploratory drawings, such as the present examples, are not merely abstract pattern (as the right-hand sketch demonstrates); but they do show his preoccupation with the idea of a repeat-pattern that fascinated him in Brancusi's famous *Endless Column*. We are also aware of an Oriental symbolism in the soft flow of rounded and hollow curves in the final object, which he calls *Woman (Rishi Kesh)*. Furthermore, at that time (1956), he was finding inspiration in the iron pots tradi-tionally cast in Gifu, in Japan. As often, Noguchi uses a technique and material which in one way or another seem contradictory to the theme. Just as elsewhere he places a heavy carved block of granite, apparently balanced – but in fact grooved in – on a thin board, so here we see him using the unmalleable material *par excellence*, cast-iron, to give an impression of feminine fluidity and softness. The result is a minor work of undeniable authority.

The title of Chillida's wrought-iron sculpture *Modulation of Space* (1963) is a signi-ficant declaration of intent. 'I am not concerned', he writes, 'with the space that lies

157

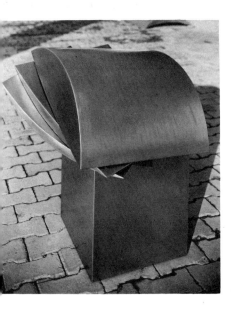

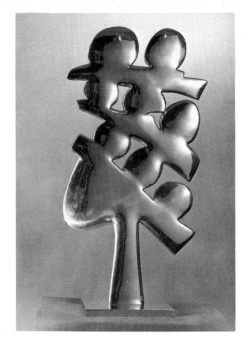

outside the form which surrounds the volume and in which the shape dwells but with the *space actually created by the shapes which dwell in them*[14] (my italics). It is an apt comment on these coils of iron that writhe like a snake. His obvious technical expertise was learned at a village smithy, to which he pays homage in his piece of 1950, *Dream Anvil*. His remarks on drawing could only come from a sculptor: 'Drawing entails laying down boundaries and chaining down the space as it tries to escape. One must think of space in terms of plastic volume, not pin it down on the surface of a flat piece of paper.' The drawing illustrated is alive with the same kind of tensions as the sculpture. Chillida no longer makes preparatory drawings for specific sculptures, but the reader will find no difficulty in identifying this Indian ink brush-drawing with the *Modulation of Space*, in parts quite precisely. The bold, thick strokes have the feel of wrought metal. Everything is unambiguously resolved in terms of simple line and curve.

The drawings by Erich Hauser, informed by a more geometric spirit, are even more to be thought of as equivalents, executed side by side with his sculptural projects in stainless steel. Hauser learned steel-engraving as a graphic art before learning to bend, weld, hammer and file metal in sculpture. His drawings (and etchings and engravings) all show the same stripping down to essentials, and a similar refinement of line. They presage the technical vigour of his sculpture. Although he is one of the youngest sculptors in this book, his work (represented, for example, at the São Paulo Biennial of 1969) is widely recognized. The sculpture illustrated (of 1971) was executed shortly after the ink drawing. Everything – line, angle, segment of circle – combine to suggest tension. One thinks of Brancusi's warning: 'Do not enter this studio unless you are a geometrician.'

Hajdu's drawing for the duralumin *Tentative XI* is in the nature of a precise 'pattern', in which one notices certain shapes that recur in his work. For example, the lower left-hand curve and the low right-hand shape that act in counterpoint are echoed in *Lia* (422). The drawings, though *premier coup* in execution, are the fruit of long exploration, and represent the final reduction. (The bracketed date on the drawing, 1960–6, indicates the long period of gestation.) The sculpture itself is *taille directe* – 'direct cut'. The sheer work involved will be obvious.

293 (opposite) ERICH HAUSER *Drawing No. 35* 1970

294 HAUSER *Curved Surfaces* 1971

295 ETIENNE HAJDU *Tentative XI* 1963

296 HAJDU Drawing for *Tentative XI* 1960–6

159

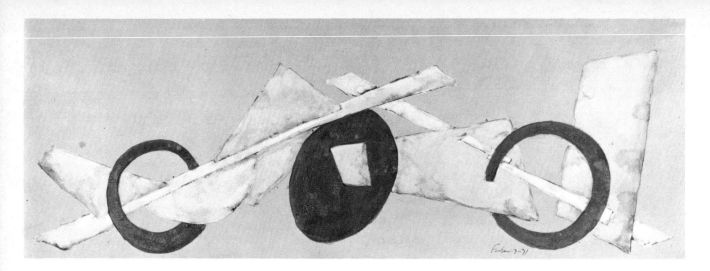

Hajdu's use of duralumin is one of a succession of experiments in cut and spot-welded metal. The essence of the design is a silhouette with rounded edges, suggesting a background space.

The work of the American sculptor Herbert Ferber could equally be discussed as 'open sculpture', but his total commitment to experiments with metals – bronze, copper (in a linear as opposed to volumetric sense), lead and steel – and strong underlying geometricization in the present work chosen to represent him, brings it closer to that of the sculptors considered in the present grouping of 'constructions'. Ferber is perhaps best known for his variations 'Homage to Piranesi' (1962–3) widely exhibited internationally (e.g. Battersea Open-air Exhibition, London, 1963, 'American Sculpture of the Twentieth Century', Musée Rodin, Paris, 1965), the Battersea example – not unlike some of Chillida's work – consisting of a complex, linear pattern of twisted bronze, appropriately imprisoned in an open tetrahedral frame. The gouache drawing for *Egremont* of 1971 presents the essential ingredients of the composition already marshalled for the sculpture. Everything is there – the contrasted forms, the rectangular buttress, the angular thrusts polarized in a satisfying harmony; a sculptor's drawing *par excellence*. The important modification in the Corten steel structure *Egremont II* (1972) is the raising of the central triangle formed by the intersecting cross-bars (that of the drawing seems to sag, in comparison), thereby strengthening and stabilizing the tensions. The addition of flanges to the buttress and the cross-bars gives the whole piece a further solidity, with an important potential for the play of shadow. Although the component parts are geometrical figures – circles, discs, triangles, etc. – the eye finds repose in more familiar shapes, comparable to those we see in Geoffrey Clarke's *Battersea* pieces (shown in the same exhibition of 1963), which recall everyday objects, oars, hoops, a rudder, and humanize the composition without seeming to be in any way gratuitous adjuncts.

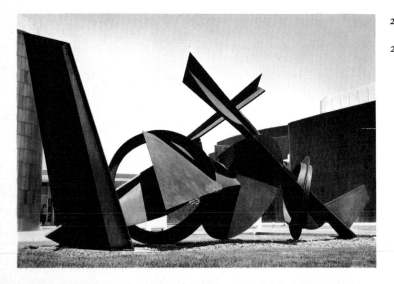

297 (above) HERBERT FERBER Drawing for *Egremont* 1971

298 FERBER *Egremont II* 1972

MEASURED AND SCHEMATIC DRAWINGS

The constructions in this group exploit a variety of modern materials, including polyester resin, polyvinyl, kapok, fibreglass and formica, as well as aluminium and wrought and welded steel. Some of them are figurative or have in them a representational element, others are abstract or near-abstract. But the drawings associated with them all have in common that they are essentially working drawings, made purely for the sculptor's needs, and bring us close to the final realization.

Berrocal is Spanish by birth but elects to live in Italy. He is a craftsman-constructor of sculpture since not only does he cast his own work, but his constructions are 'démontables' ('take-down'), composed of many pieces that dove-tail together like a three-dimensional puzzle. Some in fact offer variations of form. Another feature of this sculptor's work is that many of his pieces are designed as multiples, running into scores of copies as opposed to the normal maximum of about ten casts (for bronzes, etc). The originals are made in wrought and welded steel, the rest cast in copper. However, Berrocal restricts the multiples to the very small works; the rest have usually six copies cast in bronze. Some are made of pieces so complicated that instructions are required to assemble them. The result is fascinating and original – the whole is visibly more than the sum of the parts. The *Caryatid* illustrated is an amusing classical pastiche,

299 MIGUEL BERROCAL Working drawing for *Caryatid*

300 BERROCAL *Caryatid* 1966

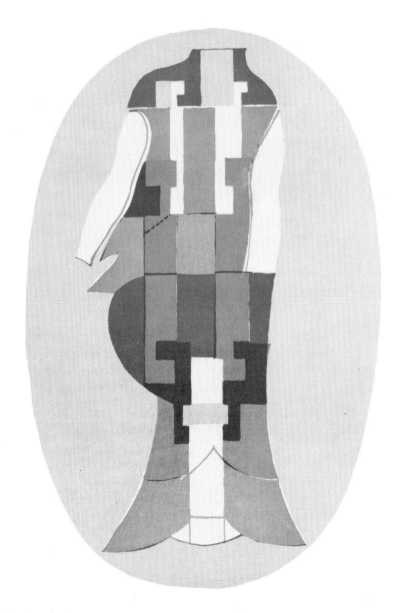

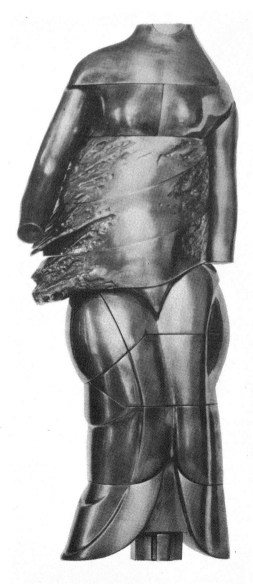

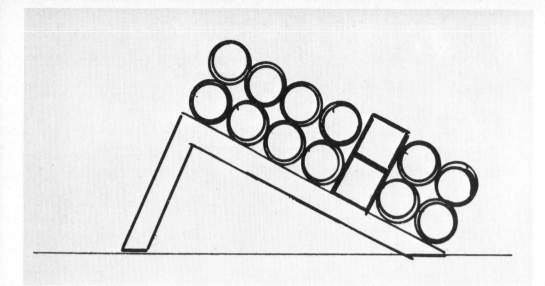

with a base that recalls a fish-tail and is sculpturally essential; one thinks of the devices used in Greek and later classicizing standing nudes to provide a more satisfactory base, constructionally and aesthetically, than two spindly legs. The figure is composed of twenty-two soft steel 'elements', as shown in the drawing, which is also a key to the way the elements are integrated.

Berrocal also uses single-hatching and cross-hatching techniques in coloured chalks to differentiate the component parts (VI, p. 166). The care with which he selects the combinations of colours – blue intersecting yellow, red in parallel with blue – show his concern for the drawing as such. Sometimes – as in *David* (shoulder) – he uses shading in parallel to indicate the third dimension. These drawings are necessarily complemented by detailed measured plans on squared paper.

Caryatid stands midway between the simpler and the more complex subjects, which vary between the two elements of *St Agatha* of 1964, and the forty-one, no less, of *Adamo Secundo* of 1966. They all have some recognizable figurative feature. Berrocal varies the finish – the *Caryatid* has an edition of five in frosted bronze, out of a total of nine.

This gifted sculptor has more than a craftsman background; he studied mathematics and science at Madrid university, and followed that with a period of architectural and sculptural studies. By the age of twenty-five he had had his first one-man exhibition in Rome; by 1966 he had won the sculpture prize at the Paris Biennale.

Louise Nevelson, the doyenne of American sculptors and a veteran of the heroic WPA period, has created her own particular kind of assemblages, very different from

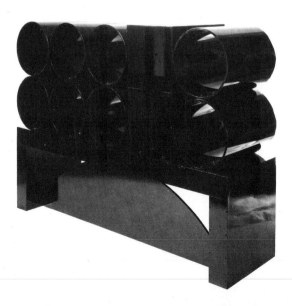

Berrocal's interlocking artifacts. Her work stands midway between that of some of the Russian constructivists (she is Russian by birth) and the architectonic creations of Tony Smith. The comparatively large scale of her most important compositions has led to a lack of one-man exhibitions of her work outside America, though individual examples of her assemblages of box-like frames are ubiquitous in European galleries and collective exhibitions. The strange evocative objects, some, like table-legs or balusters, spheres, familiar in our daily experience – others with a surrealist air of functionless tools, made in black wood or, more recently, formica, packed in vertical, asymmetrical arrangements, fascinate the eye. Her schematic drawings – hard to come by – do not do justice to her original vision, but the example shown of a section of one of her *Atmosphere and Environment* series of 1966, another different development, is at any rate a testimony to the planning that precedes each detail. The sculpture – aluminium and black epoxy – shows some deviation from the sketch-plan, but the essential rhythmic pattern of the drums, laid side by side with the contrast to the intervening cube, is adhered to.

The work of the Italian sculptor Gio Pomodoro is likewise abstract, and informed by a similar geometric spirit. He is however less pragmatic in approach than Louise Nevelson, and the mathematical bias is omnipresent. His *Sun of Cerveteri* is a monumental construction in black polyester resin. Its execution required working drawings of great precision, the details of which are considerably clarified by the use of colour and written directions. The sculpture creates a sense of movement and mystery, as the pools of light move over and are modulated by the black surface. The diagrammatic drawing (V) has the beauty of an inspired blue-print and needs no comment. It may be helpful to an understanding of the attitude of this sculptor to drawing to quote his comments in a letter to the author: 'Your projected book interests me particularly in the sense that it shows an effort to clarify that "little" which is wrenched away from the "mystery", the "occult": differentiating between the twin "anime" of the object "sculpture" – that is to say the "project" and the material, physical structure. The "project" (drawing) is agile, weightless; the "object" (sculpture) is cumbersome, heavy. The problem is to reconcile these opposite poles and yet preserve the "anima" of the original concept.'

The study for *Contacts 2*, dated 1970, detailed diagrammatic drawings in coloured and black chalk (on a sheet of proportions unsuitable for reproduction here), reveals the amount of calculation and reflection that went into that work. We see a series of geometrical drawings, orthographic projections, precise diagrammatic views of the solid form with the 'external space' and 'internal space' and various 'points of contact' which give the work its name. The sheet contains the sculptor's private comments (compare Moore's on some of his sketch-book pages): 'consider the *block*. It is the *solid*, the solid in the space, the solid is contained by it' (considera il *blocco*. E il *pieno*, nel *vuoto*, il pieno e contenuto da questo); memoranda to himself about Euclidean and Cartesian principles, and the essential question: 'Come rappresentare *il vuoto*?' (how represent *space*?). Here we have the ultimate theoretical and intellectual approach to a sculptural problem in progress. The 'layout', the exquisitely sensitive drawing and calligraphy, also reveal the sensuous element in Pomodoro's nature.

Like that of Gio Pomodoro, Tony Smith's work bears strong evidence of the Cartesian approach, but his inspiration is not purely geometrical, it is rooted rather in nature's more complex manifestations – crystalline and biomorphic. Some of his earlier work seem like experiments in plane geometry – for some time he taught architectural and mechanical drawing. He explores opposing tetrahedral forms in the

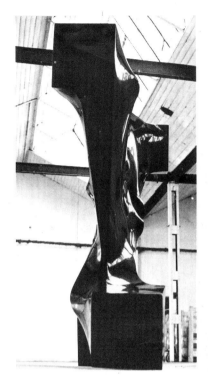

303 GIO POMODORO *Sun of Cerveteri* 1970 (*see also V, p. 165*)

163

same way as McWilliam in the *Hampstead* open-air bronze, though Smith's works are simpler and entirely lacking even contextual figurative form. Readers familiar with his creations of the geometricized slab type that precede *Smoke* will find parallels in the steel sculptures of Hauser (Swiss) and Kornbrust (German), that may be traced to a Bauhaus influence at a generation's remove. Tony Smith is American-born, and therefore the more in character in thinking in terms of large-scale artifacts to match an ambience of vast spaces and towering buildings – factors that affect even sculptors who are American only by adoption, like Lipchitz (*Between Heaven and Earth*), and have obliged the British sculptors Moore and Hepworth to plan their respective sculptures for the Lincoln Center and United Nations complex in similar terms.

We can perceive the promise of Tony Smith's fascinating schema, *Floorplan for Smoke*, even if we cannot 'read' its full three-dimensional implication and potential of modular repeats. The piece is aptly named; the vast open structure, far from being an imprisoning geometrical grid, allows us, partly because of the bevelled edges, to wander in and about the honey-comb of space-lattices. It is not easy to appreciate this 24-foot-high structure from the fixed viewpoint of the photograph, but the painted wood mock-up and ground-plan enable us to situate the eight pillars – one, as it were, leading in the modules that enclose rhombic dodecahedrons, ultimately intended to be made in steel.

Kornbrust, like Tony Smith, is severely classical in temperament, and prefers to work on the grand scale. There is a remarkable but coincidental resemblance between Smith's Bennington *Semi-architectural Structure* of 1961 and Kornbrust's *Polygonal Forms*.

Though widely known and appreciated in West Germany where he has carried out innumerable public and private commissions, Kornbrust has not yet exhibited in Britain or the USA. His work is divisible into several phases, some unfortunately not easily 'pointed' by drawings. The marble *Polygonal Forms*, carved *in situ* and completed in 1969, is related to the attractive diagrammatic drawing *Polygonal Forms* of two years earlier which involves a double perspective – side elevation and aerial view combined. The precision line-drawing of ten polygons, complete with measurements, relates to

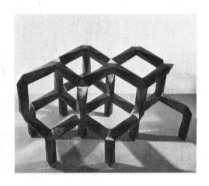

304 (top) TONY SMITH Floorplan for *Smoke* 1967

305 (above) SMITH Model for *Smoke* 1967

306 (right) SMITH *Smoke* 1967

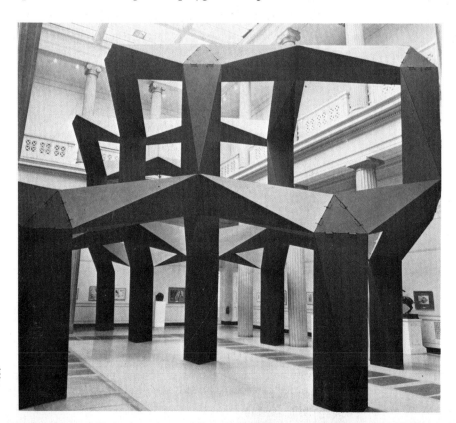

V (opposite) GIO POMODORO Working drawing for *Sun of Cerveteri* 1969–70, with indication of how sculpture turns on its axis (*see 303, p. 163*)

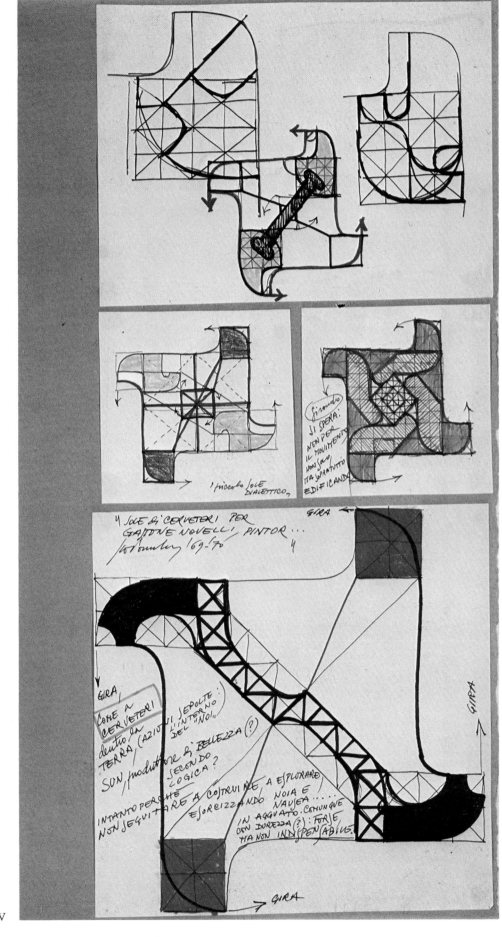

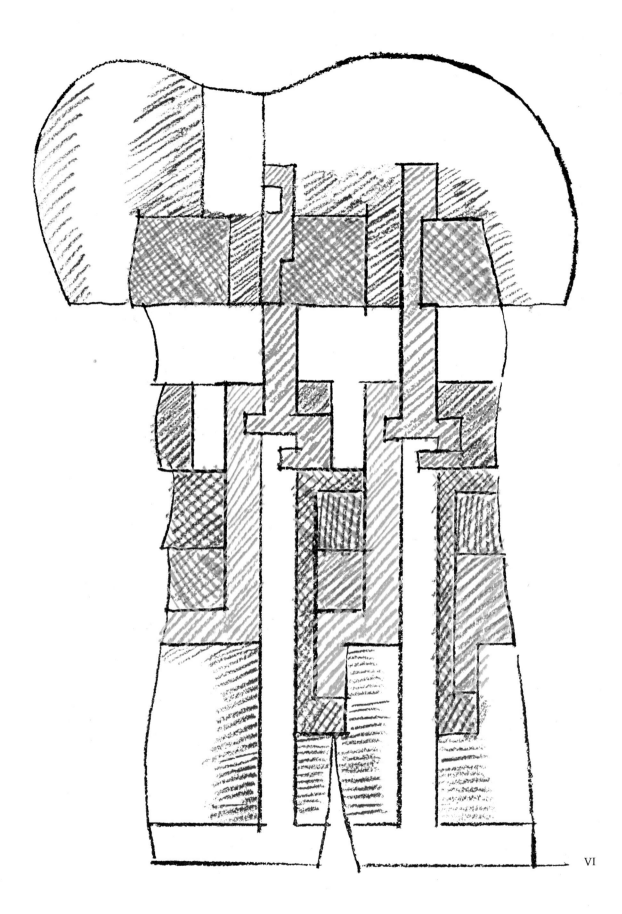

VI

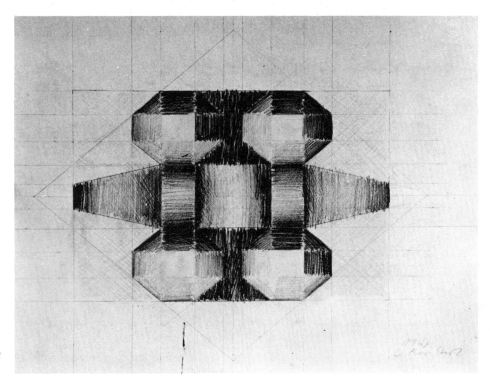

307 LEO KORNBRUST Drawing for *Polygonal Forms* 1967

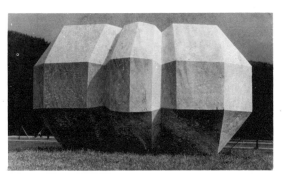

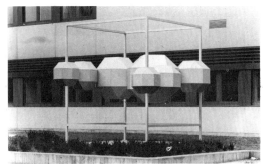

308 KORNBRUST *Polygonal Form* 1969

309 KORNBRUST *Polygonal Forms* 1969–70

310 KORNBRUST Drawing for *Polygonal Forms* 1969

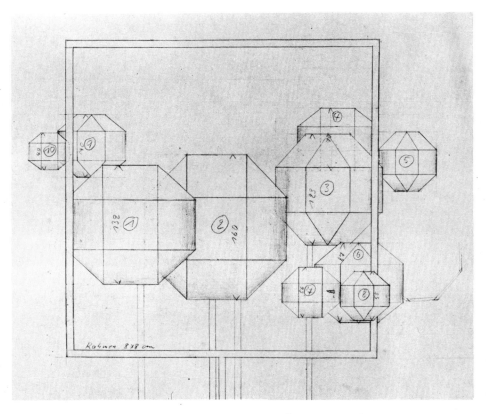

VI MIGUEL BERROCAL Drawing for *David* indicating 22 separate sections (*see p. 162*)

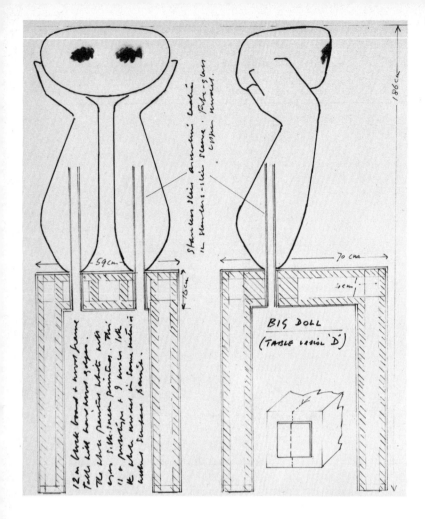

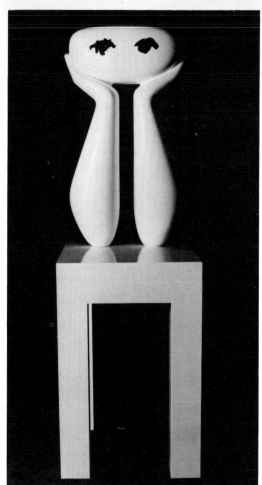

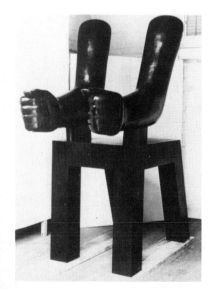

311 KENNETH ARMITAGE Working drawing for *Big Doll* 1969

312 ARMITAGE *Big Doll* 1969

313 ARMITAGE *Both Arms* 1969

the aluminium piece entitled *Polygonal Forms*, actually consisting of seven polygons, whose solid geometry makes an appreciable contrast with the flat surface of the building behind. Kornbrust shows an intuitive feeling for modulars of proportion, which like Le Corbusier he absorbed from a close study of the Parthenon and masterpieces of architecture based on classical canons.

Neither Armitage nor Oldenburg deserts the world of appearances for Platonic abstractions. Avant-garde in vision and technique, and fascinated by people and objects around them, both artists employ their own inimitable figurative idioms with a playful and refreshing exuberance. Oldenburg's preoccupation, like the Pop art painters', is with objects of mass culture, extravagantly realized in terms of three-dimensional glossies when the subject is some delicatessen fetish, more soberly and subtly represented in the objects chosen for illustration here.

The Armitage *Big Doll* belongs to a period immediately following his two years as guest-artist in Berlin, when he produced the huge *Arm* in polyester and glass-fibre, and is a light-hearted use of the same materials. The screen-printing used effectively for the doll's eyes is simulated in the working-drawing by felt-pen. The chair-base, not a mechanical necessity but essential to the total shape, is a development of the sculptor's *Both Arms* piece.

The hand-written instructions on the *Doll* drawing indicate the various materials to be used: 'stainless steel armatures' in the arms, 'fibre-glass upper material'; and for

the base, '12 m block board & wood frame table will have hard-wood edges. The whole painted white with eyes silk-screen printed. This is a prototype and I would like the whole model in same material without surface paint.' The dimensions are clearly given on the drawing. The 'emphasis by omission' of the torso is effective, and the profile-view carefully calculated. The head is an example of an almost reptilian 'period' shape, variants of which occur in sculpture by Moore, McWilliam and Chadwick.

If the sculpture of Oldenburg is a major contribution to the art of our time, he has also demonstrated his virtuosity and originality as a graphic artist. His break-through with soft sculpture is the most important aspect of his work, but the *Three-way Plug – Hard Model* is an interesting link with the Ready-made of the Surrealists. One of his aims is similar to theirs, namely to divorce objects from their normal contexts, and in his case, to high-light them by using 'alien' materials. The *Plug* construction is made of cardboard painted with spray enamel, the preliminary drawings are pencil and pen and ink shellacked. The drawing, a precise study for the construction, makes a striking contrast with the sketch-drawing for the *Soft Typewriter*, where the aim is purely exploratory. The latter is one of a series, though Oldenburg associates it with the model of the same year (1963) in vinyl, kapok, cloth and plexiglass.

About the *Three-way Plug* Oldenburg writes: '. . . it began with a loose drawing, followed by careful studies from the original and construction of the cardboard version. . . . Last summer I had a large steel version made, 108 feet long with bronze prongs which was half buried at Oberlin College, Ohio.' Such items seem midway between his usual soft sculptures and more unrealizable projects like the *Proposed Colossal Monument for the Thames Estuary: Knee* – a surrender to the American vogue for constructions in permanent materials with the air of a 'happening'.

Apropos the *Soft Typewriter* he states: 'The soft aspect of these works was not part of the original intention. I had discovered that by making ordinarily hard surfaces soft, I had arrived at another kind of sculpture and a new range of symbols. No. 61 [the work illustrated] is about the closest to a study from an original, recalling the bosom curve of a L.C. Smith I once knew. . . .' In a letter to Oldenburg I mentioned the

314 KENNETH ARMITAGE Studies for *Both Arms* 1968

315 CLAES OLDENBURG Drawing for *Three-way Plug* 1965

316 OLDENBURG *Three-way Plug— Hard Model* 1966

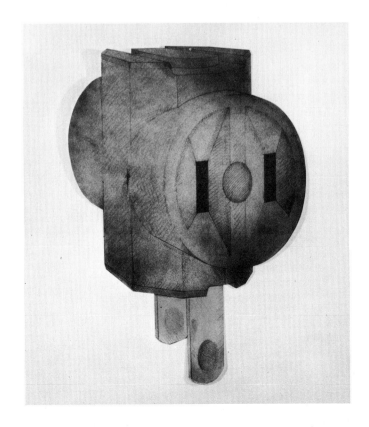

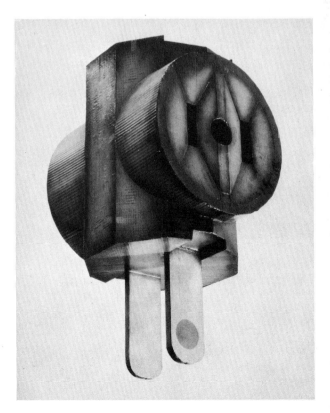

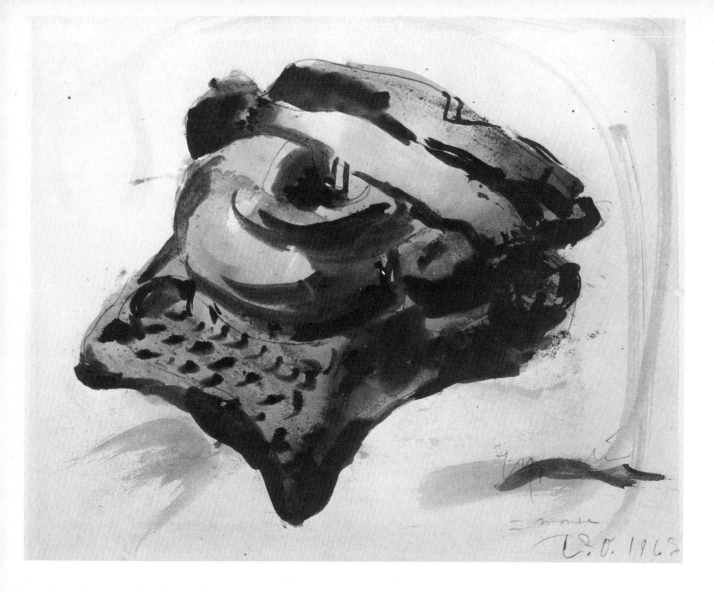

317 CLAES OLDENBURG Sketch for *Soft
Typewriter* 1963

318 OLDENBURG *Soft Typewriter* 1963

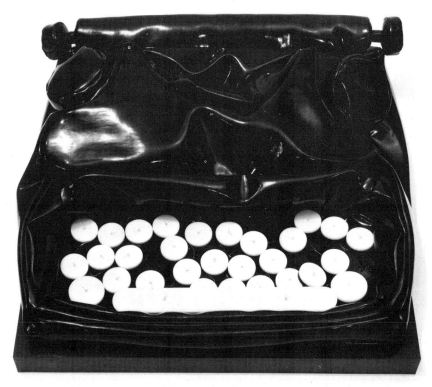

element of incongruity in his work, quoting the famous surrealistic bird's-nest tea-cup, and the mental uneasiness that large soft objects can create. He replied: 'You ask about the incongruity element. I use contrast as a motive which does make use of incongruousness. I "think the opposite" and produce a new thing that contains its opposite, e.g. telephones, bathroom furniture, typewriters. The suggestion by available material also plays a part. . . . The availability of black vinyl in late 1962 suggested sewing of a telephone, of white – the sewing of porcelain or enamel effects. Subjects are chosen for their adaptability to the representation of material conditions and states. Incongruity is a means of intensifying sensation of material states and conditions. The identity of the object, as I insist by my arbitrary comparisons of uncomparable things, is not so important. It is the concentration of a material effect in a limited form that I look for – these I use as objects. It is not a surrealist purpose.'

The *Bedroom Ensemble* is a combination of soft and hard sculpture. Oldenburg thought up the idea 'when', he says, 'I was 3,000 miles away from the Sidney Janis Gallery' (where it was to be mounted). 'I plotted the room on my floor in the stucco replica of St Marks in our phony Venice.' 'The pressure toward touching,' he continues, 'is intensified by devices that prevent touching, like the silver chain in the door to the *Bedroom Ensemble* . . . or the glass of the pastrycases.' Readers familiar with his work will think of other examples. The wash drawings (watercolour and crayon) for *Bedroom Ensemble* and *Pillows* illustrate Oldenburg's free-style approach in the preliminary studies towards the definitive work. Evidently much importance is given to the setting of the objects in the space continuum, and to such details as the precise lift of the pillows against their zebra-striped bedhead.

319 CLAES OLDENBURG Study for *Pillows* 1963

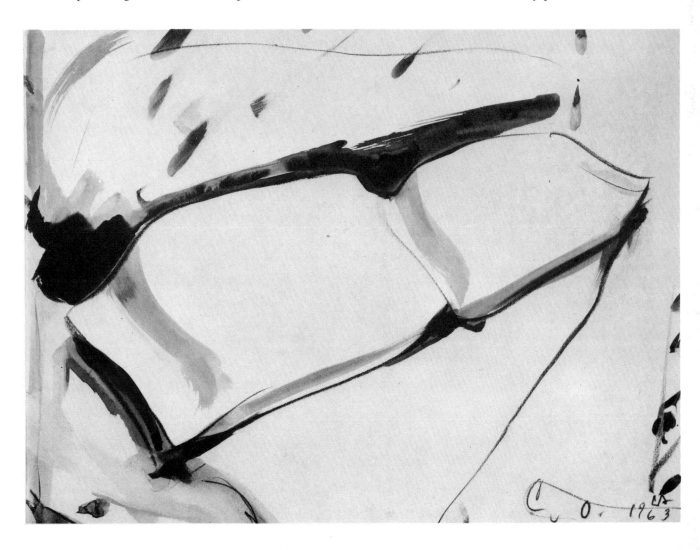

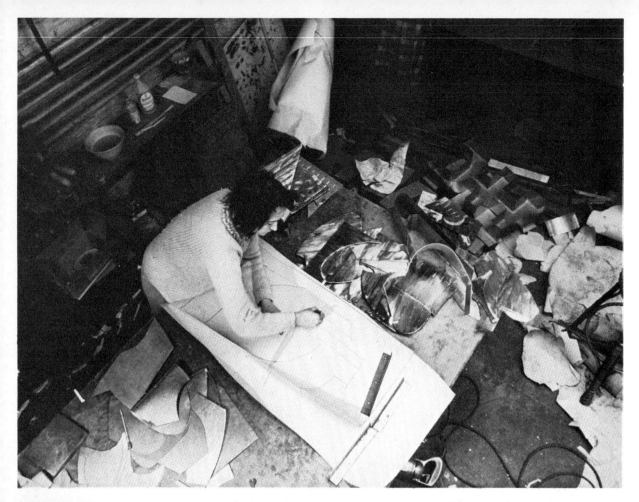

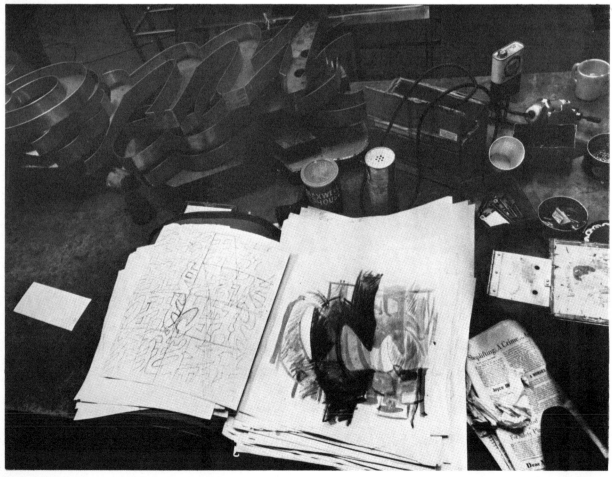

The Greek-born Chryssa, working in America, is a suitable figure on whom to end in a chapter that deals largely with sculptural innovations and new materials, since she is above all a sculptor in light. She has exploited the potential of neon captured and manipulated in tubing of her design, often boxed in plexiglas that 'repeats the work in all directions'. Yet, she seems justified in her claim that 'when the sculpture lights up, it is only one aspect of how it works'. In other words, great expertise goes into the convolutions of the lighting tubings, and as she boldly asserts: 'without electricity my sculpture will survive'. Her most ambitious creations up to date, however, have emerged from her explorations of the potential of large casts of alphabet letters (italic or roman, arranged horizontally or vertically) viewed as arrangements of form, like reliefs. Two of the most felicitous are *Times Square (air)*, of 1961–2, a detached high-relief of italic letters (almost swash) skilfully composed, with a single section of intermittently illuminated strip-lighting 'air'. The second and most impressive creation is *The Gates to Times Square*, on which the photographs reproduced show her at work. The book of pencil sketches, the assortment of metal forms around her, are evidences of 'labour spent and joy at random' – her two years of solid work on the project, certainly justified in the strikingly original result in an assortment of old and new materials – welded stainless steel, neon-tubing, fragments of commercial signs, rolled plans (textural and symbolic) and cast aluminium.

320 (opposite above) CHRYSSA Work in progress on *The Gates to Times Square* 1964–6

321 (opposite below) CHRYSSA Sketches for *Times Square* piece 1961–2

322 CHRYSSA *The Gates to Times Square* 1964–6

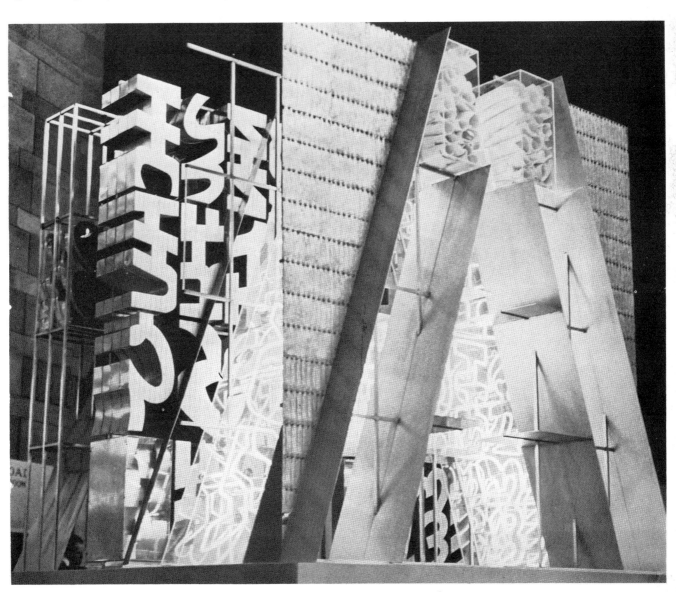

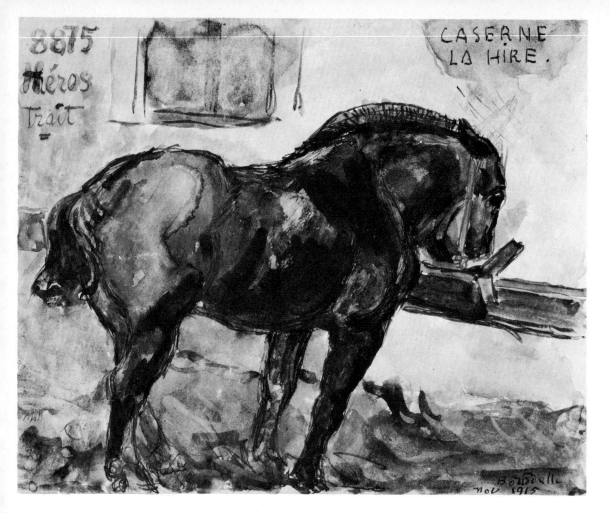

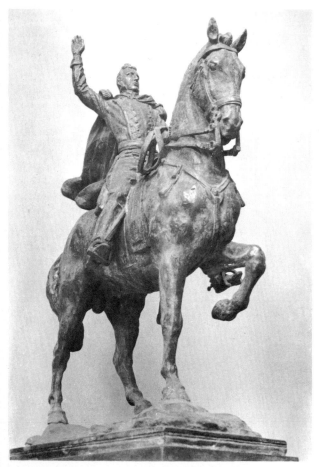

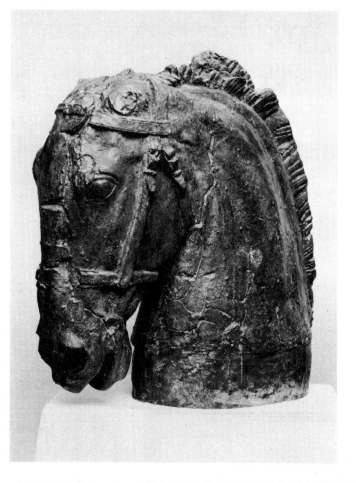

8 *Equestrian sculpture, animal, bird, fish*

EQUESTRIAN SCULPTURE

> A statue is a god or an ex-voto become representation and object.
> MALRAUX

Old-style equestrian statues are still in demand, but it is no longer generally thought necessary to provide the living pedestal of a horse for the modern 'hero' or leader. The twentieth-century equivalent of the Renaissance patrician or condottiere is the defiantly standing Churchill or the striding figure of Epstein's General Smuts. However, an equestrian statue was thought suitable for the United Nations complex in New York, and stylized or social-realist versions of equestrian subjects will doubtless still appear from time to time.

One of the more successful equestrian statues of the first quarter of the present century was the monument to General Alvear in Buenos Aires, executed by Bourdelle. It is in the heroic Renaissance tradition of the Quattrocento, and if there are no slaves or prisoners at the base, at least there are allegorical figures (Liberty, Strength, Eloquence and Victory).

Bourdelle made innumerable studies for his major sculptures, and particularly for this equestrian memorial to the hero of the Argentinian War of Independence in 1814–15. At least he could study the animal 'horse' at first hand and lost no opportunities for doing so. His first drawing, a naturalistic sketch in wash and pen, dates back to 1915 and was done in a military barracks during the first World War. This and a whole series of pen and gouache studies of the horse in various positions – sometimes lying down, sometimes between the shafts of a cart – show his eagerness to acquire a thorough understanding of the personality of the animal before attempting to formalize it in an equestrian statue. A degree of stylization was obviously necessary, as reflected in this *modello* of the bronze head which links up with the Renaissance treatment of the subject, and can be compared with the Uccello fresco (of Sir John Hawkwood) in the Duomo in Florence, and one of the Leonardo studies for the Trivulzio monument in the Royal Library, Windsor Castle, discussed in the Introduction.

With the passage of nearly half a century it is not surprising to find a new attitude expressed by a modern sculptor. 'I am no longer seeking in my equestrian figures', says Marino Marini, 'to celebrate the triumph or any victorious hero. . . . On the contrary I seek to commemorate in them something tragic, in fact a kind of Twilight of Man.' This does not mean that he is unaware of his debt to the equestrian theme in Antiquity. He admits to the influence of Roman as well as Gothic treatment in his work of the 1930s. Indeed the fact that so many of his 'horse and rider' subjects are carved in wood and coloured is a link with certain highly-stylized medieval equestrian church statues to be found in Germany. But Marini's use of colour is purely decorative.

Opposite:

323 ANTOINE BOURDELLE Equine study 1915

324 BOURDELLE Monument to General Alvear 1923

325 BOURDELLE Modello for the monument to General Alvear, *c.* 1915

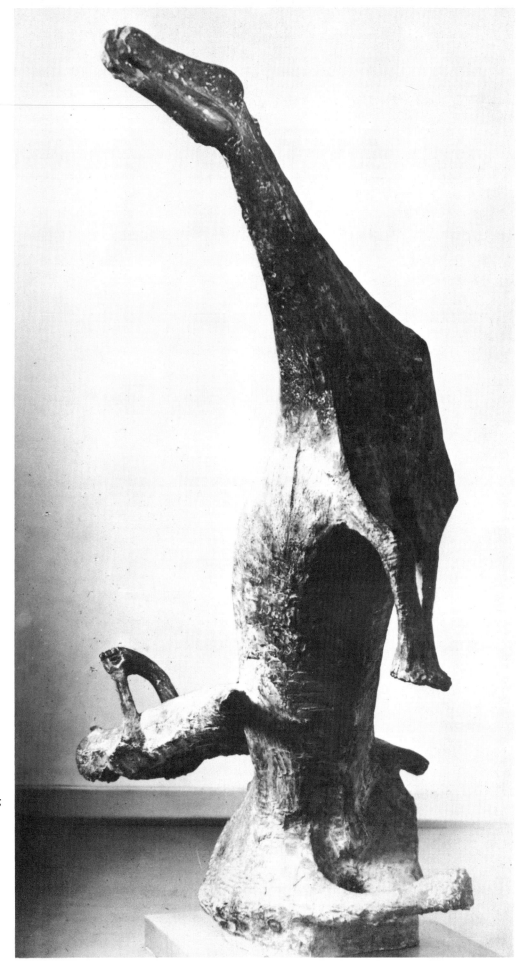

326 MARINO MARINI Drawing
related to *Miracolo* 1956

327 MARINI *Miracolo* 1953

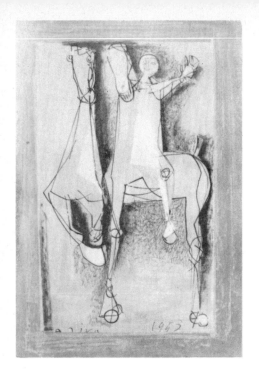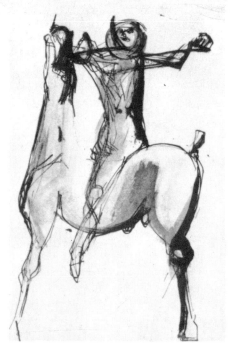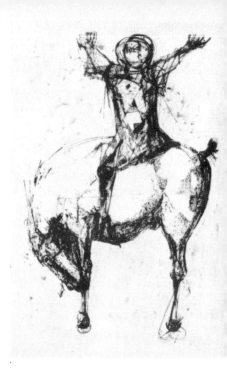

328–30 MARINO MARINI Studies for
Horse and Rider theme of (left to right)
1953, 1959, 1958

In Marini's equestrian themes one no longer thinks of a master-and-servant relation between rider and horse. Both are involved in what often seems a panic situation. In the version illustrated (326, 327) the horse is rearing perpendicularly on its haunches; in another version (Galleria dell'arte moderna, Turin), its elongated neck stretches agonizingly along the ground. In both works Marini extracts the full emotional potential.

His drawings, characteristically in oil and pencil like Barbara Hepworth's, relate to more than one sculpture, and the *Horseman* in painted wood of 1949–51 shows that his sculptures and drawings interact, and that sometimes a drawing is a reminiscence of a carving or bronze. His equestrian drawings should therefore be regarded – and this applies also to those of dancers and cardinals – as a repertoire of ideas. Note how, of the three drawings illustrated, the centre figure 'supplies' the raised neck of the horse of the sculpture, the right-hand figure the acrobat rider. Without the revealing dates we would imagine the sculpture to be a synthesis of the two.

The American Nadelman (VII, VIII, p. 183), although belonging to a generation for whom Antiquity and the Renaissance and Baroque were the dominating influences, evolved a strangely personal idiom for his horse theme. The bronze illustrated would seem more indebted to Oriental influence than classical. The drawing and sculpture, with their exaggerated curves, elegant legs and a little evidence of muscle, suggest this sculptor's predilection for female form, which is expressed in his work in a carefully balanced system of opposing curves. A modern Mannerist, he is important enough to have been represented some twenty years after his death at an exhibition of American sculpture at the Musée Rodin in Paris in 1965.

Compared with the Nadelman horse, Elisabeth Frink's are compact structures, informed by a knowledge of equine anatomy and experience of riding. This first-hand knowledge helps her to draw and model from memory, and has resulted in sensitive forms in which volume, as opposed to Renaissance musculature, plays the dominant role. Her horses express an ambivalent attitude towards the modern horse and its untamed ancestor, notably in some of her drawings, in which one is aware of a wildness akin to that of Delacroix's horses. The two present drawings, of calmer modality,

178

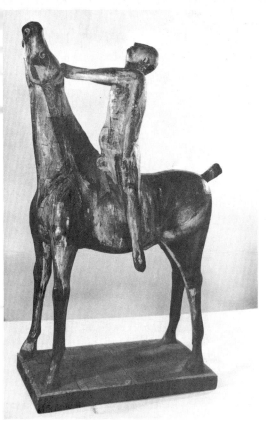

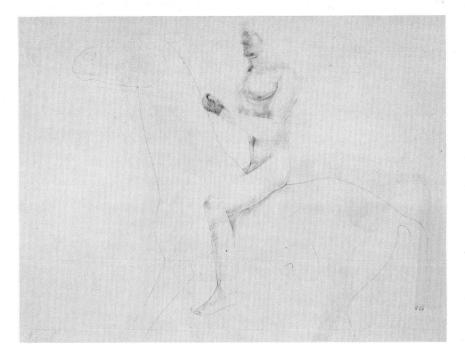

331 MARINI *Horseman* 1949–51

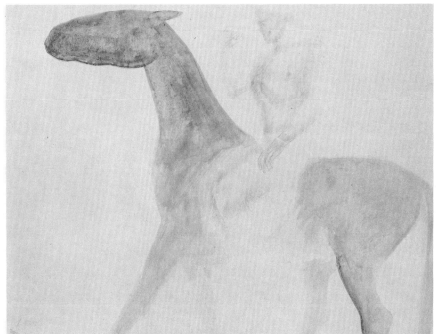

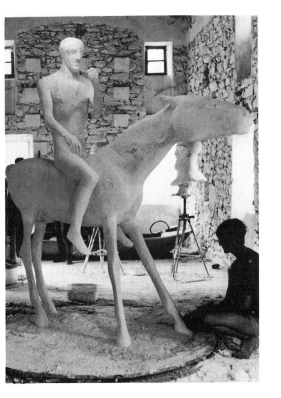

332–3 ELISABETH FRINK Studies for *Horse and Rider* 1969 and 1970

334 Elisabeth Frink in her studio with plaster master cast of *Horse and Rider*, 1969, and *Goggle Head* in background

are studies for the bronze *Horse and Rider*. The first pencil and wash concentrates on the defined planes of the head, the second prepares the general silhouette and the detail of the rider's left hand. The right hand is caught in a warding-off gesture. As often, Elisabeth Frink has taken only part of the drawing to a complete stage. This skilful use of space and a faint outline to suggest the form is a characteristic of one style of her drawing.

This applies equally to her independent drawings, for example her original illustrations for *Aesop's Fables*. But whereas in the latter her natural concern is to produce an attractive drawing in terms of the book-page, in the studies for a sculpture – which she always does in series to 'get the feel of a new theme which I can then express sculpturally' – her purpose is exploration of viewpoint and volume. We find studies of the rider reclining with one arm around the horse, others of him kneeling beside it which stress the bond of affection between man and animal but show poses she was unlikely to use for the final bronze. One becomes aware after looking at them that they have served not only for particular details – the splayed front legs appear in a somewhat terrifying drawing with the horse's head turned round aggressively towards the recoiling rider – but also for the expression of the final harmonious relationship. Elisabeth Frink's most recent sculpture on the horse theme has shown a greater concession to the naturalistic element.

ANIMAL, BIRD, FISH

> The animal holds great meaning for us.
> MARINI

Some of the most successful animal sculptures have taken the form of syntheses. Frink's *Boar* and Soukop's *Donkey*, both in Harlow New Town, Essex – a mecca of contemporary sculpture – suggest a compromise between a naturalistic realization and synthesis, in the same tradition as many animal carvings and bronzes of the High Renaissance, particularly those by the gifted pupil of Giambologna, Pietro Tacca. The last sculptor of note whose animal sculptures were compact Baryesque syntheses was Gaudier-Brzeska, in such subjects as his solid aluminium dog (Kettle's Yard, Cambridge) – a complete contrast to the naturalistic dog in Emilio Greco's Pope John relief or Giacometti's skeletal creature at the Fondation Maeght, St Paul de Vence.

Gaudier-Brzeska's most original creation in this genre is *Bird swallowing a Fish*, recording an aspect of the life-struggle in terms of volumes wittily counterpoised.

Gaudier is best known for his drawings in ink done with a fine pen – syntheses of a bird or animal in a few eloquent strokes with no attempt at shading – and for bold life-studies in black crayon. The *Bird swallowing a Fish*, however, with its whorls and largely decorative shading, could almost be taken for a work by Wyndham Lewis, leader of the Vorticist movement, with which Gaudier was of course associated. At the same time it conveys the essential information about the planes to provide a study for the carved plaster illustrated, and reminds us of Gaudier's dictum: 'sculptural ability is the defining of masses by planes.'

We now come to the claws, spikes and hooked beaks of the organic analogues, ubiquitous in the 1950s, that reflect, it would seem, the malaise of the post-war period, the tragedies of concentration camps, the despair of stateless and displaced persons. Compared with the 1960s, the 1950s was a period of subjective art. Certainly, the works we are dealing with owe not a little of their power to an evocative ambiguity.

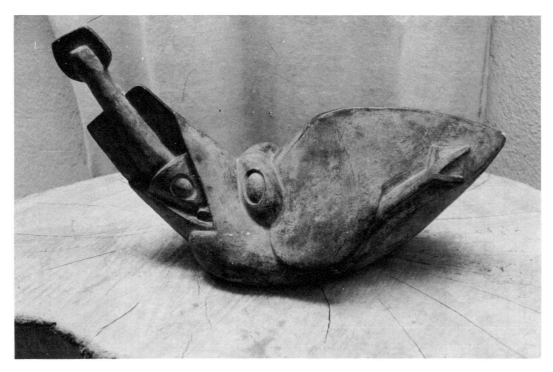

335 Henri Gaudier-Brzeska *Bird swallowing a Fish*

336 Gaudier-Brzeska Drawing for *Bird swallowing a Fish*

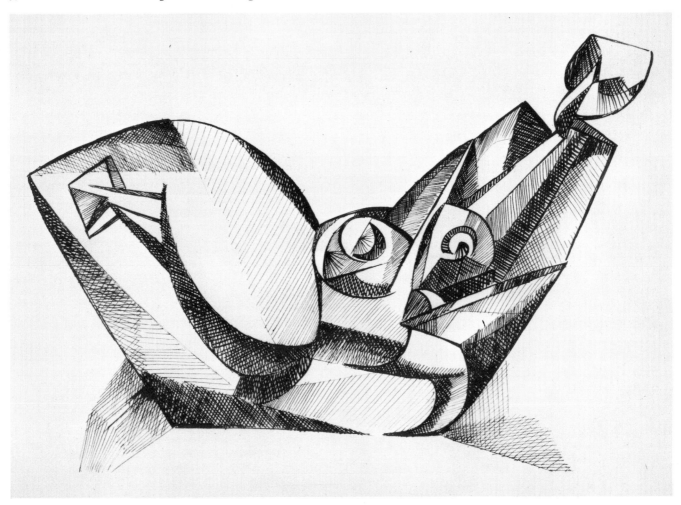

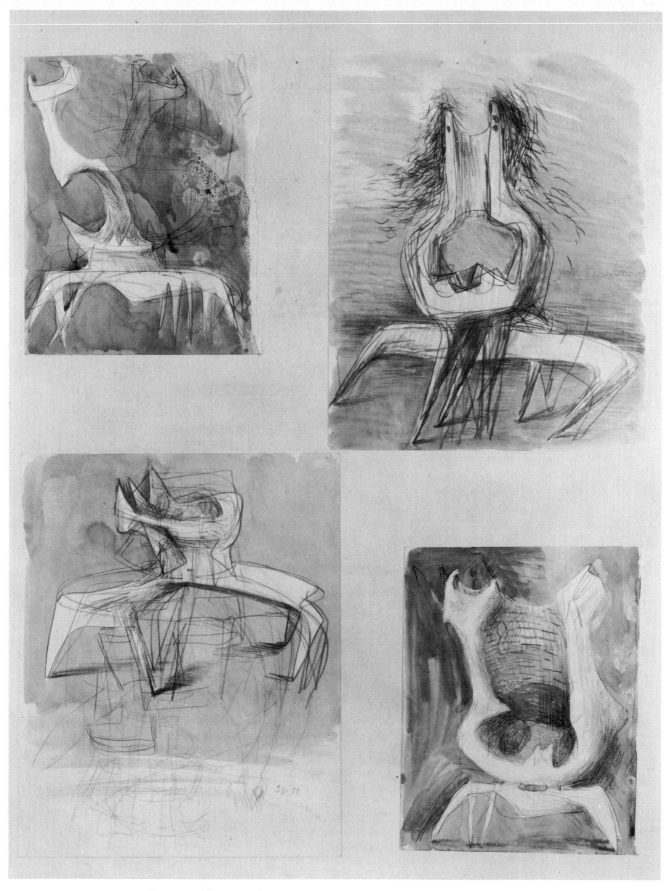

337 BERNARD MEADOWS Studies on *Crab* theme 1953–4

VII ELIE NADELMAN Study for *Horse* (*see p. 178*)

VIII NADELMAN Maquette for *Horse* (*see p. 178*)

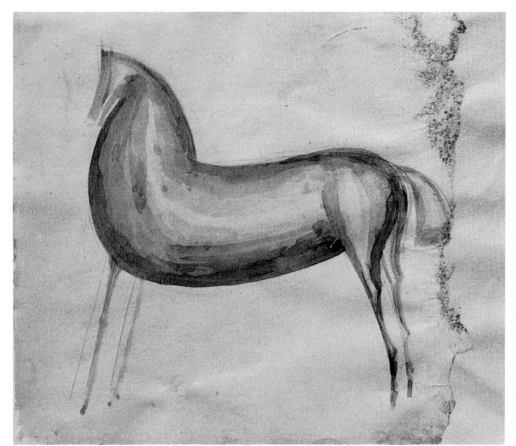

VII

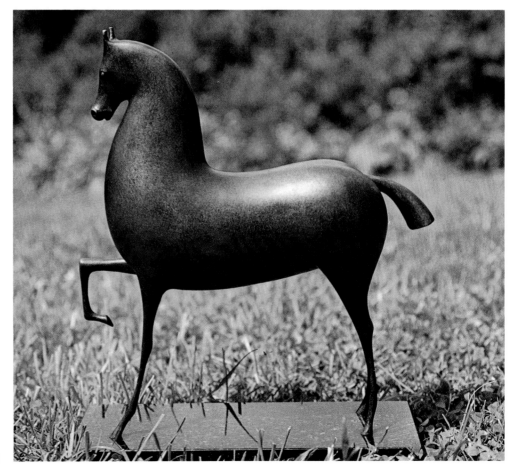

VIII

IX

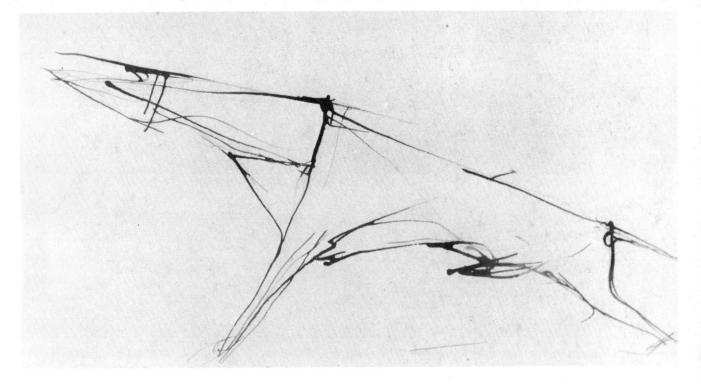

Bernard Meadows' *Crab* of 1953–4 is an ambivalent creature, combining the images of crustacean about to scurry across the sea-bed and mechanical grab. Meadows rarely dispensed with preliminary idea-drawings at this period. The present pencil and watercolour examples (337) are typical in being the object of much thought, plainly a sculptor's drawings, and works of art in their own right. The particular sketch Meadows chose as the basis of his bronze was not followed in one major respect, namely the treatment of the upper area, which in the bronze leads our eye downwards to explore the hardness of the mouth-like opening armed with teeth, and then upwards again to move round the space above.

The first-idea sketches by Lynn Chadwick are as typical of him as the *Crab* drawings, so much more elaborate, are of Meadows during roughly the same years. Chadwick had executed a whole series of 'Beasts' in the 1950s. The sketch·drawing for the *Lion* shows that the sculptor had already decided on the stance and shape. The shape is angular with a hint of a curve, flattened out in the bronze. The plane ridges around which the outer envelope is to be constructed are hinted at. The square head is reminiscent of the wounded lioness of a seventh-century BC Assyrian relief, but the sculptor has expressly avoided a recognizably naturalistic shape.

338 LYNN CHADWICK Sketch for *Lion*

IX (opposite) ETIENNE HAJDU Drawing related to *Lia* 1964 (*see 422, pp. 230–1*)

339 MEADOWS *Crab* 1953–4 (*see also 337*)

340 CHADWICK *Lion* 1960

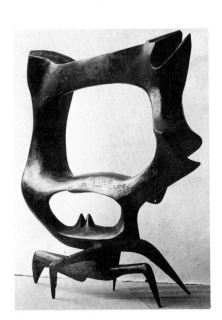

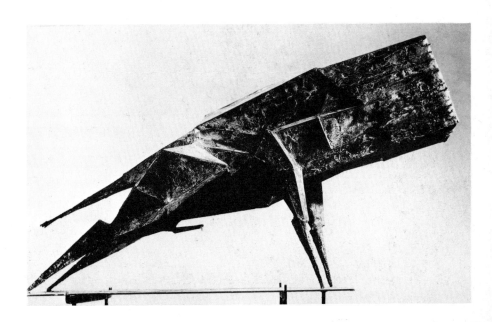

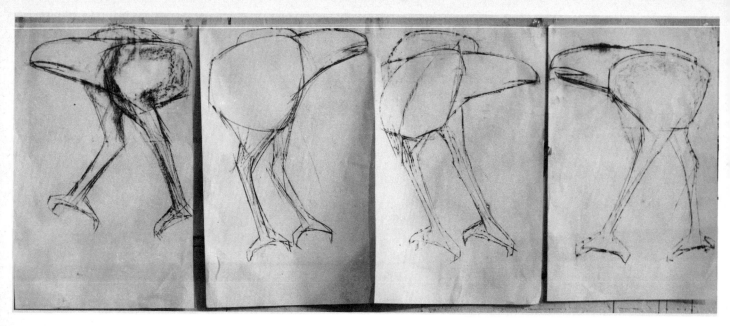

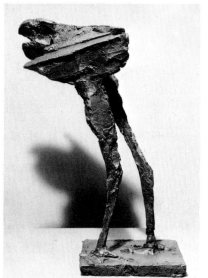

341 ELISABETH FRINK *Studies of Birds* 1961

342 FRINK *Winged Beast II* 1962

343 FRINK *Bird* 1966

344 FRINK Drawing for *Bird* 1963

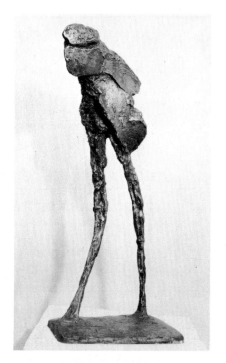

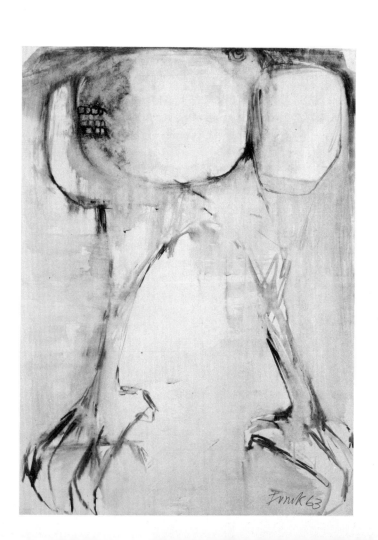

Students of drawing familiar with Villard de Honnecourt's Album (mid-thirteenth century) will notice in Chadwick a comparable analytical approach to basic shape. Both artists in their sketches aimed at reduction to essential geometric form, such as we see, for example, in the medieval artist's sheep with its body inscribed in a rectangle and its head in a right-angle triangle.

The iron filling (a mixture of powdered iron with gypsum paste which solidifies and can then be treated as a solid metal) built round the armature of iron rods produces a rhythm of contrasting surfaces and planes, and a texture reminiscent of a bat's wings – an image even more applicable to the *Strangers IV* and *Winged Figure*, discussed in Chapter 9. The surface incidents add an element of mystery to this defiant shape.

Two early sketches by Elisabeth Frink depict, respectively, a birdman in hand-to-beak combat with a huge bird, and a series of heads of airmen and birds. She was to develop both these themes sculpturally. Some of her predatory birds have long legs, like waders, but these end in claws. Others present the essential feature of a part-real, part-imagined species, an exaggeratedly predatory beak mounted on an armour-plated body.

These free-style sketches express an important aspect of Elisabeth Frink's temperament, one which finds a parallel outlet in the frightening *Goggle Heads*, and is at the same time complementary to the recent serene horse bronzes.

The aggression behind all these subjects is concentrated in the studies of the four birds and the detail of body and claw, identifiable with *Warrior Bird*, *Harbinger Bird IV* and *Winged Beast II*. Expressions of subjective emotion, they are almost surreal.

Looking at the drawing in brush and ink, *Tormented Man*, and the pinewood carving, *Oppressed Man*, by Leonard Baskin, we could apply the same epithet. As much as

345 LEONARD BASKIN *Tormented Man* 1956

346 BASKIN *Oppressed Man* 1960

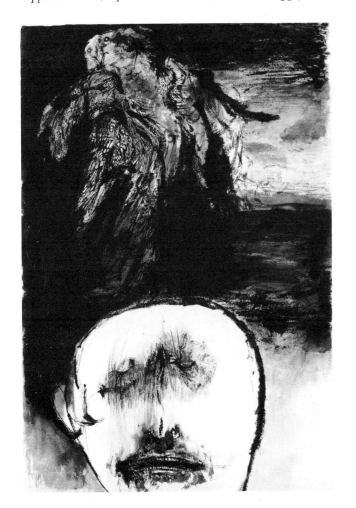

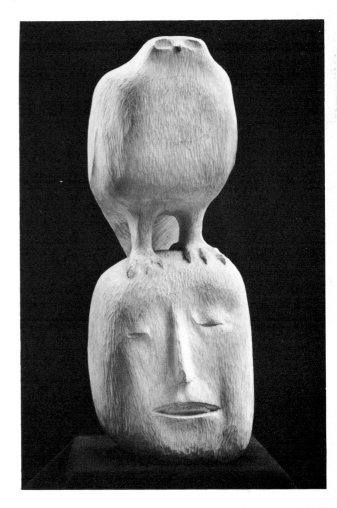

anything, they recall some of Max Ernst's creations; nor is one surprised that Baskin's work figured at the Darmstadt exhibition, 'Evidences of Anxiety in Modern Art' (in 1963 – the year American and British sculptors shared an open-air sculpture exhibition in Battersea Park and which included Baskin, Calder, Lipton, Nakian and David Smith among the former). The predatory bird perched on the man's head is both mysterious and menacing. The strong element of chiaroscuro in the drawing underlines the horror of the moon-like face with its narrow teeth, and it will be noted that the latter feature is repeated in the carving. The light-absorbing pitted surface of the pine minimizes the high-lights, and at the same time endows the man's face with a nightmare unreality and unifies the whole carving. Baskin is one of the few contemporary American sculptors equally at home in modelling or carving. In the latter medium he paid homage – in an outstanding posthumous carved portrait – to the great exemplifier of Expressionist wood-carving, Ernst Barlach (1870–1938).

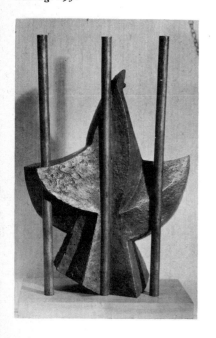

347 ANDRÉ BEAUDIN *The Bird of Marriage* 1952

The idea-sketch by Beaudin for *The Bird of Marriage*, with its gentle, aspiring curves, evocative of the dove, was executed in the same year, 1952, as Frink's first predatory *Bird*, with which it could hardly provide a more striking contrast. The Beaudin bird is imprisoned, and the wing-tip protruding between the bars is an ingredient essential to the composition rather than a signal of hope. It would, however, be wrong to deny the broad symbolism of the concept – Beaudin identifies birds with freedom in other sculptures – *Seabirds* for example. Technically this sketch stands midway between the studies for *The Hoop* (263) and the Mondrian-like reduction of *Paul Eluard* (416). *The Bird of Marriage* bronze is a notable example of the cubist idiom of intersecting flat and curved planes used in a true sculptural sense, and not for surface decoration.

In this chapter we have travelled far, from the life-studies of Bourdelle to Marini's gouaches of horses, from Nadelman's mannerism to Frink's harmonious syntheses in line and wash. It is the psychological distance separating classically-inspired equestrian subjects, where the rider is the hero-leader, from the horse seen on an equality with man, even (in panic moments) as in charge; a reflection of period *Angst*. As for the predatory birds and strange crustaceans, they embody even more dramatically the uneasiness of our times.

A reaction towards the figurative, towards realism, and the rehabilitation of the feminine curve, is however noticeable in the later phases of some of the drawings and sculpture by the same hands (Butler, Chadwick, Meadows, etc.). Art is the expression of its time, and the sculptor's drawing is his spontaneous reaction to an imaginative impulse which in part at least springs from period atmosphere.

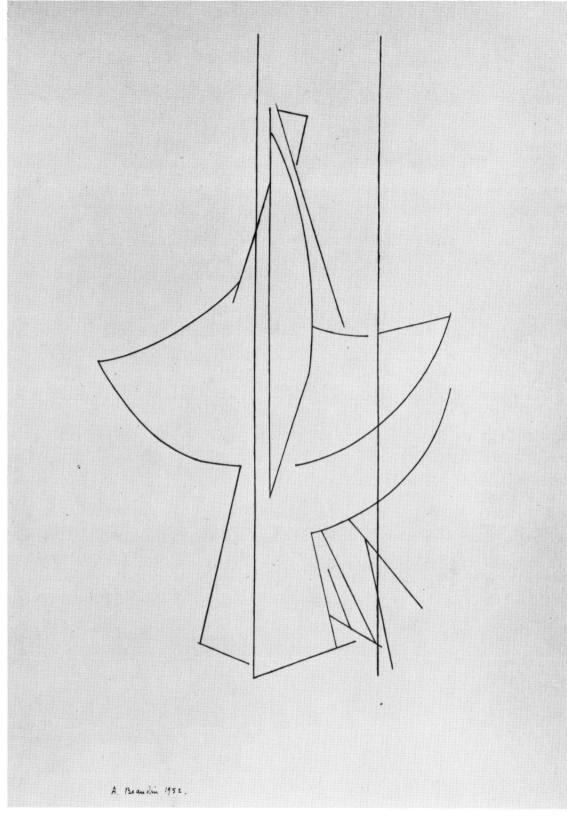

A. Beaudin 1952.

348 BEAUDIN Study for *The Bird of Marriage* 1952

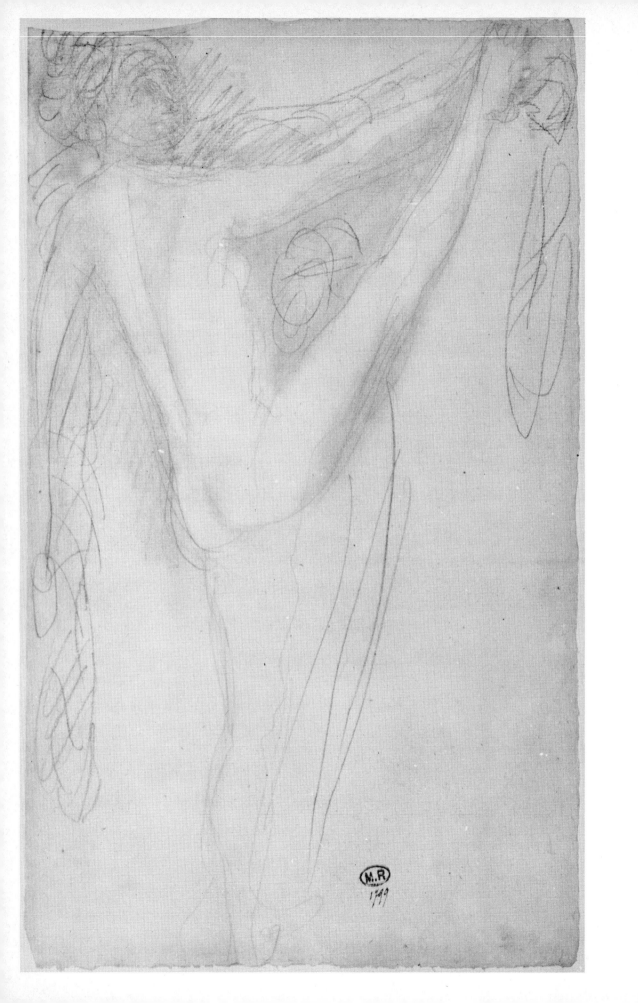

9 *The illusion of movement and the dance, drawings for mobiles*

A form does not yield its full effect instantly. We have to 'follow' it.
Time intervenes in arts of sight as in music, dance, literature.

<div align="right">OZENFANT</div>

The drawings we shall be looking at in this chapter are for mobiles or mechanically activated sculpture, and also for sculpture in which movement is implied by theme and treatment. Rodin's preoccupation with movement has been mentioned earlier, and no one has bettered his definition of movement in the sculptural sense: 'Movement is composed of different moments, straining towards something.' Other sculptors have a different aim. Moore, for example, writes: 'For me a work must have a vitality of its own, I do not mean a reflection of the vitality of life, of movement . . . physical action, frisking, dancing figures and so on, but that a work can have in it a pent up energy, an intense life of its own.' In few of his sculptures is movement in the Rodin sense a recognizable element. Instead, we have a basic feeling of stability which does not exclude, for example, the tension conveyed by a recumbent form levered on its elbows, or of a rising thigh. It is hardly necessary to point out that the converse of movement, sculpturally at any rate, is not inertia, and that vitality is a quality independent of even any hint of movement; nevertheless almost instinctively the eye craves a dynamic element. In Hellenic sculpture, even in such sitting and reclining figures as the *Three Fates* of the East pediment of the Parthenon, this is supplied by the rhythm of the drapery which leads our eyes obliquely over their rippling surface. A similar effect is observable in the skirt folds of the mother in Henry Moore's *Family Group*.

To create the illusion of movement the majority of equestrian statues show the horse with at least one hoof poised in the air. That of Henri IV is balanced on two feet, the Bernini *Marcus Curtius* rears up on its hind legs. We are so accustomed to this formalization of movement that it is only when we are confronted with attempts to treat dramatic frenzy in three-dimensional terms, as in the *Laocoön*, that we pause to consider (as did the German dramatist and critic Lessing in his *Laokoon*, 1766, a treatise on the limits of poetry and the plastic arts) whether such convulsions in which the element of time is implicit are the proper subject of sculpture, as opposed to literature (Virgil), and compare the 'frozen' movement of gesturing Baroque with what has been called its Classical equivalent in the *Winged Victory of Samothrace* or the *Chiaramonti Niobid*, in both of which the drapery seems to float in a living atmosphere rather than in a *tableau vivant*.

Flowing drapery is an obvious device for creating the illusion of movement in graphic and sculptural terms. It appears in connection with the dance in Greek and Graeco-Roman sculpture, but mostly in reliefs. The dance in Antiquity was almost entirely a ritual expression of a religious nature, whether stylized or of Dionysiac, orgiastic wildness. The dancers of ancient Egypt are contrasted by André Malraux with those of modern times: 'the representation of Egyptian dancers *fixes*, that of the

349 (opposite) AUGUSTE RODIN Study for *Dance Movement*

350 AUGUSTE RODIN *Dance Movement, c. 1910*

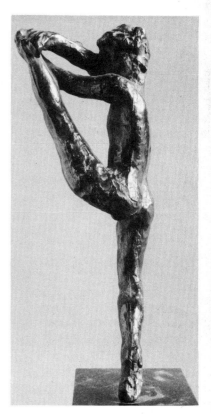

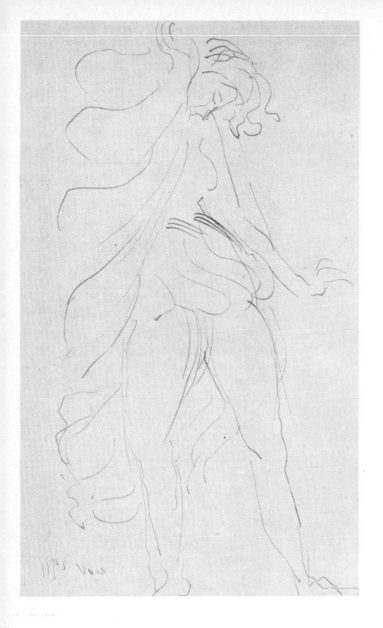

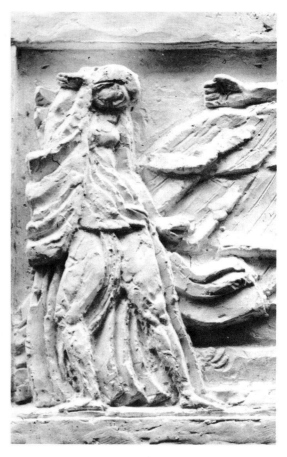

351 Antoine Bourdelle Sketch of Isadora
Duncan 1911

352 Bourdelle Maquette for *The Dance*

353 Bourdelle Plaster for relief on theme of
The Dance (Isadora Duncan) 1912

354 (opposite) Bourdelle Sketch for relief on
theme of *The Dance* (Isadora Duncan) 1911

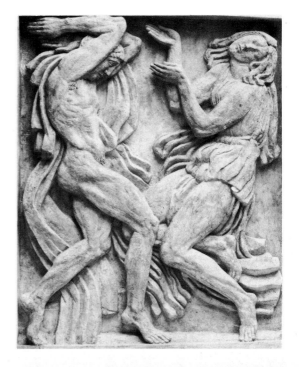

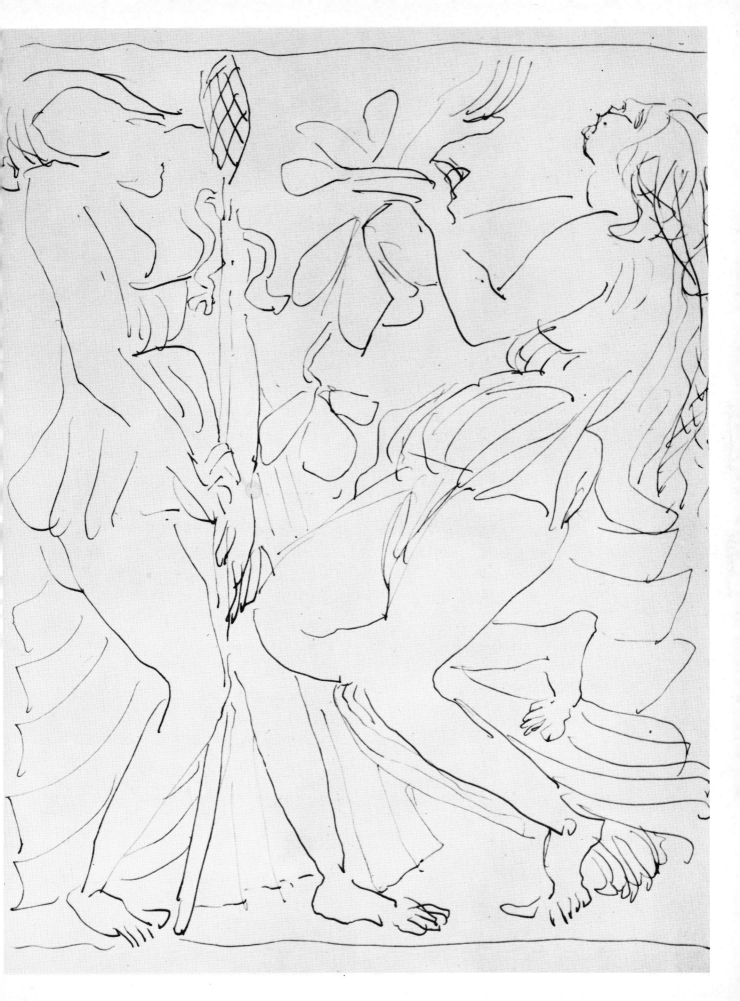

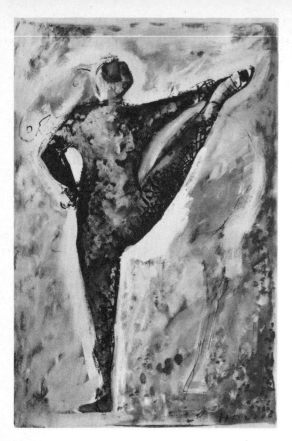

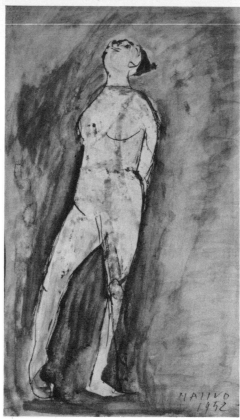

355–6 MARINO MARINI *Studies for Dancers* 1952

357 MARINI *Dancer* 1952–3

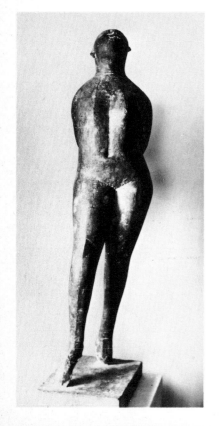

danseuse *suggests* a movement' – a perceptive distinction between the dance of the formalized hieratic rite and the dance of an individual *danseuse* or ballerina, and even more, of the dancers of individual free-expression. Two of these exponents, Isadora Duncan and Loïe Fuller, engaged the enthusiastic attention of Rodin and Bourdelle.

Rodin's studies, particularly those of the exotic and sensuous dances of the Javanese and Cambodian troupes who visited Paris, are unlikely to be surpassed. The subject of the dance had long interested him, and quite early in his career he had used a dance pose for the piece called, originally, *Inner Voice*, a bronze of 1910–11. (This was refused by Stockholm Museum on the grounds that it was of 'insufficient merit', and later became the monument to Victor Hugo, whose genius Rodin wished to honour.) *Dance Movement*, a study for the bronze of the same title, shows a characteristic fluidity of line, enhanced in this case as so often by touches of wash and tonal scribble which reflect the rapidity of execution. The directional vector lines around the right leg illustrate in two-dimensional terms Rodin's explorations towards discovering a satisfactory synthesis of dance movements. Studying his drawings, of brilliant spontaneity, one must agree with his disciple Bourdelle that they rival the bronzes for which they were studies. In both studies and bronzes Rodin showed his genius for seizing the essence of movement, so that we do not identify it with a particular dancer, but with the spirit of the dance. Mallarmé, in another context, expresses it thus: 'the *danseuse* is not a woman who dances; for she is not a woman and she does not dance [they are] not women but beings of ineffable substance, there is nothing solid in their bodies of elastic crystal, no bones, no articulation.'

I have mentioned Bourdelle's admiration for Rodin's sketches and bronzes of dancers, and a number of his own studies for the high-relief façade of the Théâtre des Champs Elysées, though tied down to a specific project, have something of the rhyth-

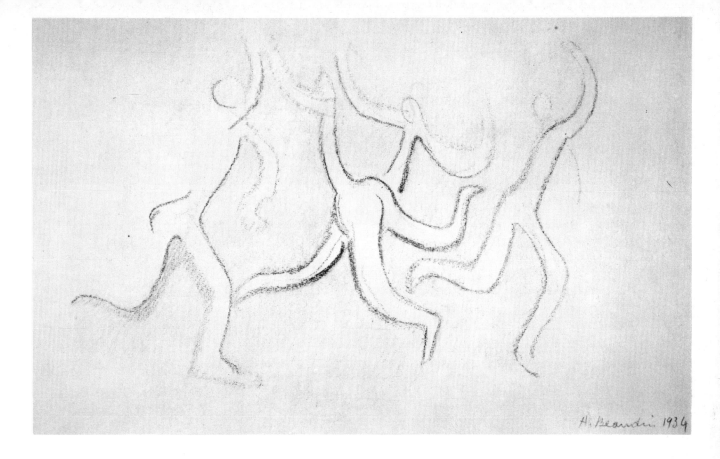

mic suppleness of Rodin's. The pen and ink sketch of Isadora Duncan is lyrical and spirited, and from it emerged one of the most successful sections of the whole relief. The second sketch takes us a stage closer to the final carving. The first example illustrates the use of drapery to suggest movement; it has all the immediacy of a *premier coup* sketch, superbly capturing the essentials. Revised, it served for the group *A Muse, Apollo and Meditation* on the façade. The second sketch is specifically related to the group called *The Dance*, and is the final phase of the sculptor's explorations. The study is followed in the right-hand figure of the relief in almost every detail; the left-hand figure was changed; it is interesting because of its relation to *Penelope with Spindle* (423) discussed in the next chapter. The most important modification to the balance of the whole is the turning of the head full-face. The sketches date from 1911; the marble carving was completed in 1912 and integrated harmoniously into Perret's distinguished building. If there is a criticism, it is that the spontaneity of the sketches is to some extent lost in the deliberate stylization of the reliefs.

Marino Marini in most of his dancer-subjects is concerned with the held pose of the ballerina. The left-hand of the two *Dancers* sketches is executed in body colour (in contrast to Rodin's, whose procedure, as we have seen, is to flood his pencil drawing with a tonal watercolour wash to relate the dancer to the background space). It is in the same position as the bronze of 1952–3 but conceived in different terms. The right-hand figure, in mixed media, relates directly to the sculpture. The 'particular' of the somewhat pert sketch has been transformed into the depersonalized and universal bronze figure. Marini's interest has become concentrated on the change of planes, barely hinted at in the drawing but marked by the 'high-line' in the bronze. The tilt of the head is equally accentuated in the drawing and the bronze. The sculpture makes no concessions to the 'romantic' feeling about ballet; it is effective in a less obvious

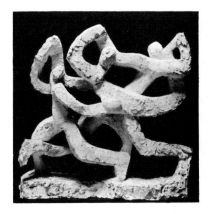

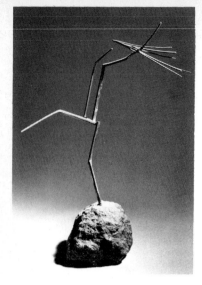

360 JULIO GONZALEZ *Small Dancer*

361 GONZALEZ *Dancer on a Midnight-blue Ground* 1941

way, expressing something about tension and the equilibrium of volume in the follow-through from pointing toe to tilted head,

Although the dance is represented by Gonzalez and Beaudin in terms of open metal form – silver in the first case, plaster for bronze in the second – the basic contrast is between expression of free movement by Gonzalez in a series of filiform lines, relieved by one sweeping curve, and by Beaudin in *Laocoön*-like enclosed rhythms. The Gonzalez brush drawing has the same élan as the sculpture. In fact it relates to other dancers by this sculptor, such as *The Dancer with the Palette* in which the streaming hair is also a feature creating the feeling of forward movement.

Gaudier-Brzeska's *Red Stone Dancer* – carved as it happened just at the period when Bourdelle's model for the Théâtre des Champs Elysées was dancing in London – derives as strongly from primitive sculpture as Bourdelle's relief from the classical tradition, but is nonetheless a personal interpretation. His drawing evokes the many-limbed bronzes of Indian gods, while the spirit of the sculpture itself is of Gauguin-esque simplicity. Gaudier is often accused of being an eclectic, but this is a harsh judgement on a brilliant young artist, killed at the age of twenty-four, and *The Red Stone Dancer*, like his *Seated Woman* of the same year, 1914, is an original work in its own right.

The drawings express frenzied movement, yet the formal design is striking and well-controlled. They are a rendering of a sequence of movements shown simultaneously,

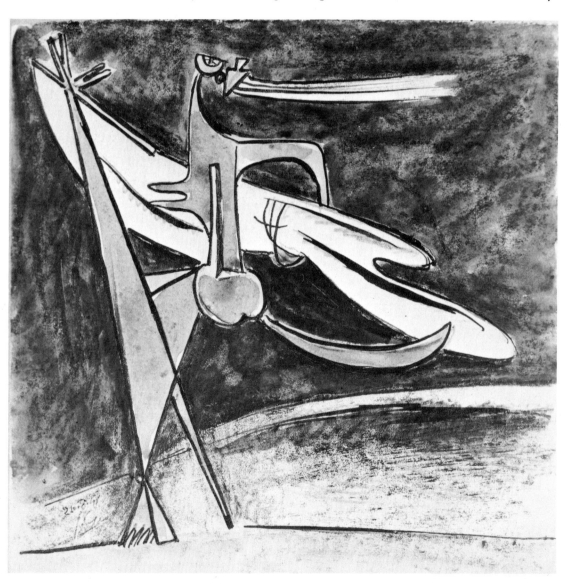

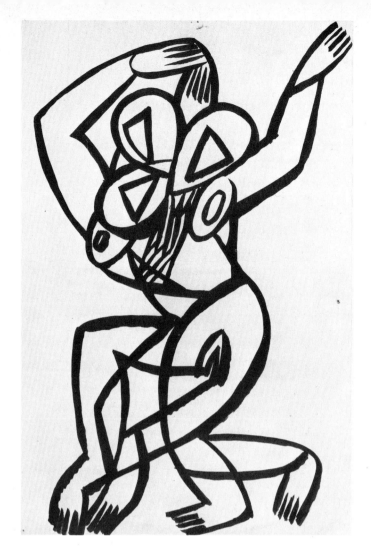

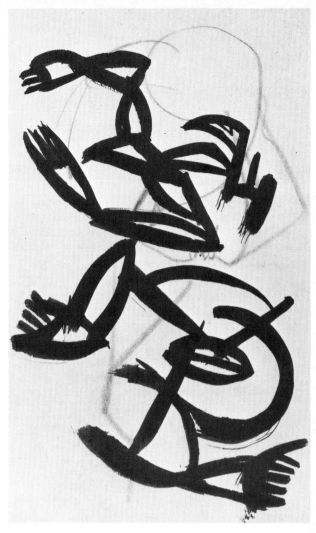

but not merged, as they are for example in Boccioni's *Unique Forms of Continuity in Space* (1913). The sculpture is a marvellous synthesis of dance rhythms and interlocking shapes, leading to the climax of the mysterious mask-head, emphasized by the encircling arm.

It might seem that by his title *Walking Man* Giacometti intended to suggest a contrast between the spectral man of his drawing and bronze and Rodin's massive, muscular, striding figure. But the subject goes back at least to an archaic Greek sculpture of the sixth century BC.

Giacometti's figure is like a walking shadow, 'comme un homme qui marche seul et dans les ténèbres' – the modern version of the man who walks 'alone and in the darkness' of Descartes. Both in the drawing and the bronze, Giacometti has created the illusion of movement and time. It is implicit in the tall, filiform figure, leaning forward as if compulsively towards an unknown goal. As we look at the nervous pencil lines of the drawing – hesitant, tentative, it is as if the paper support melted away – an impression increased by the subtle linking of the figure with the vast surrounding margin by areas of drawing where the contour is absent or broken. Equivalent effects in the bronze derive from the vibrant modelling, the proportions of head to body and of the feet to the whole, and the direction of the gaze. The figure seems eroded by the space that encompasses it.

362–3 HENRI GAUDIER-BRZESKA Drawings for *The Red Stone Dancer*, c. 1913

364 GAUDIER-BRZESKA *The Red Stone Dancer* 1914

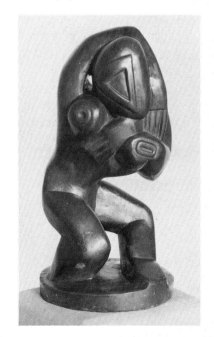

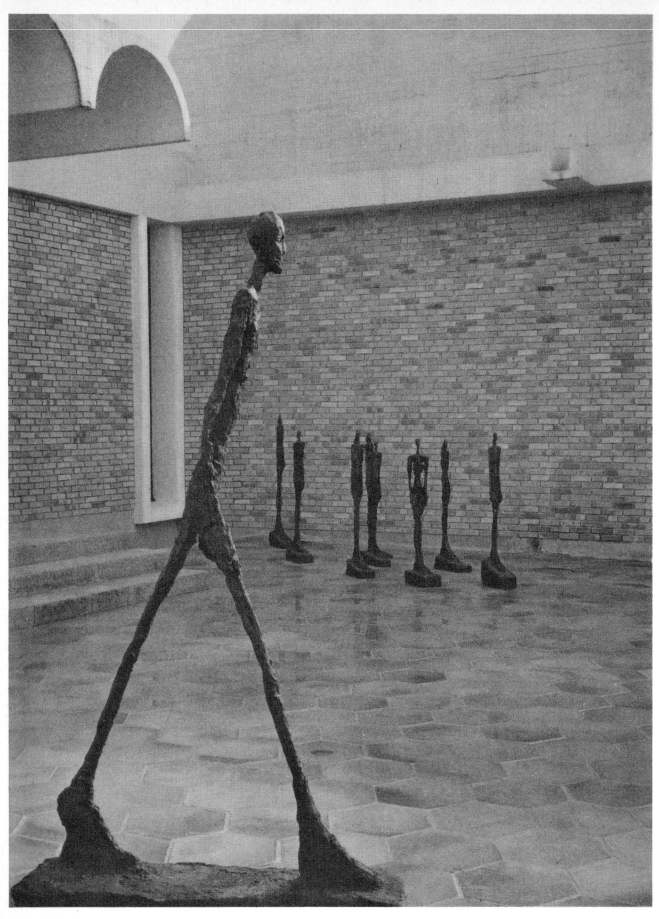

365 ALBERTO GIACOMETTI *Walking Man*

366 (opposite) GIACOMETTI Drawing for *Walking Man* 1948

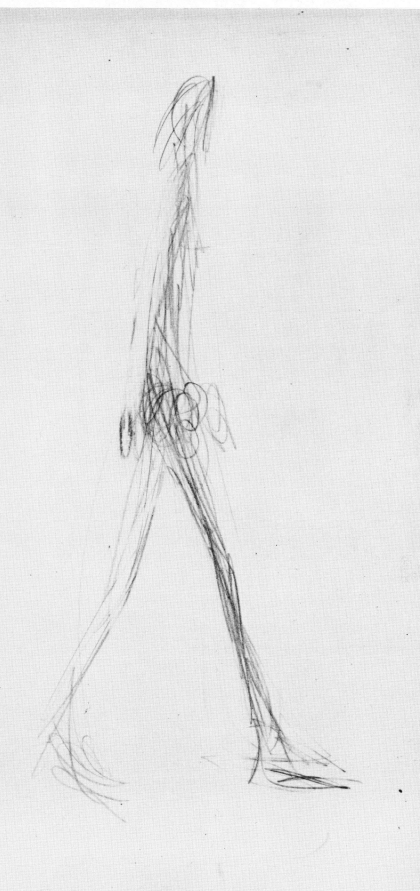

Alberto Giacometti 1948

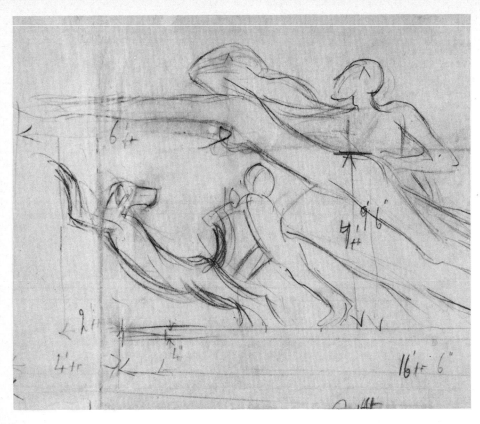

367 (left) JACOB EPSTEIN Working drawing for *Bowater House Group* 1957

368 (right) EPSTEIN Sketch for *Bowater House Group* 1957

369 (below right) EPSTEIN *Bowater House Group* 1959

Jacob Epstein had long cherished the wish to treat the theme of youth fleeing the crowded city to experience the pleasures of nature. He had the idea of a group of figures accompanied by a dog driven out by the symbolic figure of Pan. There is a suggestion of a Bacchic rout in the headlong chase of the *Bowater House Group*, the sculptor's last work. Here the feeling of movement is created by the classic device of figures leaning forward at an exaggerated angle, and is increased by the slender, outstretched arms of the girl who leads. The sketch drawing is also in fact a working drawing, on which Epstein has carefully indicated the measurements. The rhythms and thrusts have been calculated with the aim of holding the whole composition together. A parallelogram is formed by the dominating figure of the girl and the dog, whose turning head acts as a counterthrust, and, together with the vertical torso and head of the man, steadies the design. The sculptor has marked the apex of an isosceles triangle as the pivot of the whole composition, but in the sculpture the basis becomes a right-angled triangle from the left-hand side up to the girl's buttocks and down to the faun's right-hand hoof. The exaggerated forward lean of the faun results in the loss of the relationship with the boy established in the drawing. The detail of the girl is beautifully drawn; despite ill-health, Epstein had lost none of his gifts as a brilliant draughtsman.

A figure in space is a Reg Butler obsession, and 'girl on wheel' one of its variations. He used the wheel – or suggestion of a wheel-disc, segment of a circle, curved back of a chair – to convey the notion of movement. He exploits the idea brilliantly in a *Figure in Space* of 1959 in which we see the figure outstretched and pivoted on the edge of a disc, and also in the *Figure in Space* of 1958–9 – a figure upside down on a trapeze-like structure, which I have chosen partly because two casts of it can be seen in Europe (in Germany) and the other four in the United States, but above all because the sketch drawings are so characteristic of the sculptor, and are complementary to one another.

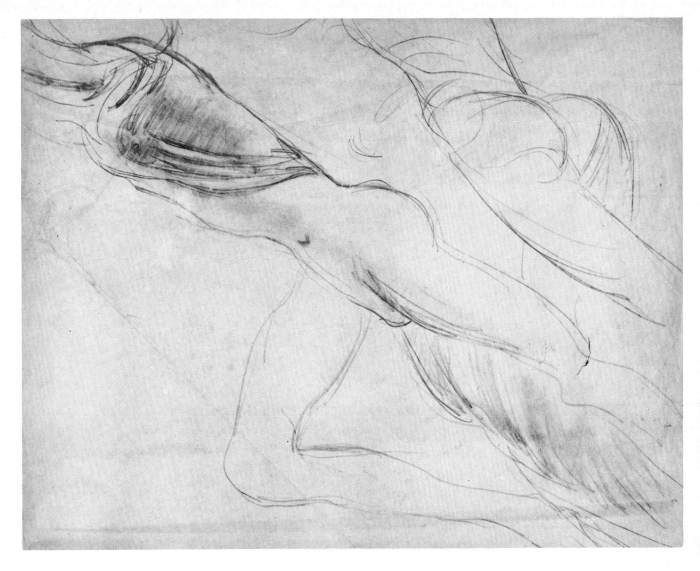

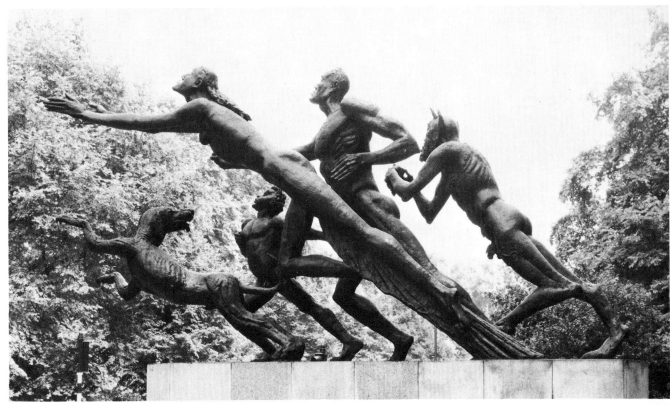

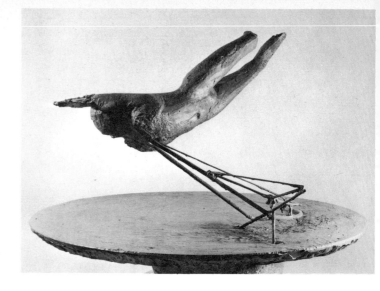

370 REG BUTLER Study for *Figure in Space*

371 BUTLER *Figure in Space* 1959

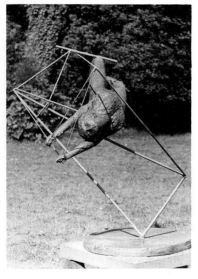

372 BUTLER *Figure in Space* 1958–9

373 BUTLER Drawing related to *Figure in Space* 1958

In the first of these drawings Butler is concerned with the spatial planes of reference; it represents a stage in the solution of structural relations, as indicated by the schema of geometrical forms – the half circle, the directional lines, etc. In the second, the sculptor has made a study of the taut neck and thorax of the model, and resolved the position of the arms and the shape of the head. The tension on the breasts and throat evident in the drawing is a striking feature of the finished bronze.

Butler's disc figure moving in the air and Frink's *Horizontal Birdman III* form an interesting comparison. The Frink carries an association with Icarus – the 'important failure' of Auden's poem. It is in fact a maquette (one of many small versions) for the Alcock and Brown Memorial at Manchester Airport. The single broken wing, the long frogman-like legs, create a totally different modality from the soaring Butler bronze.

The sketch drawing for the Frink airman's helmet has tragic overtones – the helmet is unobtrusively incorporated in the bronze in less particularized terms. The other drawing is almost exactly a two-dimensional *Birdman*, with the exception of the arm which, still at the same angle, becomes the wing.

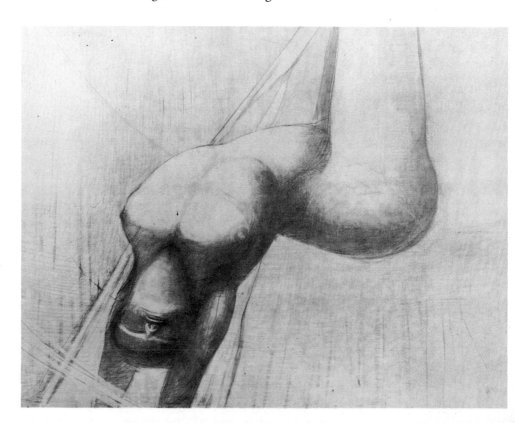

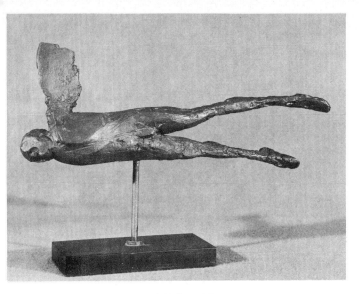

374 ELISABETH FRINK *Horizontal Birdman III* 1962

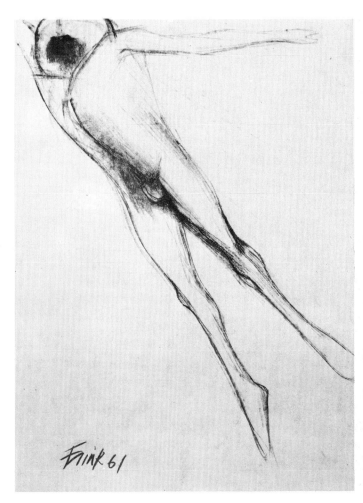

375 FRINK Drawing for *Birdman* 1961

376 FRINK Drawing for *Birdman* 1961

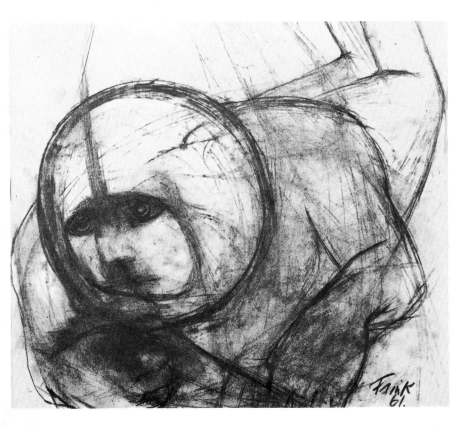

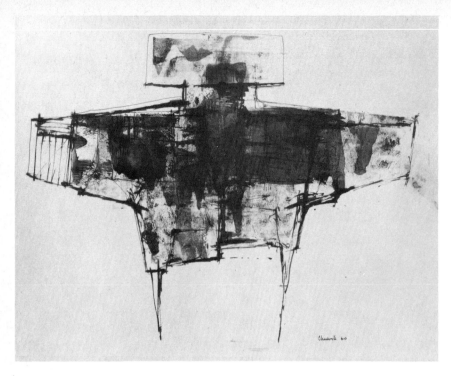

377 LYNN CHADWICK *Winged Figure*
(*Strangers*) 1960

Lynn Chadwick's *Winged Figure* drawings originated as a commission from London Airport for a sculpture to commemorate the flight of the R 34 (a double crossing of the Atlantic in July 1919). Chadwick's idea was apparently neither figurative nor conventional enough to satisfy Parliament, which had the last word. The Arts Council acquired a drawing of a *Winged Figure* – also called *Strangers* – while a related sculpture, *Strangers IV*, was shown at the Marlborough Gallery in London in 1960.

The sculpture is constructed on the same technical principles as *Lion* (340). The forms, solid and almost crystalline, register fascinating changes of plane. Daylight playing over them provides the eye with an infinity of variations as one or other of the salient lines of the composition receives emphasis. All these subsidiary patterns contribute to the mysterious shape of the whole – a shape more evocative of a Leonardo birdman with an astronaut helmet, ready to take off from slender tetrahedron legs, than of any conventional idea of modern flight.

The drawing, pen and ink and wash, is a sensitive rendering of what Chadwick aimed at in the series – broad design, the strongly textured surface contrasting with

378 CHADWICK *Strangers IV* 1959

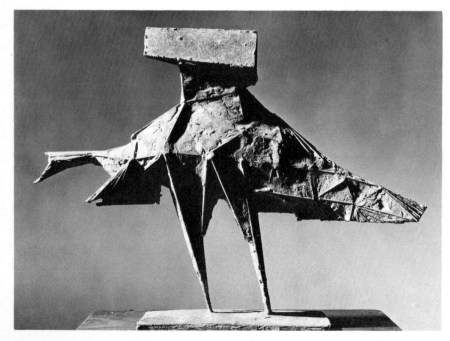

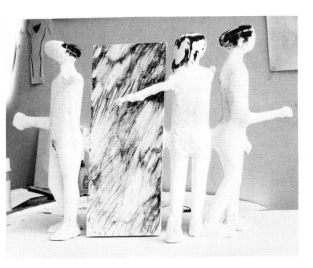
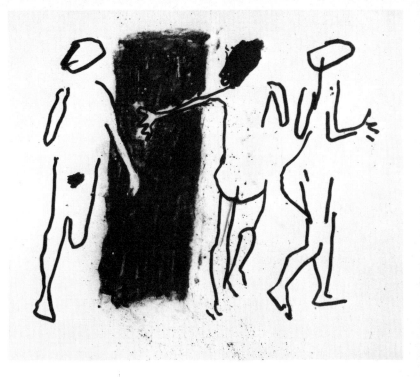

the thin spidery pen lines for the legs, and – consciously or not – a numinous evocation of a pterodactyl. Once again we are confronted with a 'period' sculptural head-shape (cf. 311, 312).

Armitage's drawing technique has varied over the years. A comparison between the early sketch relating to the bronze in Chapter 1 and those relating to groups such as *People in a Wind* of 1951, *Children playing* of 1953, and *Triarchy* of 1959 show the first development on which the following passage (in a letter to the author) throws an interesting light: 'These little marks, notes, scribbles, references but all done for looking at [are] the most vital ones in relation to the particular sculpture – more than the finished drawing.' The two drawings relating, one more indirectly, to *Girls by a Screen* of 1972 (shown here in the plaster model, but later cast in aluminium and painted), illustrate his present confident, uninhibited style. The first-idea sketch exploring the theme has been executed *con brio*, as the rapid lines and spattered ink show. The second is a frontal view, a combination of montage and bromide print, in which the right-hand girl has the curious head-shape we have seen in *Big Doll*. These

379 KENNETH ARMITAGE Model for *Girls by a Screen* 1971

380–1 ARMITAGE Sketches for *Girls by a Screen* 1971

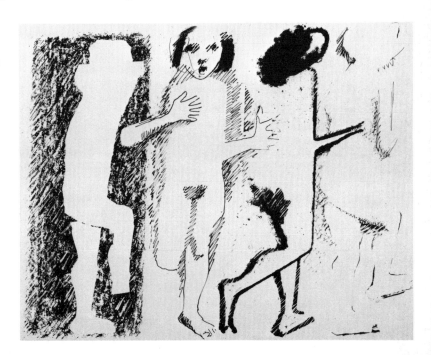

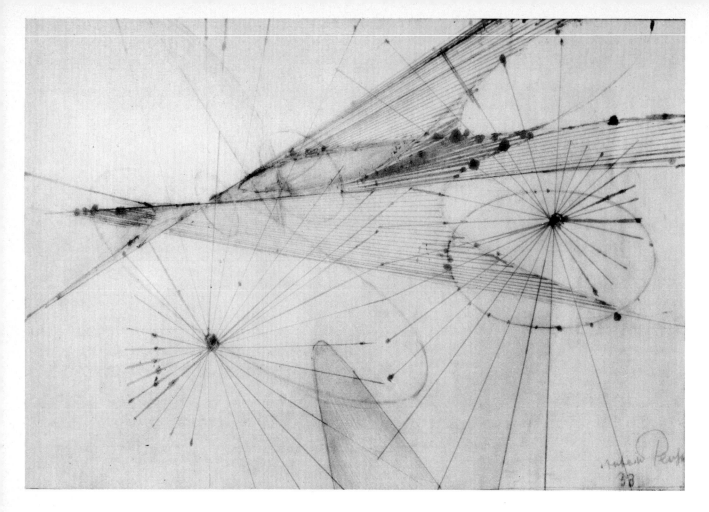

382 ANTOINE PEVSNER *Birth of the Universe* 1933

drawings are informed with the wit and lively sense of movement we associate with Armitage, and which has had its most recent manifestation in his large-scale screens, one of which, with similar walking girls (screen-print on treated birchwood ply), now stands in the Library of Nottingham University.

Before we look at drawings for mobiles activated by air or electric currents, a word should be said about the pioneer work of Antoine Pevsner and his brother Naum Gabo in their Constructivist experiments. These sculptors constructed forms in space which have their own dynamism in the changes of internal planes, produced by arrangements of functionally structural rods. Gabo eagerly exploited new materials such as plexiglas, which, like stringing across opposing planes, made inner articulations of imprisoned space visible. Antoine Pevsner's piece *Sense of Movement* is a good example, and in the absence of a specific drawing for it, I am showing one entitled *Birth of the Universe* which, particularly in the upper portion, has some affinity with it. Tensile strength and dynamic rhythm have taken over the role of mass stability. Inevitably idea-drawings for sculpture of this kind resemble engineers' blue-prints, and offer mathematical as well as aesthetic satisfaction.

Like the work by Antoine Pevsner mentioned above, Naum Gabo's *Monument for a Physics Observatory* of 1922 is an early example to add a new, time-space dimension to sculpture. Even before this work, moreover, Gabo had experimented with a mechanized mobile – a steel blade set in circular motion by an electric motor.

It was to a Europe alive with these efforts to express movement that Alexander Calder arrived in 1926, bringing to Paris in his suitcases his own independently con-

206

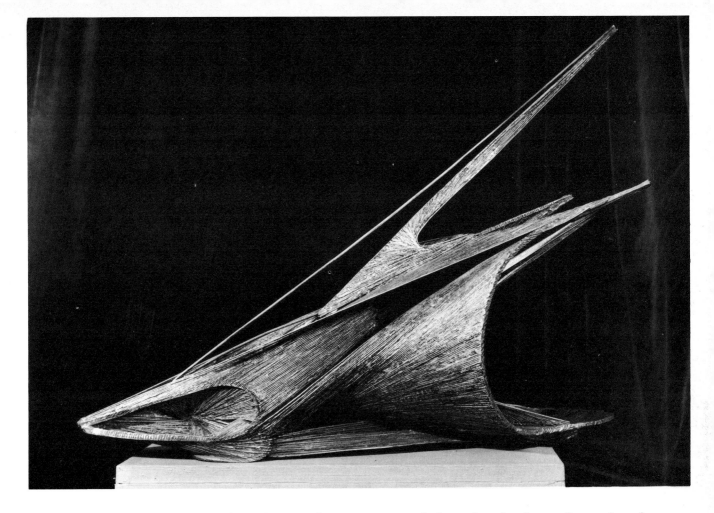

383 ANTOINE PEVSNER *Sense of Movement*

ceived mechanical mobile circus and two-dimensional wire-portraits. Light-hearted though they were, these experiments, like the first mobiles and Constructivist sculptures mentioned, were all part of the urge of the avant-garde of the time to revitalize sculpture by liberating it from solid, volumetric mass.

Calder's contribution was and remains peculiarly personal (the title of an early mobile was *Calderberry Bush*). His work alternates between the gaiety of the multi-coloured mobiles and the zoomorphic and animistic stabiles with their grim humour, as evoked by the menacing form of *Black Widow*.

The more poetic creations rely on chance air currents caught by irregularly placed metal sails, half leaf, half propeller-blade, pivoted on wire or iron stalks. These animate the space they encircle with pattern in three dimensions. The larger examples, like the ambitious mobile for the Unesco complex in Paris (1958), the drawing for which is shown overleaf, could only be planned and carried out by a sculptor, like Calder, with an engineer's training behind him.

Calder's working sketch shows the by no means random movements of the different elements involved and their relative tempi. The instructions, in French, remind us that Calder divides his time between France and his Roxbury studio in Connecticut. The small indication of scale, 'grandeur-immense', is typical. Speeds, colour and material and even background, 'greyish brown', are stated. One is looking up at three axes on which these elements, made of sheet-iron painted scarlet, vermilion and white, are to turn at various speeds. The sinuous axis on the left is of steel of 'variable thickness' and it turns 'imperceptibly'. The small centre ovoids turn 'very slowly'. The

207

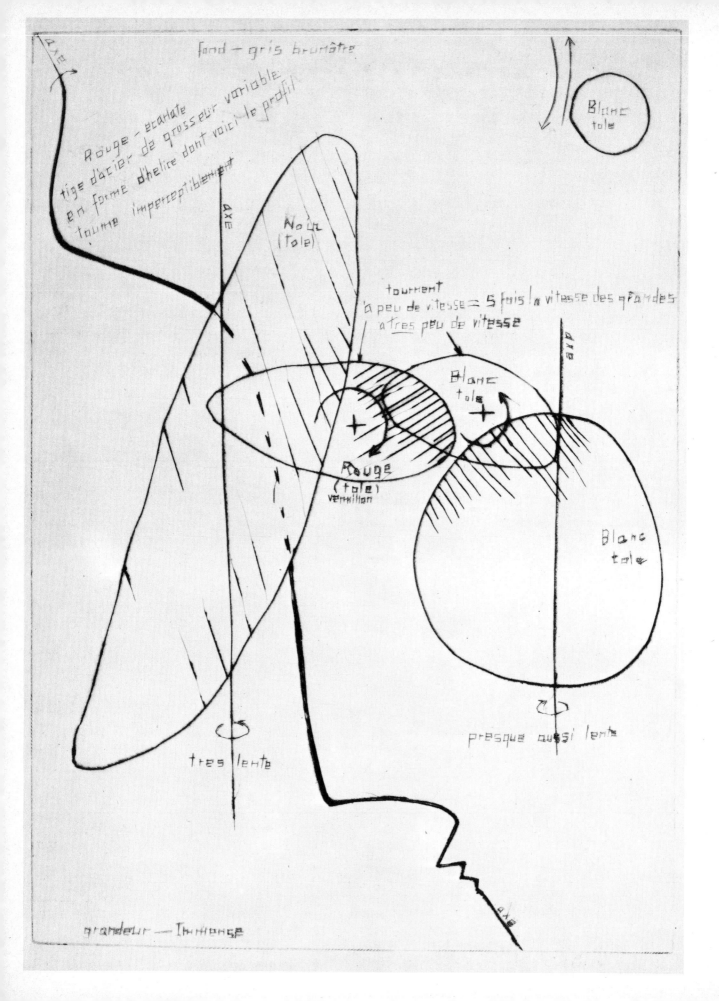

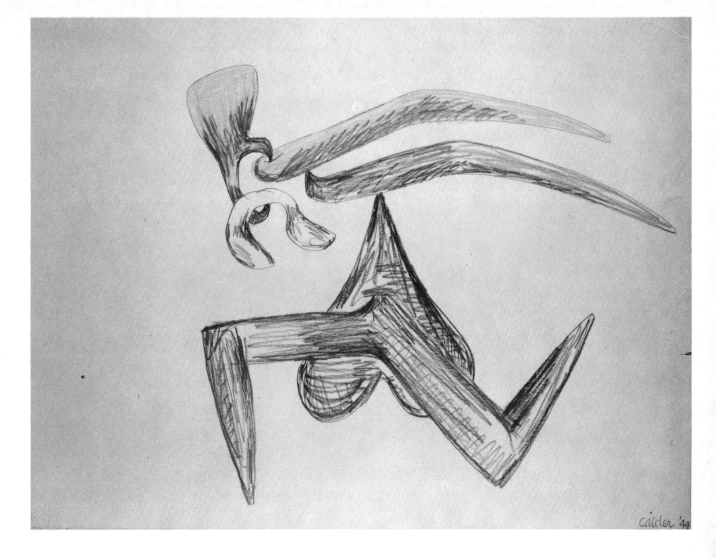

calder '44

time data are deliberately vague, and I think as they stand would pose problems of aerodynamics.

The bronze *On One Knee* is a mobile only in the limited sense that it is possible to pivot certain sections manually, but the open structure, with its different parts as finely balanced as the pans of a pair of jeweller's scales, creates the feeling of readiness to swing into motion at the slightest touch. In the drawing Calder has separated four of the six pieces; the legs and torso are shown hinged together as seen from below. It is a helpful analysis, and an interesting drawing *per se*. The main modifications in the bronze mobile are the increased spread of the shoulder blades, the neck elongations and the abbreviation of the right arm, effectively pivoted to counterpoise the kneeling left leg which anchors the whole piece.

Pol Bury, a Belgian sculptor, after a formal art training that influenced him little and a period of vagabondage, worked in an industrial plant before resuming painting on cloth in a surrealist style inspired by Magritte and Tanguy. Not until 1953 did he experiment with mobiles, manually operated at first, then in 1957 involving electro-magnets and electric motors concealed in component parts, so that the movements appear to have happened by magic. The movements are slow, sometimes impercep-tible until a faint click of two colliding spheres or (as in the illustration) egg-forms make one aware of a change of relative positions. Based on pattern of movement and

384 (opposite) ALEXANDER CALDER Working drawing for Unesco mobile

385 (above) CALDER Drawing for *On One Knee* 1944

386 CALDER *On One Knee* 1944

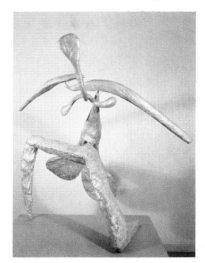

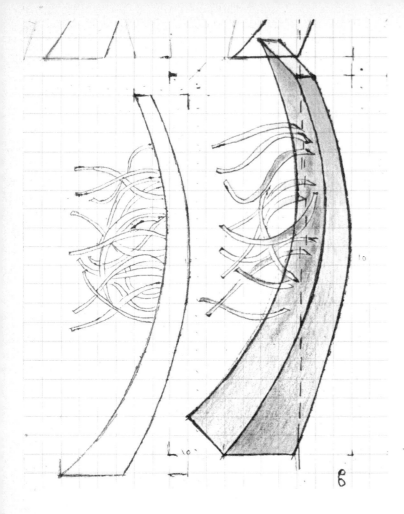

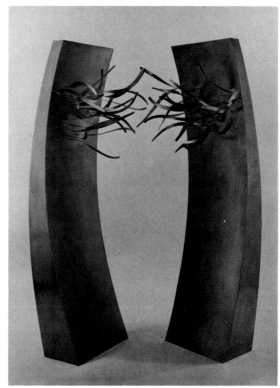

387 POL BURY Drawing for *43 Eléments se faisant face* 1968

388 BURY *43 Eléments se faisant face* 1968

Opposite:

389 BURY Drawing for *25 Eggs on a Tray*

390 BURY *25 Eggs on a Tray* 1969

the delight of surprise, his is one of the subtlest forms of kinetic sculpture. In 1955 at the 'Exposition du Mouvement' he had exhibited with Marcel Duchamp, Vasarely and Calder. The examples illustrated and the drawings for them were shown in his exhibition 'Sculpture Métallique' at the Galerie Maeght in Paris in 1969.

Bury made a dozen pen and ink sketches for the *43 Eléments se faisant face* of 1968, and to two he added colour (green and blue chalk) to reinforce their effect. They are experimental groupings of the metal 'stalks' which in the sculpture move like an insect's antennae on their curved supports. Bury carries out a whole series of schematic drawings for his elaborate projects, in which different phases of calculated movements are plotted out on squared paper.

The attraction of the piece *25 Eggs on a Tray* is partly the everchanging reflections on the highly polished stainless-steel surfaces of the 'eggs' as they respond to the dictates of the concealed electric motor and magnet. Even 'frozen' in the photograph for a split second, it is obvious that the objects are held, as it were, in suspense, defying gravity. The working drawing indicates the position of the magnet and motor respectively on a smaller model of the same subject. Half-spheres, spheres, 'eggs' on a 'tray' are all part of his conjuror's magic, with geometric volumes occupying 'a space which is modifiable at each instant'.

Even more ambitious 'working' sculptures, involving elaborate rotary movements of a towering 'forest' of metal trees, occupied a vast open area at the Fondation Maeght in 1974.

210

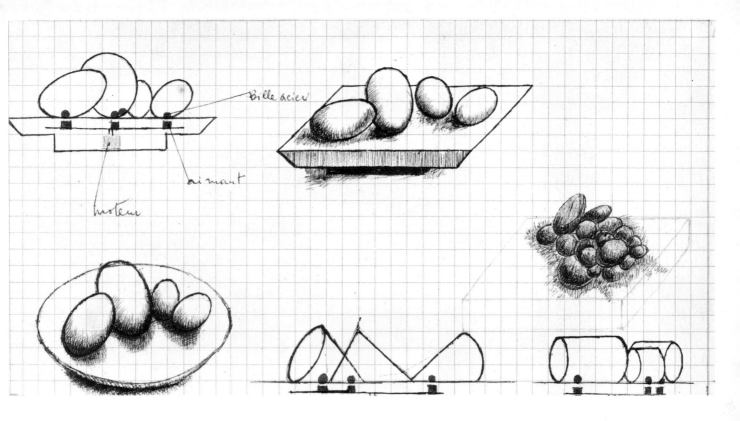

Bille acier

aimant

moteur

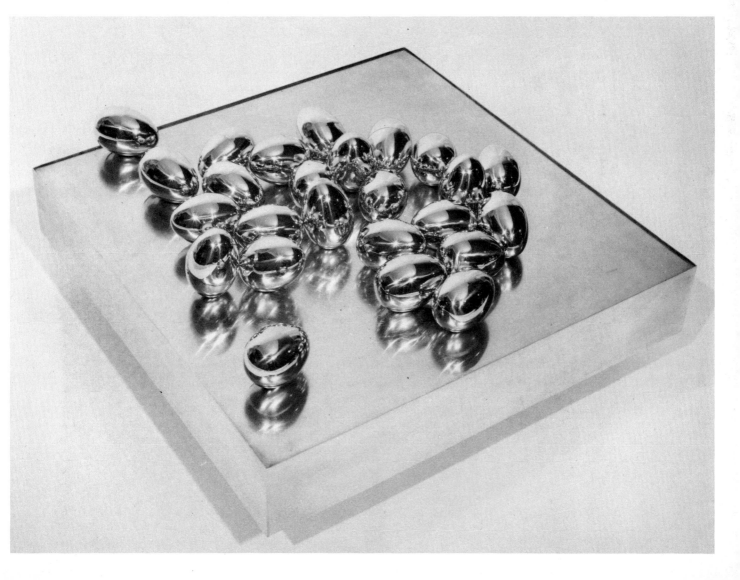

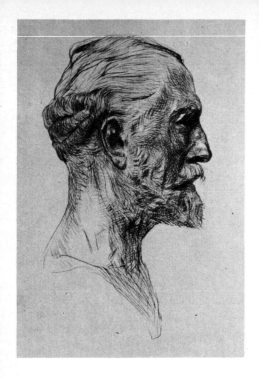

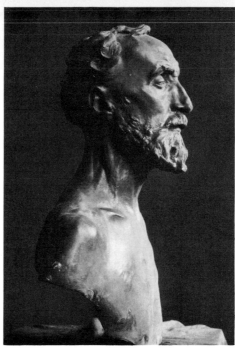

391 AUGUSTE RODIN Study for bust of *Dalou*

392 RODIN *Dalou* 1883

393 RODIN Plaster for *Balzac* 1898

394 RODIN *Balzac*

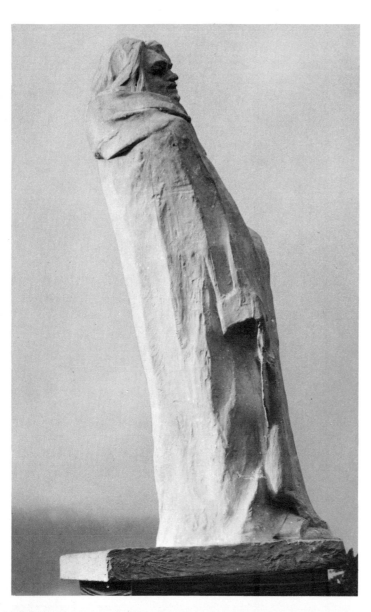

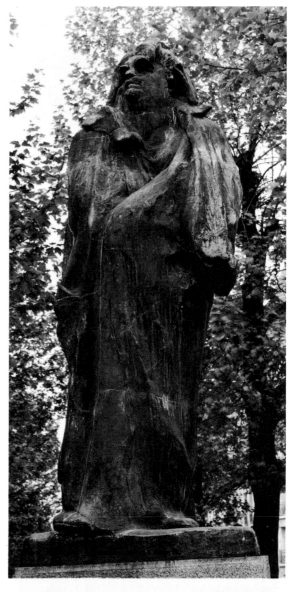

10 *Portrait head and statue, the head as form*

Since the urge to revere and record never diminishes, we see the features of the famous of succeeding generations immortalized in stone or bronze, each period evolving its own stylistic expression. Idiom and technique, however personal, cannot escape contemporary influence. Even if we are ignorant of the identity of the subject, accessories of costume, treatment of hair and – after a little experience – sculptural characteristics enable us to situate a portrait bust or statue within the broad limits of, say, ancient Roman, Early or Late Renaissance, Baroque, Neoclassical or – vaguely – modern. We carry in our memory, like markers, images of, say, the bronze bust of Dante by an anonymous fifteenth-century sculptor, or Rossellino's marble bust of Giovanni Cellini, perhaps Edward Pearce's Christopher Wren, Houdon's famous bust of Voltaire, Schadow's bust of Goethe, a Canova Napoleon, and so on.

During the nineteenth century and under the stimulus of Romanticism, portraiture in the hands of Daumier became more personally idiosyncratic and caricatural, but the academic portrait remained faithful to classical tradition. Then came Rodin.

Rodin's contribution in the medium of clay-modelling for the portrait figure cannot be over-estimated, leading as it did to the series of bronze casts of *Balzac*, then disdained but now considered perhaps his greatest masterpiece. They are not so much posthumous representations as evocations of a great literary genius – the hero as a writer. Rejected in the sculptor's life-time by the literary society that commissioned it, the plaster cast – the definitive study illustrated – was finally scaled up to its present height (almost ten feet), cast in bronze and erected at its present site in the Boulevard Raspail, Paris, only after Rodin's death. A cast of it stands appropriately and untarnished by town air in the garden of Rodin's Meudon studio, and another has been recently acquired for the New Town of Hemel Hempstead in Hertfordshire. Apparently the series of male nude studies for the representation of Balzac had been considered unbecoming and were the cause of the rejection. Little wonder that the disillusioned sculptor at one stage thought of commissioning Despiau to carve the figure in black granite. The late Sir Herbert Read has uttered a comforting dictum, applicable to this as to many initially rejected works of sculpture: 'The great work of art ultimately subdues its spectators.'

Although the bust of Dalou is not so charismatic, it is a sincere and striking portrait of a sculptor whose work Rodin respected and admired, and who, in his own bronze reliefs particularly, celebrated the life of the common man – the farm labourer, the fisherman, the factory-hand – expressively and without sentimentality. Rodin's working drawing needs little comment. The features are simply stated, the salient planes noted. In the bronze the underlying bone-structure is more clearly accentuated, the

213

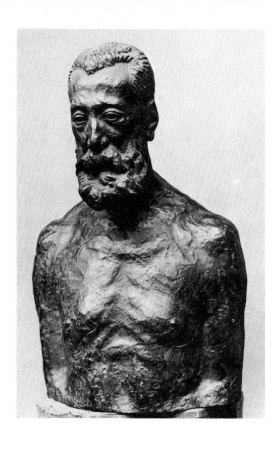

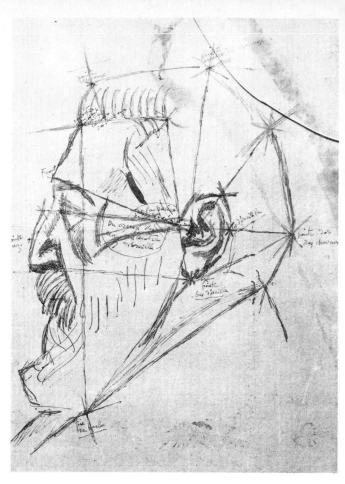

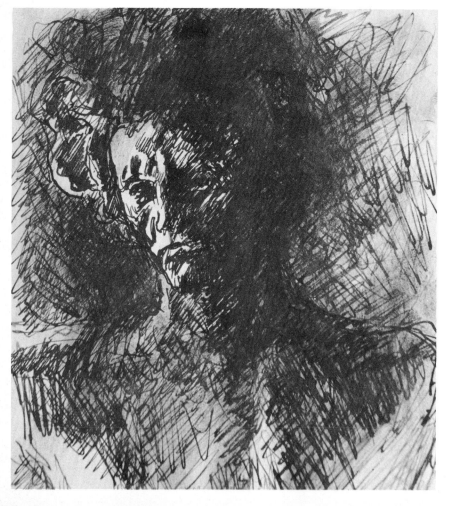

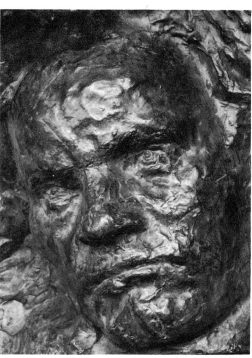

395 ANTOINE BOURDELLE *Portrait of Anatole France*
1919

396 BOURDELLE Working drawing for bust of
Anatole France 1919

397 BOURDELLE Study for *Beethoven aux grands
cheveux* 1889

398 BOURDELLE *Beethoven aux grands cheveux*

nose angle is increased, the eye-sockets are deeper and there is a slight elongation from chin to back of head.

Bourdelle's *Portrait of Anatole France* is a work in a similar spirit, a faithful and expressive record of a literary figure greatly admired at the time. The drawing is particularly informative about Bourdelle's method of working – his attention to the proportions of the head and features. He appears to have kept pretty faithfully to these in the final portrait. I have mentioned elsewhere in the book how much more successful Bourdelle is when he is less tied down to academic canons. His great admiration for Beethoven's musical genius and fortitude in adversity seems to have released him from over-much care for the representational aspect of the composer. The result is the uninhibited concentration on the spiritual qualities we see in his animated and spontaneous pen drawing and the resulting dramatic sculpture, *Beethoven aux grands cheveux*. This is only one of the Beethoven series, which comprises forty-five such studies, apart from the drawings, made between 1888 and 1903.

Besides being a general practical assistant to Alberto Giacometti, his brother Diego was the available and ever-willing model for bronze portraits. In their individual language and particular haunting character, these portraits are unique works of genius. The drawing presents us with the graphic equivalent of the rugged bronze, an apparently formless scribble, but one from which emerges the mystery of a personality held captive in one of Giacometti's characteristic space-frames. Every bump or crevice in the bronze, unidealized yet reverential, contributes to focus our attention on the questioning gaze in that long, thin face.

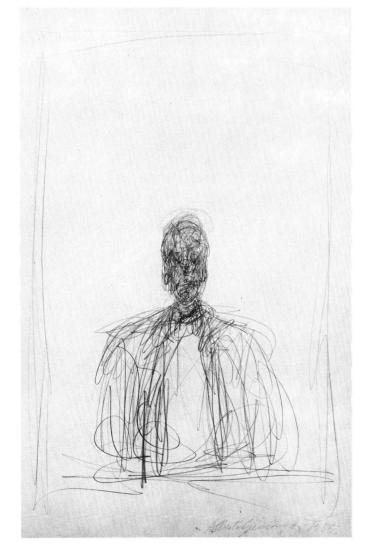

399 ALBERTO GIACOMETTI Drawing for bust of *Diego* 1955

400 GIACOMETTI *Diego* 1957

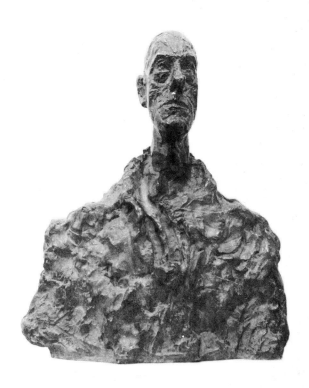

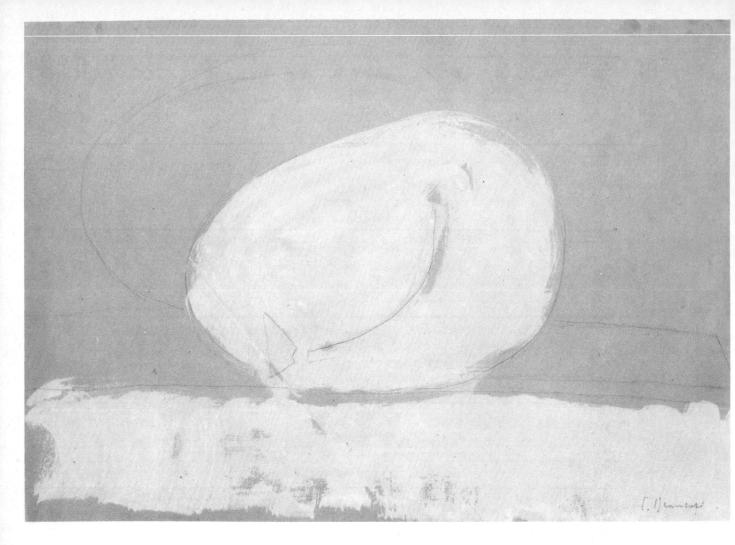

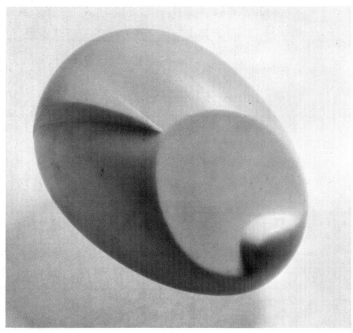

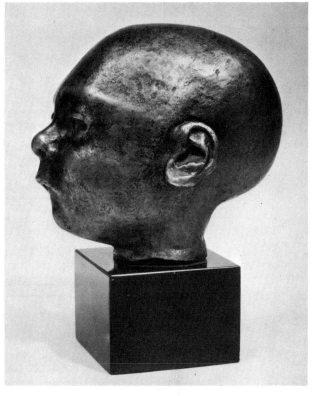

401 (top) CONSTANTIN BRANCUSI Study for *The New-born* 1914

402 BRANCUSI *The New-born* 1915

403 JACOB EPSTEIN *Head of Baby* 1902–4

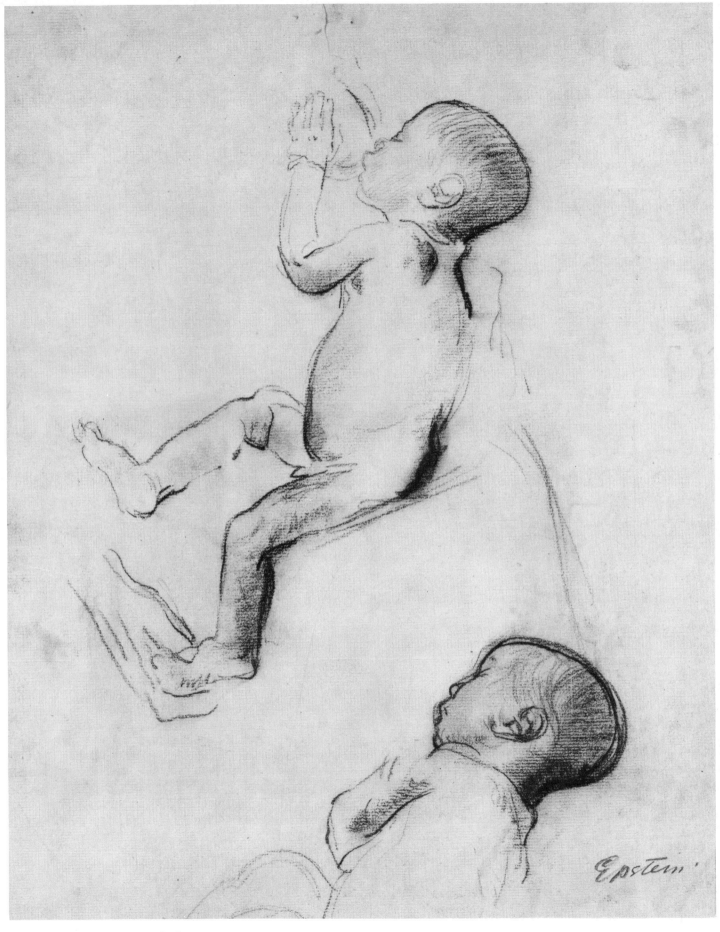

404 EPSTEIN Studies for *Head of Baby* 1902

Inevitably portraiture in a smoother style than that of Giacometti argues concentration on the pure form, rather than the 'accidents' of light, and work in such a vein is most relevantly considered under the sign of Brancusi.

Mateo Hernandez, modelling the head of a lady who asked him, 'You find, I hope, more pleasure in modelling from me than you would from a hippopotamus?' replied, 'Madame, it's the same thing.' This was perhaps a cruel way of stating the sculptor's essential preoccupation with formal qualities – a concern which was also, and above all, Brancusi's. It seems fitting, therefore, to group sculptures that show a similar concern, and to begin with a characteristic work by Brancusi himself, side by side with Epstein's bronze and drawing for the same theme, a new-born babe. Brancusi concentrates entirely on the head – one might say, the skull shape – and one is reminded of his statement: 'The egg is like the head of a new-born babe,' which could in this case be reversed without disrespect. Yet, the smooth marble is also much more, and so is the pencil and gouache drawing set off by beige-toned paper which somehow conveys the delicate nature of the egg-like skull, its vulnerability. The carving is in essence a beautiful shape exquisitely polished – Brancusi's refinement of polishing on marble and bronze is proverbial – the synthesis of a child's head, a study of opposition of flat plane with the curves of the spheroid, the inspired raised segment and the smooth irregular form which are the lips.

Epstein's drawings of a baby are studies from life, and possibly, one infers from the lightly sketched mother's breast, hand and lap, for a personal portrait. The lower study

218

406 CHATTAWAY *Skull II* 1965

of the two illustrated is recognizable in the profile view of the bronze. The sculptor has obviously been fascinated by the contrast of bone-structure with the pendulous baby-lip and soft cheek. But cover up the front of the face and we are half-way between Brancusi's *New-born* synthesis and William Chattaway's *Skull II*. Epstein's drawing is a marvellously economical statement, with enough tonal emphasis (back and shoulder-blade) to situate the figure and invest it with tenderness.

The skull inevitably carries overtones of death and mortality. There spring to mind various modalities of treatment in painting and sculpture from the 'chap fallen' Yorick of Delacroix to Holbein's distorted image – for mystification or as a memento mori – in *The Ambassadors*. Chattaway admits that he found it impossible to treat the subject in a purely detached manner. 'One must', he observes, 'show its human quality without dehumanizing it: it is a skull, not an emaciated head.' His pencil drawings 'grew' (his word) into the bronze. From several sketch drawings, I have chosen the one illustrated because while stressing structure and the geometry of the subject it is far from being a straight-forward anatomical drawing. The lightly drawn background schema is attractive in the way a faintly visible squaring-up pleases the eye on a Graham Sutherland study. Chattaway associates this study with the uptilted *Skull II*, 1965. The changes of plane are strongly marked and the build-up on a polygonal extension makes the work a more awesome object, reminiscent of the dome-shaped heads of the Bakuba tribe in Africa, or, on the grand scale, Henry Moore's *Atom Head*.

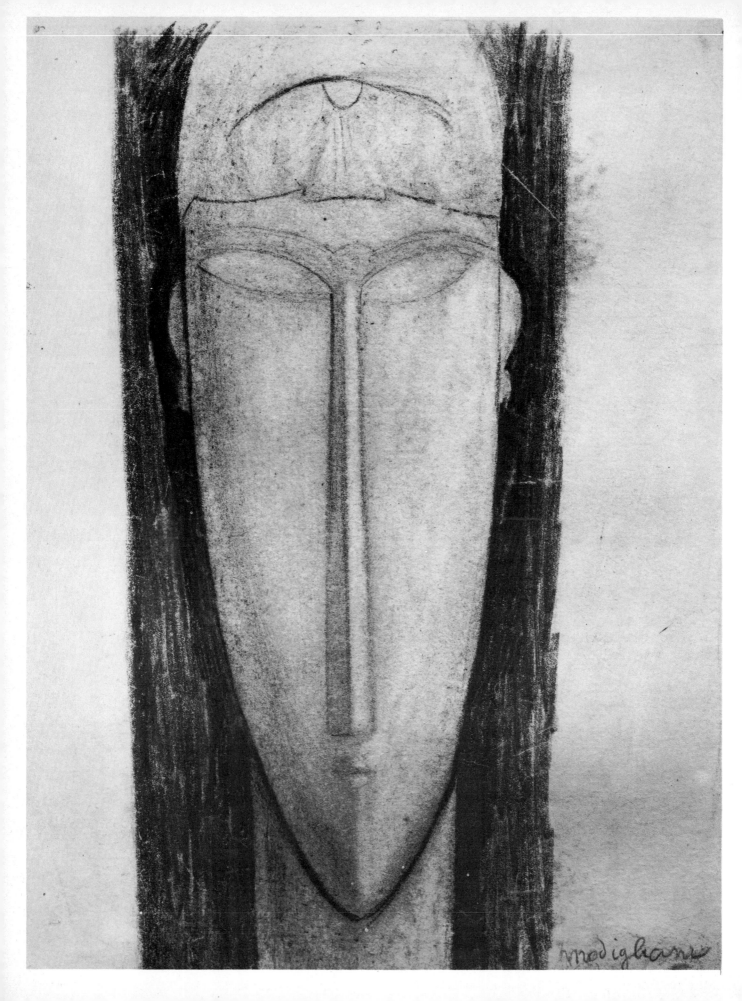

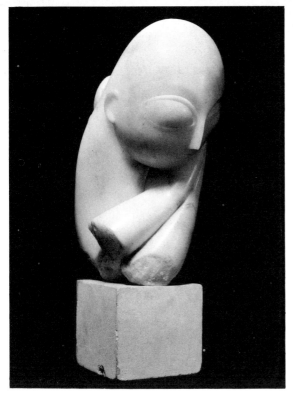

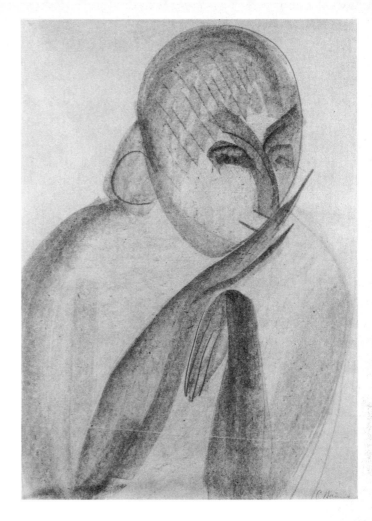

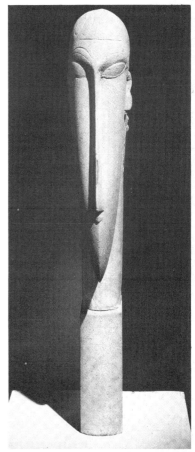

407 (left) AMEDEO MODIGLIANI Drawing on *Head* theme

408 (above) CONSTANTIN BRANCUSI *Mlle Pogany* 1913

409 (top right) BRANCUSI Drawing for *Mlle Pogany* 1912

410 (below right) MODIGLIANI *Head, c.* 1913

Modigliani in his all too short life was open to a succession of influences, and to none more than those experienced in Paris at the time when Picasso held sway in the Bateau Lavoir. He arrived in Paris in 1906, the year before Picasso painted *Les Demoiselles d'Avignon*, and like the master he admired and fell under the spell of Negro masks. It was during his time in a new studio in the Cité Falguière quarter where he was befriended by Brancusi, his neighbour, that he started on his second career – as a sculptor. According to Jacques Lipchitz, who had moved to Paris in 1909 and whose work in a cubist vein also influenced Modigliani, the *Head* carved in Euville stone belongs to the period when Modigliani was doing a series of sculptured heads; these he listed for the catalogue of the Salon d'Automne of 1912 as *Heads* (*decorative ensemble*). The drawing shown is related to such a carving. The expressive distortion is as bold as that of the odalisque necks that characterize his paintings, and is perhaps more convincing. The sole concession to the term 'decorative' in the drawing is the some-what mannered fringe, simplified in the carving. Like Gaudier-Brzeska, Modigliani was an early convert to Brancusi's gospel of direct carving, in terms of which his bold drawings for caryatids invited realization.

Brancusi's drawing *Mlle Pogany*, still some distance away from the stylized resolu-tion of the marble carving of the subject, marks the transition stage between a figura-tive study and a total synthesis of form. Executed in pencil and charcoal, it is the basis for the carving completed the following year. Both can be seen in the same museum in Philadelphia, along with a much later version (1931) also in white marble – a better

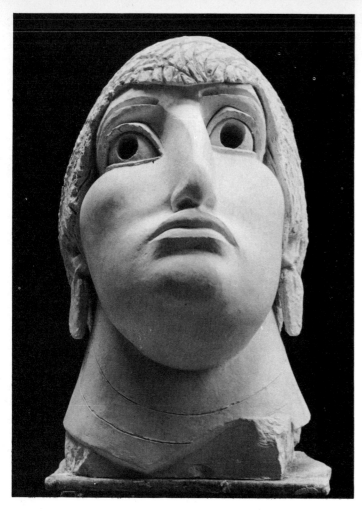

411 EMILE GILIOLI *Portrait of Babet* 1966-7

412 GILIOLI *Portrait of Babet* 1966

carving but further removed from the drawing of 1912. In the latter the essential
shapes and rhythms are all foreseen in sculptural terms and registered with spontaneous
directness: the sweeping curve of the pencil strokes in the ogee from the right arm to
the left cheek, the assimilated curve leading up to the nose. Emphasis is given to the
basic forms by the shading, done with the flat side of a charcoal stump on the head
and flipper hands.

The sculpture concentrates the effect of the drawing by means of the increased
downward angle of the head, the two arms and hands pressed together to produce a
circular movement in the whole composition. With the preternaturally huge eyes and
diminished nose it is a sophisticated adaptation of primitive simplification.

The same applies to the Gilioli *Portrait of Babet*, though this is based on other con-
ventions. The treatment of the hollowed-out eyes recalls a Gallo-Roman statue of the
first or second century BC – strong, barbaric. The drawing is likewise bold and ag-
gressive. It is executed in Indian ink and brush with contrasting effects obtained by the
use of an oily charcoal tip in some areas and almost dry, dragged strokes in others.
Gilioli made innumerable drawings of his wife Babet's head over a long period of
years. The sculptural portrait shown (plaster) is a synthesis of a number of rapid
sketches, most completely resolved in the drawing reproduced. Each of the studies is
a stage, evidently indispensable, in the creation of a final bronze in which, as Gilioli
stated, 'no longer is anything left of my wife's face', and for a three-foot high version
of the head, *La Grande Babet*.

222

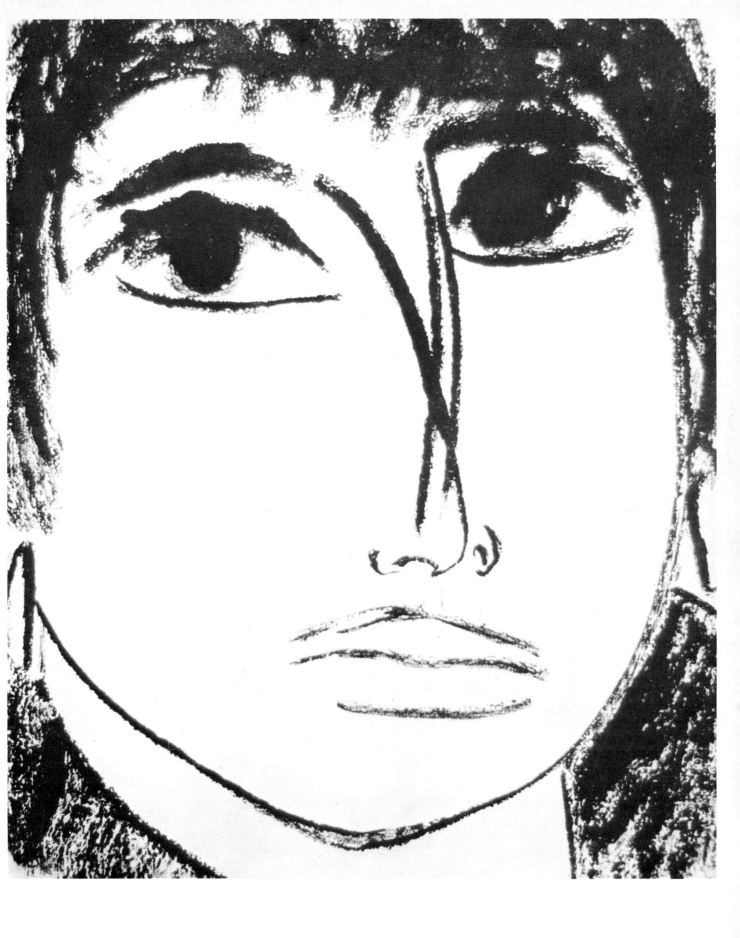

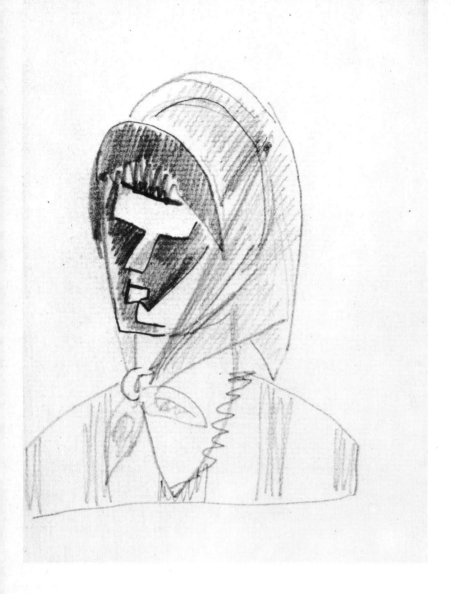

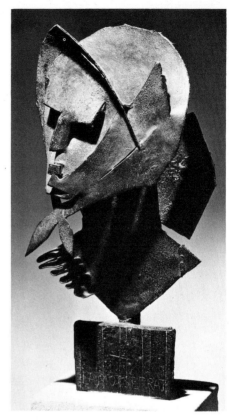

413 (left) Julio Gonzalez *Peasant Woman* 1937

414 (above) Gonzalez *Montserrat, c.* 1930

Portrait heads by Gonzalez and Beaudin – both of whom had had long careers as painters – are also simplifications, but owe nothing to the Brancusi influence. They are of different inspiration and conditioned by the techniques involved. Both sculptors were indebted to the Cubist movement; Gonzalez directly to Picasso. The drawings and sculpture of both are characterized by their emphasis on the interplay of planes, often, as in Gonzalez's early masks and Beaudin's relief profiles, offering only a frontal view.

Gonzalez's drawing relating to the *Montserrat*, an artifact in cut and welded iron, shows how an initial study can anticipate the effect of the material of the sculpture. It is a composition of flat and single-curved surfaces, distorted planes cutting into space in a series of silhouettes. The pencil drawing illustrated, with an emphasis on straight lines, focuses our attention on the intersection of the planes, brought out further by notional shadows. Everything is present in this study, entitled *Peasant Woman*, that we recognize in the metal sculpture, transformed into *Montserrat* head. The head-scarf becomes the helmet, the knot below the chin an aesthetically necessary appendage to the

224

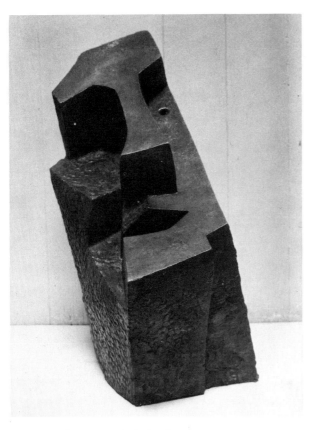

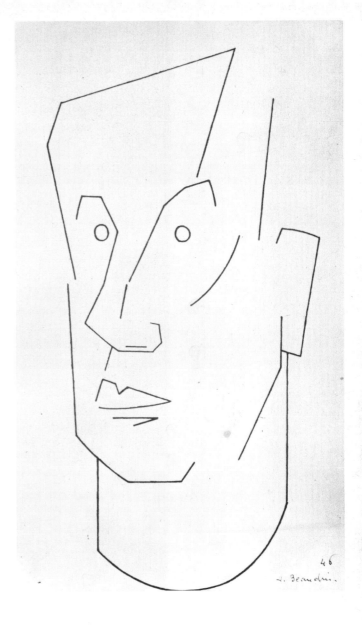

415 ANDRÉ BEAUDIN *Paul Eluard* 1947

416 BEAUDIN Drawing for *Paul Eluard* 1946

helmet-headdress. *Montserrat*, an obsessive figure in Gonzalez's work, symbolizes the Republican side in the Spanish Civil War and, later on, the French Resistance movement, with both of which, like his great friend Picasso, Gonzalez identified himself. The *Peasant Woman* transfigured into this dramatic *tour de force* in welded sculpture – the first of *Montserrat* variations – has therefore an important place in Gonzalez iconography.

Beaudin has said, 'If I do sculpture, it is because I want to see what there is behind my pictures.' In point of fact, just as in painting Beaudin largely restricts himself to the picture plane, in his drawing he dispenses with notional distance. It is not surprising therefore that he progressed slowly from bronze low reliefs (plaster modelling and carving) to the cubist idiom of the *Eluard* and the more liberated style of *The Bird of Marriage* (347). He makes his drawings in a sketch-book of minute format. They seem to indicate a rapid and spontaneous solution of his sculptural problems.

Despite the formal distortions, the *Eluard* portrait is immediately recognizable as a likeness, and captures the enigmatic expression characteristic of the poet. Beaudin has

225

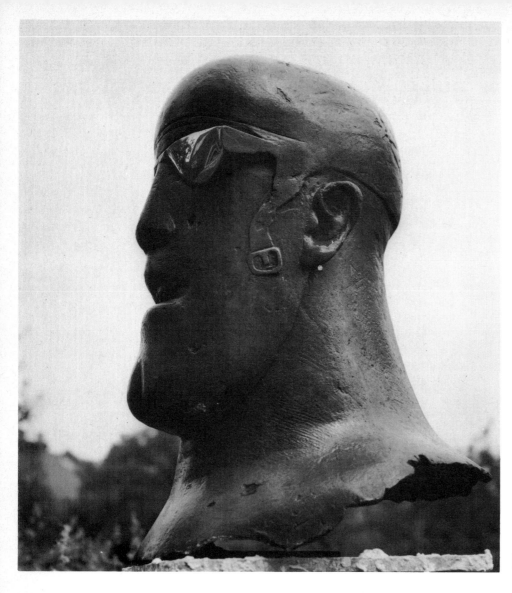

417 ELISABETH FRINK *Goggle
Head* 1969

made considerable changes from the idea-drawing, but the nose, eyes and mouth are
essentially the same. The treatment of the neck, projecting the portrait at an angle, is
an obvious improvement on the cylindrical form shown in the drawing; in the latter
it contrasts agreeably with the angularity of the rest and makes a linear connective
with the circles of the eyes. In the bronze, the sunken holes of the eyes are the sole
concession to the curve. They focus our attention on the most expressive feature, set
off by the clear-cut planes of nose and eyebrow.

Between 1965 and 1970, Elisabeth Frink, partly inspired by some early Roman busts
in the Ashmolean Museum, executed a series of 'Soldiers' Heads' in bronze, followed
by several different versions of 'Goggle Heads' whose origin is described below.
'Soldiers' Heads' with their intentionally blunt, insensitive features fall neither under the
sign of Rodin nor Brancusi. They evoke rather the image of ancient gladiators or
battered boxers. Like a family of less-intelligent Horatii, dumbly aggressive, these four
related heads are unforgettably original.

The *Goggle Head* illustrated was suggested by the photograph of a Moroccan
general in an issue of *Paris Match*. The semi-opaque sun-glasses (polished bronze in the
sculpture) are the important appurtenance, worn as a mask. The sketch was made in

226

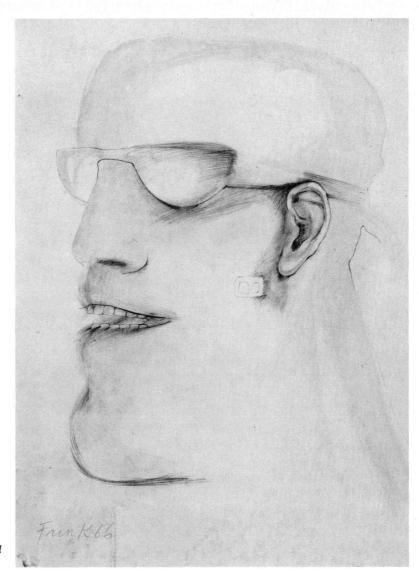

418 FRINK Drawing for *Goggle Head*
1966

1966, and although the bronze did not follow until three years later, the design is almost unmodified.

The technique of the drawing is Elizabeth Frink's familiar one of wash, lightly applied, and a hard pencil – the wash emphasizing the almost flat areas of cheek and heavy jowl. The thin lines of the lips and shark-like teeth, the bullet head enclosed in its leather helmet and the blank stare of the goggles all produce an effect of ruthless power. The predator-bird of the earlier period is no less aggressive in human shape.

The closeness of the drawing and bronze, three years apart, is explained by deeply rooted visual memories that come from various sources – press photographs and early Roman busts in the present case – which find equivalent expression in a series of drawings and sculptures at which Frink works in alternating spurts.

Goggle Head – which Frink dissociates entirely from political events – is an individual reaction to a visual impact, but one, nevertheless, that could only belong to our time, a significant note in the gamut of expressive head forms.

Baskin's portrait-sculpture *Laughing Sheriff* – a title that inevitably carries associations with the famous Hals painted portrait – and particularly the drawing, are very much of our time; yet the final sculpture, as we see in the plaster model, makes an

227

interesting comparison with some of Rodin's plaster studies of the nude male for the *Balzac* statue. The latter were of an uninhibited frankness in some cases, though the final study with the hands crossed below the abdomen is in the heroic mould. Baskin gives us an unflattering portrayal of a fleshy middle-aged officer of the law, but there is sympathy and humour in the sculpture and the down-to-earth realism of the drawing. In the past the paunchy male is associated either with the Silenuses of Antiquity or with legendary or symbolic figures in Rodin. In Baskin's work – drawing and sculpture – the Sheriff is, literally, stripped of every associational trapping except his title. What we have is a sensitive drawing in which a fine, subtle contour contrasts with the bulk and sag of the belly, emphasized by a discreet use of tonal areas. The forearm that leads us in at right angles to the picture plane suggests power and confidence, the spread hand is drawn with exquisite precision. The whole is far away from the *Angst*-ridden figure of the *Tormented Man* and the *Oppressed Man* carving, but one notes a repetition of the thin lips and small, even teeth in the *Sheriff* drawing that, like those in Frink's *Goggle Heads*, suggest a cruel streak.

The sculpture's setting, Baskin's Little Deer Isle studio, allows us to see other work in progress.

Three artists, Hajdu, Bourdelle and McWilliam, of this final group have in common their use of a person intimately connected with them as their model for full-length portrait figures. This personal element, subordinated though it is to other considerations, has been important to the result. All the works except the Hajdu *Lia*, a more fanciful evocation in polished aluminium related to form rather than to portraiture, are bronzes. Hajdu has made a practice of giving such pieces in bronze or aluminium feminine names – *Blanche*, *Palmyre*, *Livia*, and so on – and all of them have a shape-relationship, particularly in head-dress or profile. One can think of them as a sculptural parallel to, say, Elgar's 'Enigma Variations'. Fanciful, poetic, this coral-like form

419 (below) Leonard Baskin's studio at Little Deer Isle with *Laughing Sheriff* (centre)

420 (opposite) LEONARD BASKIN Drawing for *Laughing Sheriff* 1967

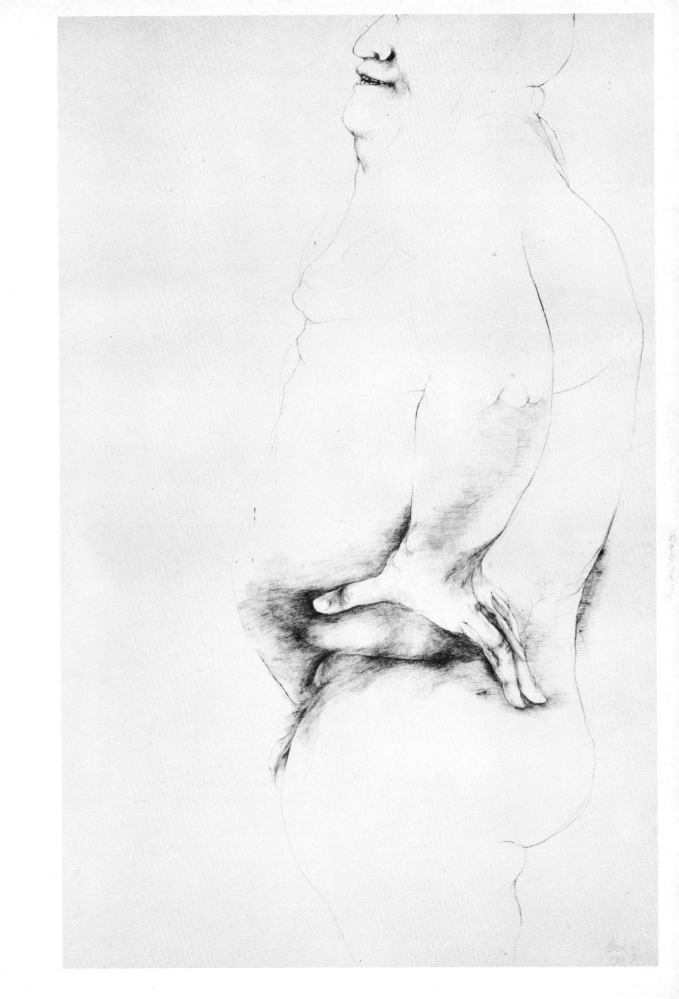

421 ANTOINE BOURDELLE Sketch of Mme Bourdelle at the British Museum

422 ETIENNE HAJDU *Lia* 1965 (*see also IX, p. 184*)

423 ANTOINE BOURDELLE *Penelope with Spindle* (small version), *c. 1907*

424 F. E. MCWILLIAM *Portrait Figure* (Elisabeth Frink) 1956

425 (opposite) MCWILLIAM *Studies of Elisabeth Frink* for *Portrait Figure* 1956

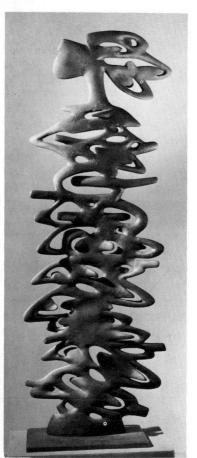

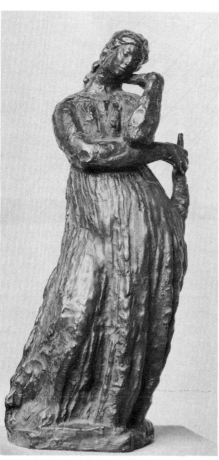

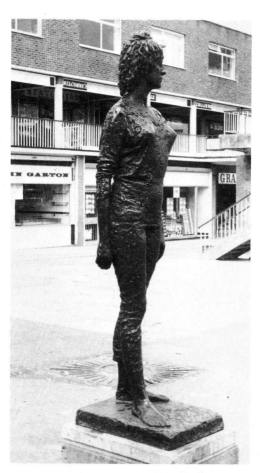

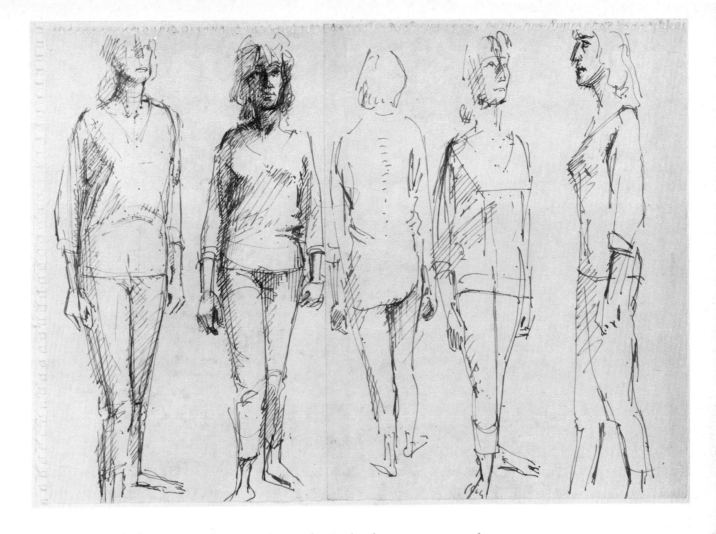

of *Lia* is the kind of creature one's imagination catches in the chance movement of shadows. Here we have, in three dimensions, subtlety of form and play of light on a spiral axis, rising to a spectacular climax in the slender neck and head with head-dress (or analogue for hair) acting as a counterpoise to the swelling of the breast. The water-colour drawing relating to *Lia* is a conceptual, poetic statement, a fanciful evocation of a personality. Hajdu has used black like Rouault in his paintings and in the leading of his stained-glass, to effect a passage between strong and sometimes clashing colours – in the sculptor's case (IX, p. 184), blue-violet against a moiré background.

The model for several of Bourdelle's semi-portrait figures was his pupil, a Greek called Cleopatra Sevastos who later became his wife. We recognize her in the *Apples* of 1907, and especially in a charming, naturalistic *Sculptress resting*, in which she leans with her right hand on a rock (the dead owl near by is doubtless an allusion to Athens), her left forearm across her raised right knee as she looks up in a thoughtful pose. The pen sketch was drawn from life while Cleopatra was gazing in rapt admiration at Hindu gods in the British Museum. It obviously suggested the pose of the bronze *Penelope with Spindle* (small version), in which the sculptor has accentuated the curve of the hip and shaped the rather amorphous skirt of the drawing, giving the knee a focus of thrust. A further improvement is the relative diminution of the head and the creation of a space between right arm and left contour of the skirt. The general effect has been to emphasize the S-shape and lend the whole a natural elegance. The rendering of the dress in the sketch – it has assumed the folds of a Dorian chiton –

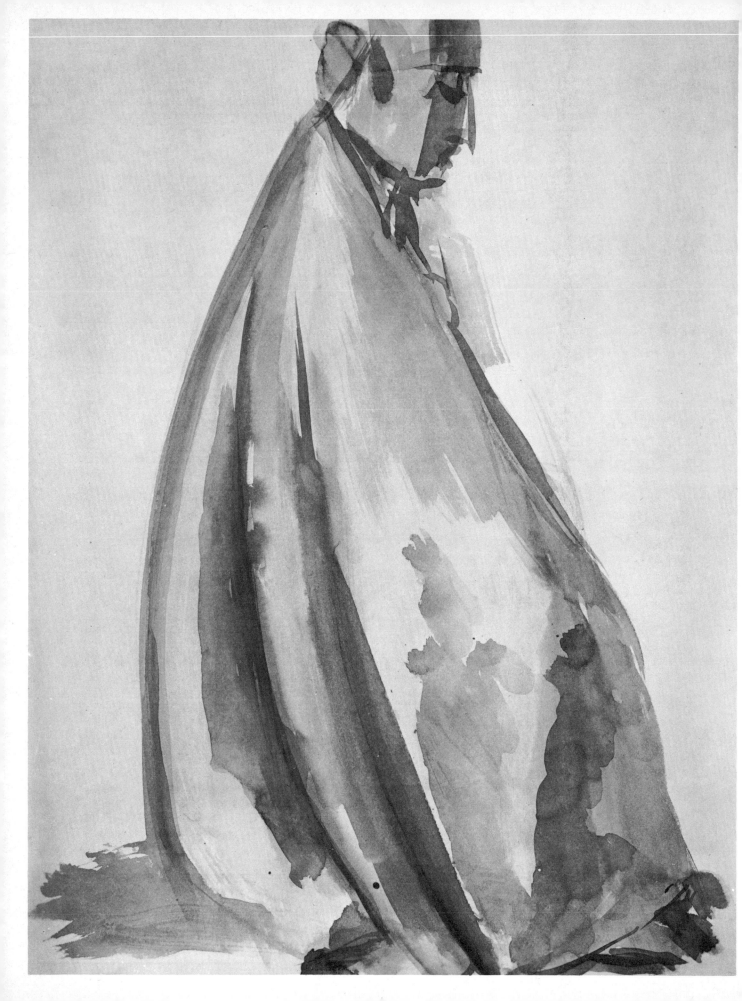

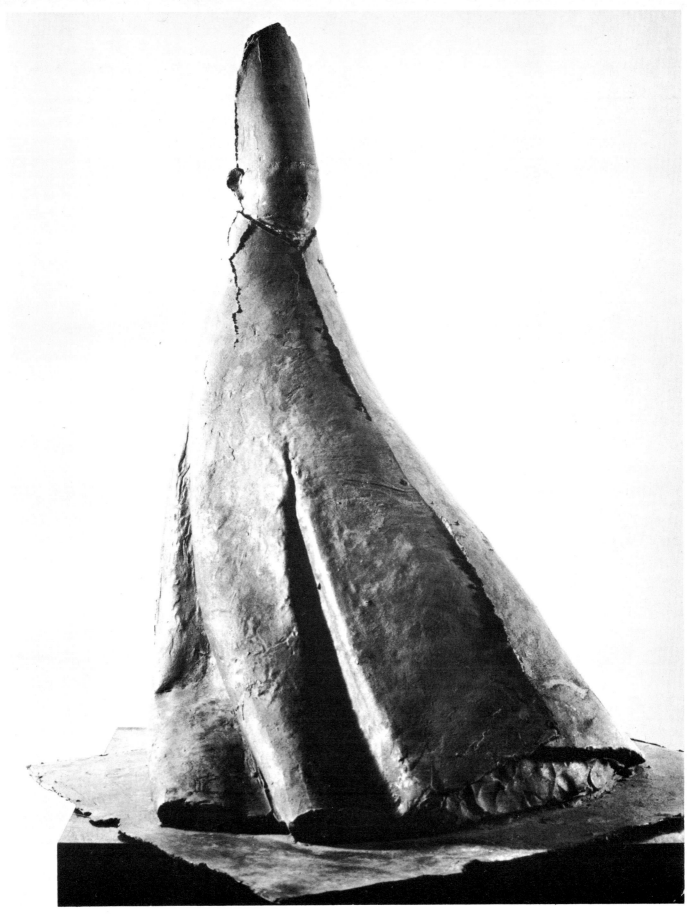

426 (left) Giacomo Manzù Study for *Seated Cardinal* 1958

427 (above) Manzù *Seated Cardinal* 1968

suggests that the mythological subject of Penelope was already in Bourdelle's mind as he drew it, and some of the easeful repose of the model has entered the bronze via the drawing and endowed it with a universal feminine quality.

McWilliam's *Portrait Figure*, a bronze which stands in the High at Harlow New Town in Essex, is in fact the outcome of sketch-drawings of the sculptor Elisabeth Frink, and there has been no attempt to universalize what is a striking likeness. The figure suggests youthful energy and extrovert confidence, both facets of the artistic persona of the subject. The page from McWilliam's sketch-book captures the stance he wanted, and already in the second sketch from the left we are approaching the final bronze with the simplification of folds. The chief modification in the bronze is the sideways turn of the head which acts in counterpoise to the striding right leg. The stylistic effect of clothes on a subject is considerable, and here their informality emphasizes the image of a 'New Town'. The contrast between the Bourdelle *Penelope* and the McWilliam, separated by precisely half a century, expresses a difference of attitude to the feminine subject as well as of costume.

The final portrait sculpture, a cardinal by Manzù, is one of a whole series of a subject that preoccupied or rather obsessed him for a long period of years. The first drawing dates back to 1934, the first sculpture to 1938, and the latest one, *Grande Cardinale*, was completed in 1970, carved in marble and almost ten feet high. There are almost as many seated as standing versions. The Tate Gallery example of 1947–8 is of a seated figure, a unique bronze cast and one of his more personal interpretations. Usually his cardinals represent, as he has stated, not 'the majesty of the Church but the majesty of form'. They are hieratic forms, highly conventionalized; elongated cones of tightly wrapped canonicals terminating in a mitre, impressive in their severity and anonymity.

Manzù has made many large-scale drawings of the subject in pen and wash as well as in chalk and tempera, always characterized by breadth of treatment. Since only one *Cardinal* was modelled from life (a commissioned portrait now in Bologna), I have chosen to reproduce a wash-drawing of a seated cardinal which relates closely to the bronze *Seated Cardinal* of 1968. This relationship is evident in the folds of the canonical robe, where the notional high-lights in the drawing correspond to the light-catching areas of the bronze, and in the form and expression of the face. Both illustrate Manzù's feeling for a satisfying shape and its underlying geometry. The often-declared as well as implicit recognition of 'sculpture as object' is an all-important aspect of the twentieth-century attitude towards sculpture, reflected particularly in the more analytical drawings reproduced in this book. It is not of course a new attitude, but never before has the attempt to divorce form from cult, symbolism, and 'subject' been so explicitly recognized.

Throughout this book, the reader will have observed the different roles played by drawings for sculpture according to the stage in the work they represent (from first-idea sketch to working drawing), according to the theme, even according to the material envisaged for the modelling, carving or construction. No less than the diverse end-products, the studies and more especially the first-idea sketches bear unmistakeably the identity of their creator. They are expressed literally in the artist's handwriting, in the closest possible proximity to the creative impulse, and with all the immediacy that pen, pencil, or brushstroke offer.

The media for drawing – except for the innovation of the felt- and ball-point pen, bromide print and silkscreen – have remained constants in the artist's armoury, where-

234

as new materials for sculpture and casting – aluminium, concrete, plexiglas, fibreglass, vinyl, polyester resins, foam rubber, expanded polystyrene – not to mention techniques of welding and brazing metal – are continually enlarging the scope of the contemporary sculptor. A close look at sculptors' drawings helps to remind us that implicit in all sculpture is the oldest of recognized disciplines, drawing; drawing not merely in the academic sense, but as the expression of a sculptural idea on paper by the simplest means. We have seen how this applies in works of art as diverse as Michelangelo's sketch-idea for the *Bruges Madonna* and Carpeaux's for *The Four Quarters of the World*, Lipchitz's for the *Prometheus* and Oldenburg's for *Soft Type-writer*.

Drawings for sculpture show us not only the points of departure for a given sculpture, such as a life-model or inanimate object, but also the subjective ideas set down on paper; the embryonic stage, the initial visualization as it emerges from the sculptor's imagination as raw material for potential development. Drawings illustrate that crucial state, on the frontier between imagination and reality, in which these two elements are polarized, as the initial act of creation. To adapt T. S. Eliot, 'every drawing is an end and a beginning' for the sculptor embarking on an exploration.

The drawings reproduced in this book, over and above their intrinsic artistic interest and merit, provide a kind of map of the way in which sculptors have dealt with one phase or another in the solution of a sculptural problem – steps we have seen leading to works of distinction and originality, and, in not a few cases, of genius.

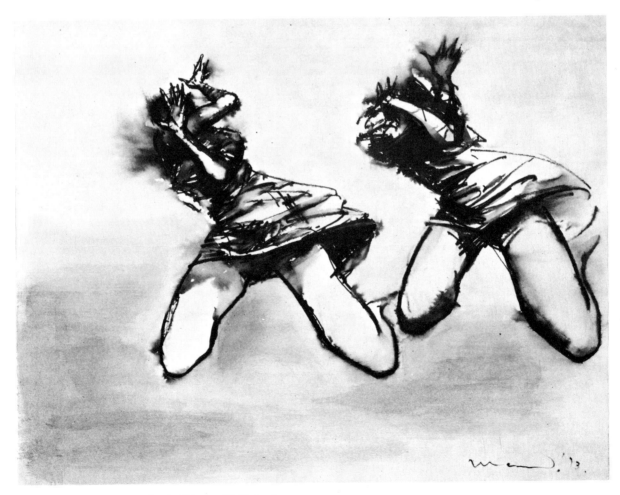

428 F. E. McWILLIAM Drawing in *Women of Belfast* series 1972

Notes on the text

1 Indeed the public of the Third Empire was shocked by the group and in particular by the depiction of two completely nude female dancers. The scandal was such that Napoleon III approved of its removal as 'obscene'. The siege of Paris in 1870 when the Opéra was used as a provision store made the issue irrelevant. In the course of almost a century the Echaillon stone deteriorated to such an extent that a carved copy was commissioned and executed by Paul Belmondo, replacing the original, which is now in the Louvre.

2 The English painter Richard Wilson made a pencil drawing of this subject (shown in an exhibition of 'British Artists in Rome', Kenwood, 1974) viewed from the side.

3 In Michelangelo's time the unit of measurement, *braccio* (modern Italian 'arm'), varied in different towns in Italy, e.g. Florence 58.3 cm, Naples 69.8 cm.

4 Both Chaudet and Nollekens were represented at the 'Age of Neoclassicism' exhibition of 1972 at Burlington House, London. Evidence of Nollekens' interest in Antiquity and its canon of proportion is illustrated by a measured drawing of his 'after the Antinous'—one of the versions of the Greek ideal nude male that survived. Antinous was the favourite youth of the Emperor Hadrian, and his head appears on the Greek idealized male nude, which was therefore the subject of study by classicizing sculptors. Nollekens' drawing was shown at the 'British Artists in Rome' exhibition, Kenwood, 1974. A statue of Antinous, represented as Dionysus, now in the Vatican Museum, had been one of the discoveries of the archaeologist Gavin Hamilton at Palestrina in 1795, but Nollekens' study seems to have been after a relief.

5 There is a poem on the subject by the fifteenth-century French poet François Villon.

6 Braque, less well known as a master of engraved plaster, was the first to recognize the promise of Chillida's work in the wrought-iron sculpture *Dream Anvil*, which has now passed appropriately into the family of another sculptor: it now belongs to Claude Laurens, the architect son of Henri Laurens.

7 'There are two particular motives and subjects which I have constantly used in my sculpture in the last twenty years; they are the *Reclining Figure* idea and the *Mother and Child* idea (perhaps of the two the *Mother and Child* has been the most fundamental obsession).' Henry Moore (quoted Herbert Read). In fact the former has proved to be the more enduring source of inspiration. The only other *Madonna and Child* Moore carved was one for St Peter's Church, Claydon, Suffolk. It was developed from one of the Northampton maquettes of 1943.

8 'Sometimes I begin to draw with no preconceived problem to solve, with only the desire to use pencil on paper.... sometimes I start with a set subject; or to solve in a block of stone of known dimensions, a sculptural problem I've given myself...'. Henry Moore (quoted Herbert Read, *Henry Moore, Sculpture and Drawings*, London, 1949).

9 Moore first chanced on the Aztec Chacmool in a half-tone illustration in a German catalogue.

10 This bronze, as the Florence Exhibition of Moore's work in 1972 showed, could also dominate an urban landscape.

11 One of these, *Cubi XII*, was shown at the exhibition of sculpture in Battersea Park, London, in 1966.

12 His large-scale ceremonial doors in nickel bronze for the Archives Centre, Churchill College, were of course cast by a foundry. See article by the author, *Connoisseur*, September 1974.

13 Kemeny himself never referred to these artifacts as 'reliefs', a term he thought inappropriate to these creations—each an individual item *sui generis*.

14 About which he said: '*le spectacle est à l'intérieur*'

Biographical notes

To keep these Notes within a reasonable compass, I have limited them to a brief 'curriculum vitae' including background and art and—where relevant—other training. The list of exhibitions is likewise necessarily selective. As far as particular sculptures are concerned, I have noted some of the important works accessible to the public in galleries or on open-air sites in various parts of the world, and also items which may be considered as 'key' works in the development of individual sculptors or as landmarks of sculpture for technical or thematic reasons. The amount of space devoted to each sculptor therefore does not necessarily reflect a value-judgement on his work as a whole; it is based rather on the need to provide a context for the works illustrated in the present book.

ADAMS, Robert

Born Northampton 1917. Trained Northampton School of Art and Royal College of Art, London. First and subsequent exhibitions mostly at Gimpel Fils Gallery, London. Also one-man exhibitions in galleries abroad, including Galerie Jeanne Bucher, Paris. 1949–60 lecturer at Central School of Arts and Crafts, London. Represented at the Venice Biennale 1952 and São Paulo Biennial 1957. One-man exhibition in the British Pavilion, Venice Biennale, 1962. A reinforced concrete wall-relief for the Stadtstheater, Gelsenkirchen, Germany, 1959, mural bas-relief for the P & O liner, *Canberra*, 1961. Work represented in open-air exhibitions Holland Park (1954 and 1957), Battersea (1960, 1963 and 1966). Influenced by seeing the welded metal sculptures of Picasso and Gonzalez. Important retrospective exhibition 1971, Camden Arts Centre, London, which included carved sculptures in wood and Sicilian marble as well as in bronze and steel. Many of his pieces have been commissioned in connection with public buildings and schools (in London, Northampton, Newark, Eltham and Hull). Represented at the Tokyo Biennial 1963 and Sonsbeck, Holland, 1966. Lives at Little Maplestead, Essex.

ARMITAGE, Kenneth

Born Leeds 1916 of Yorkshire and Irish parents. Trained Leeds College of Art, Royal College of Art and the Slade. Six and a half years in the army, including war service. 1946 appointed to staff of Bath Academy of Art. Head of the sculpture department there until 1954. Awarded a Gregory Fellowship at Leeds. 1959–65 one-man exhibitions Whitechapel Gallery, London; Gimpel Fils, New York; Paul Rosenberg, New York; Marlborough Gallery, London. Group open-air sculpture exhibitions include Holland Park, 1954, 1975; Middelheim, Antwerp, 1959; Battersea, 1960, 1963; Japan (Hakone), 1969, 1971. Guest artist Caracas, Venezuela, 1963–4; guest artist City of Berlin, 1967–9. Represented at 'British Sculptors 1972', Royal Academy (Touring Arts Council Exhibition 1972–3). Important sculptures of different phases: *Family going for a Walk; Reclining Figure; Triarchy; Diarchy; Mouton Variations; Both Arms; Single Arm; Big Doll; Screens; Girls by a Screen.* Screen for Nottingham University Library 1973. 1974 *Both Arms*, new version, casting and plate construction over 7 feet high, mounted on concrete platform, presented to the Commando Training Centre, Royal Marines, Lympstone, Devon, by the Department of the Environment. Represented in many international galleries in London, Paris, Rome, Berlin, Hamburg, New York, Toronto, etc. Best sculptor under 45 award at Venice Biennale 1958. Now lives in London.

ARP, Jean (or Hans)

Born Strasbourg 1887. Began career as a painter. Joint founder of the Dadaist movement in 1916. From about 1930 increasingly involved with relief sculpture and collages. Settled in Meudon, near Paris, 1926. Early sculptures include a marble torso (1931) and *Hybrid Fruit called Pagoda* (1934), now in the Tate Gallery, shown Battersea Open-air Exhibition 1951. *Shepherd of the Clouds* (1953), Battersea 1960, *Ambition concrète* (1953), *Ptolemy* (open sculpture, bronze, 1953), *The Forest Apparition, Celestial Objects* (1961), *Idole des lapins* (*The Hares' Idol*), 1965. Metal reliefs for Graduate Center, Harvard (1950) and the University of Caracas (1956). Important one-man exhibitions: 25th Biennale, Venice, 1950; Berne (with Schwitters) 1956; Galerie d'Art Moderne, Paris, 1962; the Tate Gallery, London. Exhibition of 'Graphic Work of 1912–59', Berne (Klipstein and Kornfeld). Other one-man exhibitions at the Galerie Maeght, Paris. Died Basle 1966. His work can be seen in most important American and European galleries such as the Museum of Modern Art, New York, the Kröller-Müller Museum, Otterlo, the Musée Nationale d'Art Moderne, Paris, the Tate Gallery, London.

BASKIN, Leonard

Born New Brunswick, New Jersey, 1922. Studied with the sculptor Maurice Glickman 1937–9, student the School of Architecture and Allied Arts, New York University, 1939–41, and School of Fine Arts, Yale, 1941–3. Served with the US Navy during World War II. To Paris 1950, studied at the Académie de la Grande Chaumière. Next to Accademia di Belle Arti, Florence. In Northampton, Mass., as artist-in-residence at Smith College for long period. Now settled in Tiverton, Devon, England. First one-man exhibition 1939 at the Glickman Studio Gallery, New York, many one-man shows since, and innumerable collective exhibitions including 'New Images of Man', Museum of Modern Art, New York, 1959; 'Modern Sculpture from the Joseph H. Hirschhorn Collection', Guggenheim Museum, New York, 1962–3; Battersea Open-air Exhibition, 1963; 'American Sculpture of the 20th Century', Musée Rodin, Paris, 1963; Holland Park

Open-air Exhibition 1975. Widely known for his graphics and awarded a Prize for Printmaking at 4th Biennial, São Paulo, 1961, where his woodcuts were part of the US representation. Exhibition of prints, drawings and sculpture circulated by the Museum of Modern Art, New York, to Rotterdam, Berlin and Paris, 1961. Examples of his work in all these fields in many national and private collections, including the Museum of Modern Art, New York, and the Grace Borgenicht Gallery, New York.

BEAUDIN, André

Born Mennécy, France (Seine-et-Oise), 1895. 1911–15 studied Ecole des Arts Décoratifs, Paris. 1921 travelled in Italy. Met Juan Gris 1922. 1923 one-man exhibition of paintings at Galerie Percier, Paris. About 1930 turned attention to sculpture, beginning with bronze reliefs, and extending repertory to sculpture in the round and 'open' sculpture, notably in *Dance* (1933), *Le Cerceau* (*The Hoop*) of 1934 and *The Bird of Marriage* (1952). During intervening years executed bronze portraits, e.g. of the poet Paul Éluard (1947). Illustrated many *livres d'artiste*, notably: Virgil *Bucolics*, Nerval's *Sylvie*; designed tapestries and mosaics for industrial interiors. Principal one-man exhibitions: Waddington Gallery, London, 1947; Freiburg, 1954; retrospective of sculptures 1930–63, Galerie Louise Leiris, Paris. Group exhibition on 'La Main' (1965), and of 'Portraits in Sculpture', Galerie Claude Bernard, 1967. Exhibition of 'The Artist & the Book', coll. W. J. Strachan, Scottish Gallery of Modern Art, Edinburgh, 1967; 'Anthology of Painting and Sculpture', Warsaw, 1968; 'Paintings and Sculptures by André Beaudin', Il Milione, Milan, 1970. 'Grand Horizon' exhibition, Galerie Louise Leiris, Paris, 1971. Work in both painting and sculpture represented in galleries all over the world.

BERROCAL, Miguel

Born Malaga 1933. Studied mathematics, science and chemistry at Madrid University, then architecture and sculpture with Angel Ferrant. Gained bursary to Madrid School of Fine Arts, followed by another, from the French government in 1955, for study in Paris. One-man exhibitions include those at La Medusa, Rome; the Galleria Apollinaire, Milan; Galerie Kriegel, Paris; Musée des Beaux-Arts, Brussels; the Albert Loeb Gallery, New York. Sculpture prize-winner at the Venice Biennale, 1964, and at a Paris Biennial. Further one-man shows at the Berlin Museum, 1966, Kunstmuseum, Lucern, Gimpel Fils, London, 1967. Represented at many group exhibitions, notably 'Dix ans d'art vivant', Fondation Maeght, 1967, and the Kunstmarkt Fair at Cologne, 1967. The Museums of Modern Art at Paris, Brussels and New York have acquired examples of his work. His metal sculptures are cast by himself. Important examples include: *Torses* (1959, 1961, 1962); *Sainte Agathe* (1964, 2 elements); *Adamo Secundo* (1966, 41 elements, iron and bronze); *David* (1966, 22 elements, wrought and welded steel); *Caryatid* (1966, 22 elements). Lives in Verona.

BOURDELLE, Antoine

Born Montauban 1861, son of cabinet-maker whose workshop is incorporated in the present Musée Bourdelle in Paris. Attended Ecole des Beaux-Arts, Paris. Taught by Falguière and Dalou, and became Rodin's chief assistant. First sculptures date from 1880. Some 'key' works: *Sappho* (1st version 1887);

Beethoven Portraits (from 1888); *Monument aux Morts de la Guerre de 1870*, Montauban (1893); *Femme sculpteur au repos* (1906); *Heraclès, Archer* (1909); *The Urn* (torso); *Le Fruit* (1911); reliefs for the Théâtre des Champs Elysées, Paris (from 1910); *Penelope with Spindle* (small version, 1907–12); *Portrait of Ingres* (1910–12); equestrian monument to General Alvear (1912–23); *Bust of Anatole France* (1919); *La France* (1925). Died Le Vésinet 1929. One-man exhibitions include: Galerie Hébrard, Paris, 1905; retrospective exhibition, 1928, Musée des Beaux-Arts, Brussels; posthumous retrospective exhibition, 1931, Musée de l'Orangerie, Paris; posthumous exhibitions in Canada, New York, California, Cincinnati, Tokyo, etc. 1949 inauguration of Musée Bourdelle, of which his daughter, Madame Bourdelle-Dufet, is the director.

BRANCUSI, Constantin

Born Rumania 1876. 1883–94 worked in various capacities from servant to shepherd. A wealthy patron paid for his training through the Arts and Crafts School, Cracow, and (1898–1902) at the School of Fine Arts, Bucharest. After travel in Europe, settled in Paris and attended the Ecole des Beaux-Arts in 1905. Began contributing sculpture to group exhibitions. Despite admiration for Rodin, turned down the offer of working under him. Influenced by primitive and pre-historic carving, as in *The Kiss* (1908) etc. and *The Spirit of Buddha* (1927). Other 'key' works include: *Mlle Pogany* (version of 1913); *Danaïde* of the same year (Tate Gallery); *The Newborn* (1915, Philadelphia Museum of Art); *Portrait of Princess X* (1916); *Bird in Space* (1919); *The Beginning of the World* (1924); *Torso of a Young Man* (1922, Philadelphia); *The Seal* (1936, Musée National d'Art Moderne, Paris). From 1938 on, exhibited in international surrealist exhibitions and represented in countless international exhibitions and collections. Most important one-man exhibition held 1955 at the Solomon R. Guggenheim Museum, New York. Died Paris 1957. 1962 a full-size model of his studio inaugurated at the Musée National d'Art Moderne, Paris.

BROWN, Ralph

Born Leeds 1928. Studied Leeds College of Art 1948–51, Hammersmith School of Art 1951–2 and Royal College of Art 1952–6, from the latter winning travel scholarship to Greece 1954 and to Italy 1957. Head of Sculpture Department, Bournemouth College of Art. Then Tutor in Sculpture School of Royal College of Art, London, since 1958. During a stay in Paris worked under Zadkine. An admirer of Rodin, he has also been influenced by Moore and Manzù. Major mixed exhibitions: open-air sculpture exhibitions, Middelheim, Antwerp, 1959; Battersea, 1960, 1963 and 1966; British Council Exhibition of British Sculpture, Japan, 1963; 'British Sculptors 1972', Royal Academy and Redfern Gallery; 'Drawings for Sculpture', Buckingham Gallery, London, 1970; Holland Park Open-air Exhibition 1975. Important sculptures include: *The Sheep-shearer, Meat Porters* (Harlow New Town, Essex); *Swimmers* (Hatfield Technical College, Herts, and Tate Gallery); *Lovers* (1971); *Pastoral* (1963); *The Queen* (1962); *Female Head* (Arts Council); *Confluence* (1966); *Wedding* (1970); *Lovers V* (1972).

BURY, Pol

Born Maine-St Pierre, Belgium, 1922, son of a garage-owner. 1929–32 visits to France. 1938 Ecole des Beaux-Arts, Mons.

1939 worked in a tool factory. Meeting with Magritte and Tanguy. 1941–3 painted and worked for the Resistance movement. 1945 participated in the International Exhibition of Surrealism. 1953 gave up painting for mobiles and 1955 exhibited Galerie Denise René, Paris, with Calder, Duchamp, Vasarely etc. in 'Exposition de Mòuvement'. 1957 made electrically activated sculptures. 1962 first one-man show Landau Gallery, Los Angeles; 1966 spent six months in New York. Contributed to 'Dix ans d'art vivant', Fondation Maeght, St Paul de Vence. 1968 developed sculpture activated by electro-magnets. University of Iowa commissioned a fountain. Participated in 'Homage to Apollinaire' exhibition, Institute of Contemporary Arts, London. 1969 one-man show Galerie Maeght, Paris (43 Eléments se faisant face, 25 Eggs on a Tray); 1970 retrospective exhibition, University of California; 1971 one-man show, under title 'Boules', Galerie Maeght; 1973 one-man 'Animated columns' (electrically activated), Fondation Maeght, St Paul de Vence. The sculptor's most ambitious, large-scale undertaking, this forest of columns involved the articulation and animation of 25 tons of steel by a system of electro-magnetic force ('e pur si muove').

BUTLER, Reg

Born Buntingford, Herts, 1913. Qualified as architect in 1937. Practical engineering experience, and during World War II worked as blacksmith. Practised as architectural draughtsman then devoted himself wholly to sculpture. Awarded a Gregory fellowship from Leeds University 1950–3; 1953 first prize in the international competition for a monument to an Unknown Political Prisoner (in which competitors included Barbara Hepworth, Antoine Pevsner, Lynn Chadwick, Germaine Richier, Elisabeth Frink). Same year became visiting sculptor to Slade School to which he is still advisor. Up to 1963, one-man exhibitions regularly held at the Hanover Gallery, London. Similar exhibitions Rotterdam, Paris, Berlin, Stockholm, Rome etc., and in America at the Curt Valentin Gallery and Pierre Matisse Gallery, New York. Retrospective show of his work held at Louisville, 1966. Obsessive preoccupations with figures (male and female) looking up or bending; figures in space; the tower and box. First works mostly in welded metal of an open character, followed by animistic creations in bronze. Among his key figures are the Manipulator (1954), Young Girl (1953), Figure in Space (several versions), Stooping Nude (1969–70). 1963 series of bronze pastiches of exotic and primitive figurines which he called 'musée imaginaire', exhibited and acquired in toto by Pierre Matisse Gallery, New York. Visited Japan 1966 as guest of the Japanese government, where he made a striking bronze bust portrait, Makoto Okuyma. Represented at the Tate Gallery 'Painting and Sculpture of a Decade, 1954–1964' (by Figure in Space, 1958–9, and Tcheekle boîte de fétiches, 1960–1). He is a brilliant draughtsman and examples of his work in this genre always accompany those of his sculpture. Lectures given to the Slade School published as Creative Development. Five painted bronze nudes shown at one-man exhibition at the Pierre Matisse Gallery, New York, March–April 1973. 1975 Stooping Nude at Holland Park Open-air Exhibition. Experiments with articulated nude figures.

CALDER, Alexander

Born Philadelphia 1898, son and grandson of sculptors. 1919 graduated as mechanical engineer in New Jersey. 1919–23 studied art while doing various jobs. Made a miniature circus, animated toys and first wire sculptures 1926–7. Took examples to Paris where they were well received at the Galerie Billet (1929). Formed important friendships with Arp and Miró. After the first period of abstract metal structures—christened 'stabiles' by Arp—held first show of mechanically activated 'mobiles'. 1927–33 commuted between America and France— a practice he has continued. Many one-man exhibitions notably at the Museum of Modern Art, New York, São Paulo, the Tate Gallery (1962), and the Galerie Maeght, Paris. Sculpture prize 26th Biennale, Venice. Contributed a vast mobile, The Whirling Spiral, for the Unesco complex, Paris, 1959. Important works characteristic of successive phases in his carrer: Calderberry Bush (1932); On One Knee and Double Helix (1944); Tower with six leaves and a point (1951, Perls Galleries, New York); Black Fungus (1957–8); Black Widow (1960, shown Battersea 1963); Fum Tata Wyn Totem (1965); Three Bollards (1970, Galerie Maeght); Horned Beast and other 'animobiles' in coloured steel (1971, 1973, Galerie Maeght).

CÉSAR (Baldaccini César)

Born Marseilles 1921. Trained Ecole des Beaux-Arts, Marseilles, and in the studio of Cornu, a pupil of Rodin's. 1943 Ecole des Beaux-Arts, Paris. Admired the work of the great Italians, especially Michelangelo and Donatello. Carved in stone, then discovered the potential of iron welding (c. 1947). Experimented with hammered lead, iron wire. Early work The Fish (Musée National d'Art Moderne, Paris) belongs to his animistic period. Worked with many techniques, crushed metal in the Compressed automobile of 1961), welding, bronze. Pied de Vestiaire and L'Homme de Saint Denis (the latter Tate Gallery) are typical of the welded winged figure, earlier period. Exhibits regularly at the Galerie Claude Bernard, Paris, and has a workshop-cum-iron foundry at Saint Denis. Recently, has given demonstrations of 'instant' temporary and destructible sculpture in soft materials. A whole section of the Venice Biennale of 1956 devoted to his work. Has influenced many modern sculptors, notably Paolozzi and Bryan Kneale.

CHADWICK, Lynn

Born London 1914. Trained as architectural draughtsman. Joined the Fleet Air Arm as a pilot (1941–4). A pioneer of mobiles from 1945. Discovered individual technique of iron-welding for sculpture. 1950 first one-man exhibition Gimpel Fils, London. Showed work at the 2nd Battersea Open-air Exhibition and the Festival of Britain, 1951. Break-through to the international scene came with his participation in the Venice Biennale of 1952: 'New Aspects of British Sculpture', and as one of prize-winners in the Unknown Political Prisoner sculpture competition. A 'key' piece, Inner Eye, of this period shown in the Holland Park exhibition, 1954. Awarded international sculpture prize at the Venice Biennale of 1956. Period of in-filled zoomorphic forms on armatures of metal rods (Lion, Winged Figure, Stranger, 1959–62). Stranger III exhibited Spoleto 'Festival of Two Worlds' Exhibition at which he was the British representative sculptor. Works shown at the Tate Gallery Exhibition 'Sculpture of a Decade, 1954–1964', and have been a feature of many international exhibitions in Europe, America and Japan from the São Paulo Biennial of 1961 onwards. One-man show at the Marlborough Gallery, London, 1974 included the Elektra series and the Seated Pair. Work in world-wide public and private collections, notably the Tate Gallery, London; Middelheim Park, Antwerp; Kröller-Müller Museum, Otterlo; Boymans Museum,

Rotterdam; Museo d'Arte Moderna, Venice; Albright-Knox Gallery, Buffalo; Art Institute of Chicago; Museum of Fine Art, Montreal; Museum of Modern Art, New York; Wilhelm-Lehmbruckmuseum, Duisburg. Now lives and works in his neo-Gothic castle, Lypiatt Park in Gloucestershire.

CHATTAWAY, William

Born Coventry 1927. 1943–5 Art School, Coventry; 1945–8, Slade School, London; 1950 settled in Paris. First one-man exhibition at the Galerie Jeanne Castel, 1963, followed by a second in 1966, and a third at the Leicester Galleries, London, in 1969, and in Coventry. Participated in group exhibitions, including the Salon de Mai 1951, 1966, 1967, 1968, and Salon de la Jeune sculpture (Musée Rodin) 1965. Works by him have been acquired by Beauvais Museum, Herbert Art Gallery, Coventry (sculpture) and drawings by the Musée National d'Art Moderne, Paris. Commissions executed for Sir Basil Spence and Lady Epstein.

CHILLIDA, Eduardo

Born San Sebastian, Spain, 1924, of a music- and art-loving family. 1942 studied architecture in Madrid. 1949 exhibited a torso in the Salon de Mai in Paris, where he had been resident in the Cité Universitaire. Participated in the exhibition 'Les Mains Eblouies', 1950, at the Galerie Maeght. 1951 executed first non-figurative iron sculpture. 1955 first one-man show at the Galerie Maeght. 1958, prize for sculpture at the 29th Venice Biennale. One-man exhibitions: McRoberts & Tunnard Gallery, London, 1965, Galerie Maeght (alabaster reliefs etc.), 1970. 1967 participated in the exhibition 'Dix ans d'art vivant' at the Fondation Maeght, St Paul de Vence. 1969 executed an iron sculpture for Unesco, Paris, and a stainless steel sculpture for the World Bank, Washington, DC. Divides his time between Spain and France. Draws a good deal but regards this activity as parallel rather than related in any close way to his sculpture. Some key works: *Torso* (1948, plaster), *Enclume de Rêve* (*Dream Anvil*) (1950) acquired by Braque, now in the collection of Claude Laurens, *Ikaraundi* (1952), *In praise of Fire*, (*c.* 1955, Museo Civico, Turin), *Enclume de Rêve No. 4* (1954–8), *Modulation of Space* (1963).

CHRISTO (Christo Javacheff)

Born Bulgaria, 1935. Studied at Academy of Fine Arts, Sofia, 1951–6, and participated in work-study at the Burian Theatre, Prague, 1956, followed by a semester at the Academy of Fine Arts, Vienna. 1958 to Paris. Executed first packages and wrapped objects. Three years later, first project for packaging a public building, for stacked oil-drums and dockside packages in Cologne Harbour. 1962 iron curtain of oil-drums set up in rue Visconti, Paris. 1964 settled in New York, and has since worked on many packaging projects, including packaging of medieval tower and fountain in Spoleto for 'Festival of Two Worlds', 1968; packaging of the Museum of Contemporary Art, Chicago, involving 2,800 square feet of drop cloths, 1968; wrapping up an area of coast at Little Bay, Australia; and the *Valley Curtain* of 1970–2. Christo has had many one-man exhibitions in America, Italy, Germany, Belgium, France, and participated in group shows in these and other countries.

CHRYSSA

Of Greek origins, educated in Athens until she left Greece to study in Paris in 1953. Next in San Francisco and, two years

later, in New York. Chryssa's work represents the polarization of European and American cultural influences, the latter evident in her 'luminist' sculpture which had been pioneered by another sculptor from a background of mixed cultures, Noguchi. Her experiments embraced work involving neon lights and typographic characters in shallow reliefs. This interest extended to commercial signs, rearranged, fractured and sometimes illuminated, which bring her into the field of Pop art. For one of the youngest sculptors in the present book she has a remarkable corpus of original and outstanding work behind her, from the *Cycladic Book* of 1955 to the ambitious *Gates to Times Square* of 1964–6, and *Clytemnestra* (multi-coloured neon tubing and moulded plexiglas), which was a feature of the '4 Documenta' Kassel, and the National-galerie, Berlin, respectively in 1968. One-man exhibitions at many US galleries, including the Walker Art Center, Minneapolis, and the Museum of Modern Art, New York, and in Europe at the Galerie Rive Droite, Paris, Galerie der Spiegel, Cologne. Represented at 36th Venice Biennale, 1972.

CLARKE, Geoffrey

Born Darley Dale, Derbyshire, 1924. Studied at schools of art in Preston, Manchester and Lancaster. Served with the RAF 1942–7. Studied and subsequently taught at the Royal College of Art, London, becoming Head of the Department of Light Transmission and Projection. 1951 awarded the silver medal for sculpture, Milan Triennale. Became known for his large and highly original engravings and aquatints on iron. Participated in the exhibition 'Young Sculpture' at the Institute of Contemporary Art, London, 1952, the Venice Biennale of 1952 and 1960, and the Battersea Open-air exhibition, 1963. His cast aluminium is done at his own workshop at Hartest in Suffolk, mostly commissioned by architects and for specific interior or exterior sites. Works include: entrance gates for Winchester College Chapel; reliefs for Castrol Building, London; Nottingham Playhouse; the High Altar Cross, Coventry Cathedral, and the *Crown of Thorns* (and for the exterior, the *Flying Cross*). He designed and cast the gates for the Civic Centre, and the six retractable gates for the banqueting hall of the same building, at Newcastle-on-Tyne; gates for Churchill College, Cambridge, and (nickel-bronze) for the Churchill Archives Library, unveiled in 1973. Exterior and free-standing sculpture include the *Torii D*, Bedford College of Physical Education (1965), *Plateau*, *Plasma stabile*, a 10-foot-high sculpture for Culham Atomic Research Centre (1965), a free-standing sculpture (aluminium on a stainless steel armature) commissioned by Sir Basil Spence. Designed and cast the aluminium relief for the Potter Pulpit in Chichester Cathedral. Especially interested in environmental sculpture and responsible for the layout and detail of the Civic Centre, Aldershot (1971). His sculpture and engraving is represented in the Tate Gallery, London, the Time–Life Building, London, the Victoria and Albert Museum and the Museum of Modern Art, New York. One-man exhibitions of sculpture and monotypes at Gimpel Fils, the Redfern Gallery, and Taranman (1975), London, and has participated in many mixed exhibitions in Europe and the United States.

COUTURIER, Robert

Born Angoulême 1905. Family came to Paris 1910. Studied lithography at the Ecole Estienne, Paris. Worked as a lithographer at Mourlot's. Began to sculpt from 1922. Contact with Maillol 1928. 1930 won the Prix Blumenthal. 1932

travelled in Greece. 1936 commissioned to do a sculpture, *Le Jardinier*, for the Palais de Chaillot, Paris, and 1938, a bronze gate for the Palais de l'Ariana, Geneva. 1939 began working as assistant to Maillol. 1940 prisoner of war of the Germans but escaped to the Unoccupied Zone. 1940–5 produced the bronze *Leda, Saint Sébastien* (plaster). His personal idiom developed and is evident in *La voilette*, (*c.* 1950, plaster and wire mesh, a technique which he was to use for *Les jeunes filles de Dourdan* of 1968 as an armature). 1946 appointed professor, Ecole des Arts Décoratifs, Paris. 1947 one-man exhibition at the Anglo-French Art Centre. *Adam and Eve*, bronze, was acquired by the Musée National d'Art Moderne, Paris, and from this date on many foreign galleries bought his work. His *Girl with Hoop* (shown Tokyo and New York) is typical of his work in the early 1950s. Occasionally carves in marble and Euville stone. Among his most notable carvings are *Manazuru* (1963) and *Portrait sans visage* (1968–9); and among his bronzes *The Three Graces* (1968). Now an international figure, he had already in 1959 had a one-man exhibition at the Venice Biennale, and in 1970 he was given a one-man exhibition at the Musée Rodin. Since then he has executed a version of *Hommage à Maillol* in bronze, and participated in the exhibition 'Cultures of the World and Modern Art', Munich, 1972. 1973 worked on a colossal bronze, *The Tree of Science*, for the new Faculté de Pharmacie, Paris.

DESPIAU, Charles

Born Mont-de-Marsan (Landes) 1874, son of a master-plasterer. To Paris at seventeen, first to the Ecole des Arts Décoratifs, then the Ecole des Beaux-Arts. At the former under H. Lemaire, a pupil of Carpeaux, at the latter under Barrias. Exhibited Salon des Artistes Français 1898, but his first characteristic work is the modelling of the head of *A Little Girl from the Landes* (1904). 1907 worked with Rodin, without any sacrifice of individual simplicity of modelling—mostly the female figure, based on models who were friends or relations. He also modelled portraits. Died 1946. Among representative works: *Young Girl Standing* (1925, Musée National d'Art Moderne, Paris), *Assia* (Petit Palais), and *Eve* (bronze nude, exhibited Battersea Park, London, 1948). A fine draughtsman, and many of his lithographs appear in the *livres d'artiste*. He illustrated, notably, *Poèmes* by Baudelaire (1933), *Les Olympiques* (1943).

DODEIGNE, Eugène

Born Rouvreux, Belgium, 1923. 1935 apprenticed to his stone-mason father. Then attended the Ecole des Beaux-Arts, Tourcoing. 1945 to Paris, attended the Ecole des Beaux-Arts. Spent a period of time in Vézélay in Burgundy, famous for its carvings. 1950 settled at Bondues (Département Nord of France) which he has made his home and studio. Significantly he himself constructed both—including a kiln in which he casts his lost-wax bronzes. He also works in 'Belgium granite' —tough calcareous stone. 1953 first one-man show Lille (Galerie Marcel Evrard), followed in the same year by that at Galerie Veranneman, Brussels. Similar shows at Galerie Claude Bernard, Paris, 1958; Galerie Springer, Cologne, 1962; Galerie Jeanne Bucher, Paris, 1964; the Boymans Museum, Rotterdam, 1965; and the Musées Royaux des Beaux-Arts, Brussels, 1971. First London exhibition at the Buckingham Gallery, 1971. Has participated in many international exhibitions, at Middelheim, Kassel, Carnegie Institute, Pittsburgh, Musée Rodin, Fondation Maeght, St Paul de Vence, Avignon

Festival. Tokyo Biennial 1967 etc. Works in alternating periods of carving, modelling and drawing: 'Every year there is a period when I do nothing but draw . . . in these drawings I choose sculptural themes for future realisation' (letter to author). Important works include: (carving) *Torsos*, *St Bernard* (Chapel of Fondation Maeght), *Personnages* (groups of giant figures), sculptures for Lille University precincts, figures in the Town Hall Square, Hanover, and in the gardens of the Kröller-Müller Museum, Holland: (bronzes) *Madeleine*, *Couchée*, *Hidden Hands*, *Prayer*—the latter shown, along with many drawings related to them, at the Buckingham Gallery exhibition, London, 1971.

EPSTEIN, Jacob

Born New York, 1880, of Russian-Polish parents. Did not accept the orthodox Jewish faith, but remained deeply religious. 1902–5 in Paris, but his work was unacceptable both to the Ecole des Beaux-Arts and the Académie Julian. At a period when sculptors 'farmed out' their clay and plaster models to be carved in stone, Epstein was deeply influenced by the direct carving seen in the Louvre and in Italy, and by the Ghiberti bronze doors of the Baptistery, Florence. London 1905–7. 1907–8 worked on controversial stone reliefs for the British Medical Association building, London. Similar controversy over monument to Oscar Wilde (1911), Cimetière Père Lachaise, Paris. Also 1911 carved *Mother and Child* (shown Battersea Open-air Exhibition 1960). *Rock-drill* (Tate Gallery) is key piece in style inspired by Vorticist conceptions, a landmark in animist sculpture. Stone carving (memorial to W.H. Hudson) *Rima* erected 1925; like *Genesis* (1931), *Ecce Homo* (1935) and *Adam* (1939) it was treated by the public and many critics with a derision that *Night* (1928–9) mostly escaped. His bronze portrait busts were admired (1916, of his first wife; several of Kathleen Garman, the present Lady Epstein as *Girl with Gardenias*, *Esther*, etc.), particularly those of children. Public commissions: *Madonna and Child* (1952) for the church in Cavendish Square, a *Christ in Majesty* for Llandaff Cathedral, the statue of *Field-Marshal Smuts* (Parliament Square), *St Michael* for Coventry Cathedral, and finally his last large work, the *Bowater House Group*. One of his most successful carvings was the *Lazarus* (1947) in New College, Oxford. Died 1959. 1961 Tate Gallery retrospective exhibition. 1971 Leicester Gallery, London, put on a show of his sculptures and drawings of the period 1900–32.

FERBER, Herbert

Born New York 1906. Studied at the College of the City of New York 1923–6; took degree in dentistry. Studied sculpture at the Fine Arts Institute of Design, New York. 1937 first one-man exhibition Midtown Galleries, New York. Many other one-man exhibitions including Retrospective organized by the Walker Art Center, Minneapolis, Minnesota, 1962, which included *Homage to Piranesi* variations, and was circulated in the US and abroad. Represented in many international group shows, including 1st Biennial, São Paulo, 1951; 'Modern Art in the US' (touring eight European cities 1955–6); 'Documenta II', Kassel, 1959; Festival of Two Worlds, Spoleto, 1962; Battersea Open-air Exhibition, 1963; 'American Sculpture of the Twentieth Century', Musée Rodin, Paris, 1965. For many years Ferber belonged to the Abstract Expressionist group in New York. He experimented with open metal forms of a linear kind such as *Calligraphy on a Wall* of 1957. Following his *Homage to Piranesi* series, he worked on the larger scale of the *Egremont II* (1972), which rests, plinthless, on the ground.

FRINK, Elizabeth

Born Thurlow, Suffolk. Attended the Guildford School of Art 1947-9, and Chelsea School of Art 1949-53. First London exhibition 1952, when the Tate Gallery bought *Harbinger Bird* bronze. Represented Holland Park and Battersea Park open-air exhibitions, 1954 and 1957 respectively, and was among those chosen to represent Great Britain in the international competition for the monument to *An Unknown Political Prisoner*. Work included in the open-air sculpture exhibition Middelheim, 1959. One of her first commissions was the *Wild Boar* (concrete, later bronze) for Harlow New Town, Essex; another was *Man and Dog* for Bethnal Green, London. *Warriors, Harbinger Birds*, the *Dead King* theme (shown Battersea 1963), the *Horizontal Birdman* (Battersea 1960), *Goggle Head, Horse and Rider*, and *Soldiers' Heads* (1965) have been features of successive exhibitions. She has a studio and an etching press in London. She has made a name for her lithographic illustrations to *Aesop's Fables* and the high quality of her pencil drawings. Since 1958 has had exhibitions at the Waddington Galleries, London, including a retrospective, with new *Horse* themes, 1972. 1975 two public sculptures in London: a life-size *Horse and Rider* (close in conception to the theme as treated in 1969), Piccadilly (commissioned by Trafalgar House Investments Ltd.), and *Shepherd with His Sheep* commissioned by the Paternoster Development Ltd., Paternoster Place, unveiled by Yehudi Menuhin, 30 July 1975.

GAUDIER-BRZESKA, Henri

Born St Jean de Braye, near Orléans, 1891. Visited England as a student 1906 and 1908. 1910 met Sophie Brzeska, with whom he lived until he joined the French army in 1914 at the outbreak of World War I. Between 1911 and that date—along with Wyndham Lewis, Nevinson and others—he had been a prime-mover in the Vorticist movement, London Group. Killed in action 1915. His pioneering sculpture absorbed Cycladic and exotic influences, after quickly passing through more traditional stages. Thanks to the percipience of H.S. Ede, emeritus curator of Kettle's Yard Museum, Cambridge, most of Gaudier's work can be seen either in that collection or the Kettle's Yard Donation Gallery in the Musée National d'Art Moderne, Paris. Some key works: *Bird swallowing a Fish* (1914), *Red Stone Dancer* of the same year, *Dog* (original a marble carving), *Seated Woman*. A brilliant, prolific draughtsman of nudes, animals, portraits, which can be seen in the Kettle's Yard Collection and the Tate Gallery. In London the Mercury Gallery in 1968 and the Maltzahn Gallery in 1974 have held exhibitions of Gaudier-Brzeska's drawings, and there have been similar exhibitions at Edinburgh and elsewhere. His work is represented in the Museum of Modern Art, New York.

GIACOMETTI, Alberto

Born Stampa in the Grisons 1901. Father Impressionist painter. Went to Paris 1922. Early sculpture influenced by Rodin and Bourdelle. Admired Henri Laurens' work and Cycladic and Etruscan sculpture. His Surrealist period, 1930 to *c.* 1935, resulted in his famous *Palace at 4 a.m.*—a construction involving several different materials. 1938 during a long spell in hospital as a result of breaking his foot he became fascinated by the problems of carriage and balance; the use of plaster of paris for orthopaedic purposes had a curious aesthetic effect on subsequent sculptures—for example in the heavily weighted feet of his filiform bronzes. 1940 onwards dispensed with

models for painting, but continued to use his brother Diego as model for bronze heads (*Grande Tête*, 1954-5). Died 1966. His work was shown after World War II in many European and American galleries and museums: Galerie Maeght, Paris, 1951 and 1954, Pierre Matisse Gallery, New York, 1948 and 1950; Kunsthalle, Berne, 1956, etc. The Tate Gallery owns a large collection of his sculpture, likewise the Musée National d'Art Moderne, Paris. The Galerie Claude Bernard exhibited his work posthumously, including an important representative collection of his drawings, 1968. Some important sculptures: *Walking Man* (1948), *L'Homme qui pointe* (1947), *Sept Figures— La Forêt* (drawing *Triptych*), *Head of Diego* (1957). The permanent collection of work at the Fondation Maeght, St Paul de Vence, consists of the Cour Giacometti (open-air) as well as indoor items.

GILIOLI, Emile

Born Paris 1911, of Italian parents. Spent youth in Italy, returned to France 1927. Art training at the Ecole des Arts Décoratifs, Nice, and Ecole des Beaux-Arts, Paris. Called up for war service 1939 and remained in the Dauphiné up to 1945. Important encounters for artistic education were those with Monsieur Farcy, the enlightened director of the Musée de Grenoble, Poliakoff, and later Deyrolle and Vasarely. 1941 first exhibition, Grenoble. 1949 participated in the exhibition 'La Sculpture en France de Rodin à nos jours', Maison de la Pensée, Paris. 1953 tapestries shown at the Demeure, Paris. 1955 sculpture at the Galerie Denise René and the 3rd Biennial, São Paulo. Since then has participated in the 'Exposition internationale de Sculpture contemporaine' at the Musée Rodin in 1956 and in exhibitions in Stockholm, 1960, Oslo, 1968, Montreal, 1967, and in Paris at the Galerie Dina Vierny, 1962. One-man retrospective, Grenoble 1969. Public commissions include: Monument du Vercors, bas-relief at Montrouge (1951); sculpture for the Swimming Pool Sonia Henie, Beverley Hills (1959); sculpture in homage to Dag Hammarskjöld, Jonkoping. Works as a carver in marble as well as a modeller in bronze and *peintre-cartonnier*. Particularly fascinated by the sphere theme. Works include: *La Halle au Vin* (1946); *The Sphere* (1947); *Babet* (1954); *Portrait of Babet* (1966); *The Sleeper* (carving, 1962); *La Poupée* (1947-61); *L'Ange combattant* (1969).

GONZALEZ, Julio

Born Barcelona 1876. Both father and grandfather practised as goldsmiths. 1892 father taught him metalwork. Meantime attended the School of Fine Arts, Barcelona. 1900 exhibited metalwork at an international exhibition in Chicago. 1899 first stay in Paris. Met Picasso Paris 1904, whom he later initiated into metal welding sculpture. His brother, to whom he was deeply attached, died 1908 and it was not until 1926 that he resumed creative work. His *Mask of a Poet* dates from 1928. Important works about this time are small cut-out mask *Montserrat* (1930/35), *Petite Maternité* (1933). *Head with Mirror, Egyptian Torso* (iron, 1935). 1932 joined the Constructivists. 1937-9 returned to work in compact form with *Montserrat* (Spanish Pavilion, World Exhibition, Paris, 1937). It is also the period of *Cactus Man I* and *II* (1939/40). 1940 gave up welding because of oxygen shortage but 1941/2 modelled *Small Frightened Montserrat* and *Head of the Monserrat No. 2* in wax. Died 1942. Gonzalez' work has been exhibited all over the world. Retrospective memorial exhibitions at the Galerie

de France, Paris, and Tate Gallery, 1970, with an exhibition of smaller pieces and drawings at Gimpel Fils, London.

GRECO, Emilio

Born Catania, Sicily, 1913. Now resides in Rome where he occupies the chair for sculpture at the Academy of Fine Arts. Taught previously at the equivalent academy at Naples. Left school, aged thirteen, and learned to carve stone in the workshop of a monumental mason of funerary subjects. One-man shows in Rome, 1946, Milan, 1950, Naples, 1950, London, 1952, 1955, 1959, Florence, 1953, Rhode Island Museum, 1954, and at many Biennials including Venice, 1956, Antwerp, 1953, São Paolo, 1959, winning the Town of Venice Prize at the first-mentioned. One-man shows also at the Musée Rodin, in Tokyo, Adelaide, Victoria, and Melbourne 1966; 'Bronzes and Drawings' at Roland, Browse & Delbanco, London, 1973. Tends to work in series: the *Seated Girls* culminating in the *Grande figura seduta*; the *Bathers* (cast of *La grande Bagnante*, exhibited Venice Biennale, is in the Tate Gallery). Won the competition with his *Pinocchio* monument at Collodi, on which he worked 1953–6, and on the *Monument to Pope John XXIII* in St Peter's, Rome, from 1965–7. Known by his many bronzes of nubile girls and portraits such as *Anna* of 1962. A brilliant draughtsman, he has illustrated an outstanding Ovid.

HAJDU, Etienne

Born Turda, Rumania, 1907, of Hungarian parents. Arrived Paris 1927 and worked under Bourdelle at the Académie de la Grande-Chaumière. Naturalized French citizen 1930. 1930–8 visited Crete and Greece and became interested in early Greek art. 1939 first showed his work (with Vieira da Silva) at Galerie Jeanne Bucher. One-man exhibitions there 1946, 1948, 1953, 1956, 1958, 1960, 1961. Meantime Tokyo, 1950; Middelheim Biennal, 1951; São Paulo Biennial 1956; Hanover Gallery, London 1957; Stedelijk Museum, Amsterdam, 1961. 1962, 1965 and 1968 one-man exhibitions at Knoedler & Co, New York and Paris; 1969 the New York branch. First works were carvings mostly in marble (1941–5), a material to which he has frequently returned since. His *Pentelican Marble* (1957) is in the Pierre Granville collection, Paris. Developed direct cutting also, in metal, copper and aluminium, and reliefs in these materials and hammered lead. *Tentative XI* (1963) is a direct metal cut, likewise *Lia* (aluminium, 1965). *The Corpuscles* (1968) represented his experiments in high-relief which he has since continued, leading to such works in the round, but open, as the monument to Louis Pasteur (1967) for Lille and the Fountain for Grenoble of the same year. Among important works: *Cock* (1954, Guggenheim Museum, New York), *Bonds* (1958, hammered aluminium), *Entre les Deux Etoiles* (1967–8, high relief, aluminium), *Convergence* (1968, mat bronze). His *Tête* (1960, marble) was included in the exhibition 'Painting and Sculpture of a Decade, 1954–1964' at the Tate Gallery, 1964. His work is represented in galleries in Europe, the USA and Japan, and in the Musée National d'Art Moderne, Paris.

HAUSER, Erich

Born Rietheim, Germany, 1930. Attended school there and the High School in Spaichingen. 1945–8 apprenticeship as steel engraver in Tuttlingen, classes in drawing and modelling. By 1952 was doing sculpture in his own right in Schramberg 1954 and 1958 Young Artist prize in Baden-Württemberg; equivalent prize for the Kunsthalle in Baden-Baden and Mannheim, in 1959 and 1960 respectively. 1961 joined Darmstadt Sezession. 1962 exhibited with the New Württemberg Group and in the major Art Exhibition in Munich. 1963 participated in the 3rd Paris Biennial, the 7th Biennial for Sculpture in Middelheim, Antwerp, and at the Galerie Parnass, Wuppertal. Appointed guest-lecturer at the Polytechnic at Hamburg, 1964–5. One-man exhibitions 1961–70 include those at Ulm, Freiburg, Stuttgart, Vienna, Hanover, Zurich, Nuremberg and Mannheim. Has participated in innumerable group exhibitions, among them (since 1963): 'Sculpture of the Present', Europa-Center, Berlin, 1966; City of Carrara 5th Biennale Internazionale di Scultura, 1967; São Paulo Biennial 1969 (Special Prize-winner). Among his commissions for architecture are: relief for the foyer of the Stadttheater, Bonn (1964); *Wall of pillars* for the University of Constance (1968); steel sculpture for the Anne-Frank Modern School, Ludwigshafen. Characteristic works (known by numbers and date): *Stainless Steel 9/62* (Kunsthalle, Hamburg); *Outdoor concrete sculpture 4/62* (High School, Stuttgart); *Stainless Steel 2/64* (Ulm); Theatre Foyer relief (1964, Bonn); *Stainless Steel 3/65* (University of Tübingen); *Hanover Relief* (1965); *Stainless Steel 12/67* (von Velsen collection, Cologne); *Column in Space 7/68* (Pfalzgalerie, Kaiserlautern); *Column wall 30/69* (São Paulo, 10th Biennial); *Curved Surfaces 1971* (Gimpel Fils, 1971). Hauser has exhibited a great number of etchings and drawings.

HEPWORTH, Barbara

Born Wakefield 1903. Attended Leeds School of Art, Royal College of Art, London, 1921–4. Travelling Scholarship to Italy. 1927 first exhibition London, followed by one in Paris, 1932, and with Unit One in London. Lived and worked in London up to 1939; then in St Ives, Cornwall. Died there in 1975. Retrospective exhibitions 1950 25th Venice Biennale; 1954 Whitechapel Gallery, London. Contributed two large sculptures for the Festival of Britain, 1951. Retrospective exhibitions in the United States (1955–7), São Paulo (5th Biennial 1959), Montevideo, Buenos Aires, Santiago, Caracas (1960), Antwerp, Middelheim Park (1961), Musée Rodin (1961), Tokyo 7th Biennial. Represented at the Tate Gallery 'British Sculpture in the Sixties', 1965; 'Painting and Sculpture of a Decade, 1954–1964'. Retrospective held there 1968. Other important one-man exhibitions: Kröller-Müller, Otterlo, 1965; Gimpel Fils, 1965; Marlborough-Gerson, New York, 1966; Marlborough Fine Art, London, 1970. Seventieth Birthday Exhibition, Tate Gallery, 1973. Represented at all the Holland Park and Battersea Park open-air exhibitions and at the Hakone open-air museum, Japan. Many works are associated with architecture, e.g. *Winged figure* (1965, aluminium with strings), John Lewis's, Oxford Street, London; *Orpheus* (brass), Mullard House, London; *Meridian* (bronze) for State House, London; *Square with Two Circles* (1963), Churchill College, Cambridge; *Memorial to Dag Hammarskjöld* (1962), Lincoln Center, New York. Some pieces of special interest, including those illustrated: *Two Figures* (1943, wood); *Bicentric Form* (blue limestone), Tate Gallery; *Pastoral* (1953, marble); *Stringed Figure (Curlew)* (1956); *Crete* (1964, bronze); *Figures Waiting* (1968, polished bronze); *Three Obliques (Walk In)* (1969); *Nine Figures on a Hill* (1970, bronze); *Three Part Vertical* (1971, white marble).

IPOUSTÉGUY, Jean-Robert

Born Dun-sur-Meuse 1920. Began career as painter of frescoes and worker in stained glass. Encouraged to become a sculptor by Henri-Georges Adam. First exhibited Salon de Mai 1956, regularly thereafter. One-man exhibition at the Galerie Claude Bernard 1962; similar shows there 1966, 1968, 1973, and of drawings—*Etudes anatomiques*—1969. Awarded Prix Bright for sculpture Venice Biennale, 1964. During World War II worked at a submarine base, a period reflected in two works directly: *Le Sous-marin* and *Le Fusilier-marin, Woman in the Bath* (1966). Divides his time between Paris and Carrara where he works in marble. Important works: *Discours sous Mistra* (1964, cement and also in bronze); *Ecbatane* (1965); *La Terre* and *Remoulus* (1962), both shown at the Tate Gallery exhibition 'Painting and Sculpture of a Decade, 1954–1964'; *Alexandre devant Ecbatane* (1970). One-man exhibitions': Copenhagen (Gallery Birch); Galleria Galatea, Turin; Kunsthalle, Darmstadt, 1968 (Special Prize-winner exhibition); Kunsthalle, Basle; von der Heydt Museum, Wuppertal.

KEMENY, Zoltan

Born Banica, Rumania 1907. Began as a cabinet-maker, then studied architecture at the Fine Arts School, Budapest. Moved to Paris 1930 and worked as an industrial designer. Settled in Switzerland 1942, died Zurich 1965. One-man exhibitions Zurich, London, Berlin and Paris (Galerie Paul Facchelli, 1955, 1957, 1959). Used sheet iron, metal scraps, copper, etc. which he hammered and bent into shapes that are like three-dimensional pictures or high-reliefs. Exhibited regularly at the Galerie Maeght, Paris. Tate Gallery 'Painting and Sculpture of a Decade, 1954–1964', showed four works, of which two involved copper, one leather and iron and one aluminium, testifying to his technical virtuosity in different materials. Work well represented at the Musée National d'Art Moderne, Paris. Retrospective memorial exhibition of his work by the Arts Council, Tate Gallery, 1967, and more recently at the Fondation Maeght, St Paul de Vence, 1974.

KORNBRUST, Leo

Born St Wendel, Saarland, 1929. Trained as cabinet-maker. Later studied at the Academy of Arts, Munich. 1951-7 pupil of Toni Stadler. Worked for a period at bronze foundry in order to learn techniques. Won bursary to the Villa Massimo, Rome, and to the Cité Internationale des Arts, Paris. 1967 awarded the Albert Weisgeber Prize by the city of St Ingbert. Kornbrust works in wood, stone, marble and casts in bronze, concrete and steel. Commissions in St Wendel (Broadcasting Headquarters). Open-air exhibition at the Europapark, Klagenfurt, 1969. One-man exhibitions: Munich, Baden-Baden, Frankfurt, Hanover, Cologne, Wurzburg, Helsinki and Vienna. Obsessive themes: the classical column (variations); the torso; polygons; bollard-like shapes in various natural materials: marble, sandstone etc. Usually works on a vast scale, for open-air siting in association with architecture. His work can be seen in many museums, including the Rockefeller Collection, New York. A commission of 1970 was for *Tastobjekte* (objects for feeling) in concrete for an open-air swimming pool at Hüttersdorf in Germany. Represented in many German galleries including the Springer Galerie, Berlin. 1971-2 organized a Symposium of carved stone which involved fourteen sculptors including himself, of many nations, sculpting new works *in situ* for an open-air site at St Wendel.

LAURENS, Henri

Born Paris 1885. Father a cooper. Apprenticed to a decorative sculptor and later did direct carving in stone for various buildings under supervision, attending evening classes in drawing. 1911 met Braque who introduced him to Cubism. A tubercular condition of his bones, a source of pain all through his life, caused him to have a leg amputated 1914. 1916 joined the Cubist circle and met Picasso; first exhibition. Important sculptures (including reliefs) of his Cubist period are *Woman with the Fan* (1921), *Woman with Guitar*. 1924–32 executed many small bronzes, on some of which he based larger versions. They include: *La Petite Maternité* (1932) and a series of *Ondines* and *Océanides*. First visit to the seaside 1937 increased his preoccupation with sea subjects such as *Sirène* (1938), *Amphion* (1937). 1938 small and large versions of *La Musicienne*; exhibitions at Oslo, Stockholm and Copenhagen with Braque and Picasso. Other important works: *Fisher-girl* (1939), *L'Adieu, La Nuit* and *La Femme Fleur*, 1950 *Reclining Woman with Raised Arms* (all bronzes). Several works commissioned for Exposition Universelle 1937, Paris. 1951 Musée National d'Art Moderne retrospective exhibition; museum acquired *Cariatide* (stone), *La Sirène, L'Adieu* and *La Grande Musicienne* (bronzes) 1946–52. 1953 awarded Grand Prix for sculpture São Paulo Biennial. Died 1954. Laurens's son Claude presented a large number of his works to French National Museums, shown at the 'Exposition Donation', Grand Palais, Paris, 1967. 1970 Hayward Gallery exhibition of sculpture and drawings.

LIPCHITZ, Jacques

Born Druskieniki, Lithuania, 1891. Studied architecture. 1909 to Paris, attended Académie Julien. Worked in classical convention (*Little Italian Girl, Woman with Gazelle*) before seeing Boccioni's *Bottle in Space*. Military service in Russia 1912-13. Cubist period followed (e.g. *Head*, 1915-16; *Guitar Player*, 1918). 1925 experimented with open forms ('transparentes'). Classical myths had for him contemporary significance (*Europa and the Bull*, 1941; *Theseus*, 1942; *Prometheus*). Biomorphic form exploited to create a sense of exuberance (*Pastoral; The Song of the Vowels; Printemps*). 1960 *Between Heaven and Earth* (bronze) erected Performing Arts Center, Los Angeles. 1963 began to spend summers in Lucca, Italy. During final years resided permanently in Pieve di Camaiore. Died Capri 1973. Exhibitions: first one-man exhibition Galerie Rosenberg, Paris; 1937 retrospective Petit Palais; *Prometheus* for Paris World Fair; 1954 major retrospective the Museum of Modern Art, New York; 1958 travelling exhibition toured cities of Holland, Switzerland and France; 1963 retrospective, University of California, San Francisco Museum of Art, Philadelphia, etc.; 1966 'Images from Italy' exhibition Marlborough-Gerson Gallery, New York; 1970 retrospective in Germany, Austria, Tel Aviv; 1972 'My Life in Sculpture', Metropolitan Museum of Art, New York. Commissions: *Bellerophon taming Pegasus* for Columbia Law School; *Our Tree of Life* for Mount Scopus, Israel.

LIPTON, Seymour

Born New York 1903. 1922-3 attended the City College; degree in dentistry. 1932 turned to sculpture; first experiments figurative woodcarving. 1938 first one-man exhibition ACA Gallery, New York. 1940 exhibited at World's Fair and American Artists Congress show, New York. 1940-65 taught

sculpture at the New School for Social Research, New York. One-man show of 1943 (St Etienne Gallery, New York) including bronze-casting in an abstract style. 1946 exhibited at the Whitney Museum of American Art. 1947 developed a technique in lead-soldered sheet-steel. 1949 began using a technique of brazing rods on to sheet steel, using oxyacetylene torch. 1951 one-man show at the American University, Washington, DC, and the Museum of Modern Art, New York. Won first prize 1957 São Paulo Biennial and 1958 one-man show Venice Biennale. Commissioned to do various sculptures in metal for architectural projects—the IBM Watson Research Center in Yorktown Heights, New York (*Argonauts I* and *II*), and for Philharmonic Hall, Lincoln Center (*Archangel*). Some important pieces: *Sanctuary* (1953), *Sentinel* (1957), *The Sorcerer*, *The Defender* (1963), *The Empty Room* (1964)—all in nickel silver on monel metal. *The Prophet* (1957) shown Battersea Park 1963. Represented 'Sculpture in the City', 4th Festival of Two Worlds, Spoleto, 1962, and (with three pieces) 'Etats-Unis—sculpture du XXe siècle', Musée Rodin, Paris, 1965, 'A Decade of Recent Work', Milwaukee Art Center, University of Wisconsin, 1969.

LOBO, Baltasar

Born Zamora, Spain, 1911. As a boy employed as carver of statues in Valladolid. Exhibited work there when sixteen. Won bursary to the Madrid school of art. After the Spanish Civil War settled in Paris. Became assistant to Henri Laurens. Worked at sculpture during 1939–45 but did not exhibit until 1945, when he sent work to 'Masters of Contemporary Sculpture', Galerie Vendôme, Paris. Periodic one-man exhibitions from 1957 onwards at Galerie Villand Galanis, Paris. Commissions include monument at Annecy, 1952, to the Spanish Resistance Fighters who fell in the Vercors, and a large bronze *Maternity* for Caracas. Carves in marble and stone but also models for bronze. 1970 retrospective exhibition 'La Femme et l'Enfant 1946–1958', of carvings and bronzes, shows obsessive theme. Work in France, Sweden, Japan, Norway, Belgium, Holland, Finland, Czechoslovakia.

MAILLOL, Aristide

Born Banyuls-sur-mer 1861, son of a fisherman. Decided to become a painter, went to Paris 1881, failed entrance examination to the Ecole des Beaux-Arts. 1885 admitted to Atelier Cabanel. 1889 met Bourdelle. Stimulated by visits to Musée de Cluny, achieved some success in initial tapestries. 1895 turned to sculpture (eye trouble rendered the close work required for tapestry too difficult). 1900 met Ambroise Vollard, who in 1902 offered him an exhibition. 1903 settled in Marly-le-Roi. Count Kessler became his friend and patron and later commissioned wood-engravings for Virgil's *Eclogues* and Longus' *Daphnis and Chloë*. Commissioned to do a memorial statue to Blanqui. Important works: *Action in Chains* (study 1905–6, completed 1908, but unacceptable to the inhabitants of Puget-Théniers, near Grenoble); *La Méditerrannée* (bronze). Book-illustration (invented the hand-made Auvergne Montval paper) and the war interrupted sculptural work. 1918 *Venus with Necklace* (exhibited Petit Palais 1928). 1930 *Monument to Claude Debussy*; central figure from *Les Trois Nymphes* (Maillol describes this central figure as 'un merveilleux modèle'. She is Lucile Passavant, herself a sculptor, represented 'Artistes témoins de leur temps', 1972, and at the Madden Galleries, London, 1969. Maillol employed her as a pupil, and she cut his designs for wood-engravings.) Whole group exhibited

Petit Palais 1937, lead version in the Tate Gallery. 1938 *The River* completed. 1941 *Harmony* (using his favourite model, Dina Vierny, who became his inseparable companion during the German Occupation). 1933 in large scale exhibition in New York; retrospective show in Basle. Killed in a motor accident 1944. 1963 André Malraux, then minister of 'Affaires culturelles', took up Dina Vierny's generous gift of eighteen of Maillol's bronzes, now sited in the Jardin des Tuileries. Ten of Maillol's bronzes, including a cast of *The River*, are in the Museum of Modern Art, New York.

MANZÙ, Giacomo

Born Bergamo 1908, son of a cobbler. Apprenticed to a woodcarver 1919. During military service in Verona, was impressed by the bronze doors of San Zeno Maggiore. Studied at the Academy of Arts, Verona. Visits to Paris but settled Milan 1930, returning Bergamo 1933–4. Influenced by the Impressionist sculpture of Medardo Rosso. Low-relief work favourably noticed at group exhibition at Galleria del Milione, Milan. About this time, made bronze sculpture of a favourite rush-seated chair, which became almost a fetish object and recurs in his work, sometimes with a girl seated on it. *Reclining Woman* (1937) and about twenty drawings related to the sculpture *Susanna* acquired by the Tate Gallery 1950. 1938 embarked on a series of more than fifty *Cardinals* (e.g. *Grande Cardinale* 1970), bronze reliefs (e.g. *Gates of Death*, St Peter's, Rome), *Lovers*, *Dancers*, nubile girls (*Inge*), etc. First one-man show outside Italy at Hanover Gallery, London, 1953. Important travelling exhibitions 1959–60. Represented in most important museums of the world including the Middelheim open-air collection, Antwerp, Bristol City Art Gallery (*Girl playing*). *Cardinals* (marble and bronze) are ubiquitous—Salzburg, Rome, New York, London, Parma, etc. *Girl on a Chair* (several versions) Museo dell'Arte Moderna, Turin, also in Toronto, Oslo, etc. (seven versions 1947–55). Manzù leapt into world fame following the 1948 Venice Biennale where he won the Grand Prix for Italian sculpture. Most important work to date, bronze reliefs for St Peter's, Rome, unveiled 1964 by Paul V, successor of Pope John XXIII, the original commissioner.

MARINI, Marino

Born Pistoia 1901, son of a bank clerk. Studied painting and sculpture at the Academy of Florence. 1919 Paris, influenced by the new movements, returned there for longer periods 1928 on. 1929–40 professor at the Art School in Monza. 1935 won first prize for sculpture at the Rome Quadriennale. 1936 first of many horse sculptures executed (painted wood). 1940 appointed professor Brera Academy, Milan. In Switzerland 1942–6. Won the Town of Venice Prize for sculpture, Biennale, 1952. Varied his work between the *Pomona* (1941), *Torso* and *Horse and Rider* themes. (Tate Gallery acquired 1947 bronze version of latter in 1952.) 1952–3 *Dancer* (*Danzatrice*) and portrait busts cast in bronze from plaster (sometimes coloured, as exhibited Milan, 1972) of contemporary figures, e.g. Germaine Richier, Henry Moore, Igor Stravinsky (a cast in the Minneapolis Institute of Art). Work in collections and museums throughout the world. Among important works: *Ersilia* (1931, polychrome wood); *Pomona* (1941, bronze, Musées Royaux des Beaux-Arts, Brussels); *Young Woman* (1943, bronze, Collection Bär, Zurich); *Horseman* (1949, polychrome wood, Kunstverein, Düsseldorf); *Pomona* (1949, bronze, State

Museum, Copenhagen); *Dancer* (1952–3, bronze, Kunst-museum, Essen); *Grande Cavaliere* (1953, polychrome wood, Kröller-Müller Museum, Otterlo); *Miracolo* (1959–60, poly-chrome wood, Galleria Civica, Turin); *Warrior* (1959–60, bronze, Germanisches Nationalmuseum, Nuremberg). 1973 Museo Marino Marini inaugurated in Milan, where the sculptor now lives.

MASON, Raymond

Born Birmingham, 1922. Studied at the College of Arts and Crafts there. 1942 Royal College of Art, London. 1943 Ruskin School of Fine Arts, Oxford, then the Slade, London. 1946 exhibited work in London, entered the Ecole des Beaux-Arts, Paris. Group exhibition Galerie Maeght, 'Les Mains éblouies', 1947; showed work at the Salon de Mai the following year. 1954 and 1956 exhibitions at Gallery Beaux-Arts, London. 1960 first one-man sculpture exhibition Galeries Janine Hao, Paris; the next 1965 Galerie Claude Bernard, followed by one in 1971 on the theme of Les Halles. Characteristic work is in high relief for bronze casting. Later experimented with epoxyde resin sculpture painted with acrylic gouache. Does innumerable sketch drawings and studies, not always directly for a given sculpture but as preparatory for future work. Characteristic works: *Tramway de Barcelone* (1953), *Odéon Crossroad,* (1958–9), *Boulevard St Germain* (1958), *The Crowd* (1963–5), *Three Torsos* (1963); series *Le départ des fruits et légumes du cœur de Paris*—models in the round as described above.

McWILLIAM, F. E.

Born Banbridge, Ireland, son of a doctor. Attended the Slade 1928–31, then spent a year in Paris. 1938 joined British Sur-realist Group. 1940 in Surrealist Exhibition at Zwemmer's Gallery, London. 1940–5 with the RAF on home and foreign service, including in the Far East. 1948 represented Battersea Open-air Exhibition with carved male figures in reinforced concrete. Period of open metal sculpture (e.g. *Seated Woman with Hat*, 1953, bronze), contrasting with backward glances at figurative Surrealism (e.g. *The Irish Head*, 1949). 1949 first one-man show of many at Hanover Gallery, London. After 1956 series of one-man exhibitions Waddington Galleries, London. Represented in innumerable group exhibitions, notably at the Festival of Britain, Middelheim Biennial, Holland Park, Battersea Park (1960, 1963, 1966), São Paulo 4th Biennial, 1957, 'Paintings and Sculpture of a Decade, 1954–1964', Tate Gallery, and a major exhibition devoted solely to his work at Hillsborough, Co. Down, 1971. Work has marked phases: hieratic bronzes (*Princess Macha*, 1957), animistic bronzes (*Witch of Agnesi*, 1959), horizontal bronze figures (1961–2), developing into the *Puy de Dôme* sculpture (1962) at Southampton Uni-versity and the 'Crankshaft'-type figures of the same year. Polished bronzes 1965 (e.g. *May Day*). Other key pieces include the large Hampstead (now Camden) Civic Centre sculpture, London, the bronze portrait of Elisabeth Frink, Harlow, Essex. Compositions symbolizing the Irish tragedy shown Dawson Gallery, Dublin, 1973, and then Waddington Gallery, London.

MEADOWS, Bernard

Born Norwich, 1915. 1934–6 Norwich School of Art. 1936–40 studio assistant to Henry Moore. 1938–40 Royal College of Art, London. Served with the RAF during World War II.

1952 represented 'Recent Sculpture', British Pavilion, 26th Venice Biennale. Sculpture shown open-air sculpture exhibi-tions Middelheim, 1953; Battersea Park, 1952; Holland Park, 1957. International group exhibitions: 1957 'Ten Young British Sculptors', São Paulo, 4th Biennial, etc.; 1958 Brussels International Fair; 1960–2 Boymans Museum, Rotterdam; 1961 Padua; Musée Rodin, Paris; 1964 represented Great Britain Venice Biennale; 'Painting and Sculpture of a Decade, 1954–1964' Tate Gallery (*Fallen Bird, Armed Bust*, 1963). One-man exhibitions: Gimpel Fils, London, 1957, 1959, 1963, 1965, 1967; Paul Rosenberg Gallery, New York, 1959, 1962. 1972 whole room of Burlington House, London, devoted to his work (including the Prospect House, Norwich, project) at 'British Sculptors 1972' exhibition; *Help* (small version) and *Pointing Figure with Child* (1971) in show of smaller pieces relating to the same exhibition, Redfern Gallery, London. Other typical themes include variations on *Cock* (Arts Council 'Contemporary British Sculpture', 1961) and *Crab*. 1962 appointed Professor of Sculpture, Royal College of Art. Most important commissioned work was for the Eastern Counties Newspapers building, Norwich, 1969. Prize-winner International Exhibition of Drawings, Lugano. One-man exhibition 'Sculptor's Drawings', Taranman Gallery, London, 1975.

MODIGLIANI, Amedeo

Born Leghorn, Italy, 1884, the fourth child of Flaminio Modigliani and Eugénie Garsin. 1895 severe attack of pleurisy, followed by tuberculosis. Began studies of painting and draw-ing. 1901 for health reasons a tour of Italian towns including Rome and Florence. Studied at the art academies in Florence and Venice. 1906 went to Paris. Friendship with Dr Paul Alexandre, his patron who bought his entire output until he left for the Front in World War I. 1910 exhibited paintings, 1912 sculptures (Salon d'automne). Discovery of Negro art and the work of Brancusi, Picasso and Lipchitz. Gave up carving because of diminishing physical strength. Died 1920. Archaic influences can be detected in the few surviving sculptures, such as the carved *Caryatid* (Museum of Modern Art, New York), the limestone head in the Solomon R. Guggenheim Museum, New York, the *Head* in Euville stone (Tate Gallery) and *Tête de Femme* (2 versions, Musée National d'Art Moderne, Paris).

MOORE, Henry

Born Castleford, Yorks, 1898, son of a miner. Served in World War I. Attended Leeds School of Art 1919–21. 1921 student at the Royal College of Art, London; later instructor in sculpture. During travels in Italy particularly impressed by the works of Giotto and Masaccio in painting, and in sculpture those of the Pisano family and Michelangelo. 1932 to the first years of World War II taught at Chelsea School of Art and settled in Much Hadham (1940). 'Shelter' drawings brought him to public attention but his sculpture had already won full recognition in enlightened circles. More general recognition came with the *Madonna and Child*, com-missioned for St Matthew's church, Northampton, by the Rector, Walter Hussey. 1945 first of many honorary degrees, from Leeds University. 1951 visited Greece. Exhibitions: 1946 one-man at the Museum of Modern Art, New York. 1948 International Prize for sculpture, Venice Biennale; 1953 São Paulo International Prize for sculpture; 1959 the same prize, Tokyo Biennial. Main retrospectives: 1968 Tate Gallery,

for Moore's 70th birthday; Kröller-Müller Museum, Otterlo; 1970 Knoedler and Marlborough Gallery, New York; 1972 Forte Belvedere, Florence. Important works include: *Mother and Child* (1924–5); *Reclining Figure* (1929, Brown Horton stone, Leeds City Art Gallery); *Reclining Figure* (1935–6, elmwood, Albright-Knox Gallery, Buffalo); *Reclining Figure* (1936, elmwood, Wakefield Art Gallery); an 'open' *Recumbent Figure* (1938, Tate Gallery); *Helmets* (1939–40); *Reclining Figure* (1945, elmwood, Cranbrook Academy; Fischer Gallery); *Three Standing Figures* (1947–8, Battersea); *Family Group* (Barclay School, Stevenage); *Helmet Head No. 2* (1950); *Standing Figure* (1951 Dumfries); *Reclining Figure* (1951, for Festival of Britain); *Draped Reclining Figure* (1952–3, Time-Life Building); *King and Queen* (Dumfries; Middelheim Park, Antwerp); *Family Group* (1955, Harlow New Town); *Fallen Warrior* (Huddersfield; Walker Art Gallery; Glyptothek, Munich, etc.); Unesco *Reclining Figure* (1959, Paris); *Two-piece Reclining Figure* (1963–5, Lincoln Center); *Archer* (1964, Toronto Square); *Locking-piece* (1963–4, Millbank, London); *Oval with Points* (1968–70, Princeton University); 1973–4 sketch-book of drawings and series of etchings of sheep; a sculpture entitled *Sheep-form*; 1975 *Four-piece Reclining Figure* for the Union of Swiss Banks, Schloss Wolfsberg, near Zurich; inauguration of the Moore Sculpture Center, Art Gallery of Ontario (sculpture and plaster moulds).

NADELMAN, Elie

Born Warsaw 1882. Attended High School of Liberal Arts. 1900 military service in the Russian army. Followed art courses in Cracow and Munich, to Paris 1903. 1909 first one-man exhibition, Galerie Drouet. 1913 a sculpture shown at the famous Armory Exhibition in the USA. At the outbreak of World War I tried to join up, but was unable to get back to Russia. Thanks to the generosity of Helena Rubinstein was able to pursue his work in America. First American exhibitions held New York 1914 and 1917. *Man in Open Air* (1915) and *Standing Woman* (c. 1909) acquired by the Museum of Modern Art, New York. 1919 began with his wife to make a large private art collection, sold after Wall Street crash. About 1930 undertook commissions, e.g. for the Fuller Building and the Manhattan Trust Bank. Works of this period now in New York State Theatre, Lincoln Center. Taught sculpture at Bronx Veterans' Hospital 1942 up to his death in 1946. Most characteristic mannerist works include the *Horse* (1914), *Danseuse* (1918, coloured wood), and *Acrobat series* (1924). His work has been shown posthumously in most exhibitions of American art, from Paris to Moscow.

NAKIAN, Reuben

Born New York 1897. Studied art and illustration at the Art Students League 1921 and at the art school of the painter Robert Henri. 1916–20 assistant to the sculptor Paul Manship and up to 1923 shared a studio with Gaston Lachaise. 1922 began to exhibit at 'Salons of America', New York. Won Guggenheim Fellowship and travelled in France and Italy. Influenced by the work of Brancusi, but aimed at evolving totally personal idiom. After sculpting some New Deal heroes (he had benefited by the enlightened patronage of that Roosevelt period), he switched interest to abstract sculpture and reacted against social realism. Incised drawings on terra-cotta, and 1955–60, large sheet-metal constructions. 1949–55 Egan Gallery of New York became his patron; one-man exhibitions there up to present. One such show was part of the US representation, 6th São

Paulo Biennial 1961, then shown Los Angeles County Museum, 1962, and finally the Gallery of Modern Art, Washington DC, 1963. Designed façade decoration for the Leob Student Center of New York University, completed 1961. Some important works: *The Duchess of Alba* (1959); *Mars and Venus* (1959–60); *Hecuba* (1960–2, exhibited Battersea Open-air Exhibition, 1963); *The Rape of Lucrece* (1955–8); *Voyage to Crete* (1960–2); *Maja* (1962–3). Apart from sketch-drawings for sculpture, Nakian has illustrated an edition of Mallarmé's *L'Après-midi d'un Faune*.

NEVELSON, Louise

Born Kiev, Russia, 1900. Emigrated to the US with her family 1905. Studied with Kenneth Hayes Millar, Art Students' League, New York, 1929–30, then with Hans Hofman, Munich, 1931. Began as sculptor in wood of non-figurative forms. Her originality is most evident in the assemblages of forms, mostly of carved or turned wood, evoking homely items such as boxes, balusters, scrolls, combined with spheres, cones and cubes, and arranged in asymmetrical fashion on frames. There is a surrealist element in her work, which can also sometimes be read symbolically, line by line. Typical works: *Total Obscurity* (exhibited 'American Sculpture of the 20th Century', Paris, 1965); the *Cathedral* series (e.g. *Sky Cathedral*, Kröller-Müller Museum, Otterlo). Progression from isolated totems, painted white or black, to series of 'black altars', and, in recent years, to perspex 'transparent sculpture'. Work exhibited all over the world, e.g. 'Painting and Sculpture of a Decade, 1954–1964', Tate Gallery, 1964; Fondation Maeght, St Paul de Vence, 1967. One of her *Transparents* (No. 5) acquired by Galerie Jeanne Bucher, Paris, 1969, and another by the Museo Civico d'Arte Moderna, Turin, the same year.

NOGUCHI, Isamu

Born Los Angeles 1904. Father a Japanese poet and professor of English at Keio University, married to the American writer Leonie Gilmour. Childhood in Japan where he learned the craft of joinery, later to affect his attitude to sculpture. 1917 attended experimental school in Indiana, later School of La Porte in the same State. Worked with the sculptor Gutson Borglum, helping him with gigantic portrait heads of Mount Rushmore. After a course in medicine turned back to art and attended Leonardo da Vinci School and East Side School. A Guggenheim Foundation award enabled him to travel to the East via Paris. Met Brancusi and stayed as his assistant in Paris for two years. Further period of travel, to study drawing in Peking, pottery in Kyoto—experiences which were to be profound influences on his future sculpture and attitudes. From 1936 important commissions, including the prize-winning relief for the Associated Press Building, Rockefeller Center, New York; fountain (1939) for the Ford Motor Company Building (International Exhibition, New York), Bridges of the Park of Peace, Hiroshima (1952), sculpture (1958, granite) for the garden of the Unesco complex, Paris. 1929 first one-man exhibition Eugene Schoen Gallery; then at Marie Sterner Gallery; Albright Gallery, Buffalo; Sidney Burney Gallery, London; 1949 Egan Gallery, New York; Chicago Art Club, etc. Represented in many prestigious international exhibitions, e.g. 'Modern Art in the United States', shown in eight European cities; 'Painting and Sculpture of a Decade 1954–1964', Tate Gallery, 1964, etc. Major works at the Kröller-Müller Museum Otterlo, the Israel Museum,

Jerusalem, and many US galleries including the Cordier-Ekstrom Gallery, New York. Among key works are *Kouros* (1946), *The Cry* (1959), *The Sun* (1959–64), *Mu* (1950), *Black Sun* (1960–3). Has made influential contributions to environmental planning (gardens) and light sculptures ('lunars'). ('My regard for stone as the basic element of sculpture is related to my involvement with gardens.')

OLDENBURG, Claes

Born Stockholm 1929. Early years divided between New York and Oslo (his father in the Swedish diplomatic service). Graduated Yale University 1950, worked as a reporter in Chicago. 1952 decided to become an artist. 1953 took American citizenship. 1957 started making three-dimensional objects and joined an avant-garde movement against the Abstract Impressionism then in vogue. Associated with the group (Jim Dine, George Segal, Robert Whitman, etc.) whose art had kinship with Dadaism and Surrealism. 1959 first one-man exhibition in the Judson Gallery, New York. Became obsessed with objects of everyday life and 1959–60 made hundreds of sketches and collages, translated as flat constructions in burlap and cardboard, etc. 1960 became fascinated by the furniture in stores and advertisements, which he used as the basis of his painted plaster artifacts and soft-sculptures, first shown the Green Gallery, New York, 1962. Then became obsessed with various objects including the Chrysler Airflow car, food (e.g. 'floor burgers'), typewriters, scissors, handsaw, etc. His wife Pat sewed his first soft sculptures. 1965 his 'Colossal monuments'. He describes *Bedroom ensembles* as a turning point of taste: 'geometry, abstraction, rationality—these are the themes that are expressed formally in 'Bedroom'—the previous work had been self-indulgent and full of color, the new work was limited to black and white'. Apropos soft sculpture, he wrote to me: 'The soft aspect of these works was not the point of the original intention. I discovered that by making ordinarily hard surfaces soft I had arrived at another kind of sculpture and a range of new symbols.' Drawing became increasingly important for his sculpture. 1970 Tate Gallery one-man retrospective of sculpture and drawings 1963–70. Other exhibitions have been held New York, Stockholm, Venice (US representation 1964 Biennale), Toronto, São Paulo, Paris.

PEVSNER, Antoine

Born Orel, Russia, 1886. Elder brother of Naum Gabo. 1902–9 studied at School of Fine Arts, Kiev. 1910 entered Academy of Fine Arts, Kiev. 1911 visited Paris; stayed there 1913–14. Then still a painter (becoming a sculptor only *c.* 1923). Met Modigliani and Archipenko. 1916–17 in Oslo with Naum Gabo. 1917 appointed professor at the Academy of Fine Arts, Moscow. Joint exhibition by the brothers in Moscow. Their studio closed by the authorities because of their refusal to harness their art to the service of the Revolution. 1923 to Germany, then to France where he became naturalized. 1931 helped found the movement 'Abstraction-Création'. 1946–52 member of the Salon des Réalités Nouvelles, becoming its Vice-President 1953. Died 1962. 1947 first one-man exhibition Galerie René Drouin. 1956 large retrospective exhibition Musée d'National d'Art Moderne. 1958 Venice Biennale devoted room to his work. Some of his most important creations include: *Projection in Space* (1939); *Developable Surfaces* (1936, 1938); *Developable Column of Victory* (1946); *Column of Peace*

(1954); maquette of a monument symbolizing the liberation of the spirit (1952, Tate Gallery), his entry for the *Unknown Political Prisoner* competition which won the second prize; the full-scale version, 1954, Kröller-Müller Museum, Otterlo. Work represented in the major galleries of the world, including the Tate Gallery, London, the Museum of Modern Art, New York, and the Stedelijk Museum, Amsterdam.

POMODORO, Gio

Born Orciano di Pesaro, Italy, 1930. In his early years he worked in close association with his brother, Arnaldo. With him he formed the '3 P Group' (the two Pomodoros and Giorgio Perfetti) who worked with precious metals as goldsmiths and showed work at the 28th Venice Biennale. Prior to this Gio had joined the Numero Gallery group in Florence, practising painting and sculpture. Works exhibited at the 'Vitality of Art' exhibition, Venice, then in Amsterdam 1959–60. 1959 represented at the 'Biennal des Jeunes Artistes', Paris, won first prize for sculpture. His special contribution has been his individual development of the 'three-dimensional relief' (e.g. *Uno*, polished bronze, Tate Gallery; '*Incontro*, and the more elaborate *Folla* (*Crowd*)). Also constructions in black polystyrene (sculpture in Martha Jackson Gallery, New York); *Sun of Cerveteri* and the piece *Marat* of 1969. Work represented at Tate Gallery 'Painting and Sculpture of a Decade, 1954–1964' exhibition, 1964.

RICHIER, Germaine

Born Grans, near Arles, 1904. Studied at Ecole des Beaux-Arts, Montpellier, 1922–5. To Paris, worked under Bourdelle until 1929. 1934 first exhibited Paris. 1939–45 Zurich. 1945 exhibited with Marini and Wotruba at the Kunsthalle, Basle. Sculpture by then characterized by obsession with animals and insects (*Spider* 1946), to be followed by a period of biomorphic creatures and human distortions (e.g. *Pentacle*, 1954, and *The Ogre*, 1949). 1951 awarded first prize for sculpture, São Paulo Biennial. 1956 one-man exhibition Musée National d'Art Moderne, Paris. 1959 similar exhibition at Château Grimaldi, Antibes. Paris galleries that have shown her work include the Galerie Maeght and Galeries Creuzevault. One of her last major works was *The Chess-board*. *L'Eau* (1953–4, bronze, acquired Tate Gallery 1956) is typical of her animistic work. Died Paris 1959. Musée National d'Art Moderne, Paris, contains a representative collection of her sculpture, and examples of her work are also to be seen in the major public galleries of Europe and the US.

RODIN, Auguste

Born Paris 1840. Early enthusiasm for literature as well as art, and especially for Dante. Failed to gain entry to the Ecole des Beaux-Arts. Worked as a stone mason in Brussels. Admiration for the work of Michelangelo and Puget began when he saw their work in museums. 1875–6 visits to Italy enabled him to appreciate the work of the great Italian sculptors. (When *Age of Bronze* shown in Brussels and Paris, he was accused of having taken a cast from life.) 1882 exhibition in London; met Camille Claudel who inspired many of his works as his mistress and model. 1891 commissioned by the Société des gens de lettres to make a monument to Balzac. The model became the subject of a long dispute; the bronze was erected on its present site (Boulevard Raspail, Paris) only in 1939.

1902, 1903 visits to London; 1903 elected President of the International Society of Sculptures and Engravers. 1906 series of wash drawings of Cambodian dancers in Paris. Honorary degree from Glasgow University; exhibition Grosvenor House, London; presented sixteen bronzes, a marble and a terracotta sculpture to the Victoria and Albert Museum, London. 1916 completed plaster mastercast of the *Gates of Hell*. 1916 the French government accepted the offer of all his work. 1917 Rodin married Marie-Rose Beuret, his partner and mistress since 1864. She died a month after the wedding, and the sculptor survived her only by eight months. Among the most important examples of various phases of his work are: *Man with the Broken Nose* (1862); *The Age of Bronze* (1877); *The Faun*; *St John the Baptist* (1880), and beginning of work on the *Gates of Hell*; *The Thinker, Eve* (1880–1); *Crouching Woman* (1882); *Marsyas torso* (1883); Portrait of *Dalou* (1883); work for *Burghers of Calais* (1884, erected 1895); *Meditation* and *La belle Heaulmière* (c. 1885); *The Prodigal Son* (1885–7); *Iris, Messenger of the Gods* (1890); *Cybele* (1905); *The Walking Man* (large version 1906); *Dance Movement* (c. 1910); final studies for monument to *Balzac* (c. 1897–8, bronze erected posthumously 1939).

SMITH, David

Born Decatur, Indiana, 1906. Ohio University 1924–5. Studied poetry while earning living as a riveter in the Studebaker factory. Attended courses at Washington University and began studying painting. 1925 free-lance journalistic work. 1931 extended his interest to sculpture. 1933 executed sculpture in wood, wire and lead. 1935 travelled in Europe, Russia and the Middle East. Meantime impressed by the metal welded work of Picasso and Gonzalez. 1940 practised sculpture under the Federal Art Project. (Matisse's remark on seeing one of his sculptures: 'It looked better before you unwrapped it.') 1938 first one-man show of iron sculpture; executed 'lost wax' bronzes. 1939 first arc-welded piece. During World War II, rejected by the army, he worked as a 'first-class armour-plate welder'. By 1944 working as full-time sculptor, pioneer of artifacts made of discards and bits and pieces. Died 1965. Exhibitions: 1951 São Paulo Biennial; 1958 29th Venice Biennale; 1962 Spoleto 'Festival of Two Worlds'; 1963 Battersea Open-air Exhibition. Some key pieces of different periods: *Cockfight* (1945, steel); *Twenty-four Y's* (1950, welded and painted steel); *Tank Totems* (1953, steel); *Star Cage* (1954); *Voltri* series; *Zig* series (1961); *Cubi* series (No. IX shown Battersea, 1963, No. XII shown Battersea 1966). 1968 retrospective exhibitions at the Museum of Modern Art, New York; Tate Gallery, London.

SMITH, Tony

Born New Jersey 1912. 1937–8 attended the New Bauhaus, Chicago; worked on buildings designed by Frank Lloyd Wright. 1964 first public exhibition of sculpture under title 'Black, White and Gray'. 1966 first one-man show at Wadsworth Atheneum followed by one at the Institute of Contemporary Art at the University of Pennsylvania, and of 'Sculpture and Prints', Whitney Museum of American Art, New York. 1967 one-man exhibitions at Walker Art Center, Minnesota; Bryant Park, New York; Galerie Müller, Stuttgart; also participated in numerous collective exhibitions, e.g. 'American Sculpture of the Sixties' (Los Angeles County Museum and the Philadelphia Museum), 5th Guggenheim International Exhibition (Solomon Guggenheim Museum, New York; Art Gallery of Ontario, Toronto, Ottawa and Montreal). Other one-man exhibitions: Galerie Renée Ziegler, Zurich; Galerie Yvon Lambert, Paris; Donald Morris Gallery, Detroit; Fischbach Gallery, New York. Participated 24th Venice Biennale; 'The Art of the Real', shown at the Museum of Modern Art, New York, Tate Gallery, the Centre National d'Art Contemporain, Paris; the First International Exhibition of Modern Sculpture, Hakone Open-air Museum, Japan; 1971 'Living American Art', Kröller-Müller Museum, Otterlo; 11th International Biennial of Outdoor Sculpture, Arnhem (Sonsbeek '71') Middelheim, Antwerp. 1971 awarded the Fine Arts Medal (American Institute of Architects). Important works marking phases: *The Throne* (1963); *Tower of Winds* (1962); *Cigarette mock-up for steel*; *Smoke* (1967); *Wandering Rocks* (1967); *Asteriskos* (steel, San Antonio, Texas). Architectural structures: Bennington Semi-architectural Structure, model for Betty Parson's House; Stamos House, East Marion, Long Island (realized).

UBAC, Raoul

Born Malmédy, Ardennes, 1910. Father a 'juge de paix', grandfather a collector of pictures. 1920–8 studies at Malmédy, followed by a walking tour of Europe and a stay in Paris. Returned to Malmédy, was caught up in the Surrealist movement and attended the School of Applied Arts, Paris. Made a tour of Australia and Dalmatia—'c'est là que naquit mon amour de la pierre' he wrote. 1939 learned engraving at Hayter's famous Atelier 17 in Paris, until at the outbreak of war he had to take refuge in Carcassonne. Met Magritte, and writers Queneau, Eluard and Frénaud (later he illustrated many avant-garde works by Frénaud and others with lithography and etching). Engraving and ultimately carving on slate followed a chance experiment on a fragment of slate with a nail while on holiday in Haute Savoie. 1951 first exhibition of paintings at the Galerie Maeght, then at Wuppertal (engraved and carved slate). 1957 settled at the village of Dieudonné, near Paris, and developed both his painting and sculpture. 1961 executed a series of torsos in slate. 1964 executed high-relief slate sculptures (Stations of the Cross) for the Fondation Maeght. 1966 one-man exhibition of '*labours*' and '*torses*', Galerie Maeght. 1968 retrospective exhibitions in Charleroi, Brussels, and the Musée National d'Art Moderne, Paris. Some important works: 'slate wall' for David Thompson, Pittsburgh; mosaic wall of slates for drinking fountain, Evian-les-Bains; stained-glass windows for Ezy-sur-Eure, for Varengeville (with Braque). Has also designed many large-scale tapestries ('Nouvelles Tapisseries' Exhibition, Paris, 1975) Mosaic for the Nouvelle Ecole Militaire de Saint-Cyr, Versailles. His major contribution to sculpture are reliefs, torsos, '*stèles*' (free-standing), built-up paintings, and particularly the engravings on slate.

UNDERWOOD, Leon

Born London 1890. 1904 left school to work in his father's antique shop. 1907–10 Regent Street Polytechnic. 1910–12 Royal College of Art. For two years travelled in Poland, at the outbreak of war joined a cavalry regiment, serving in France 1916–17. Refresher course at the Slade, won a Prix de Rome 1918. 1919 opened the Brook Green School of Art, Girdler's Road, London, where he lived and had his studio. While holding exhibitions of etchings and drawings he began to sculpt. 1925–6 to America, then Mexico where he was fascinated by Aztec art, undertaking a long trek by mule and

canoe. Returned to London and re-opened his school. Represented Battersea Open-air Exhibition, 1948 (*Mind Slave*, marble). One-man exhibitions: 1934 Leicester Galleries, London; 1935, 1945 Beaux-Arts Galleries, London; 1939 Zwemmer's, London; 1969 Minories Gallery, Colchester; 1972 Archer Gallery, London; 1973 Agnews, London. Key sculptures: *June of Youth* (1937); *Herald of New Day* (1932-3); *Totem to the Artist* (1929-30, Tate Gallery); *Atalanta* (1939); *Political Prisoner* (1955); *The Dove's Return* (1962); *Isaac and Jacob* (1962). Died 1975.

WOTRUBA, Fritz

Born Vienna 1907, father Czechoslovakian, mother Hungarian. 1921-4 apprenticed to an engraver and copied reproductions of famous sculptors' drawings. Attended Vienna School of Fine Arts. 1927 first experiments in stone carvings. 1930 his *Young Girl* bought by the city of Vienna. 'Discovered' the sculpture of Lehmbruck and Maillol and influenced by their work. 1931 exhibited at the Folkwang Museum, Essen, and first open-air international exhibition of sculpture, Zurich. Hitler's anti-semitic campaign forced him to leave Austria. Settled in Zurich and did his carving (red sandstone) in a stone-cutter's shed. 1937 the sculptor Maillol saw an early torso carving of his at the Jeu de Paume gallery and invited him to his Meudon studio. 1938-45 period of exile in Switzerland where he met Marini and Richier. 1945 appointed head of a master-class at the Academy of Plastic Arts, Vienna. 1947 one-man exhibition in the Musée National d'Art Moderne, Paris. 1948 represented at Venice Biennale. 1951 visited Henry Moore at Much Hadham. 1960 first large-scale exhibition in New York. Had by then exhibited in many countries and had works acquired by many galleries including the Tate Gallery (*Man Standing*, 1950); Kröller-Müller, Otterlo (*Figure Standing*, 1958); Museum des 20 Jahrhunderts, Vienna (*Figure Relief*, 1958). Works shown in the open-air exhibitions in Battersea (1951), Holland Park (1954), also at the Musée Rodin (1956). *Grosse Figur* (1963) at the 'Painting and Sculpture of a Decade, 1954-1964' exhibition, Tate Gallery, 1964. *Recumbent Figures* (1963) and the *Standing Figures* are obsessive themes which recurred throughout his career. Died Vienna 1975.

ZADKINE, Ossip

Born Smolensk, 1890, father teacher of classics, mother of Scottish descent. 1905 sent to England and attended an art school in Sunderland. 1906 took a job as a wood-carver in London, returning to Smolensk in 1908 and then back to London to attend the Central School of Arts and Crafts. 1909 to Paris and in 1910 attended La Ruche studio. Impressed by Rodin's work. Met Brancusi and Gaudier-Brzeska who invited him to exhibit sculpture at the Post-Impressionist Exhibition, London, 1913. 1914 joined the French army, disabled 1918. Wrote about this period: 'I think that the sculptors of my generation such as Gaudier-Brzeska, Duchamp-Villon, Archipenko, Brancusi, Lipchitz and myself may be considered as continuing the ancient tradition of the stone-masons and wood-carvers who coming from the forests, gave free expression to their dreams of fantastic birds and of mighty tree-trunks.' Met Stravinsky and Isadora Duncan, and musical instruments began to appear in his carvings and bronzes (e.g. *Girl with Lute*, 1918; *The Musicians*, 1924, of which the Moscow Museum of Western Art bought a bronze cast). 1933 retrospective Musées Royaux des Beaux-Arts, Brussels. *Homo sapiens* (1935, elm carving) expressed anxiety about the rise of Nazism. 1941 left France for America, taught and lectured in New York. Continued to associate himself with the French cause, e.g. *The Prisoner, Phoenix* (1943-4). 1946 seeing the ruins of Rotterdam led to maquette (terracotta), later to become *The Destroyed City*. Terracotta broken en route from Germany to Paris, where from 1947 he settled again. 1950 Grand Prix for sculpture, Venice Biennale; exhibition Leicester Galleries, London. 1960 awarded Grand Prix of the City of Paris. About this time executed *The Two Brothers*, a tribute to Theo and Vincent van Gogh (refused by the town of Auvers-sur-Oise). December 1951 *The Destroyed City* model shown in the Musée National d'Art Moderne, May 1953 the definitive version unveiled, Leuvehaven Quay, Rotterdam. Retrospective exhibitions: 1958 Paris; 1961 Tate Gallery, London. Died 1967. Other works include: *Orpheus* (1928, plaster); *The Composer* (1936); *Christ on the Cross* (1939-40); *Orpheus* (1948, bronze); *Centaur* (1952); *Prometheus* (1954); *The Human Forest* (1948, plaster; cast for bronze, Amsterdam 1965); *The Dwelling* (1960); *Composition* (1966, terracotta).

Selected bibliography

GENERAL, FOR SCULPTURE BACKGROUND

AVERY, Charles, *Florentine Renaissance Sculpture*, London 1970, New York 1973.

BURCKHART, J., *The Civilization of the Renaissance in Italy*, London 1938.

MAILLARD, Robert, *New Dictionary of Modern Sculpture*, Paris 1960, London 1962, New York 1971.

HAMMACHER, A. M. *Modern English Sculpture*, London 1967.

HAMMACHER, A. M., *The Evolution of Modern Sculpture*, London 1970, Paris, New York 1971.

READ, Herbert, *A Concise History of Modern Sculpture*, London, New York 1964.

ROGERS, L. R., *Sculpture*, London, New York, Toronto 1969.

WORKS SPECIFICALLY CONCERNED WITH DRAWING

BOWNESS, Alan, *Drawings from a Sculptor's Landscape*, London 1966.

CHASE, Elisabeth, *Rodin, Later Drawings*, London 1963.

CLARK, Kenneth, *Henry Moore Drawings*, London, New York 1974.

HUTTER, Heribert, *Drawing: History and Technique*, London, New York 1974.

MICHINSON, David, *Unpublished Drawings of Henry Moore*, Turin 1971, New York 1972.

POPHAM, A. E., *The Drawings of Leonardo da Vinci*, London 1973.

RAWSON, Philip, *The Appreciation of Drawing*, London, New York 1969.

WILDE, Johannes, *Michelangelo and His Studio*, London 1953, New York 1969.

MONOGRAPHS ON SOME INDIVIDUAL SCULPTORS

Armitage, Kenneth, by Norbert Lynton, London 1962.

Arp, by Eduard Trier, London 1968.

Bourdelle, by Ionel Jianou and Michel Dufet, Paris 1970.

Brancusi, by Ionel Jianou, Paris 1963.

Bury, Pol, by Dore Ashton, Paris 1970.

Chadwick, Lynn, by Alan Bowness, London 1962.

Chillida, Eduardo, by Pierre Volboudt, London, New York 1968.

Christo, by Lawrence Alloway, London, New York 1969.

Chryssa, by Sam Hunter, London, New York 1974.

Couturier, by Ionel Jianou, Paris 1969.

Frink, Elizabeth, The Art of, by Edwin Mullins, London 1972.

Epstein, by Richard Buckle, London 1963.

Gonzalez, by P. R. Descargues, Paris 1971.

Greco, Emilio: Pàpa Giovanni, by Giovanni Fallini, Rome 1967.

Hajdu, by Robert Ganzo, Paris 1971.

Hauser, by Gerhard Bott, Institute of Modern Art, Nuremberg, 1970.

Hepworth, by Alan Bowness, London, New York 1971.

Kemeny, by Gaeton Picon and Rathka, Paris 1973.

Lipchitz, J., My Life in Sculpture, London, New York 1972.

Maillol, by Waldemar George, Paris 1971.

Manzù, by John Rewald, London 1967.

Marini, Marino, Sculpture, Painting and Drawing, by A. M. Hammacher, London 1971.

McWilliam, by Roland Penrose, London 1964.

Moore, (*Henry Moore on Sculpture*), ed. Philip James, London 1966, New York 1971.

Nakian, by Frank O'Hara, Museum of Modern Art, New York 1966.

Noguchi, Isamu, A Sculptor's World, New York 1966, Tokyo 1967, London 1968.

Rodin, by Ionel Jianou and L. Goldscheider, London 1967.

Smith, David, Sculpture and Writings by David Smith, ed. Cleve Gray, London, New York 1968.

Smith, Tony, by Lucy R. Lippard, London, New York 1972.

Ubac (various contributors), Paris 1970.

Underwood, Leon, by Christopher Neve, London 1974.

Wotruba by Heer, Neuchâtel, Switzerland 1965.

Zadkine by Ionel Jianou, Paris.

See also Strachen, W. J., 'The Sculptor and His Drawing', in *The Connoisseur*, (1) Reg Butler, March 1974; (2) Bernard Meadows, April 1974; (3) F. E. McWilliam, May 1974; (4) Kenneth Armitage, July 1974; (5) Lynn Chadwick, August 1974; (6) Geoffrey Clarke, September 1974; (7) Elisabeth Frink, 1976.

List of illustrations

Dimensions are given in centimetres and inches, height alone or preceeding length and depth. Dimensions of drawings, which show a comparatively small range of variation, are given only where format is particularly relevant, or when a drawing has been enlarged on reproduction.

COLOUR PLATES

MONOCHROME ILLUSTRATIONS

263 Studies for *The Hoop*. Pencil.

265 Maquette for *The Hoop* 1934. Plaster for bronze 21 (8¼). Galerie Louise Leiris, Paris.

347 *The Bird of Marriage* 1952. Bronze 47.5 (18⅝).

348 Study for *The Bird of Marriage* 1952. Pen. Musée de Beaune.

358 Sketch for *Dance* 1934. Pencil.

359 *Dance* 1934. Plaster for bronze 38 × 41.5 (15 × 16¼).

415 *Paul Eluard* 1947. Bronze 43 (16⅞).

416 Drawing for *Paul Eluard* 1946. Pen and ink.

BERNINI, Gianlorenzo

10 Drawing for equestrian monument to Louis XIV 1671–7. Pen and wash, black and sepia ink. Museo Bassano, Bassano del Grappa.

11 Maquette for equestrian monument to Louis XIV 1671–7. Terracotta. Galleria Borghese, Rome.

12 *Marcus Curtius* (as altered by Girardon; originally *Louis XIV*) 1671–7. Marble *c.* 200 (78¾). Versailles.

18 Drawing for *Fonte del Tritone*. Pen and wash. Royal Library, Windsor Castle. Reproduced by gracious permission of Her Majesty the Queen.

19 *Fonte del Tritone, c.* 1632–40. Travertine marble. Piazza Barberini, Rome.

BERROCAL, Miguel

299 Working drawing for *Caryatid*. Gouache.

300 *Caryatid* 1966. Interlocking sectional sculpture with 22 elements in wrought and welded steel, frosted bronze finish, 38 (14⅞).

BOUCHARDON, Edmé

14 Working drawing for equestrian monument to Louis XV 1750s. Cabinet des Dessins, Louvre, Paris.

15 Maquette for equestrian monument to Louis XV 1750s–60s (one of many preparatory studies for the final bronze of 1763, destroyed in the Revolution). Wax. Musée de Besançon.

20 Study for *The Marne* 1739–43. Sanguine chalk. Cabinet des Dessins, Louvre, Paris.

21 *Fountain of the Four Seasons* 1739–43 (upper portion). Marble. Rue de Grenelle, Paris.

BOURDELLE, Antoine

132 Study for *The Urn* (torso). Pen and ink and sepia wash. Musée Bourdelle, Paris.

133 Study for *The Urn* (torso). Pen and ink and sepia wash. Musée Bourdelle, Paris.

134 *The Urn* (torso), *c.* 1928. Bronze 98 (38⅝).

323 Equine study from life for the monument to General Alvear 1915. Pen and wash.

324 Monument to General Alvear 1923. Bronze 5.5m (18ft). Buenos Aires.

325 Modello (detail) for the monument to General Alvear, *c.* 1915. Bronze.

351 Sketch of Isadora Duncan 1911. Pen and ink. (Printed reversed for comparison with the sculpture.)

352 Maquette for *The Dance*. Plaster.

353 Plaster for high relief on theme of *The Dance* (Isadora Duncan) 1912. For bronze on Théâtre des Champs Elysées 177 × 150 (69⅝ × 59). Musée Bourdelle, Paris.

354 Sketch for relief on theme of *The Dance* (Isadora Duncan) 1912 Pen and ink.

395 *Portrait of Anatole France* 1919. Bronze 60 (23.5). Musée Bourdelle, Paris.

396 Working drawing for bust of *Anatole France* 1919. Musée Bourdelle, Paris.

397 Study for *Beethoven aux grands cheveux* 1889. Pen and wash 15 × 14 (5⅞ × 5½).

398 *Beethoven aux grands cheveux* 1889. Bronze 47 (18½). Musée Bourdelle, Paris.

421 Sketch of Mme Bourdelle at the British Museum. Pen and ink. Musée Bourdelle, Paris.

423 *Penelope with Spindle* (small version), *c.* 1907. Bronze 26 (10¼). Musée Bourdelle, Paris.

BRANCUSI, Constantin

220 *Portrait of Princess X* 1916. Polished bronze on limestone base 55.9 (22). Philadelphia Museum of Art, Louise and Walter Arensberg Collection.

221 Drawing for *Portrait of Princess X, c.* 1913–15. Pencil and crayon. Philadelphia Museum of Art, Louise and Walter Arensberg Collection.

401 Study for *The New-born* 1914. Pencil and gouache on beige paper. Philadelphia Museum of Art, Louise and Walter Arensberg Collection.

402 *The New-born* 1915. Marble 12.7 × 21.6 × 15.2 (5 × 8½ × 6). Philadelphia Museum of Art, Louise and Walter Arensberg Collection.

408 *Mlle Pogany* 1913. White marble 44.5 × 30.5 × 22.2 (17½ × 12 × 8¾). Philadelphia Museum of Art.

409 Drawing for *Mlle Pogany* 1912. Pencil and charcoal. Philadelphia Museum of Art, A. E. Gallatin Collection.

BROWN, Ralph

69 *Pastoral* 1963. Aluminium relief 55.9 × 78.7 (22 × 31).

70 Drawing for *Pastoral* 1963. Pencil. Collection the artist.

71 Drawing for *Lovers* 1971. Pencil 38 × 48.2 (15 × 19).

72 *Lovers V* 1972. Aluminium relief 91.5 × 111.8 (36 × 44). Collection Duke of Bedford (and others).

232 Study for head of *Stepping Woman* 1962. Pencil.

233 Study of *Stepping Woman* 1962, for *The Queen* 1962. Pencil.

234 *The Queen* 1962. Bronze 185.4 (73). Leicester Galleries, London.

BURY, Pol

387 Drawing for *43 Eléments se faisant face* 1968. Pen and ink, green and blue chalk. Galerie Maeght, Paris.

388 *43 Eléments se faisant face* 1968. Stainless steel 200 × 50 × 60 78¾ × 19⅝ × 23⅝). Galerie Maeght, Paris.

389 Drawing for *25 Eggs on a Tray*. Pen and coloured inks.

390 *25 Eggs on a Tray* 1969. Polished stainless-steel electro-magnetic mobile 50 × 50 × 20 (19⅞ × 19⅞ × 7⅞).

BUTLER, Reg

116 Study for *Three Watchers* (for *Unknown Political Prisoner*). Wash and indelible pencil.

117 Study for *Unknown Political Prisoner*. Wash and indelible pencil. Tate Gallery, London.

118 Study for *Unknown Political Prisoner* 1951–2. Collection the artist.

119 Detail of maquette for *Unknown Political Prisoner*. Bronze and steel wire 43.8 (17¼).

185 *Stooping Nude* 1969–70. Painted bronze 222.2 (87½). Pierre Matisse Gallery, New York.

186 Study for *Stooping Nude*. Pencil.

187 Study for *Stooping Nude*. Pencil.

370 Study for *Figure in Space*. Pencil.

371 *Figure in Space* 1959. Bronze 61 (24). Private collection, USA.

372 *Figure in Space* 1958–9. Bronze 142.2 (56). Two casts, Public Collection, Frankfurt, and Brandeis University, Mass.

373 Drawing related to *Figure in Space* 1958. Pencil. Collection the artist.

CALDER, Alexander

268 *Family with Sculptures* (incorporating drawing for *Double Helix*) 1944. Pencil 57.1 × 78.1 (22½ × 30¾). Perls Galleries, New York.

269 *Double Helix* 1944. Bronze, mobile sculpture in three pieces 83.8 (33). Perls Galleries, New York.

270 *Sculpture Project II*, study for *Black Fungus* 1944. Pen and ink.

271 *Black Fungus* 1957. Iron stabile *c.* 2.8m (9ft).

384 Working drawing for Unesco mobile. Pen and ink.

385 Drawing for *On One Knee* 1944. Pencil and crayon.

386 *On One Knee* 1944. Bronze, mobile, 6 pieces 101.8 (44½).

CANOVA, Antonio

29 Sketch for *Paolina Borghese as Conquering Venus* 1805–7. Pencil. Museo Bassano, Bassano del Grappa.

30 *Paolina Borghese as Conquering Venus* 1805–7. Marble, life-size. Museo di Villa Borghese, Rome.

35 Drawing for *Italian Venus*, *c.* 1810–12. Pen and ink on Ingres paper. Museo Bassano, Bassano del Grappa.

38 *Italian Venus*, *c.* 1810–12. Marble, life-size. Palazzo Pitti, Florence.

39 Drawing for *Italian Venus*, *c.* 1810–12. Pencil. Museo Bassano, Bassano del Grappa.

42 Model for *Dancer with Hands on Hips* 1806–10. Plaster. Gypsoteca Canoviana, Possagno.

43 *Dancer* 1806–10. Marble, life-size. Palazzo Corsini, Rome.

CARPEAUX, Jean-Baptiste

22 Sketch for *Fountain of the Four Quarters of the World*. Cabinet des Dessins, Louvre, Paris.

23 Maquette for *Fountain of the Four Quarters of the World*. Clay. Louvre, Paris.

24 Model for *Fountain of the Four Quarters of the World*. Bronze. Louvre, Paris.

52 Study for *Ugolino*, *c.* 1857–61. Pen and ink. Cabinet des Dessins, Louvre, Paris.

53 *Ugolino* 1857–61. Marble version. Tuileries Gardens, Paris.

54 Study for *Ugolino*, *c.* 1857–61. Pencil. Cabinet des Dessins, Louvre, Paris.

55 Model for *The Dance* 1862. Plaster. (Euville stone version recarved by Paul Belmondo 1969.)

56 Study for *The Dance*, *c.* 1865–9. Pencil. Cabinet des Dessins, Louvre, Paris.

57 Study for *The Dance*, *c.* 1865–9. Pencil. Cabinet des Dessins, Louvre, Paris.

58 Sheet of studies for *The Dance*, *c.* 1865–9. Pen and ink. Cabinet des Dessins, Louvre, Paris.

CÉSAR

101 *Arrachage* (paper-tearing) 1961. 64 × 50 (25¼ × 19⅝). Galerie Claude Bernard, Paris.

102 *Pied de Vestiaire* 1958–60. Bronze 139 × 80 (55½ × 32). Galerie Claude Bernard, Paris.

CHADWICK, Lynn

244 *Seated Pair* 1968–9. Pencil and wash.

245 *Seated Pair* 1973. Bronze, man 170 (65), woman 173 (66⅛).

246 Group of *Elektras* 1969. Bronze 218 (86½). Collection the artist.

276 Study for *Inner Eye* 1951. Pen and ink.

277 Study for *Inner Eye* 1951. Pen and ink.

278 *Inner Eye* 1952. Welded iron and crystal 258.5 (90). Museum of Modern Art, New York.

338 Sketch for *Lion*. Pen and ink.

340 *Lion* 1960. Bronze, cast from welded iron frame 106.6 (42). Israel Museum and elsewhere.

377 *Winged Figure* (*Stranger*) 1960. Pen and wash 41.5 × 54.5 (16¼ × 21½). Marlborough Fine Arts Ltd.

378 *Stranger(s) IV* 1959. Bronze 61.5 (24).

254

CHATTAWAY, William

179 *Study of Reclining Figure*. Wash drawing.

180 *Reclining Figure* 1962. Bronze l. 45.5 (18).

405 Drawing related to *Skull II*. Pencil.

406 *Skull II* 1965. Plaster for bronze 35 (15).

CHAUDET, Denis-Antoine

47 Drawing for niche sculpture. Pen and ink. Cabinet des Dessins, Louvre, Paris.

CHILLIDA, Eduardo

143 Study for *Torso*. Pen and ink 31 × 28 (12 × 9⅛).

144 Master cast of *Torso*. Plaster. Galerie Maeght, Paris.

291 *Modulation of Space* 1963. Wrought iron 55 × 70 (21⅝ × 27½). Tate Gallery, London.

292 Sketch for *Modulation of Space*. Brush and Indian ink.

CHRISTO

130 *Packed coast, project for West Coast, 15 miles long* 1968. Photo collage. Detail, whole 61 × 73.6 (24 × 29). Collection Gerd Hatje, Stuttgart.

131 *Wrapped Coast*, Little Bay, Australia 1969. One million square feet. Co-ordinator John Kaldor.

CHRYSSA

320 Work in progress on *The Gates to Times Square* 1964–6.

321 Idea sketch-book for *Times Square* piece etc. 1961–2.

322 *The Gates to Times Square* 1964–6. Welded stainless steel, neon tubing, commercial signs, rolled plans, cast aluminium, 305 × 305 × 305 (120 × 120 × 120). Albright-Knox Gallery, Buffalo. Gift of Mr and Mrs Albert A. List.

CIGOLI, Lodovico

13 Drawing of Giambologna's equestrian monument to Henry IV of France, early 17th century. Pen and brown ink, blue wash and oxidized white. Ashmolean Museum, Oxford.

CLARKE, Geoffrey

127 Drawing in *Torii* series 1965. Monotype.

128 *Torii* sculpture 1965. Cast aluminium 244 (96). Physical Training College, Bedford.

283 Monotype drawing for *Battersea I* 1962. Monotype, one of series exhibited Taranman Gallery, London 1975. Collection Mr C. J. Hewett.

284 *Battersea Group* 1962. Sandcast pure aluminium 106.6 × 335.5 × 91.5 (42 × 132 × 36).

COUTURIER, Robert

77 *Hommage à Maillol* 1969. Wash drawing.

78 Model for *Desire (Hommage à Maillol)*. Plaster 41 (16).

147 Drawing for *Double Torso* 1963. Lithographic chalk 60 × 16 (25⅝ × 6¼).

148 *Double Torso* 1963. Stone 300 (118⅛). Sigiku-Goyen Garden, Tokyo.

260 Studies for *The Three Graces* 1967. Charcoal.

261 *The Three Graces* 1963–8. Plaster for bronze 300 (118⅛).

262 *Les jeunes filles de Dourdan*. Plaster and wire mesh for bronze 300 (118⅛). Dourdan Holiday City.

264 Maquette for a *Girl with Hoop* 1952. Bronze 46 (18⅛). Collection Hoshizaki, Japan, Eli Birer, New York etc. Shown for contrast with Beaudin's on same subject (263, 265).

DESPIAU, Charles

155 Drawing for *Assia*. Pencil.

156 Model for *Assia*, c. 1938. Plaster for bronze 91.4 (72).

DODEIGNE, Eugène

149 Drawing for bronze *Torso* 1965. Pencil.

150 *Torso* 1967. Bronze l. 122 (48). Shown upside down for comparison with drawing. Collection H. R. Süess.

151 Drawing for carved stone *Torso* 1965. Charcoal.

152 *Torso* 1966. Soignies stone. Over life-size.

217 Studies for *Seated Figure*.

218 Studies for *Hidden Hands*. Charcoal heightened with white chalk.

219 *Seated Figure*. Soignies stone 235 (84).

DONATELLO (Attrib.)

40 *Drapery study*, probably mid-15th century. Musée de Besançon.

DONATELLO

41 *Judith and Holofernes*, c. 1456–60. Probably originally a fountain. Bronze 236 (93) with base. Piazza della Signoria, Florence.

EPSTEIN, Jacob

83 Full-scale model for *Maternity* 1907. Plaster.

84 *Maternity* 1908 (mutilated 1937). Photographed on the B.M.A. building in the Strand, London. Portland stone.

85 *Pregnant Woman*, study for *Maternity* 1907. Ink and pencil.

86 Study for *Night* 1928. Pen and conté. Collection Lady Epstein.

87 Study for Night 1928. Pen and conté. Collection Lady Epstein.

88 *Night* 1929. Portland stone relief. 244 × 244 × 91.5 (96 × 96 × 36). St James's Park Underground Station, London.

367 Working drawing for *Bowater House Group* 1957. Conté crayon. Collection Lady Epstein.

368 Sketch for *Bowater House Group* 1957. Pencil and black chalk. Collection Lady Epstein.

369 *Bowater House Group* 1959. Bronze 285.2 (114).

403 *Head of Baby* 1902–4. Bronze 25.4 (10).

404 Studies for *Head of Baby* 1902. Charcoal. Private collection.

FERBER, Herbert

297 Drawing for *Egremont* 1971. Gouache.

298 *Egremont II* 1972. Corten steel 266.8 (105). Pasadena Museum of Modern Art, California.

FRINK, Elisabeth

332 Study for *Horse and Rider* 1969. Pencil and wash.

333 Study for *Horse and Rider* 1970. Pencil and wash.

334 Studio with plaster master cast of *Horse and Rider* 1969, *c.* 213.5 (84), and *Goggle Head* in background.

341 *Studies of Birds* 1961. Pen.

342 *Winged Beast II* 1962. Bronze 36.8 (14½).

343 *Bird* 1966. Bronze 43.2 (17).

344 Drawing for *Bird* 1963. Wash 75 × 55 (29½ × 21¾).

374 *Horizontal Birdman III*, maquette for Alcock and Brown Memorial, Manchester Airport, 1962. Bronze l. 80 (31½).

375 Drawing for *Birdman* 1961. Pencil.

376 Drawing for *Birdman* 1961. Pencil.

417 *Goggle Head* 1969. Bronze (part polished) 64.8 (25½).

418 Drawing for *Goggle Head* 1966. Pencil and wash 76.2 × 55.9 (30 × 22).

GAUDIER-BRZESKA, Henri

335 *Bird swallowing a Fish*. Plaster 31.7 (12½). Kettle's Yard, Cambridge. (A bronze cast in the same collection is in the Tate Gallery, London.)

336 Drawing for *Bird swallowing a Fish*. Pen and ink. Kettle's Yard, Cambridge.

362 Drawing for *The Red Stone Dancer, c.* 1913. Ink and brush. Musée National d'Art Moderne, Paris.

363 Drawing for *The Red Stone Dancer, c.* 1913. Ink and brush. Mattzahn Gallery, London.

364 *The Red Stone Dancer* 1914. Bronze 43.3 (17). Tate Gallery, London.

GHIBERTI, Lorenzo

1 *The Scourging of Christ* 1403–24. Panel of bronze relief 42 × 39 (16½ × 15⅜). North Doors, Baptistery, Florence.

2 Studies for *The Scourging of Christ* 1403–24. Pen and ink. Albertina, Vienna.

GIACOMETTI, Alberto

165 *Large Figurine* 1960. Pencil.

166 *Figurine on a Pedestal* 1959. Bronze 60 (23⅝). Galerie Claude Bernard, Paris.

167 *Triptych* 1951. Pencil. Galerie Claude Bernard, Paris.

365 *Walking Man* 1948. Bronze 186 (73¼). Fondation Maeght, St Paul de Vence.

366 Drawing for *Walking Man* 1948. Pencil 50 × 34.5 (19⅝ × 13½).

399 Drawing for a bust of *Diego* 1955. Pencil 49 × 31 (19¼ × 12⅛). Galerie Claude Bernard, Paris.

400 *Diego* 1957. Bronze 42 × 36 (16½ × 14⅛). Galerie Claude Bernard, Paris.

GIAMBOLOGNA (Giovanni da Bologna)

8 *Cosimo I, c.* 1587–97. Bronze 4.5m (14¾ft). Piazza della Signoria, Florence.

GILIOLI, Emile

145 *The Sleeper* 1962. Carrara marble, 40 (15¾).

Drawing for *The Sleeper*. Pencil,

224 Sketch for *The Sphere*. Charcoal.

225 *The Sphere* 1947. Plaster l. 80 (31½).

411 *Portrait of Babet* 1966–7. Plaster for bronze 78 (30¾).

412 *Portrait of Babet* 1966. Charcoal and ink.

GONZALEZ, Julio

247 Study for *Cactus Man* 1939. Indian ink and coloured chalks 21 × 9 (8¼ × 3½).

248 *Cactus Man II* 1939–40. Bronze 78 (30¾).

281 Drawing in *Petite Maternité* series 1934. Pen and ink 24 × 9.5 (9⅜ × 3¾).

282 *Petite Maternité, c.* 1933–4. Copper 76 (30). Collection Madame Prévot-Douatte.

360 *Small Dancer*. Silver 22 (8⅝). Musée National d'Art Moderne, Paris.

361 *Dancer on a Midnight-blue Ground* 1941. Wash drawing. Galerie de France, Paris.

413 *Peasant Woman* 1937. Pencil.

414 *Montserrat, c.* 1930. Wrought and welded iron 32 (22⅝).

GOUJON, Jean

3 *Study of two female nudes*. Musée de Besançon.

4,5 *Nymphs of the Seine*, panels from the *Fountain of Innocents*, 1547–9. Stone reliefs. Louvre, Paris.

6 *Study of Venus and Cupid*. Black pencil. Musée de Besançon.

GRECO, Emilio

67 *Pope John visiting the Prisoners and the Sick* 1965–7. Bronze 7 × 2.75m (23 × 9ft). St Peter's, Rome.

68 Study for *Pope John visiting the Prisoners and the Sick* 1962. Pen and ink 70 × 50 (27½ × 19⅝). Pinacoteca Vaticana, Rome.

122 Drawing for *Pinocchio* 1953. Pen and ink 66 × 47 (26 × 18½). Tate Gallery, London.

123 *Pinocchio* 1953–6. Bronze 500 (197). Parco Nazionale di Pinocchio, Collodi.

124 The sculptor working on the plaster model for *Pinocchio*, Rome 1955.

168 Drawing for *La Grande Bagnante* 1956. Pen and ink 66 × 47 (26 × 18½). Tate Gallery, London.

169 *La grande Bagnante* 1956. Bronze 216 (85). Galleria Nazionale d'Arte Moderna, Rome.

HAJDU, Etienne

79 Preparatory exercise for *The Corpuscles* 1964. Brush drawing 31.5 × 45 (12⅜ × 17¾).

80 *The Corpuscles* 1968. Polished aluminium relief 39 × 54 (15⅜ × 21¼). Collection Mademoiselle A. K. Paris.

295 *Tentative XI* 1963. Direct cut duralumin 80 × 41 (31½ × 16⅛). Galerie Knoedler, Paris.

296 Drawing for *Tentative XI* 1960–6. Pencil 83 × 63 (32⅝ × 24¾).

422 *Lia* 1965. Cut and welded aluminium 127 (50). Musée de Dijon.

HAUSER, Erich

293 *Drawing No. 35* 1970. Ink 100 × 70 (39⅜ × 27½).

294 *Curved Surfaces* 1971. Polished steel 91 × 100 × 84 (35¾ × 39⅜ × 33).

HEPWORTH, Barbara

108 *Single Form* 1961. Walnut 84 (33).

109 *Single Form* (memorial to Dag Hammarskjöld) 1964. Bronze 6.4m (21ft). United Nations Centre, New York.

110 *Meridian* 1959. Black bronze against Cornish granite screen 4.57m., base 0·61m. widening to 3·05m. (15ft, base 2ft widening to 10ft). State House, London.

111 Project for *Spring Morning* 1957. Oil and ink 53.3 × 31.1 (21 × 12¼).

112 *Figures* (project for iron sculpture) 1957. Ink 36.2 × 30.5 (14¼ × 10).

279 *Oblique Forms* 1968. Oil and pencil 63.5 × 76.2 (25 × 30).

280 *Three Obliques* (*Walk In*) 1968. Bronze textured and patinated, inner circles polished bronze 299 × 457 (118 × 180). Cardiff; Long Island, N.Y.

IPOUSTÉGUY, Jean-Robert

183 Study for *Woman in the Bath* 1969. Galerie Claude Bernard, Paris.

184 *Woman in the Bath*. Bronze 150 × 200 × 109 (59 × 78¾ × 43). Galerie Claude Bernard, Paris.

KEMENY, Zoltan

285 *Optimized Image* 1962. Brass 52 × 68 (20½ × 26¾). Galerie Maeght, Paris.

286 Study related to *Optimized Image* 1962. Pencil. Galerie Maeght, Paris.

KORNBRUST, Leo

307 Drawing for *Polygonal Forms* 1967. Conté.

308 *Polygonal Forms* 1969. Marble 145 × 270 (57 × 106¼). Europapark, Klagenfurt.

309 *Polygonal Forms* 1969–70. Aluminium and stainless steel 350 × 350 × 350 (138 × 138 × 138). Wireless Headquarters, Saarlouis.

310 Drawing for *Polygonal Forms* 1969. Pen.

LAURENS, Henri

170 Sketch for *Fisher-girl* 1939. Pencil. Galerie Louise Leiris, Paris.

171 *Fisher-girl* 1939. Bronze 30 (11⅘). Galerie Louise Leiris, Paris.

172 Sketch for *Reclining Woman*. Pencil 37.5 × 55 (14¾ × 21⅝). Galerie Louise Leiris, Paris.

173 *Autumn* 1948. Bronze 170 (66). Galerie Louise Leiris, Paris.

174 *Reclining Woman with Raised Arms* 1950. Bronze 10 × 27 × 4 (3⅞ × 10⅝ × 1½). Galerie Louise Leiris, Paris.

213 Drawing for *La Femme Fleur* 1942. Pencil. Galerie Louise Leiris, Paris.

214 *La Femme Fleur* 1942. Bronze 27 × 32 × 22 (10⅝ × 12⅝ × 8⅝). Galerie Louise Leiris, Paris.

LEONARDO DA VINCI

9 Sketches for an equestrian monument to Trivulzio, *c.* 1506–13. Pen and ink. Royal Library, Windsor Castle. Reproduced by gracious permission of Her Majesty the Queen.

LIPCHITZ, Jacques

204 Working model and plaster for *Prometheus* (destr.).

205 Armature for the plaster model of *Prometheus*.

206–7 Studies for *Prometheus*. Pencil.

208 First model for *Prometheus* 1936. Plaster 45 (17¾).

209 *Prometheus*. Bronze 38 (15).

210 Maquette for *Between Heaven and Earth* 1958. Bronze 116.8 (46). Marlborough Gallery, New York.

211 The sculptor at work on plaster for *Peace on Earth* (*Between Heaven and Earth*), commissioned for Performing Arts Center, Los Angeles, California, September 1957. Total height 3.60m. (11¼ft).

212 Study for *Between Heaven and Earth* 1958. Ink and pencil. Marlborough Gallery, New York.

LIPTON, Seymour

249 Drawing for *Sentinel* 1959. Crayon on typing paper 20.3 × 28 (8 × 11). Collection the artist.

250 *Sentinel* 1959. Nickel-silver on monel metal 206 (89). Collection Yale Art Gallery, Yale University, New Haven.

251 *The Defender* 1963. Nickel-silver on monel metal 185.7 (81). Collection the artist.

252 Drawing for *The Defender* 1963. Crayon on typing paper. Detail, size of whole 20.3 × 28 (8 × 11). Collection the artist.

266 Drawing for *The Sorcerer* 1957. Crayon on typing paper 20.3 × 28 (8 × 11). Collection Mr and Mrs Alvin Lane, New York.

267　*The Sorcerer* 1957. Nickel-silver on monel metal 153.6 (60½). Whitney Museum of American Art, New York.

LOBO, Baltasar

193　Sketch for marble *Mother and Child, c.* 1949. Pen and ink.

194　*Mother and Child* 1953. Marble l. 52 (20½). Collection Pignon, Paris.

195　*Woman and Child* 1949–50. Bronze l. 52 (20½).

196　Drawing for bronze *Mother and Child* 1949. Wash.

197　*Woman and Child*, model for *Maternity* 1950. Plaster, partly carved.

198　*Maternity* 1950. Bronze 26 (10¼).

MAILLOL, Aristide

120　Drawing of Dina Vierny. Black pencil 100 × 38 (39⅜ × 14⅞). Collection Dina Vierny.

121　*The River (La Garonne)* 1938. Bronze, over life-size. Tuileries Gardens, Paris.

157　*Young Woman Crouching* 1900. Bronze, life-size.

158　Study for *Young Woman Crouching*. Sanguine and chalk.

159　*Venus with Necklace* 1918. Bronze 176.5 (34¾). Tate Gallery, London.

160　Plaster for *Venus with Necklace*. Life-size.

161　*Action in Chains* 1905–8. Bronze 119.4 (47). Musée National d'Art Moderne, Paris.

162　*Torso*, for *Action in Chains*, 1904–5. Bronze (fragment) 130.2 (51¼).

MANZÙ, Giacomo

61　*Angel of the Assumption*, study for the *Gates of Death* 1962. Pencil. Raccolte Amici di Manzù, Ardea.

62　Idea sketch for *The Death of Abel*, subject for the *Gates of Death* 1961. Pen and ink. Raccolte Amici di Manzù, Ardea.

63　*Gates of Death* 1964. Bronze relief 7.65 × 3.65m (25 × 12ft). St. Peter's, Rome.

64　*Death on Earth*, study for the *Gates of Death* 1963. Pencil, pen and ink.

65　*Death on Earth*, study for the *Gates of Death* 1963. Pencil. Raccolte Amici di Manzù-André.

66　*Death on Earth*, model for panel for the *Gates of Death* 1963. Plaster for bronze 61 × 31 (24 × 12).

177　*Reclining Figure*, study for *Susanna* 1937. Pen and ink. Tate Gallery, London.

178　*Susanna* 1942–52. Bronze 50 × 174 × 51 (19¾ × 68½ × 20). Tate Gallery, London.

181　*The Lovers* 1968. Plaster for bronze 125 (49⅛).

182　Study for *The Lovers* 1966. Pencil and pastel. Raccolte Amici di Manzù, Ardea.

426　Study for *Seated Cardinal* 1958. Pen and wash.

427　*Seated Cardinal* 1968. Bronze 80 (31½). Rosenberg Gallery, New York.

MARINI, Marino

141　*Pomona Composition* 1949. Oil on canvas 160 × 100 (63 × 39⅜). Kunsthaus, Zurich.

142　*Pomona* 1941. Bronze 160 (63). Musées Royaux des Beaux-Arts, Brussels.

326　Drawing related to *Miracolo* 1956. Tempera on canvas 83.5 × 62 (32⅞ × 24⅜). Kunsthaus, Zurich, gift of W. and N. Bär.

327　*Miracolo* 1953. Bronze 255 (100⅜). Städtische Kunsthalle, Mannheim.

328　Study for *Horse and Rider* theme 1953. Tempera. Pierre Matisse Gallery, New York.

329　Study for *Horse and Rider* theme 1959. Tempera. Collection Dr and Mrs Sarnoff, Bethesda.

330　Study for *Horse and Rider* theme 1958. Watercolour and ink. Private collection.

331　*Horseman* 1949–51. Carved and painted wood 180 (70⅞). Kunstverein, Düsseldorf.

355　Study for *Dancer* 1952. Mixed media. Collection Baron Lambert, Brussels.

356　Study for *Dancer* 1952. Mixed media. Collection Dr Max Fischer, Stuttgart.

357　*Dancer* 1952–3. Bronze 155 (61), Koninklijk Museum, Antwerp.

MASON, Raymond

73　*Crowd study* 1963. Indian ink. Galerie Claude Bernard, Paris.

74　*Odéon Crossroad* 1958–9. Bronze relief 16 × 10 × 27 (6¼ × 4 × 10⅝). Galerie Claude Bernard, Paris.

McWILLIAM, F. E.

125　Studies for *Hampstead Figure*, for Hampstead (now Camden) Civic Centre, London.

126　*Hampstead Figure*, 1964, for Hampstead Civic Centre, London. Bronze 244 × 213 × 152 (96 × 84 × 60).

175　Studies for *Girl on a Raised Arm* 1969. Sepia felt pen.

176　*Girl with Raised Arm*. Mat and polished bronze, flat surfaces engraved 18 × 26.5 (7 × 10½).

228　Studies for head of *Princess Macha* 1957. Pen and ink.

229　*Princess Macha* 1957. Bronze 244 (96). Altnagelvin Hospital, Londonderry.

230　Drawings for *Princess Macha* 1956. Conté crayon.

231　Wax model for *Princess Macha*.

424　*Portrait Figure* (Elisabeth Frink) 1956. Bronze 183 (72). Harlow New Town, Essex.

425　Studies of Elisabeth Frink for *Portrait Figure* 1956. Pen and ink.

428　Drawings in *Women of Belfast* series 1972. Blue felt pen and wash.

MEADOWS, Bernard

91 Idea-sketch for sculpture project for Eastern Counties Newspaper building, Norwich, 1969–71. Pencil.

92 *Help* theme related to Norwich period. Pencil and watercolour for bronze.

93 Sculpture on Eastern Counties Newspaper building, Norwich, 1969–71. Polished bronze and granite agglomerate, 3 × 6 × 1.5m (10 × 20 × 5ft).

226 *Pointing Figure with Child* 1966. Polished bronze 76.2 (30). Churchill College, Cambridge.

227 Study for *Pointing Figure with Child* 1965. Pencil and watercolour.

337 Studies on *Crab* theme 1953–4. Pencil and watercolour. Collection Director C. M. Berger, Halmstad, Sweden.

339 *Crab* 1953–4. Bronze 33 (13). Clare College, Cambridge.

MICHELANGELO

25 *Torso of a river god*, c. 1520. Clay and oakum over wood. Accademia, Florence.

26 Working drawings for a recumbent statue (*Day*), c. 1520–5. Pen and brown ink. British Museum, London.

27 *Night*, c. 1520–4. Marble 191 (75). Medici Chapel, Florence.

28 Study for *Night*, c. 1520–4. Black chalk over sketch made with stylus, pen and light brown ink. British Museum, London.

31 *Bruges Madonna*, c. 1504–6. Marble 126 (49⅝). Church of Notre Dame, Bruges.

32 Sketch for *Bruges Madonna*, c. 1504. Pen and ink. British Museum, London.

33 *Madonna and Child* (*Madonna lattante*) 1524–34. Marble 223 (88). Medici Chapel, Florence.

34 Study for Medici *Madonna and Child*, c. 1520–4. Pen and ink. Albertina, Vienna.

MODIGLIANI, Amedeo

407 Drawing on *Head* theme. Charcoal and conté.

410 *Head*, c. 1913. Euville stone 63 (24¾). Tate Gallery, London.

MOORE, Henry

44 *Fragment* 1957. Bronze l. 18 (7¼).

45 *Draped Reclining Woman* 1957–8. Bronze l. 239 (102). Federal Parliament, State of Baden, Stuttgart.

46 *Draped Torso* 1953. Bronze 83 (35). Ferens Art Gallery, Hull.

89 *North Wind* 1928–9. Portland stone l. 244 (96). St James's Park Underground station, London.

90 Idea-sketch for *North Wind* 1928. Pencil and sepia wash.

105 Sketches for Unesco *Reclining Figure* 1956. Pencil.

106 Unesco *Reclining Figure* 1957–8. Roman Travertine marble 244 (96). Paris.

107 Sketches for Unesco *Reclining Figure* 1956. Pencil. Collection the artist.

188 Page from sketchbook. Detail: studies for *Mother and Child* 1925. Pen and pencil, detail enlarged, whole leaf 16.5 × 14 (6½ × 5½). Collection the artist.

189 *Mother and Child* 1924–5. Green Hornton stone 57.1 (22½). City Art Gallery, Manchester.

190 Page from sketchbook—studies for *Family Groups* 1944. Chalk, pen and watercolour. Collection Miss Jill Craigie.

191 Maquette for *Family Group* (Harlow piece) 1944. Terracotta 15.5 (6⅛).

192 *Family Group* 1955. Hadene stone 164 (68). Harlow New Town, Essex.

199 *Reclining Figure* 1945. Elmwood l. 184 (75). Originally for Cranbrook Academy, Michegan, since 1972 Fischer Fine Art, London.

200 *Reclining Figure* 1951. Plaster for bronze l. 228.5 (90).

201 *Ideas for wood carving* 1942. Chalk, pencil, pen and wash. Private collection.

202 *Draped Reclining Figure* 1952–3. Plaster for bronze (bronze patinated) 157.5 (62).

203 *Ideas for sculpture—reclining figures* 1939. Pen, pencil, chalk and wash 25.4 × 43.2 (10 × 17). Collection the artist.

239 *Standing Figure* 1951. Bronze 221 (87).

240 *Helmet Head No. 2* 1950. Lead 39.4 (15½). Private collection.

241 *Heads* 1939. Chalk and watercolour 17.8 × 25.4 (7 × 10). Collection Lord Clark.

242 *Heads No. 2* 1950. Coloured wax crayon and watercolour 57.1 × 39.4 (22½ × 15½).

243 *Standing Figures* from *Ideas for metal sculptures* series (detail) 1948. Wax chalks and watercolour, whole sheet 29.3 × 24.1 (11 × 9½).

NAKIAN, Reuben

272 *The Duchess of Alba* 1959. Direct steel l. 289.5 (114). Los Angeles County Museum of Art, Los Angeles, California.

273 Drawing in *Duchess of Alba* series 1959–60. Ink and wash 31 × 36 (12¼ × 14¼). Los Angeles County Museum of Art, Los Angeles, California.

274 Drawing in *Mars and Venus* series 1959–60. Wash, brush and ink 36.5 × 42.9 (14 × 16⅞). The Museum of Modern Art, New York (gift of Charles Egan in memory of J. B. Neumann).

275 *Mars and Venus* 1959–60. Welded steel, painted l. 411.5 (162). Albright-Knox Gallery, Buffalo, New York.

NEVELSON, Louise

301 Study for *Atmosphere and Environment II* 1966. Ink 21.5 × 28 (8½ × 11). Pace Gallery, New York.

302 *Atmosphere and Environment IX, Part II* 1966. Aluminium and black epoxy enamel 111.7 × 152.4 × 45.7 (44 × 60 × 18).

NOGUCHI, Isamu

256 *Humpty Dumpty* 1945. Black slate 167.6 (66). Whitney Museum of American Art, New York.

257 'Cut-outs' for *Humpty Dumpty* 1945. Pen and brush on graph paper.

258 'Cut-outs' for *Fish-face* ('How to Make a Sculpture') 1945.

259 *Fish-face* 1945. Black slate 61 (24).

289 *Woman (Rishi Kesh)* 1956. Cast iron l. 45.7 (18). Museum of Modern Art, New York.

290 Sketches for *Woman* 1955. Pencil.

NOLLEKENS, Joseph

48 Page from sketchbook, *c.* 1802. Pen and ink over pencil. Ashmolean Museum, Oxford.

OLDENBURG, Claes

129 *Proposed Colossal Monument for the Thames Estuary: Knee* 1966. Pencil and wash 38.2 × 55.8 (15 × 22). Collection Mr and Mrs John de Menil, Houston, Texas.

315 Drawing for *Three-way Plug* 1965. Cut-out, pencil and pen and ink 101.6 × 64.8 (40 × 25½). Collection Dr Hubert Peeters, Bruges.

316 *Three-way Plug—Hard Model* 1966. Cardboard painted with spray enamel 64.8 × 97.5 × 49.2 (25½ × 38⅜ × 19⅜). Collection Dr Hubert Peeters, Bruges.

317 Sketch for *Soft Typewriter* 1963. Pencil and watercolour 28 × 35 (11 × 13¾). Collection Karin Bergquist Lindegren, Stockholm.

318 *Soft Typewriter* 1963. Vinyl, kapok, cloth and plexiglass 69.2 × 66 × 22.8 (27½ × 26 × 9).

319 Study for *Bed and Dresser* 1963. Watercolour and crayon 45.8 × 60.3 (18 × 23¾).

PEVSNER, Antoine

382 *Birth of the Universe* 1933.

383 *Sense of Movement*. Bronze l. 61 (24). Musée National d'Art Moderne, Paris.

POLLAIUOLO, Antonio

7 Study for Sforza monument, second half of 15th century. Staatliche Graphische Sammlung, Munich.

POMODORO, Gio

96 *Crowd IV* 1963. Polished bronze 175 × 76 (68⅞ × 30). Marlborough Gallery, Rome.

97 Studies for *Crowd* 1963. Pen and ink and watercolour 60 × 50 (33¾ × 19⅝).

303 *Sun of Cerveteri* 1970. Black polyester resin 180 × 180 × 55 (70⅞ × 70⅞ × 21⅝). Martha Jackson Gallery, New York.

PUGET, Pierre

49 Sketch for a fountain, mid-17th century. Pencil. Musée de Besançon.

50 Study for *Milo of Crotona* 1683. Brush and bistre ink 37 × 28 (14½ × 11). Musée de Rennes.

51 *Milo of Crotona* 1673–82. Marble 183 (72). Louvre, Paris.

QUERCIA, Jacopo della

16 *Fonte Gaia* (detail) 1414–9. Piazza del Campo, Siena (before restoration, now in Palazzo Pubblico).

17 Drawing for *Fonte Gaia* 1414–19. Pen and ink. Victoria and Albert Museum, London.

RICHIER, Germaine

235 *The Ogre* 1949. Bronze 76 (29⅞).

236 Study for *The Ogre*. Black pencil 65 × 30 (25½ × 11¾). Galerie Creuzevault, Paris.

237 Study for *Pentacle*. Black pencil 65 × 30 (25½ × 11¾). Galerie Creuzevault, Paris.

238 *Pentacle* 1954. Bronze 183 (71).

RODIN, Auguste

59 *Adoration*, study for the *Gates of Hell* 1870–90. Sepia ink and blue gouache 18.1 × 9.2 (7⅛ × 3⅝). Fogg Art Museum, Harvard University, Cambridge, Mass.

60 *Gates of Hell* 1880–1938. Bronze 635 × 400 × 85 (250 × 157½ × 33½). Musée Rodin, Paris.

153 *Nude Study*. Pencil and wash.

154 *The Faun*. Marble 122 (48).

163 Drawing for *Crouching Woman*. Pencil and sepia wash.

164 *Crouching Woman*, *c.* 1880–2. Bronze 95 (37½). Musée Rodin, Paris.

349 *Dance Movement*, study for bronze. Pencil and wash. Musée Rodin, Paris.

350 *Dance Movement*, *c.* 1910. Bronze 31.1 (12¼). Musée Rodin, Paris.

391 Study for bust of *Dalou*. Petit Palais, Paris.

392 *Dalou* 1883. Bronze 52.1 (20½).

393 Plaster for *Balzac* 1898. Definitive plaster for bronze.

394 *Balzac*. Bronze 296 (117). Boulevard Raspail, Paris (erected 1939).

SMITH, David

253 *Tank Totem IV, Untitled* and *Tank Totem III* 1953. Steel, painted.

254–5 Studies for *Personages* and *Tank Totems* 1952. Pencil.

SMITH, Tony

304 Floorplan for *Smoke* 1967.

305 Model for *Smoke* 1967. Painted wood.

306 *Smoke* 1967. Painted wood mock-up 7.32 × 10.36 × 14.63m (24 × 34 × 48ft). Photographed at Corcoran Gallery, Washington DC, now dismantled.

UBAC, Raoul

81 *Torso*. Slate relief 100 × 57 (39⅜ × 22½). Galerie Maeght, Paris.

82 Rubbing from incised plank of wood 17 × 29 (6½ × 11½).

138 Sketch of torso 1968. Pen and ink 21 × 13.4 (8¼ × 5¼).

139 Sketch of torso 1968. Black biro 17.2 × 10.8 (6¾ × 4¼).

140 *Large Torso* 1966. Slate 100 × 57 (39⅜ × 22½).

UNDERWOOD, Leon

135 Sketches for *June of Youth* 1934. Pen and pencil.

136-7 *June of Youth* 1937. Bronze 61 (24). Tate Gallery, London.

WOTRUBA, Fritz

94 Sketches for *Figure Relief* 1956-7. Pen and ink.

95 *Figure Relief* 1957-8. Bronze 3.5 × 5.5m (11½ × 16⅛ft). Museum des 20 Jahrhunderts, Vienna.

287 Sketches for *Recumbent Figure* 1962-3. Pen and pencil.

288 *Recumbent Figure* 1963. Bronze l. 160 (63).

ZADKINE, Ossip

113 Drawing for *The Destroyed City* 1950. Pen and wash. Collection Madame Zadkine.

114 Drawing for *The Destroyed City* 1950. Pen and wash Collection Madame Zadkine.

115 Model for *The Destroyed City* 1950-1. Plaster 300 (120).

215 *Floral and Human Forms* 1964. Terracotta 43 × 58 × 12 (16⅞ × 22⅞ × 30½).

216 Drawing for *Floral and Human Forms* 1964. Pen and ink.

PHOTOGRAPHIC ACKNOWLEDGMENTS

Adelys 60; Anderson 27, 33, 38; Oliver Baker 250; Galerie Claude Bernard, Paris 73-4, 101-2, 165, 167, 183-4, 399-400; Bernis, Paris 156; John Bignell 218; Musée Bourdelle, Paris 324, 395-6, 421, 423; Fotoservizi Bozzetto 10, 29, 35, 39; British Council 75, 377; Brogi 1; Bulloz 14-5, 21, 55, 153, 160, 391-4; C. H. Cannings 83, 85, 369; Mario Carrieri 427; Cartoni 63; Geoffrey Clements 249, 251-2, 266, 315, 318-9, 345; Connaissance des Arts 362; Henri Creuzevault 236-7; Delagenière 166; Sala Dino 97; Jean Dubait *frontispiece*, 263; Egan Gallery, New York 272-3, 275; Crispin Eurich 284; David Farrell 110, 340, 378; Fischer Gallery, London 199; Fogg Art Museum 60; Florin 150; Galerie de France, Paris 248, 282, 413-4; Claude Gaspari 81, 140, 285, 291-2, 366, 388, 390;(Foto) Ghedina 42; Gimpel Fils, London 162, 293-4; Giraudon 12, 23-4, 51, 53, 382-3, 383; F. Guillbaud 361; Howard Harrison 320-1; Peter Hujar 322; Jacqueline Hyde, Paris 179-80, 405; Martha Jackson Gallery 96-7, 303; Sidney Janis Gallery, New York 129, 316-9; G. Karquel 78, 262, 264; Bruno Krupp 294; Paul Laib 84, 88; Marc Lavrillier 398; Galerie Louise Leiris, Paris *title page*, 170-4, 213-4, 265, 347-8, 358-9, 415-6; Galerie Maeght 387; Mansell-Alinari 4, 5, 8, 11, 16, 19, 25, 30-1, 36-7, 41, 43; Marlborough Galleries 210-1, 245; Maywald 121, 157-8; Lynton Monay 69; Ugo Mulas 96; O. E. Nelson 212, 346; Pace Gallery, New York 301-2; Perls Galleries, New York 268-70, 385-6; Mario Perotti 426; Claude Poilbarbe 323; Publifoto, Rome 124; Queste 77; Roger-Viollet 115; F. Catalá Rosa, Barcelona 144; Walter Rosenblum 420; Oscar Savio 61-2, 64-5, 181; Shunk-Kaldor 131; Thomas Simmons 71; David Smith 253-5; Frank J. Thomas 298; Marc Vaux 115, 161, 193, 204-5, 208-9, 215-6; Victoria and Albert Museum, London 17, 230, 384, 407; Villand & Galanis, Paris 194-5; Waddington Galleries, London, 175, 343, 375-6; Etienne Bertrand Weill 103, 223; Mottke Weissman, Paris 198

Index

Italic figures indicate monochrome illustrations, roman numerals indicate colour

DATE DUE

DATE DUE